Q-Art is an art education research, publishing and events organisation
that aims to break down barriers to art education. We ask questions,
share insight, and facilitate debate across the art education sector
through books, symposia, talks, workshops, videos and open crits.
See: www.q-art.org.uk

Other publications by Q-Art include:

Allen, J. and Rowles, S. (2013)
*15 Methods: 20 Questions – Interviews with UK Art and Design Educators
Uncovering the Process, Value and Potential of Art Education.*
Q-Art. London. ISBN 978-0-9564355-3-8

Rowles, S. (2013)
*Art Crits: 20 Questions – A Pocket Guide: Featuring Interviews with
UK Fine Art Staff on the Topic of the Art Crit.*
Q-Art. London. ISBN: 978-0-9564355-2-1

Rowles, S. (2011)
*11 Course Leaders: 20 Questions – A Collection of Interviews with
11 London BA Fine Art Course Leaders.*
Q-Art. London. ISBN: 978-0-9564355-1-4

Rowles, S. (2008)
*12 Gallerists: 20 Questions – A Collection of Interviews with
12 London Gallerists.*
Q-Art. London. ISBN: 978-0-9564355-0-7

This publication has been produced with support from a-n;
Kingston University; Swansea College of Art – University of Wales
Trinity Saint David; and The Glasgow School of Art.

Interviews for this book were gathered between January and July 2016.
All those interviewed for this publication were in their respective positions
at the time of interview. Some may have moved on since.

The book was published in October 2016 by Q-Art. www.q-art.org.uk

ISBN: 978-0-9564355-8-3

Design: Jens Dan Johansen | www.jensdanjohansen.com

Copyediting: Isabelle Gressel

'Q-Art' is the trading name of Q-Art London Community Interest
Company. Company No. 08587499.

PROFESSIONAL PRACTICE:
20 QUESTIONS

CONTENTS

ACKNOWLEDGMENTS

Special thanks to:

Dave, Amy & Ruby Allen
Jason Grant
Isabelle Gressel
Jens Dan Johansen
The Q-Art team
Ray & Sue Rowles

And to all those who participated in our research towards this book:

Jo Addison, Michael Agnew, Jesse Alexander, Libby Anson, Prof Michael
Archer, Maggie Ayliffe, Joanna Bailey, Dr Angela Bartram, Richard Bell,
Hannah Birkett, Lesley Black, Tiffany Black, Chloe Brown, Doug Bur-
ton, David Butler, Hakon Casperon, Nicola Chaimberlain, Prof. Matthew
Cornford, Susan Diab, Craig Ellis, Dr Stephen Felmingham, Mick Finch,
Brendan Fletcher, Helen Fox, Dr Mary Anne Francis, Sheila Gaffney,
Adam Gillam, Keith Grant, Dr Marianne Greated, Prof. Vicky Gunn, Jim
Hamlyn, Mark Harrison, Sophia Hayes, Kirsty Hendry, Dr Katrine Hjelde,
Dean Hughes, Dr Atsuhide Ito, Jake Jackson, Jason & Becky, Alison Jones,
Brigitte Jurack, Dr Dean Kenning, Bella Kerr, Michelle Letowska, Chris-
tian Lloyd, Prof. Fran Lloyd, Dennis Magee, John McClenaghen, Dr Neil
McLeod, Michael Mersinis, Martin Newth, Gillian Nicol, Fay Nicolson,
Laura Onions, Dr Alistair Payne, Lewis Prosser, Lesley Punton, Carla Rees,
Amanda Roderick, Soraya Rodriguez, Dr Naomi Salaman, Jeanie Scott,
Eddie Summerton, Marie Taylor, Alexis Teplin, Caroline Thraves, Mandy
Ure, Paul Vivian, Dr Ian Walsh, Richard Waring, Dr Allan Watson, Arthur
Watson, Amelia Webster, Dr Catrin Webster, Caroline Wright.

OUR PARTNERS

A note about the evolution of the book, the wider project and our partners.

We would like to thank our publication's partners: a-n[1]; Kingston University; Swansea College of Art, University of Wales Trinity Saint David; and The Glasgow School of Art, all of whose sponsorship and support made this book possible. In particular we would like to thank: Gillian Nicol (Deputy Director, a-n), Jeanie Scott (Executive Director, a-n), Mandy Ure (Acting Head of the School of Fine Art and Head of Department of Fine Art, Kingston University), Dr Dean Kenning (Research Fellow in Fine Art, Kingston University), Bella Kerr (Programme Director, Foundation Art and Design, Swansea College of Art), Dr Ian Walsh (Dean of Art and Design, Swansea College of Art), Amanda Roderick (Director, Mission Gallery, Swansea), Prof. Vicky Gunn (Head of Learning and Teaching, The Glasgow School of Art), and Dr Alistair Payne (Head of the School of Fine Art, The Glasgow School of Art).

As well as supporting our research and development time, the partners have collaborated with us over the past 18 months on a series of related events, publicity and further resources.

The idea to produce a book on the subject of how undergraduate fine art students are prepared for life after their course emerged at a symposium we organised with Swansea College of Art in June 2015.[2] This symposium looked at how the location of an art school might impact on its curriculum, who attends, and what graduates go on to do. A sector-wide audience from across the UK attended the event which a-n reported on.[3]

However, the project has its earliest roots in a 2012 report that Q-Art's founding director, Sarah Rowles, produced for a-n on the topic of professional practice in UK undergraduate fine art and applied art courses.[4] The

report was commissioned to assess what effect, if any, the then impending tuition fee rise[5] and perceived increasing employability agenda would have on the emphasis that these courses put on preparing their students for life after the course.

In Autumn 2015 we approached the partners and secured funding for the publication, and in January 2016 we invited undergraduate fine art programme leaders and their staff from all over the UK to participate in our research for the book. Between January and June 2016 we gathered 46 interviews and written responses, 32 of which are included in this publication.

In June 2016 we held a symposium in partnership with The Glasgow School of Art to unpack the themes that were emerging from the interviews and responses we had gathered.[6] Book contributors from across the UK spoke at the symposium and again, we invited a sector-wide audience to join the discussion and a-n reported on the event.[7]

Book launch: Autumn 2016 in London in partnership with Kingston University.[8]

1. a-n The Artists Information Company. See: www.a-n.co.uk

2. On 27ᵗʰ June 2015 Q-Art organized 'Green & Golden: A symposium exploring the impact of location on art education and the art school' in collaboration with Swansea College of Art, University of Wales Trinity Saint David. You can find out more and watch videos of each presentation here: www.q-art.org.uk/portfolio/symposium-location-and-art-education-swansea-college-of-art

3. See: a-n. *Location, education, art: symposium discusses art schools and importance of place.* Available from <www.a-n.co.uk/news/location-education-art-symposium-discusses-art-schools-and-importance-of-place> [Accessed September 21, 2016].

4. Rowles, S. (2013). *The lay of the land: current approaches to professional practice in visual and applied arts BA Courses.* a-n.

5. From 2012 universities in England were able to charge tuition fees of up to £9,000 per year for Home and EU students.

6. On 25ᵗʰ June 2016 Q-Art organised the 'Transitions Out of Fine Art Education' symposium in collaboration with The Glasgow School of Art. See: www.q-art.org.uk/portfolio/symposium-transitions-out-of-art-school

7. See a-n: *Life beyond art school: what next, where next, and how to make it happen.* Available from <www.a-n.co.uk/news/life-beyond-art-school-what-next-where-next-and-how-to-make-it-happen> [Accessed September 21, 2016].

8. Details not known at time of print. Refer to www.q-art.org.uk for update.

INTRODUCTION

Across many disciplines, the preparation for working life after graduation is often labelled as 'professional practice', hence its use in the title of this book. However, with no clear-cut route that an art graduate might take, the term itself, although recognized in the field of visual art education, is subject to much contestation.

Our central questions in this project were: When it comes to an undergraduate fine art education, what is professional practice? How are students prepared for life after their course and what are they being prepared for? How might attitudes and approaches be shaped by factors such as location, the wider course philosophy, and the cultural and political climate?

These seemed important questions to ask, not only because of the current economic climate of rising tuitions fees and a reduction in maintenance grants – and what this might mean for those who are thinking about studying art at undergraduate level – but also because the concept of 'professional practice' in a fine art context seems to stir controversy. On the one hand there is the practical consideration that most of those who embark on a fine art course will need to make some sort of living once they graduate, not least to pay off a substantial student loan. On the other, is the complex question about whether a fine art course has a responsibility to prepare students to earn a living once they've graduated, and if they do, what form this preparation might take and what they are preparing them for.

In our research for this book we spoke with over 75 undergraduate fine art staff from around the UK, and asked them to unpack this topic. In addition to the above questions, we asked them about the history, philosophy, and structure of their wider course; the impact of the location of their course and its demographic; about their own recollections of how

they were prepared for life beyond art school; and about their own views on the language of employability, professional practice and what defines a successful graduate. The responses we received were rich, various, nuanced and heavily shaped by context.

Perhaps unsurprisingly, many of those we interviewed told us that their courses are equipping people to continue working as artists. This simple statement however, is layered with complexity as staff offer a range of interpretations of what it is to be an 'artist'. They propose different ways of preparing students and different ideas about what it means to continue working in this way.

If we take the commonly held idea of a practising artist as someone who is making work in dialogue with the contemporary art world, then the ways that undergraduate courses support this are vast. We discovered that provision ranges from distinct professional practice sessions such as preparing CVs, writing funding applications, and pricing work, to taking part in exhibition, project and placement opportunities, through to the core pedagogy of crits, seminars and tutorials. The extent to which any of these components are assessed or identified as professional practice varies considerably from course to course. In addition to this there are examples of funded studio and residency opportunities for graduates.

As well as this perhaps more 'typical' view of what a fine art course is preparing students for, we were interested to discover that there is an increasingly holistic view of what an art practice is. A view where being an artist is also seen as possessing a set of characteristics that graduates will take with them into all walks of life, and where the physical making of art work might be something they return to as and when they can. Indeed, the model that many people will recognise – of being signed up to a gallery and making a living from continually producing work – appears to be losing its dominance as the sole marker of 'success'. This has perhaps been brought about by the tough economic climate and difficulties of maintaining a studio, the ever-growing number of fine art graduates, a recognition that very few people ever attain this lifestyle, and changing values and aspirations about what constitutes success.

Linked to this, there is also growing recognition and support for the different directions a fine art graduate might take. The book includes examples of directed and self-directed placements and initiatives that support students in pursuit of alternative destinations. The staff we interviewed described how destinations could range from work in the more commonly associated fields of museums, galleries, and teaching, to the perhaps less familiar fields of nursing and catering.

Location was a significant contextual factor in the interviews. We were fascinated by the question of how a course in a rural or even an island location fared when preparing students, and we wondered what the challenges and opportunities were in these locations. For instance, one might assume that when preparing students to go on working as contemporary artists, that the courses in major art centres such as London are at a distinct advantage. But living and maintaining a studio in the city are increasingly difficult due to high costs. This is in contrast to other parts of the UK where low rents and support for artists from councils and funding bodies make it easier for graduates to stay on in the place in which they studied. Throughout the book there are examples of institutions offering placements with their local art spaces, and taking a strong and active role in developing new art scenes and audiences.

We found that across all courses there is advocacy of the types of attributes that students can gain from an art degree, such as critical and lateral thinking, self-awareness, and the ability to experiment and take risks. It is clear that these courses share a common aim to produce graduates who are active in shaping their own future, which is invaluable in an increasingly uncertain world.

All of the texts in this book can be accessed in any order and provide a context-enriched overview of the current provision and attitudes towards professional practice across the UK.

Our three institutional partners – Kingston University, The Glasgow School of Art, and Swansea College of Art – each have a chapter made up of several interviews with a range of staff and other professionals working in the local sector. These partner chapters build a picture of the ecosystem

that the art institution is a part of and offer a multi-faceted view of the different ways an undergraduate student is supported during their course. These chapters are placed throughout the book, with single texts from staff at other institutions interspersed between them. Our fourth partner a-n has a text towards the end of the book, ahead of a short excerpt from our forthcoming project where we have been working with final year students from Plymouth College of Art.

If you are a prospective student, or a parent of one, a schoolteacher, or sector professional, we hope that this book gives you an insight into how undergraduate fine art courses are preparing students for their future. If you are a current student or teacher at undergraduate level, we hope that you use this book to gain insight into the professional practice provision across the UK, and that it offers you ideas and inspiration so that you are able to question and actively shape the future of visual art education.

PLYMOUTH COLLEGE OF ART

Dr Stephen Felmingham is the programme leader for BA (Hons) Painting, Drawing and Printmaking at Plymouth College of Art. We spoke in an office at the art school.

Can you tell me a bit about Plymouth College of Art, historically and now?
Plymouth College of Art is an art college that has always served its community. It still serves its community, that population of people in Devon in the South West who emerge in every generation, who are going to be creative, who are going to be makers. However the picture is starting to change rapidly now that we're a Higher Education Institution[1]. Nationally we're getting much more talked about and we're pulling students in from across the UK, Europe, and internationally. Then in London, we may have Nick Serota talking about the College because of the Creative School, and the Continuum,[2] and the College becoming a Tate Exchange partner.

So the college has had a long relationship with the city of Plymouth, through many manifestations. It has held this position in the culture of the city for nearly 160 years. It has always been Plymouth's art college – if you didn't go to university, if back then you weren't good enough to go to university somehow, you would probably want to do the art college route if you were creative and had something to say.

Has the role of the College changed?
Historically, like most art and design institutions, we were a technical college, putting out those designers, ceramicists, architects and artists that industry needed. In many ways we're still doing the same kind of thing. The vocational aspect of it, i.e. the link with employability and the industries that students will work in, is very strong. This is the mission for

the College now, to make sure that the students who come here leave with the skills and resources and a formed idea of the next steps they're going to take in their careers.

Is this link to employability important?
It's vital. Otherwise, why are we spending all this time teaching them technical skills, if they can't afford to practise them and have to go and stack shelves in a supermarket afterwards? So we have to make it real. We have to make it a real choice. In all of our degree programmes, that's what we're doing. You've met students today in the College that you know are going to be busy afterwards, without question.

Does Fine Art have an industry?
It can be easier to identify an industry in other programmes. In Fashion, Surface Pattern, Photography, Illustration, and so forth, those industries are really there, with doors that say, 'Design Team', and you can knock on them. It's a bit more difficult with Painting and Drawing, but nonetheless it is still possible to make that happen. We spend a lot of time working with artists and printmakers and arts organisations who take on our students in placements in the second year, and we are busy with the Creative School to give students a start in teaching if they feel that is their route.

The offer in terms of programmes of study which connect directly to industry also means that the kind of students that come here are ambitious as well as wanting to understand more about the value of making now.

Can you elaborate on what you mean by the value of making?
Yes. It's the idea that there's another language that exists outside of the 'academy', outside of what has been preferred in education as the State idea of what learning is, which is based around rational Cartesian thinking. We are in the business of teaching the other language that exists, the human language of gesture, drawing and making objects which communicates on a different level. Our mainstream school system doesn't

support it and endeavours to knock it out of us in many ways, but I think the importance of that kind of communication is growing. I think it's growing alongside the steady rise in practice-led PhDs, practice-led MAs, and practice-led education or research-led curriculums, in higher education. The Creative School has been a real success story, so it shows that the idea is percolating to parents of school age children as well.

So here, our research culture as a Higher Education Institution is about practice-led research. This means that the value of making in its own terms is also an act of research. It's not just about the object or the thing that arrives at the end, that is, if you like, just the outcome. It's about the process of making, and an understanding that, that in itself is research.

So what are you researching, as you're making?
This is a debate we're having in the College right now. For example, when we ask students to write dissertations we have different options: they can write an academic essay, or they can write a research-led piece of writing around their practice. This option is led by the practice of making. Through the process of building something, you arrive at a certain kind of outcome. You do have words associated with this, but the words don't necessarily have to describe what's happening. They could act as another set of words, which could give another, more nuanced understanding of the project.

This is almost like how poetry operates, where it can give a deeper understanding beyond the fact that there's a collection of words, it gives a deeper understanding of life, for instance. So the object or the thing, which can be a painting, or a drawing, or a ceramic, whatever it might be, or the piece of glass – is valued as the research process and outcome at the same time and the words might exist alongside to give the understanding that can come from written language.

Okay.
So let's take this a bit further – things emerge, do they not, as you make something? You start to realise a material won't work, doesn't hang

together, doesn't quite do what you want. The research then starts to get diverted by the needs of the material, or the process. Things start to change, and you might get a different outcome in the end, probably one which you didn't intend. So the material and the process are key in this, and through them the ideas emerge.

Making is inherently about material and process. To make, you have to bring stuff together, whether you dig it out of the ground, or whether it's pixels or digital media, you have to bring things together to make things. So it's kind of a negotiation with stuff, with the matter. People like Tim Ingold talk about this a lot. There's a lot of theorisation about negotiation with matter, and going with the flow rather than against the grain, that you flow with matter. And that in itself could be a practice-led research project.

Can you tell me about the ethos of the BA (Hons) Painting, Drawing and Printmaking course?

I came three years ago, and was asked to write a programme which had a material and process-led approach. I come from a fine art teaching background, I spent seven years at Leeds with a Fine Art programme there, so I kind of knew what fine art did. I also knew that drawing was my specialism, and I wanted to make that the central part of a new kind of programme of study that looked at the technical aspects alongside the critical: at the 'how' and the 'why' at the same time. Because I felt in some ways that, as a sector, we tended to let down graduates who had come to do Fine Art degrees with drawing and painting in their folders. In my experience, students would have a great time making sonic art, super 8 films and installation; and then they would arrive at graduation, and some would turn to me and say, 'This has been really good fun, but we never did anything about that painting, did we, that was in my folder?'

So I felt that if we have a duty as educators to the generation of people that arise every few years who are painters and drawers, that we were failing them through not teaching drawing, or not really thinking about d_____ nd painting, and by association, about printmaking as well.

What is the demographic on your course?

Like the rest of the sector we have around 70% female students. We also have something like 50% mature students, people who didn't in the first place understand that art school was for them, or that family or some other pressure made them do another kind of degree. The other 50% are from Foundation, A-level and are under 24 years old. This is another thing we need to talk about as a sector, that our demographic will shift because the people that will still see the value in art and design education will probably be older students, probably self-funding. Having said that, there is an incredible richness on the programme, everyone pulling in the same direction with their various life experiences.

How is the course structured over the three years?

The first year is an introductory year for painting, drawing and print-making. Students are introduced to painting and printmaking processes and they have a core drawing curriculum. The second year, they're asked to reflect on their first year, and to focus on a discipline area. If they choose to focus on print it doesn't mean to say that they don't ever paint or draw again, it just means that they will attend all the specialist printmaking workshops. It works similarly with painting and with drawing. By the time they get to the third year, we expect them to start assimilating these media. They might take a hybrid approach, so someone who's using print as a layer in painting, someone who's using drawing in a much more expanded way, and this may work through their painting. So there's that sense in which in our degree show you might see painting, drawing and printmaking in the same piece of work from a student.

We've also set up this year what we've called the 'Collaboration Series', where we've asked artists to come in and bring a real part of their practice into the studio. They make a piece of work and the students will then see or take part in this process, and even the person who's doing it is not entirely sure what's going to happen next. It's a part of the 'research-led curriculum' where everyone's in the same boat, and nobody quite knows what's going to happen next.

What's the purpose of this?

It's getting the artist to bring a risky bit of their practice in, rather than just give a presentation to students where they say 'These are my successful pieces that I'm happy with.' All this is bound up in professional practice and students experiencing the life of the artist, how you are as an artist, how you behave, and how an artist might be in their studio. It cuts through the myths and misinformation about what artists do in their studio. There's kind of a sense of 'Is that what this is about, then?' Yes, it is. It's about a kind of perpetual failure, creative failure, and a kind of anxiety because this is about you, this is about your own communication.

What is the course aiming to do? What kind of graduate is it trying to create?

When I wrote the programme I wanted to think about the kind of person I wanted to have at the end of this process. More than the fact that they would know about painting and printmaking – what could they be as well as that? What kind of person would they be? There's an idea, which is actually more of a business idea, called 'T-shaped thinking'. In T-shaped thinking the upstroke of the 'T' is the core discipline, which here in the College could be painting, printmaking, surface pattern, fashion etc. It represents a core body of knowledge that you deliver to the student over the course of three years. This gives them tremendous confidence when they walk into their chosen industry.

The cross stroke of the 'T' is an ability to empathise or to work across disciplines. So through that core knowledge they can also arrive at a place where they empathise with someone who's working in a different discipline, understand how they can have common problems, and they can work with them. So that was the kind of person that I wanted at the end. I think to deliver that core discipline we need to spend time, in the first two years of the degree, teaching them how to be confident with the tools of their practice as well as negotiating the critical aspects of learning and teaching.

Would you say that is quite a unique approach?

It certainly feels like we are unique! Students are applying to the

programme without making other choices because there isn't anything out there like us at the moment. We had trouble initially finding staff who could deliver the teaching because artists themselves hadn't had this training in the last 30 years, so it was a sort of chicken and egg situation. Finding people who not only had the knowledge, but could also teach on some of this stuff was tough. You're looking at pockets of excellence around the country where it is still held and where there are still people, who have not just understood it from watching lots of YouTube videos, but have actually come from a lineage where this knowledge has been passed on, where it is still alive.

I was telling the students about those art materials manuals you get from charity shops, from the 1950s, or even earlier Victorian ones. And you look through, and there are 12 different kinds of varnish, and you think, 'Why did they need so many different kinds of varnish? What is that all about?' We've lost that understanding.

So we say to the students, we've got enough language in this age, in terms of materials, to be able to write a short paragraph, whereas before we could write a novel. And if a material is that important, in a painting for instance, that it can affect its reading by just changing the quality of a surface, which it can, then our understanding of this language has been eroded by our lack of understanding of materials. That's fallen out of our education since… the 1960s or earlier really, I suppose.

There's been a move latterly towards a position of post-disciplinarity. But we've introduced the idea of three disciplines because we believe that these don't represent boundaries, but they're, if you like, springboards. They're things that you react against, and decide that you're not inside them, and you can move, you can work across them.

Do you have a particular idea of what you want someone to do when they leave?

That's an interesting question. That is the classic question from the open day. 'Okay. So what can people do out of this? Where's the painting, drawing, printmaking job centre, then?' Where's the ad saying, 'Artists wanted, £45,000 a year starting salary.' Well, I'd like to know where that is, because I'd like to be there first, actually, thank you very much!

So it comes down to what the course is designed to do. I've talked a little about the technical teaching and lateral thinking aspect of it, and that doesn't necessarily fly with parents, because you've got an empathetic and confident person, but there's still no job for them, somehow. I suppose in some ways I find myself in tension with the higher education sector, where employability has become the watchword, and that somehow the university sector has become kind of a funnel for industry, that we just bring people in here as a training for their future job. I believe fine art education has to produce people who can think much further ahead than that, to be problem-solvers in areas that we are not even aware exist yet.

My programme, I like to think, aspires to an older idea of university, to knowledge for its own sake, that you go to university to learn, because that in itself was intrinsically a good thing to do. Again, that doesn't fly with parents anymore! But maybe there's something about the idea of learning through a liberal arts education, which is in itself intrinsically useful for life; if we consider the idea that business leaders are now asking for fine art graduates on their boards, this idea that lateral thinking is something that a fine arts type graduate would offer doesn't seem so unlikely. The ability to be agile in your thinking, the ability to be an entrepreneur, to notice opportunities for yourself and for your practice, is the natural territory of an arts student. Certainly my students are natural entrepreneurs, and would see opportunities for studio space, exhibitions, funding, and also the opportunities in their own painting, drawing and printmaking, because that's what artists do. They have to be really fast on their feet, because the world is not going to give them a living.

So I kind of shock parents and students and say the role doesn't exist yet that the student is going to take on, and that the course is designed to grow the role around them as they move through the programme, and that we have the elements in place, that we put them through a process. I'm doing it now with the second years. We've introduced them to a range of different place-ments, from education through to printmaking studios, working with artists, studio residencies, and so on.

They can take these on and start to grow their role and an understand-ing of what they might be doing when they leave. They might also find a

placement opportunity themselves. I had a tutorial with someone before this interview, who wants to work with an art therapy unit. They want to bring that as their professional practice placement. So that student will start to work there and we give them credits for that. And that may become her job; that may become her role. She may work in that through the third year, and emerge as an art therapist and a painter. Somebody else may start to become very active in the arts sector, and start running conferences and events.

There is the idea also in the college to incubate student business ideas. Recently the enterprise team came to me and said, 'I'm sure your students would love to sell paintings on our website.' I said, 'No, we wouldn't! We really wouldn't. We can do that much better ourselves, in another way, and that's not what we call employability.'

Instead we've got students in the second and third year who can run events, who can organise things really well. I said that it would be much more interesting from our point of view for the College to start an events organising incubator company. My students would start it up, and we'd attract people who wanted to run exhibitions or conferences in the region, and they would ask the students to organise them and they'd be paid for it. That's what I call employability, and that's feeding straight back into the ethos of the programme. So it's not about us selling our paintings over the website, that's very 1990s. Let's use this core skill base that we've got here, these agile entrepreneurial students who can really run things. And let them run other stuff. So the role starts to grow as they move through the three years. So by the time they leave, it's almost seamless. They just keep doing what they've been doing.

We're kind of making the future for ourselves, in many ways.

At our Symposium in Swansea in June 2015[3], you spoke about the Student Conference. Can you tell me a bit more about this?

The Student Conference is there to debate and change things in the College, in the city, and in the region. The second years organise and run it. The first years come in, and have, if you like, the poster strand of it. They present their arts manifestos and things in it. The third years come

into it, and deliver aspects of their dissertation research. It also brings people in from the region, from the city, who are interested in the questions and the debate that the students initiate. The students asked you down here to launch their Crit Club tomorrow and that is an example of a legacy that's come from the conference. Another thing that has emerged through the conference is that the students have seen the rationale and urgency of creating a common space in the city, that the University Fine Art students and emerging artists can also be part of. They have had an idea of getting a building, separate to the institution, a neutral space that could become a space of criticality and debate where you might start holding events and shows. It may be nomadic. It may not need a building but if they do, they'll make it happen. They will stick their boot in the council door, and they will make it happen.

What is the arts scene like in Plymouth?

You could probably count the critical galleries in Plymouth on the fingers of one hand. There are lots of galleries, gallery shops in the region that are selling pictures and so forth on the high street, but the people who are showing interesting work that an audience might want to come and see, experience, and be part of, they're relatively few. More are starting to emerge, and I think they're going to come from the agency of the art school as a change-maker in its own city. The city feels very vibrant now. The students that come here realise that it's all to play for in Plymouth and they are now going to stay. They become the audience that then feeds back into the system, and everything starts to almost kind of bootstrap itself up. That's how it works. That's how it worked in Leeds and that's how I think it's going to work here.

Is that starting to happen here? Is this something you're aiming for with the course?

This is my first graduating year, so it's early days. Third year students are already starting to have shows in local galleries and be very successful in selling work; they're taking on studios in Ocean Studios, which is a new studio complex in Royal William Yard. They're already there, they're moving quite

fast. The way the programme works is by making everything happen much earlier, so the first year students already organise a show. They already start thinking about it. The second years, they're already doing it. So we will see what's going to happen next. Although I haven't had a graduating cohort yet, I think we can see it starting to happen around us now.

Are there any advantages of being in Plymouth to being in London?

Since the war Plymouth has been a working-class naval town. I think that gives it a certain set of opportunities, in the same way that it gave Liverpool opportunities in the '90s to develop from what was the remains of the docks, and their heritage. It was fertile ground if you like, and it gave them the opportunity to turn it round, to become a leading visual arts city. I think the same opportunity exists for Plymouth. The difference is here you can make a difference, whereas in London the energy can be lost in the mass of people. Here the challenge is to build an audience: you can build an audience from people who don't commonly go to art galleries, but that's quite tough. So you also need people who do go to art galleries to come and see things in Plymouth, those who are thinking critically already. Plymouth is on the coast. It means that, unlike an inland town, where you've got an audience that comes from 360 degrees around you, in Plymouth we've only got 180 degrees, because the other half is the sea. So already we've got half the possibility for audience than somewhere like Leeds, for instance.

So how do you build that audience?

I think building the audience relates to how the student demographic will change as the programme grows. Feeder colleges that used to send their students to London and Bournemouth and Falmouth are now sending some of them here. Some are those students who arrive from families who commonly talk about culture, who have got those books on the shelves. I'm not making a value judgement about those students above somebody else who is the first person from their family to go into Higher Education, because both sets of students have got different things to offer. But it's

important to have a few of the first kind in the student group, pepper them in if you like, those kind of active, knowledgeable, already kind of ahead, cultured students – because they will start to form the audience, almost like the kernel of the audience, and it will start to build around them.

Do you need to engage with London to be successful?

Plymouth is on the periphery. We talked at the conference about the centre and the periphery, and how sometimes the roles can change, and how sometimes being on the periphery is preferable as it gives us a lot more agency. London is where the market is, and is likely to be for some time, so not engaging is not an option. But the real question is whether you need to live there anymore to make it work for you. I see artists leaving London now because it has become impossible to survive, to have a studio in the midst of all the real estate. The dynamic before was to make it in London and leave for the provinces with your black book of contacts to keep you connected. I think students are making choices about not going to London to study now because of the cost, and this is going to drive change as they stay in the cities where the art school is and start to work. We are already seeing communities of artists in Colchester, Margate and so on who would in the past have been living in London.

How do the expectations of what you do next, or the preparation for it, compare to when you were at art school?

I was at Middlesex Polytechnic in the late 1980s. It was just about the people you met, and the experience. Certainly nobody talked about what was next. I remember we went on a visit to the Lisson Gallery. Nicholas Logsdail stood in front of the 25 of us and pointed at us all in turn, and said, 'Do you know, in ten years' time, only three of you will still be doing anything related to the arts?' And I thought, 'Ah, thanks, Nick, that's great. Thank you.'

But actually, he was absolutely right. About 5% of the cohort will do what is always considered to be the premium thing, an artist working in a studio, with a gallery representation. But what about the other 95%, who

go off and do other things? Remember, the important thing is, this is an undergraduate degree. It is not a preparation for being represented by the Gagosian Gallery. What can we expect to deliver in an undergraduate degree? I think we're advancing this gallery-ready idea far too quickly. People are burning out, almost. They're in danger of skipping the first part of a book, and getting to the last chapter too soon.

Is the art course aiming to produce artists?

We make artists on this programme. That's what it says on the tin. But how could we think about this as a role in society? I talk to students about, 'Well, no, you're an artist first, and you might teach as well.' So you are an artist who is also doing that. You're not taking time off; you are permanently an artist. The things that you do, the mindfulness, becomes part of your practice, whatever that is. When someone says, 'What do you do,' you say 'I'm an artist. At the moment, I'm working as a gallery explainer in Plymouth Museum.'

When do we acknowledge the fact that putting thousands of arts graduates out there every year, into a sector that is already creaking, precarious, and has hardly any money in it, may not be a viable thing to do? We need to start acknowledging that there are people who don't do the core thing, which is apparently the studio artist/gallery representation route, but that there's quite a number of other things that can be done as well, that could be equally valid. I could rattle off the list that Fine Art programmes usually give: curation, promotion, arts administration, the museum sector and so on. Of course, they could be all that, but it ignores the fact that a Fine Arts graduate, or a graduate from Painting, Drawing and Printmaking, could also be extremely successful in an entirely different walk of life, and that could also be a creative act as well. Their painting practice may drive something else which is more important to them.

And if we regard it as a liberal arts education, that it actually enhances a quality of life – and this is all probably very reactionary – that's also how you've got to look at it, because these are human beings. These are students who are paying money, but they're also people who deserve some

acknowledgement that actually it's okay, you don't have to feel guilty if you do something else after you graduate, because you have gained that ability to understand and empathise from a broad liberal arts education, and that is immensely valuable.

So who is an art education for?

I would say it's for the people who feel a strong vocation to develop their creativity, and that for them there isn't another choice. Anybody else will rapidly fall by the wayside, because it's hard work. It's one of the most difficult degrees you can do. You know, give me anything else, you can pass it. But art is a divergent discipline, there are no answers. Anybody who hasn't got that need to be here will probably not continue. The people that arrive to do this are a self-selecting group of people who know that this is what they've got to do, and there is no alternative, they have to do it. If they don't, they will probably become very depressed and unhappy.

What do you think is the role of the art school in society?

Hope, certainly. Hope. I think that the art school offers a chance, or a space in an environment where making is okay. Where being able to express yourself, and communicate through making, is okay even for a bit. Where you can find what kind of creative you are. Even if you come here and do a degree, then maybe you go off and take on another role, that oasis of time exists for you in your life and the art school operates like a shelter for the kind of creative practice which is not given space any more.

There is certainly pressure on the creative curriculum from a neo-liberal agenda – that's happening all around us now. But the art school is the centre; the flame still burns here. I think the role of the art school now is to guard the flame, to still be the space where these people can come, and we can still keep it going. It sounds a bit *Fahrenheit 451*,[4] doesn't it, really? But I think in some ways it is, there is an urgency here. The art school is a node from which it's still possible to operate in this way. Even the conversation we're having now, or conversations they're having in the studio now, these are not things you can have in other walks of life. Acts of making are not

given much space in schools, and art schools have to be there as beacons of hope for the next generation.

1. Set up in 1856, Plymouth College of Art is one of the last few remaining specialist independent art and design institutions. In 2015 it became a Higher Education Institution.

2. In 2013 Plymouth College of Art established a Continuum of creative learning and practice from age four to postgraduate level. The Red House – the Plymouth School of Creative Arts – is a 4–16 mainstream, city centre all-through school sponsored by Plymouth College of Art. The vision for Plymouth School of Creative Arts grew out of a response to the serious erosion of the arts and creativity in schools.

3. On 27th June 2015 Q-Art organized 'Green & Golden: A symposium exploring the impact of location on art education and the art school' in collaboration with Swansea College of Art. Stephen spoke at this event. You can watch a video of his presentation here: www.q-art.org.uk/portfolio/symposium-location-and-art-education-swansea-college-of-art

4. Novel by Ray Bradbury, published 1953.

NEWCASTLE UNIVERSITY

David Butler is coordinator of LifeWorkArt and BA (Hons) Fine Art Admissions Tutor in the School of Arts & Cultures at Newcastle University. David provided a written response to a set of questions that we sent him via email.

Can you tell us a bit about your own background and how long you have been working at Newcastle and coordinating LifeWorkArt?

I graduated from art school in 1974 so my art education was free and supported by a good grant. I practiced as an artist but earned an income in other ways which is how I learned to manage projects. Some of this was art related, some not – for example, working on gas conversion (well paid!) and running a performing arts programme. Between 1985–99 I was working with a-n publications[1] in various roles: editing artists newsletter, commissioning books, running conferences and professional development programmes. I then worked freelance as a consultant before joining Newcastle University in 2003. So my background was a move many people make from practising artist to working with artists on projects. That was a journey I was unaware of when at art school but which current students are very aware of, often when they come for interview.

Can you give us a brief outline of the BA Fine Art course, its ethos, structure, and an idea of who studies on it?

Fine Art at Newcastle University is a four-year programme and we have sustained this despite the rising level of fees. Newcastle had a four-year course (along with other university based courses such as the ones at Slade, Reading, Glasgow) before the polytechnics were incorporated into the university system and we have maintained that. This doesn't mean

we have a foundation year as part of the programme. The 'extra' year is spread through the course and allows substantial time for art history, professional development and international exchange without taking away from studio time.

We don't have a painting or sculpture department or any other medium specific department; we run a contemporary art programme. That doesn't stop students specialising but it does enable them to move across and combine disciplines. Art history is an important element of the programme as is professional development – both of these relating to the context of thinking about and making art and operating as an artist or in other roles in the sector.

We have about 85:15 female/male ratio. That probably mirrors most fine art programmes and begs the question: does that indicate a gender shift in the arts or will the arts remain male dominated despite the shifts in student demographics?

Can you tell us a bit about the art scene in Newcastle and any links that might exist between the art scene and the University?

Newcastle is a post-industrial city with two art schools, Newcastle University and Northumbria University. It is a relatively small city with a high level of visual art activity that has been mainly powered by the two universities through student and graduate activity. Apart from large institutions like Baltic and Tyne & Wear Museums most visual arts organisations have developed from grass roots artists' initiatives. This creates a lively and very open art scene with a number of models in it that is very fertile for students to engage with both independently and as part of teaching programmes.

A significant development over the past five years has been artists occupying empty office spaces in the city centre. This is not a new phenomenon for Newcastle or elsewhere but the scale and location are important. This is in a block right in the centre of the city, not the outskirts, and it now houses 400 emerging and established artists, four galleries, several exhibiting spaces within studios, a theatre, a DIY Maker Space, a cinema

workshop, a youth project and several established arts organisations who have moved into the zone.

This will change when redevelopment of the city centre happens but it isn't clear when that will be. In the meantime, those people are asking 'what next'? Newcastle University has a researcher in residence based in one of the studio blocks whose goal is to map and explore the activity and to ask the question: 'what new ideas for developing the city centre are emerging from this critical mass of artists and arts organisations?'

As part of this research we are talking to our graduates, so this is a very dynamic link. As the Coordinator of LifeWorkArt I've also had an active role working with artists and arts organisations: giving advice and support, working on projects together and being involved in dialogues around the future of the arts scene in the region.

Tell us about LifeWorkArt (LWA).

LWA is a professional practice programme that runs throughout all four years of the BA Fine Art course and works with the two year MFA course. It has also developed two postgraduate modules on Freelancing in Arts & Cultures available to students in the Business School and the School of Arts & Cultures. LWA has been running since 2003 when I started at Newcastle. It was set up with Higher Education Funding Council for England funding for the development of teaching and learning. The name LifeWorkArt was selected (not by me) as describing the way artists work. There is, of course, a downside to this as it also describes the precariousness of art practice that blurs distinctions between work and private life.

The aim of LWA is to support students in developing projects outside the university. These projects range across exhibiting; public art; placements with artists and arts organisations; educational, community and participatory projects; art therapy; event and festival organisation; publishing and more. They can be individual or group projects and are driven by students, not by the programme.

The introduction to LWA takes place in semester 1 of the first year through a series of weekly visits to artists, studios, and galleries. This

introduces students to the visual art ecology in Newcastle, to different models of working, and allows them to build up a network of contacts for future projects. In semester 2 all first year students put on an exhibition of work and in the past two years the NewBridge Project (studios and gallery) have collaborated with us on this. NewBridge was set up by Newcastle Fine Art graduates six years ago and pioneered the model for the current use of empty office space in the city centre mentioned above – so that is a powerful partnership for students. The exhibition is supported through workshops on planning, funding, proposal writing etc., and is delivered through student groups who are responsible for its different aspects.

So there is nothing complex about that first year structure, though it is worth noting that the delivery is very dependent on building and maintaining good working relationships with artists and arts organisations in the city. Its impact is to give students a good grounding in how to independently organise projects over the next three years of their degree. A key part is not teaching business or planning skills up front. The approach is to take a project and ask: what needs to be done to make this happen, so skills are acquired as they are needed and when they are seen as useful.

Are students assessed for LWA projects?

Assessment is through individual reflective reports that enable students to evaluate successful projects and those that may not have worked, and to analyse ongoing projects. There is an interesting question around credits for projects. LWA curriculum projects are part of 40 credit studio modules and have a credit weighting in the module (though there is a 20 credit elective LWA module in final year). However, a lot of LWA projects happen outside of the module, and the lack of credits for them seems not to bother students. They are more interested in the value they get.

What is the course designed to prepare students for?

We are preparing students to make considered decisions about what they are doing after graduation. We want them to have thought about that, to have built up a body of valuable experience and skills, to have tried

working in different situations and roles, and to have a good sense of how their choices relate to and impact on their art practice.

You mentioned that some of the areas that students develop projects in include educational projects and also art therapy. How do you think the discipline lends itself to these pathways/projects?

The teaching of art has a long tradition but there is a broader arena of work that incudes participatory, community, and therapeutic practices to name but a few. The skills and knowledge of art practice are obviously of value here but so are problem solving, working collaboratively etc. That broad range of expertise developed as an art student has value in these areas but more importantly, I think, is the interest students have in working in these areas. This isn't something that is acquired at university; students often arrive aware of and looking for these experiences. A lot of LWA projects are built around these areas of practice. These include projects set up by students and established projects that students join, for example, an ongoing project with people who have aphasia.[2]

What do people do when they leave your course? What does a 'successful' graduate of your course look like in your opinion?

Graduates work as artists, curators, in different roles in galleries and museums, in critical writing and publishing, film, TV, media. They work in education in formal and informal settings, in art therapy and related areas, in community and participatory settings. Graduates have worked in advertising, design, jewellery making. They have set up studios, galleries, workshops etc. The range is broad but generally they remain in the cultural sector. It involves freelancing and portfolio working. This probably reflects the sector generally.

It isn't our role to encourage certain routes over others. In fact we need to be careful describing what those routes might be. We can give students information and experience about how the sector works now, but the sector they will work in will be partly moulded by them and we can't predict how that will be. So the notion of a 'successful' graduate needs to be driven by how graduates measure success. That comes back to the understanding

they develop at art school about their practice and the kinds of role they see themselves playing.

Do you think art schools should have a role in preparing students for life after art school?

I find this a strange question. Art schools have always done this. The Royal Academy was set up partly to provide training for artists to improve their professional status. The rapid development of art schools in the nineteenth century was powered by the importance of art and design in industrial and commercial development. We tend to back off from those views of art education now and regard it maybe in a more purist way. That is possibly why, despite the continuing value of art and design to the economy (not to mention our cultural wellbeing), the government can take its current crazy view on the value of creative subjects in the school curriculum – with the possible outcome of there not being any!

On the more specific note of how we teach in HE I would take the Artist Placement Group[3] view that context is half the work – context being understood as meaning who you are, where you are, who you are working with, what you are trying to do etc. So students set up projects (exhibitions, screenings, community projects, whatever) and develop professional aptitudes in doing that. The important thing is that the learning of those 'professional' aptitudes is powered by the work (i.e. the project). In pedagogic terms this would be 'situated learning'. Its value is that it is quicker and it sticks. But note: like everything else a student does it demands critical reflection.

Have you noticed that fees have impacted on students' expectations and who is studying fine art?

Factors including economics, school education, university fees and maybe a growing public awareness of the arts in an institutional sense mean students arrive asking more informed questions about working as an artist or in the arts than they did ten or fifteen years ago.

Have those expectations affected what and who a fine art education is for today? Undoubtedly fees affect choice and government quotas and

entrance qualification practices affect selection. However, I'd say students are studying fine art for similar reasons as in the past: a drive to make, a need to exercise the imagination, and a questioning of themselves and the world around them.

What do you think is the role of the art school or a fine art education in society?
Numbers remain high and students value fine art for all those reasons I just gave. However, I'm not convinced they are equally valued politically. University fine art courses retain strength because HE remains a well-funded part of the education sector due to student fees. If that changes, and the government has looked at shifting some of that finance to the FE sector, then that will raise questions about value for different subjects in HE that will not just be driven by recruitment. Do we have a framework for that discussion? Do we have any shared values to power that discussion similar to the combination of cultural and economic value in the nineteenth century that prompted setting up a large number of art schools across the country? The marginalising of creative subjects in the school curriculum, despite the value of the creative sector to the national economy, would indicate not.

So one role for the art school currently is to re-establish the importance of creative production, thinking through making and cultural value within the precepts of a good education.

1.　Now a-n The Artists Information Company.
　　See: www.a-n.co.uk.

2.　'Aphasia is a condition that affects the brain and leads to problems using language correctly'. NHS. (2016). *Asphasia.* Available from <www.nhs.uk/conditions/Aphasia/Pages/ Introduction.aspx> [Accessed September 13, 2016].

3.　'The Artist Placement Group emerged in London in the 1960s. The organisation actively sought to reposition the role of the artist within a wider social context, including government and commerce'. Tate. (2016). Artist Placement Group. Available from <www2.tate.org.uk/ artistplacementgroup/> [Accessed September, 13 2016].

PARTNER INTERVIEWS

SWANSEA COLLEGE OF ART, UNIVERSITY OF WALES TRINITY SAINT DAVID

Dr Catrin Webster is the Programme Director for the BA Fine Art course and the MA Contemporary Dialogues course at Swansea College of Art, University of Wales Trinity Saint David (UWTSD). She has worked at the college since 2006. We spoke with Catrin in the Dynevor Centre for Art, Design and Media.

Can you describe Swansea as a place?

The word Swansea comes from the Vikings, it was Sweyn-ey. The original access point to Swansea for the Vikings was from the sea, which is how it grew into a really big port, but that's also why it got badly bombed in the Blitz. Swansea is right on the seafront and there is a massive five miles of sand in the city. It's not gentrified like Brighton or those types of resorts; it's actually quite an open, wild, and very beautiful beach. If you go one way you can go to the Gower, a national park. If you go in the other direction, you're up in the Brecon Beacons in half an hour. So it's got all of this amazing nature around it. It also has fantastic links with the trains because of its industrial past. It's quite exciting I think in terms of its actual geography.

What is it like as a place to work, as an artist?

I think Swansea is an incredibly rich place to live and work as an artist and that is partly due to the fact that it has an industrial heritage of making. In the recent past, the industrial side of the city has diminished but I think there is still an element of that in our culture and in the society here. It is a culture and society premised on using manual labour to create something. I think that that underpins the psychology of the city. Along with that, there is a real sense of community, as people have worked very closely together for years. I think the general populous is quite supportive

of creative endeavour, even if they perhaps wouldn't say so themselves. A little example is that I did a project about colour and landscape at the Glynn Vivian Art Gallery and they had an over-55s group. There was a gentleman who had worked as a powder coater and he was talking to me about powder coating and how you would mix colours. He understood that from an industrial background. So there's a correspondence. It isn't a perfect match but there is something about that.

The other thing about Swansea is that because so much of the traditional industries are in decline – we've just heard about redundancies at Port Talbot Steelworks and possible closure of the plant – there is a lot of unemployment in the area. That causes certain problems but it also means, partly because of the unemployment, that there is a lot of empty space and potential.

Now, practicing artists require three things: time, space and some sort of money. Somewhere like Swansea has a lot of empty space and it has been proven that some of that space can be negotiated for people to use for creative endeavours. So that's the first problem sort of resolved. If you haven't got a job, ironically that does mean that you have time. Unfortunately that doesn't supply the third element, money, but because it's relatively cheap to live here, it does also enable people to live on very limited budgets. So in terms of the greater creativity in the area, it has created a condition where it is possible for people to pursue or create something that doesn't have necessarily a market goal at the end of it.

Our high street was a very run-down area. It had mostly boarded up shops and was popular with people with drug and alcohol problems. However, the interesting thing is, just as you will have seen in Hoxton and various other places in the UK, art studios and a gallery have since opened there. Elysium took over a big empty office space and put in a gallery and various studio spaces. Now, in a very short space of time, the whole high street is being rejuvenated and gentrified.

I always say to the students, 'Nothing comes from nothing and something always comes from something. So if you do nothing, I can guarantee you nothing will happen, but if you do something, something will happen.

I don't know what that something will be and it might not be what you expect but something will happen.' I think it's that notion of being creative in its very purest form, creativity with no end purpose in mind, apart from a cultural purpose. That idea of pure creativity does seem to captivate the imaginations of people and have some greater impact.

Can you outline the philosophy of the BA Fine Art course?
We haven't got a house style and our teaching staff have very diverse creative backgrounds and interests. There is a huge diversity of approach from conceptual content to material making. We want to facilitate students to find their own voice within that.

Fundamentally, it's a studio-based course. It's all about the studio. The studio is a physical manifestation of your thought processes and it's where you explore material potentials. Even if the work is conceptually based, that happens in the studio. If there was any thought at some point that this course could be taught without studios, I would resign. I do not think that it is possible to be an artist without a studio.

The course is premised on the individual student developing their own voice and finding themselves. I tell students, 'You can take inspiration from other artists but you can't *be* another artist. The only artist you're ever going to be good at being is yourself. If you take someone like Tracey Emin, she's been successful by showing the world who Tracey Emin is. You can't be Tracey Emin, but you can find what it is in your life that's important to you and then we can find the language together for you to communicate that.' At the end of the day that is all that anybody can do. I don't believe that you can force people into styles.

Who comes on the course?
In our current first year, we've got 20 students. Over the three years, I think we have got about 70. Before fees were introduced we had almost twice that. I think historically we have recruited quite well locally and we're really keen to try and encourage people to be creative in the area. This year our intake for September is 30 plus so things are moving in the

right direction for us. We have got good relationships with schools and colleges in the area and we also run Saturday art classes and summer schools. We try to encourage people to come and have a look around the courses, come and talk to us, see what we have to offer. It's a massive commitment and I want someone to come here because they want to be here. Another thing is that we used to get quite a few part-time students.

We had a really interesting story of somebody who hadn't been through the education system, who dropped into a summer school out of curiosity, then ended up enrolling on the foundation before completing the BA and the MA. They recently wrote an essay that got 95%. That's the thing. It doesn't matter who you are or where you are, if education is working then that will work for us as society. Just because you're a single mum in her 40s who's never been through the education system, it doesn't mean that you're not the next Derrida. You could be.

I personally think that if the government wants a big injection of cash into higher education, they should go back to people like me, who have benefited from a free education. I've got a PhD, an MA, a BA. They should be asking me for a substantial contribution on my tax bill towards higher education. They should be targeting the people that have already got the jobs, not charging fees to students who might get the jobs.

Is the BA Fine Art course a modular one?

Yes and each module is coordinated by a particular member of staff and they can make it their own.

One of our staff members runs a module called 'Zeitgeist' in which he looks at what is going on in contemporary politics in the world and how artists could potentially find strategies to respond to that. Another runs a module called 'Sight and Audience'. The member of staff who delivers that is very interested in the relationship between an artwork and how it's received, the purpose of the gallery, and all of those things. I run a professional practice module in year 2.

In the first year modules can be very practical. Students will learn how to operate in the workshops. We've had students come here with no

experience of using metal who have now gone on to New York to make metal sculptures after the course.

Why do you choose the modular approach?

Modules are an underlying structure. They create a template into which each member of staff can embed their passions, experience, knowledge and current research. Modules can be more or less conspicuous depending on the approach of the staff member who is leading them. Also, people often forget that many of the students that come to this college don't know that much about the art world before they arrive and aren't familiar with the terminology we use. If I say 'site-specific' you know what I'm talking about but if you've never heard of that in that context, what does it mean? And then you have the term 'found object'. I had a really interesting conversation with an archaeologist about this. I was talking about found objects and I thought they'd know what a found object was because that's what archaeologists do, they find objects, but they didn't understand it at all. Of course, I'm talking about Arte Povera, I'm talking about Duchamp, I'm talking about re-contextualisation of an object within a gallery context. What I'm talking about is really complicated, but I don't know that I'm being really complicated because it seems straightforward to me. We have to enable our students to become familiar with all of those things that, in some way, we take for granted. Therefore the modules offer an approach to how we might want to organise and disseminate information to enable a broad understanding of the cultural context in which we work.

The modules should stimulate an interest and a curiosity, which the student then pursues in their own independent learning time. So students will have 12 hours of contact a week, through seminars, tutorials, or lectures, as part of their modules. There's then at least 60 or 70 hours a week where students have time to carry on with their own practice.

There is also loads of stuff that happens beyond the modules. We take the students to The Brecon Beacons for five days, and we sit on a mountain. They also go to the Venice Biennale, go on visits to London and Cardiff, and of course to galleries and events in Swansea.

You mentioned that you had a professional practice module. Is it through this that you prepare students for life after art school?

I think the notion of employability, or what happens after art school, is involved in all of the teaching, from putting on a show and thinking about how you communicate an idea to your audience, to your relationship to the outside world. It's also in things like learning how to use a spot welder. If you know how to weld that's a very useful tool to equip yourself with, and a very good transferable skill.

The professional practice module that I teach in the second year specifically focuses on the mechanisms and processes that you have to face if you are going to develop your career as an artist. In that module we ask them things like, 'So, when you leave college, how are you going to be an artist? What are you going to do?' and they might go, 'I don't know. I want to have an exhibition.' I say, 'Okay, so where would you have an exhibition? Would you have it in the Tate Gallery?' 'Oh yes, I'd love an exhibition in the Tate Gallery.' 'Okay, so aim for the Tate Gallery, but are you going to go there straight away? What do you think might be a process whereby you have enough exposure for your work for it to end up in the Tate Gallery? There's absolutely no reason why you shouldn't have an exhibition in the Tate Gallery, and if you want one you should make that your aim, but you have to think of it in a five-year, six-year, seven-year trajectory and be pragmatic about it. Take the steps that you need to take. So where could you show your work tomorrow?' Then they say, 'Well, there's the Elysium gallery,' which is an artist-led gallery. 'Exactly. You could use that opportunity to get somebody in to see your work. You could invite people to come and see the work. You could make a website.'

We also look at how they might fund their work, for instance through residencies or workshops. They're in groups and they go off and do some research where they'll find as much as they can about residencies and present what they find to the group. We also talk about writing a statement and a CV, and the difference between a CV that you might produce for an exhibition and a CV that you might produce for McDonald's. Our technician from the photography department has also been doing sessions

with them about how to document work in the studio space.

More generally, I expect and direct students to go to local galleries in Swansea and galleries in Cardiff. If they are going to London for a social event, they should make sure they go to the galleries whilst they're there. We try to embed that just as a way of being but it's up to the student to take that on. In terms of how to become a successful artist, students need to know how to develop that knowledge themselves because it is knowledge, and it shifts and changes all the time.

We have a third-year module called 'Marketing and Self-Promotion', which I used to teach. We would go all over Wales and meet different curators. One of the things they would always say is, 'The most important thing is that you have good images.' You're going to have to represent yourself photographically and through a statement, and those are important because that's representing you.

My colleague teaches the 'Marketing and Self-Promotion' module at the moment. She has a completely different way of doing it. The students are performing their work and they've actually become quite famous locally because they dress up as their artwork and go into Swansea city centre and they're reviewed constantly by the local newspaper. That's been really successful. That's what I'm saying about the modules – it's up to that module tutor. As teaching staff we use our expertise to deliver that module to the best of our best abilities. So for me I see it as my responsibility to use my network on behalf of my students. I can say, 'Look, there's this fantastic opportunity for you. All you've got to do is write the letter, send the CV, send the statement. Get in touch. Talk to this person,' because it's about people making connections with people.

Would you say the main aim of the course is for people to continue working as artists once they leave?

It's a good question. I think the staff's passion is art and being artists, so whether we like it or not it's kind of what we're doing. However, we are aware that there are lots of other types of employment that our students go into, which aren't always related to fine art practice.

For instance, as part of the professional practice module, they have to write a proposal and I encourage them to propose something they want to actually do. So for example there was a student who worked in a social club. She proposed to use the social club as an art studio on the days when they weren't using it and that happened. It became Red Door Studios, and it ran for a few years. Then she got a job working in arts administration. Again, do something and something will happen. We didn't know that that was going to be the outcome of that action.

I don't want the Professional Practice module to be a spurious thing that you do as part of your course because you have to. I want this to be something that's useful to students when they leave. We've had a number of artists from here go on to be, for example, the education officer for the Mission Gallery or curator at Chapter, a multi-artform venue in Cardiff. So it is possible to use this course to go into other types of art-type practice. I would say maybe five per cent of the students go on to do teacher training. Some students come in right from the outset with that as what they want to do.

Are you happy for them to do that?

Yes I am because again it is how we influence, direct and shape our culture. Nothing, potentially, is more important than teaching.

Can you support such an ambition through your professional practice module?

Yes and we do. We run a projects with local schools in which students are paid to go into a school to deliver a five-day workshop. Through that they get first-hand experience of what it's like being in a classroom. I also ran a project with a colleague from Exeter University alongside ten students, where we worked with 15 schools in the area. From that, three or four students decided that they wanted to go into teaching afterwards. There's also a substantial three-year Arts Council Wales project where they have artists going into schools. What I really would like to do is try and actually forge a better relationship with the Arts Council whereby as part of our course they get involved in that project in some way.

One other thing to add in terms of professional practice is that we have also recently added an optional fourth year to the undergraduate course, to make an integrated masters course, allowing students to leave with a postgraduate qualification, called an MArt. The MA students get studio space in the Elysium studios, which we rent. It has 24-hour access, and they are in with other professional artists. So they're not in a university context, they're actually making their work just in a professional studio. Our MDes (Master of Design) students are also in there – so they are coming from graphics, illustration, advertising etc. and we've now got a cohort of around 50 students there altogether. That's made a fantastic postgraduate platform. People who are graphic designers have ended up doing performance work, for example or making video utilising equipment they've never used before. Off the back of that students are advertising skill-swaps on Facebook.

What's the thinking behind having them in Elysium rather than in the faculty building?

For me it was trying to make that transition from being in an institution easier for them. They can go in whenever they want and they are working alongside people who are operating outside of the institution. So informally they're getting that professional practice conversation from people who are at a level that they're going to be at when they leave. Once they finish the course they have the opportunity to then rent a space at Elysium. A space this size (indicates a space about 3 x 4 metres) is about £50 a month.

Less than London!

Yes, and you can have smaller spaces for, like, £20 a month. So even if you've got the worst paid part-time job you can still probably just about afford that little space. So we're trying to develop more links with the Elysium Gallery to support them and for them to support us. The students went to the United States with an exhibition last year from the Elysium Gallery. So the gallery has a network, and the students then become

involved in that network. Again, in a low-key unofficial way they're making those contacts. They go to the openings. It's just different from being here in the art school.

In terms of that thing about London, I have heard of studio rents that are as much as £700 a month. Unless you are a commercially successful artist it's impossible to maintain a space like that. It will be interesting to see what that might mean for places in five or ten years' time, as people migrate out of London because it's unaffordable. I think Swansea is really well placed because it has got, at the moment, affordable space.

Do you have any support for graduates of the course?

Any graduate from the course can apply to be our artist-in-residence where they get a studio space here and have a show at the end. They also get paid, not a very large amount of money, for a certain amount of time a week to work with us and they tend to support the technical staff. When staff have been away I have also employed graduates so that they get some teaching experience. We're just writing some modules for evening classes and I'm keen that my recent MA graduates deliver those evening classes. I'm also looking for funding for students to do PhDs, which maybe could give them some teaching experience. That would then release some of our staff from teaching so that they could do some research, so that we have a much more joined-up relationship between research, practice and teaching. Not everybody wants to do a PhD. Not everybody wants to teach in an art college. However there are a percentage of students who do and who would be very good at it. So in terms of employability, we can try to create bridges for that to happen.

Arts Council Wales seems to be very supportive. Do you perceive that to be the case?

I think that the Arts Council is aware of the potential of the arts to contribute to the economy and also to wellbeing. One of our big problems in Wales is our health statistics – we are not a very healthy nation. We have lots of problems with mental health issues and also physical health issues. I

think there is an understanding of the correlation between creativity, self-confidence, self-expression, having a voice, and how all of that contributes to wellbeing. At one point I was involved with an art and health organisation and I read a lot of research about ideas like art on prescription. If you prescribe workshops for someone, rather than antidepressants, it actually makes that person better long-term because not only is it enabling that person to have a voice, to express themselves, to learn skills, to be creative, but it's also networking that person with other people and it's putting them in a place within their society, their community, when they might have previously been isolated.

What was your own route into teaching?

I did my foundation course at Falmouth, and a four-year undergraduate at Slade followed by an MA. I got a job as a teaching fellow at Cardiff Institute, but after that I didn't do any teaching for a couple of years as I cycled round Wales and did loads of art work and lived in a tent and crazy things like that. Then I went to The British School at Rome for a few months. When I returned I got invited to do some workshops in galleries with collections and projects, and I then got invited to do lectures and ended up doing a bit of teaching in Carmarthen for a year. I got invited here to do a lecture and on the back of that I was asked to do the professional practice course. I replaced a member of staff for a year, and when somebody retired, and I ended up applying for what was a permanent 0.4 position. After that I got the full-time job.

Do you maintain a practice?

Yes. I have just had a painting accepted into round two of the John Moores Painting Prize, so fingers crossed! What I've been doing really in terms of my practice is blocking time. So I was in Buenos Aires for a month and over Christmas on a residency. It's really important that I keep up a practice, because even little things, like for this John Moores prize, the painting I submitted is on cardboard, it hasn't got a frame, so I had to devise a way of hanging it. Then a student came to me and they said, 'I've

got this big work on paper and I don't know how to hang it.' I said, 'Well, actually, I just devised a way of hanging this.' It's things like that. If you're engaged in things, even on a very simple practical level, then that's feeding in to your teaching, isn't it? All of those little problem-solving things that you do, and obviously the bigger conceptual questions, so if I'm not engaged with it personally, then I haven't got anything to teach about.

Amanda Roderick is Director of Mission Gallery, a contemporary visual art, applied art and design gallery based on the marina in Swansea, Wales. Bella Kerr is Programme Director of the Foundation Art and Design course at Swansea College of Art (about to be the Cert HE: Art and Design Foundation). She is also Chair of the Mission Gallery Board. We interviewed them together at the Dynevor Centre in Swansea. The focus of this interview was on partnership working.

Amanda, can you begin by telling us a bit about your background and how you ended up becoming Director at Mission Gallery?
Amanda: Ok yes. I did my foundation in Swansea and I then studied a BA in Art, Design and Theory at the University of East Anglia. I had taken two years out after my foundation and during that time, became less interested in pursuing a fine art practice as an artist, which is what I had originally intended, and instead wanted to focus on a career in a gallery. I moved back to Wales in 1997 after graduating and began as a volunteer at Mission Gallery. I helped to secure more long term funding and have had multiple roles there since, such as Administrator and Development Officer, before becoming its Director five years ago.

And Bella, can you tell us a little bit about your background?
Bella: I did a foundation course at Central School and a BA in Fine Art at Middlesex. I spent a couple of years making films before doing a film-making course at Goldsmiths. I started teaching on the tail of that, initially teaching Photography on the foundation course in Maidstone. I then worked

in various art schools – Cardiff, Bristol and at Swansea leading the fine art area of foundation for two years before becoming course leader in 2004. In total I have been teaching for about 25 years. I became Chair of the Mission Gallery Board two years ago.

Can you tell us a bit about Mission Gallery and its ethos?

Amanda: Mission Gallery was set up in 1977 by a group of Swansea based artists who had studied outside of Wales and then moved back here and wanted a space to show work. During this time, Swansea was fortunate to have councillors who were very supportive of arts and culture. They gave two buildings to the artists on a peppercorn rent: Mission Gallery was originally a semi-derelict chapel built in 1868 and Swansea Studios, across the road from the gallery, was an old car showroom.

Our current vice-chair Keith Bayliss was one of the original artists and many others are still actively involved as Friends of the Gallery. It was a real labour of love for many of those artists; they renovated it and ran it on a voluntary basis for decades until 2003, and it was open every day without fail: When I started volunteering at Mission it was clear how hard working and committed everyone was, despite not getting paid. We had exhibitions by Gillian Wearing and Catherine Yass and even then we had big ambitions to be outward looking, showing work by artists from outside of Wales, as well as supporting those based in the region. In 2003 the gallery became revenue funded,[1] at last receiving secure funding which meant paid posts and a bigger budget for our programme.

In terms of our ethos, we have always trusted and encouraged artists to use the space in whatever way they want and to push themselves outside of their comfort zones. The gallery is a very powerful, unique space and it works well for site-specific shows. Some artists prefer to use the space in a more commercial way and this works well too; we try to have a few shows like this every couple of years. We have a very broad programme.

The first Director of Mission Gallery, Jane Phillips, was passionate about craft and design and had a really strong vision to introduce this element into the gallery's programme, which has continued. Selling artist's work in this

way really turned the gallery around in terms of generating its own income, as well as supporting artists and makers, because we usually buy all work from them outright.

When Jane passed away we set up the Jane Phillips Award to support early career artists with their professional development. Every year the Jane Phillips Award has different awards, residencies and bursaries for artists at various stages of their careers. The Award supports students and graduates at Swansea College of Art as well as those outside of Wales; there is a Travel & Research Bursary; International Residencies; a Curatorial Award and an Exhibition Award & Bursary, usually to support an artist with their first solo exhibiting opportunity. We also offer residencies to students at foundation level and A-level through our Raising the Bar[2] education programme, which we run in partnership with Swansea College of Art. This initiative gives the students the opportunity to work alongside professional artists and designers in a series of master classes in different areas, including drawing, fashion & textiles, architecture, glass, photography, and curating and contemporary arts practice. We regularly work in partnership with the National Waterfront Museum to show the outcomes of these residencies.

Can you tell us a bit about what the art scene is like in Swansea? We noticed as we walked here from the station that the high street looks a lot different from when we visited here a year ago. It seemed like there were more galleries ... and also a cinema front?

Amanda: Yes, there's Cinema & Co, Bloc and Volcano...

Bella: ... there's also Galerie Simpson. Cinema & Co is an independent cinema set up by Theo Tennant, who is in the middle of a degree at Central Saint Martins. I think he came here because he has relatives living locally and has worked out that you can get cheap space here to do something like this. Elysium was also on the High Street at one stage but has since moved to various other places in the city.

What is Elysium?

Amanda: Elysium is an artist led, self-sustaining enterprise comprising

of affordable artist workspaces and a contemporary art gallery. It has spaces in four locations across Swansea City Centre. They currently look after over 100 artists and have additional project and resource spaces, including workspaces for Swansea College of Art MA students. Mission Gallery's Jane Phillips Award Residency space is also based there and is made possible because of this partnership. Jonathan Powell, the director of Elysium, has been brilliant at instigating a lot of the activity in the High Street. He is very good at connecting up with people and organisations, and we collaborate on projects together a lot.

Bella: High Street was an area of despair just two or three years ago and people were asking serious questions about what was going on, because it is the first thing you see when you get off the train. I think they have already quite successfully reinvented it.

Amanda: It definitely feels like it is changing for the better. The art college was out of town and isolated but it moved and is now more connected with the City. It's improving all the time. We have also all got quite long-term plans to work with each other. This interconnectedness between art organisations helps the whole city

Is working together important?

Amanda: It is important and really positive but only if the collaborations are authentic and meaningful and bring benefit in some way. We recently had an artist from Brooklyn come to Mission Gallery on a month long residency. She noticed straight away how everyone connects up naturally as part of an evolving creative process, providing genuine support for one another. She said the whole City felt like an art school or a college campus because of the way you can walk around it comfortably, accessing all the galleries, museums, the art college, and it is easy to meet people here.

But I also feel that sometimes we have to do it just to survive and these partnerships take time to nurture, with lots of conversations, often over many years. We invest a great deal of staff time for what may be an 'in kind' contribution, which smaller organisations are desperate for nonethe-

less. We work hard to achieve these sorts of partnerships and our strength in this area is commented upon favourably, but our capacity is often stretched.

Why do you say that?

Bella: Well, funding is being cut to local authorities and Swansea is looking at 50% budget cuts. At the same time Arts Council Wales have had a 4.7% cut. They haven't handed that on to revenue funded places like Mission Gallery this year, but in the coming years that may bite. We have also got the elections coming up in Wales in May and then the EU Referendum. Swansea gets a lot of European money, it always has done. We are on a tipping point, but no one knows which way it is going to tip except probably towards less money overall – but it might not be as simple as that. It might not be an overall cut, it might be that some things are preserved and other things are not supported in the future. There are all sorts of possibilities emerging at the moment and all sorts of concerns about what may happen over the next two or three years.

The city art gallery, the Glynn Vivian, is just about the reopen its doors after an £8.5m redevelopment. There's a possibility that they could be turned into a trust or have funding removed by the local authority who currently run the gallery, or by the Arts Council. They have to renegotiate their relationship with everybody and then that has a knock-on effect for Mission. It is a web of interconnectedness.

Amanda: It is very much a changing landscape. Mission are going through a capital redevelopment[3] as well, where we will be looking to move offsite and work in various locations around the city. Although this is a practical issue and something that we will have to do because of our redevelopment, it is also an important part of our creative strategy, how we like to work and collaborate.

Bella: As chair of Mission Gallery I have been involved in negotiations with the Arts Council about how this redevelopment is funded.

Amanda: We have had to examine how we work, and almost take the organisation apart to see how we can do things differently and become

more sustainable. This was initially because of the development and it's the kind of scrutiny you would expect when a project of that magnitude begins. It has had many benefits outside of that project that have been useful, and it will help us in the future in terms of how we engage with our audiences. We need to think of clever ways to merge commercial ideas with how we are still publicly funded, in order to continue supporting artists. That could be through selling their work and other things that might generate income.

Bella: One of the big things that has emerged in this process is the strength of Mission Gallery's education programme, which is supplementing education right the way through from primary to secondary level. It is also supporting a lot of education at foundation and HE level and is possibly about to pick up on the hole that has emerged in adult education since the funding cuts, perhaps stepping in to offer mature students the opportunity to go to something like a life drawing class.

What are some of the opportunities of working together in this climate?

Bella: A lot of people in a lot of cities are saying that the universities are the richest institutions. It is the one place that has secure funding as long as it is recruiting. Our University has set up a memorandum of understanding with Mission Gallery and many other cultural providers in the city, whereby even if money isn't changing hands there is an understanding that there will be a sharing of resources and assistance in kind.

I think the University has to understand how much they need the cultural providers; that it can't be an ivory tower, that it has to be permeable, and that you can't run art and design courses unless there is a gallery on your doorstep to visit. And there can't just be one gallery, there has to be two, three or four galleries, otherwise there is no critical mass of making. The Arts Council are probably also expecting quite a lot from the University. We are now in that dialogue, trying to understand how the future might shape up in terms of use of sharing space, resources, money, and personnel.

For example, the education programme Criw Celf West[4] is a big project that Mission Gallery is running over two years, that is teaching at all

levels throughout primary and secondary. To deliver something like this it is far better to negotiate and use the facilities in the University than to have to invest in facilities in the gallery. Especially with something like buying computers and software that will go out of date. The University is constantly updating and at present has the funds to do it. It also has a lot of downtime in the evenings and on Saturdays and Sundays. There are mutual needs. For the University, they have got to see the recruitment possibilities of opening up their doors to people who are attending at all levels of school education. It answers the problem of money getting thinner and thinner on the ground.

Is this relationship with the university a new thing or is it something that has always existed in some form?

Amanda: I think we have had a relationship with the university over the last 15 or 20 years and that has come about through our volunteer programme and through the fact that a lot of our exhibiting artists have been lecturers. I think nearly every visual art and craft lecturer at the University has had an exhibition in some form at Mission Gallery. We also provide a facility for professional practice for students, as staff bring their students down for talks with big name artists. A lot of the staff here are Bella's ex-students from Foundation who have come back to Swansea looking for jobs in the arts and we have provided that sort of employment. Others are volunteering whilst doing their degrees or their foundation courses.

But I think the relationship has to become more business-like and not so one-sided. I think we have to be a bit cannier about it, so that we are not just an annex of the university. I think that is beginning to be understood a lot more.

Bella: I think volunteering is good because it cuts both ways. The gallery receives the benefit of the volunteer and the volunteer receives the benefit of learning about the business. But it has been an immense gift to the university to have that free piece of learning. I think the exchange is more than fair in terms of the gallery's contribution, and I think this does need to be redressed.

Universities will complain about lack of money, but I am sitting here looking at a great big photocopier and they are all over the building. I can take my card out of my pocket and I can use it as much as I like and that is worth many pounds. There is also heat and light and all of the things that we have in excess in this room. If we were doing this interview down at Mission we would be sharing the space with a co-worker, it would be a lot colder and there would be a very small printer.

Amanda: When we do eventually go off-site, which could be another two years away, there is the offer of administrative and project space through Swansea College of Art, which will be brilliant. Mission will never be a 'big' space and I think it has been understood that we can work together on joint marketing initiatives, citywide exhibitions and projects so our presence is felt across the city, outside of the gallery walls. We have never wanted to be physically bound by the building, so this fits perfectly with our strong outreach programme and shared philosophy of collaboration.

Bella: I think that it will be hugely beneficial for the University to have professional gallery activities in the spaces of the University.

Bella, I wondered if you could tell us a bit about the Foundation course, in terms of who comes and what it is preparing people for?

Bella: We get a real cross section of local school leavers, and an increasing number of students of all ages and levels of qualification attending Foundation now. Increasingly there isn't a standard student. I think word has gone out that it is a place to re-evaluate and reinvent yourself.

In its simplest form, it is about getting students ready to progress onto BA courses and building the person for a point beyond their education. That may come sooner for a lot of them because, if they are already graduates they may not be going onto any other education, so they are going out into the world again. Or they may be leaping over BA and going directly onto an MA.

We are increasingly having to anticipate their lives. When I was a student that expanse of the BA stretched out as this luxurious place and I had all the time in the world. I think my students now see the world

pressing up against the end of the course and, with that, the need to earn money. I was funded for most of my education and then went out into a world where I could get housing and other benefits. I always worked, but there was a safety net if you had a period when you were in transition from one thing to another.

Amanda: That's also how I was able to volunteer for six years. I did some work obviously, but I was able to completely commit to Mission Gallery as we had the safety net of housing benefit and graduates haven't got that now. We do notice a difference in how much people can commit because they are more afraid of how they are going to live. If they can get paid work for that afternoon they are not going to come and work for free. It was a very different way of thinking back then.

Bella: I think the shame of that is that they now need the volunteering more than ever to succeed in the field they have chosen. This morning in the foundation studios we had a couple of great talks by two young women in their twenties about their progress through volunteering, internships and working in Venice as invigilators and how it got them to the point where they are now. They needed a certain amount of support and freedom to be able to get to that point. It is a puzzle that, increasingly, my students are trying to work out: how can they go into the world?

What is Swansea like as a place for those starting out in the arts?

Amanda: It's good in the sense of lots of affordable studio space, but there should be more spaces and opportunity for them – and despite the efforts of Mission and Elysium, this is still the case. Following graduation, there are funding opportunities for early career artists, which helps them a lot. Many of the young artists we have shown have received Production or Research and Development Grants. As Mission Gallery and many other galleries in Wales have small programming budgets these grants offer substantial support for an artist project. I don't know if that happens in England?

Bella, would you say that preparation for life after the course comes clearly through the pedagogy of the foundation course? Or do you think it is equally as important to structure additional talks like those you had this morning?

Bella: I think what we did today is an interesting example in that, while it is extra to the course in one way, it is also embedded, not only in the timetable but also physically. We have this idea that the space is our tool and that when we bring things into the space they become part of the course. Traditionally, contextual studies is taught in a lecture theatre. You all get up, leave the studio and you go to the lecture theatre, you sit in the dark and someone shows some slides. We stopped doing that because it was hard to book a lecture theatre to fit the timetable. We started to set up a projector in the studio space and moved our chairs and did talks on the spot. The same with life drawing. These days we do it in the studio and it really works because the course is happening in the space around the class.

So this morning, before visiting the Elysium studio space and Mission Gallery, we started the day by picking up our chairs and setting up a projector in the foundation studios, so that the two visiting artists could talk about their work. The artists who were speaking today talked about letting their practice evolve from making through to arts administration, curatorial roles, internships and invigilation. This is a really useful message. Considering your future is something you should do as part of your learning and your practice.

In terms of our pedagogy and the projects we introduce, I usually set a site-specific project. When you look at a site you have to look at location, you have to look at audience, you have to look at the public and private nature of your practice. This year, as the introduction to fine art, I set an art and politics project for which the students had to write a manifesto. I read them the Oldenburg manifesto *I Am for an Art*, which is wonderful. We asked students to write a six-point manifesto and to address any issues that interested them. They were encouraged to think about who they might be in the future, what kind of artist they might want to be, what kind of art they might want to make and what they

might want of their relationship with the world. Instead of just saying, 'I am here learning, I am an empty vessel, I am in education' we are immediately asking them to think beyond that, and project not only into the future, but out into the world. If they want to talk about current political, social and other issues then the manifesto, and the piece of work they make from it, is a place to present those thoughts.

Within the fine art pathway of the Foundation course is your goal to prepare people to be artists?

Bella: I think for people who want to be artists we are preparing them adequately to consider the possibility. We are also talking to them about being all sorts of other things. We are very clearly saying, 'Look there are people who run galleries, there are people who are arts administrators, there are people who write, there are people who work in all sorts of places in the creative industries or cultural industries or whatever you want to call them.' I think fine art is potentially a basis for many of those careers. A small percentage of people will be practitioners and a huge number will be working creatively and in all sorts of ways, in a far broader set of contexts.

I would say that in the last five years this is a message we have increasingly received from the students and we have put out to them more strongly. It has come from both sides.

Do you hope that your students will stay here once they have finished and contribute to the art scene in Swansea?

Bella: I hope they do the thing that is right for them. Swansea is quite a small city and the great things about a small city are all the things we have talked about. The bad thing is that if you grow up here you have to go somewhere else to experience all the other things in life. You either travel or you go and study somewhere else. For some people it is absolutely essential that they go somewhere else. That might be somewhere else that is quite like Swansea or it might be a bigger city. I would hope some of those people never come back, not because I don't think they should be here, but because I hope that they find what they need elsewhere. There

will always be people who do come back. Welsh culture has a strong sense of home, place and family, and people want to come back to that. I have been teaching here for long enough to see people who had gone away come back again and become very active here. For me it is very exciting to see that success and to be able to reintroduce them to the course as people who have made that journey.

We have had people who stayed for BA but went away for MA. Ryan L. Moule and Alex Duncan both did Foundation and both stayed here to do their BAs. Both then went on to do MAs at the Royal College of Art. Ryan came back and is now teaching here and has shown at Mission Gallery, but is still very connected to elsewhere. Alex is suddenly everywhere. The staying was very important for Alex, as his work was very rooted in this place and the sea; he literally works with stuff that is shaped by the sea. Alex was himself shaped by being here and he needed to be here for long enough to mature as an artist in order to take that elsewhere and then let it grow. I think that worked well for him. Again that has been quite symbiotic with the cultural scene here. He was shown at Mission Gallery after graduating and then won the Wakelin Prize, which is run by the Glynn Vivian. He is also doing plenty of other things in London and elsewhere.

In England there have been cuts to the arts in schools. We get the impression talking to others in Wales that it is a bit different here...?

Amanda: I think it probably is the case that it is a bit healthier here but obviously we are still facing a lot of heavy cuts. The former chair of the Arts Council of Wales, Professor Dai Smith wrote a document about education and cultural life in Wales. The Welsh Government accepted it and now fund the arts quite heavily through schools and galleries. The Criw Celf West project that we facilitate is where we receive most of our education funding. So now what happens is, instead of the local authorities running many of these education projects, the money is given to venues and galleries like Mission. This is potentially very positive for Wales.

1. Core funding from Arts Council of Wales.

2. 'Raising the Bar is an arts education programme that offers additional opportunities to gifted and talented AS and A Level Art and Design students to develop their creative practice and knowledge of the visual and applied arts'. Mission Gallery (2016). *Raising the Bar*. Available from <www.missiongallery.co.uk/raising-the-bar/about-raising-the-bar/> [Accessed 13 September, 2016].

3. In 2013, Mission Gallery began a Feasibility Study for a major capital re-development of the whole building, allowing it to expand and grow. It is a £1.3 million project largely funded by Arts Council of Wales.

4. 'Criw Celf provides children and young people with an opportunity to develop their artistic skills working outside of a school setting alongside professional artists in a variety of different gallery and site-specific settings'. Arts Council of Wales (2016). *Criw Celf*. Available from <www.arts.wales/arts-in-wales/inspire/reach/criw-celf> [Accessed 13 September, 2016].

Jason and Becky are collaborative artists living and working in Swansea. They are recent graduates from Swansea College of Art. We met in a bar in Swansea city centre.

What course did you study?

Jason: BA Fine Art from 2010–2013

Becky: And MA Fine Art Contemporary Dialogues after that.

Jason: I did what is now the foundation here in 1985.

Becky: And I'd done a national diploma in graphic design at Swansea College in 2002.

What made you choose to study fine art?

Jason: We were running a design agency together in 2008 when there was a downturn in the economy. We had a fair amount of work but we were struggling to get paid for most of it, so we just thought, 'Well, what do we really want to do?' I was painting at that point, I have always been painting, and thought I'd look into doing fine art. Also I think it's fair to say our design practice was always fairly experimental.

Becky: Yes. People weren't really ready for whatever we did.

Jason: We were just generally talking about it and we both applied. Although it was fine art, we applied to separate pathways and thought we were going to be in separate places.

Becky: Yes, but we were all in the same group.

Jason: So it didn't make any difference.

Was the course what you were expecting?

Jason: I don't know what I expected. I don't think I expected anything.

Becky: I don't know if I expected it. I didn't even know what fine art was before we started applying.

How come you didn't study fine art straight from school?

Becky: I don't know, actually. I remember at the time I knew that I wanted to do graphics, and the college lecturers were really insistent on you going to university when you finish college, and I was adamant that I didn't want to go to uni because I wanted to get a job in graphics. So then I worked in graphics for, I think, six or seven years and then realised I didn't want to work with a computer anymore.

Jason: I think for me it was a similar kind of thing. I was pushed in a direction of doing design work rather than anything else. I was interested in it, and I did do some fine art as part of the foundation work, but I was definitely angled to design by the staff. It made sense at the time because when I left my foundation I was 18 and I had a very fixed idea about what you need to do with your life, which is make some money and get a job, all that kind of stuff. It took a long time to figure out that maybe making money isn't the be all and end all of your career really.

Could you tell us a bit about your practice?

Becky: It's collaborative. We don't really have a specific medium. We've found more recently that we're currently not working so well in a studio space. I don't know if we make a lot of the work outside of the studio space, but we certainly come up with the ideas outside of the studio.

Do you have a studio?

Jason: We have a studio at the moment although we are leaving that at the end of this month so that we can only work outside. A lot of our work at the moment is about the space between buildings. We are hoping to do more of our work on-site, so actually go and work where we're talking about really. In the past we've gone out and done lots of walks and making notes, and then gone back to the studio to make stuff, before going back out and re-visiting. Now we're just going to travel around a bit and see what happens.

Becky: I think we've been tagged as 'performance artists' but we don't see ourselves as performance artists.

Jason: Not at all.

Becky: A lot of the work that we've done has been performative and involves participants.

Jason: We would see ourselves as instigators rather than performers, so instigators for viewers as performers in the work, rather than being the performance ourselves.

Becky: We're interested in watching the behaviour of people, sometimes provoked, and sometimes not.

How do you sustain your practice?
Becky: Luck.

Is it something that you do full time?
Jason: Pretty much.

Becky: It changes, doesn't it? So I've got a part-time job at the moment, which is term time only in the university library. I've had that since January.

Jason: Our practice has been pretty much full time.

Becky: When we graduated, we worked with Bella Kerr[1] on a project commission and we applied for and received Arts Council funding for that. So we've had research & development funding and production funding.

Jason: I think we were really lucky because we were offered that project with a group of artists, some of whom already had got funding. So we were straight out of college really, and straight onto someone else's application. So on the first one, we were just named artists in an application of five or six people to get money from the Arts Council. They were tried and tested artists who'd had money and done successful things before. That meant that when we applied ourselves we had that kind of record, which helped I think.

Becky: We've just been lucky enough to get one thing after the next. So, just as we're about to be homeless something comes up. We've had a little bit of lecturing in the university, and had some residencies that have

been funded. I think just luck and hard work, and support from galleries Elysium and Mission and the university and that network.

Do you sell your work?
 Jason: Sell it? No.
 Becky: There really isn't anything to sell.
 Jason: If only one day we'll make something that we can sell!
 Becky: We have had one commissioned piece of work, which was an audio walk.
 Jason: We've yet to figure out how to make a saleable item.

Would you want to?
 Jason: I don't know really. We're not against it but it just never happens. We'll just keep on doing what we do, I guess, and maybe at some point we'll make something that everybody says, 'Oh my God, I want to buy 500 of them!'
 Becky: But then we wouldn't want to be doing that, because you'd get bored of making 500 of the same thing.
 Jason: It just never happens. I don't think it ever will really. Who knows?
 Becky: I don't think it's that we're not interested in making products – we'd just rather make experiences.
 Jason: Yes, a lot of it is experiential.
 Becky: Situations or simulations rather than products. Maybe we could sell tickets.
 Jason: Yes, maybe. It's not something that we've ever really thought about how to commodify really. It just is what it is.
 Becky: I think doing design work, we got sick of that monetary value being attached to something, instead of it being a value of something else worthwhile.
 Jason: Yeah, I think working within a design industry, we got fed up of changing stuff for people who were paying for it. So actually what you end up doing is not producing anything that you think is any good, or that you

want to do, because you have to change it to get the money. Now we don't have to change it for anybody, even if that means we don't get paid for it. Maybe there's a feeling that if we did change anything to get paid for it, then that would be really against what we're trying to do.

You said the Arts Council funded research and development? Can you say a bit more about what that is?

Becky: R&D is to fund something that's extra to your practice. It's for you to do something different that you wouldn't normally be doing.

Jason: It allows you the time to do that without the pressure of having to make any money from it. So you can experiment really.

Can you tell us about the project that you're doing in schools?

Becky: We are creative practitioners for the Lead Creative Schools Scheme.[2]

Jason: Which is part-funded by the Arts Council and the Welsh government. I think it's a five-year project in total, and the first stage is for two years. We work as artists with a creative agent who organises what happens between us and the school. We work in a comprehensive school with Years 7 and 8 predominantly, but it's not about teaching them anything. We are there to help the teachers to deliver the existing curriculum in a different way and to help the kids learn in a more creative way.

So for example, if the topic they are working on is biodiversity, we will plan the session and the biology teacher will also be part of the group. So if we want to find stuff out about biology, he'll be there to help, not just the kids, but us too. So there's a lot of learning for us as well.

Becky: Then the teacher will see how we have tried to engage the kids in a creative way, rather than just giving them that information. It's meant to be that we are learning something from him and we are then trying to engage the kids, and he is learning how we do that.

Do you see this work as part of your practice?

Becky: I think everything is part of our practice.

Jason: Yes. I think it's inevitable really.

Becky: There are things that the kids might say that we haven't thought about, and then that will feed in to something that we do next. So, yes, it's all as part of our practice. This interview is part of our practice. Or when we're here drinking coffee after you've left, that's part of our practice as well. It's very hard to separate our life from our practice.

Jason: When we go home together, in some ways that makes it much easier to say, 'It never really ends.' There's no separation. That sounds like it could be a really negative thing, but I don't think it is. I think we made a fairly conscious decision some time ago that our practice would be about all of the things that we are interested in. So then it doesn't ever feel like we're working. We're always just talking, and making stuff, and thinking about what we're interested in doing.

So, with the school, although we're not particularly interested in teaching biodiversity, the way that we do it is linked to all of the things that we're interested in doing. Like little interventions around the school, little subversive things and stuff like that. For example, one of the first things we noticed in the school was a series of head shots of the staff members next to the head teacher's office, with the senior staff at the top and positions like cleaners and support staff nearer the bottom. Our immediate thought was to mix them all up and rearrange them, to mess with their hierarchy. It's all based on our practice really.

How did you get into working with the school in the first place?

Becky: We were invited by a creative agent, but first of all our names had to be on the list of creative practitioners.

Jason: There's an Arts Council list that you join, and then you can apply. We were asked to do this one by Lucy Donald. Some people have applied and had interviews. Some artists have been interviewed by the kids that they're going to be working with.

As well as being a creative agent for the Arts Council, Lucy was the education officer for Mission Gallery. We'd done some Raising the Bar 'master classes'[3] with sixth-formers at Mission Gallery with her previously.

Becky: Lucy was also in the same group of artist studios that we're in, at Elysium. So we know her from there as well.

How did you first get involved in running the master classes?
Becky: During our degree, we asked Mission if we could do a performative event in between two shows. We just sent them an email saying, 'This is what it'll look like. This is what we want to do, and can we do it in between your switchover?'

Jason: Because we knew that between the show coming down, and the next show going up, they had all this time when nothing was happening really.

Becky: We didn't know if they would say yes because we were aware of the hierarchy of Swansea galleries. You start with a grassroots gallery, like Elysium, and then you have to work your way up. You can't just walk straight into the Tate. It's not a written rule that there's a hierarchy of galleries, but you're just aware of it.

That's interesting. They said yes though?
Jason: They said yes. So we did a one-night performative event called *The Tension Between Us*, which involved the construction of a four-foot cube which we sat inside, in the dark, playing synthesisers. The performance was as much by us as by the audience – it was designed to test the limits of what an audience could withstand in terms of sound and duration. Then CIVIC came after that, which was also in Mission Gallery.

What was CIVIC?
Jason: When we finished the degree, Bella was curating a show called CIVIC, which was a response by artists and architects to the city. We had experimented with architectural interventions during our degree, and Bella wanted us to do something for CIVIC at Mission Gallery. Each artist worked with an architect, so there were four pairs. It was a really good opportunity. We looked a bit at how you can remap the institution so that the boundaries are more blurred. We're generally interested in that. It makes things more exciting.

Becky: It was a massive project.

Jason: Yes, and it's still ongoing. We're going to Venice in July as part of it.

Did you have an idea of what you wanted to do after art school, both when you were on the course and before you went in? And, do you think your course prepared you for life after art school, and if so, how?

Becky: I don't know if we did really. I think the idea was just not to do design anymore, and to not have to get our work changed anymore.

Jason: I don't think we had any idea about how we would ever make any money. It wasn't a consideration really. I think we just thought we would somehow.

Becky: Yes, and I don't think we were aware of the definite divide between commercial art and art that's in galleries, or at least I wasn't aware of that.

Jason: I don't know whether this is a negative statement or not, but I distinctly remember in the first two weeks of the BA Fine Art course being asked, 'What did you do before you came here?' and saying, 'Oh, we were at a design agency' and being told, 'Oh well, that's okay, you'll have something to fall back on when you finish here.' And here I am, thinking, 'Oh, I've just signed up for three years of this and what I don't want to do is to go back to what I was doing.' Although, in hindsight, I think that's a very valuable and realistic thing to say to someone.

Becky: Maybe it's more about how you sustain a practice...

Jason: Absolutely.

Did you get any other guidance about how you might do that?

Becky: No. The only way that we found out that stuff was by finding it out ourselves. Even to the extent where we would push the staff and say 'Can you show me what a funding form looks like and what you have to fill in to get funding for something?' But that didn't happen. I don't know if that's a good thing or a bad thing because maybe you should be focusing on developing your practice.

Jason: Yes, I think it's a difficult thing for them.

Becky: And you can fill in the forms later on.

Jason: I think we were quite determined to do that, and to actually succeed and have a practice when we left. I'm not sure that's the case for everyone, certainly not here. There were a lot of people who either fell by the wayside or may have left and then gone on to do something else.

Becky: I think when we were at the art school, the course was reluctant to focus too much on the professional practice side of things. It was more on you developing what you're interested in. Now I think that there's more of an emphasis on professional development. Just from talking to people that have been there since we left, we know that they do have lessons focused on professional practice. But I don't know if that's a good or a bad thing. If you really want to know how to do that stuff then you'll go and find out. So yeah, if you are professional then you'll go and find out. I think you already have to have a professional attitude before you go and be professional!

Jason: And it's not like you can't find out, is it?

Becky: I think it's difficult though, because we already came from a background where we were professionals and had had to deal with paperwork and invoicing and clients, so we already knew how that works. If we had gone in there straight from college, it would be more difficult. Also, the Arts Council here are really helpful.

Jason: Yes the Arts Council were brilliant, weren't they? We went to meet them. They had funding surgeries. We booked an appointment and we went and chatted to them.

Becky: We didn't know anything really when we went. They just tell you, 'This is what you can apply for' or, 'You can't apply for this.'

What's the art scene like in Swansea? And what drew you to work and have a practice here?

Becky: It's quite a hard question because I don't know what the arts scene is like in lots of other places, and so it's hard to compare. There's the Swansea/Cardiff argument, which I don't really want to get into.

What do you mean?

Jason: It's like anywhere where you've got a finite amount of funding, and say, two/three/four big cities. There's generally a feeling that ... it's like siblings, isn't it? That the other one always does slightly better than you. I don't think that's the case. I think it's just the nature of people.

Becky: Yes, I don't think that exists really or if it's just fabricated by people who live in the opposite place. We've done a couple of residencies in Cardiff and shown work there, and all the people we've met have been really nice.

Jason: The arts scene here is okay, there's lots going on. It's certainly been very good for us, hasn't it? We've done lots of things.

Becky: Yes.

Jason: There's a willingness to try stuff, definitely. Whether it quite gets the support that it needs from outside of itself, I'm not so sure. I think there's a lot of hard work that goes unnoticed.

What do you mean by that?

Jason: There's a lot of people who are not necessarily funding their own stuff, but are doing a lot of good work on very, very little resource. I think it's acknowledged within the art scene itself, but maybe not so much from outside of that scene. There's an awful lot of good stuff happening. Whether that gets noticed on a larger scale I don't know.

Do you mean it's not acknowledged by the wider public?

Jason: Yes, so whether the wider public in this city get to know about it. There seems to be a lack of understanding of what's going on. There's a bridge missing between those two things I think.

Becky: Yes. I don't know if that's just our opinion or if that's a general opinion. So whereas museums and leisure centres or libraries are accessible to the public, it seems like the galleries aren't as accessible. Maybe that's just to do with location and because the museum is closed at the moment. Mission is definitely visible and the public will go in because it's right there in the marina, but perhaps the smaller galleries don't get as much help from the city in attracting the public. I don't know.

Jason: I think that's fair. I don't think the city gives enough back to a lot of people who work fairly hard. That's probably true everywhere. I don't think that's unique to this place.

Becky: There's a lot of support though, for us anyway or artists that are just graduating. There's a load of support from Elysium and Mission.

Jason: I think within the art community there's loads of support, and the galleries and the studios and the Arts Council couldn't be more supportive or helpful, and without them we'd be absolutely stuffed. I just think there's a lack of recognition in the wider community about what's going on here.

Do you think the reason for them supporting you so well is because you're actually taking your work to the public rather than just expecting them to come to you?

Jason: Possibly. We like to be in the public.

Becky: Yes. We like whatever we make or whatever environment that we create to be experienced by people that aren't going to art galleries, so just the general public, to try and reach a bit further.

Jason: Yes, and so maybe working in that kind of space makes us more acutely aware of that missing connection between the art community and the wider community.

Why is that important for you, to make those links?

Becky: We want to communicate with normal people. We want more new people to see stuff instead of always the same audience.

Jason: Well, do you know what I think? I think it's more than that. I think it's because for a long time we were...

Becky: ... outside. We wouldn't have walked into a gallery really.

Jason: No. I think that what we do, and what an awful lot of people do, would be really interesting and enjoyed by more people than it currently is.

Becky: Well, it's a lot to do with our background as well, where we would design something and then present it and you get a wow from whoever the client is or the viewer is. We just want that to happen for normal people when they're walking around because...

Jason: You're egotistical.

Becky: Yes.

[laughter]

Jason: I don't remember who said it, but someone did say it somewhere, that designers are addicted to the 'reveal' of whatever they've created. I think it's true...

Becky: That's true for us, yes. It's the same kind of feeling when you show a client what you've done and then they go, 'Urgh. I'm not ready for that' but without having to change it, it's what we want to do for a viewer. It's a lot easier to get that response from people that are not walking into a gallery and expecting to be wowed. It's like a better site for the work.

Is there a particular goal that you have for your practice or something you're aiming for? What is your measure of success?

Becky: Success is to just to keep doing really interesting work so that we don't have to get another job and we can carry on playing.

Jason: Yes.

Becky: Success is really a bad word.

Jason: Do you think so? Maybe it's undefinable.

Becky: Well, it's too defined by people in terms of money and career progression.

Jason: Well, that's the point, isn't it? What would be successful? I don't know.

Becky: To carry on doing it 'til we're dead.

Jason: I don't know. You've made me think now. Survive.

Becky: To survive.

Jason: I think if you can manage to make a living then I think that would be incredibly successful. To be able to do it all the time I think would be enough of a success.

Becky: Yes.

Jason: I don't think you can hope for much more than that.

1. Bella Kerr is Programme Director of the Foundation Art and Design course at Swansea College of Art (about to be the Cert HE: Art and Design Foundation) and Chair of the Mission Gallery Board. Refer to her interview with Mission Gallery Director Amanda Roderick.

2. 'Arts Council of Wales' Lead Creative Schools Scheme aims to promote new ways of working in schools, providing the opportunity to develop an innovative and bespoke programme of learning designed to improve the quality of teaching and learning'. Arts Council of Wales (2016). The Lead Creative Schools Scheme. Available from <www.arts.wales/what-we-do/creative-learning/the-lead-creative-schools-scheme> [Accessed September 14, 2016].

3. 'Raising the Bar is an arts education programme that offers additional opportunities to gifted and talented AS and A Level Art and Design students, to develop their creative practice and knowledge of the visual and applied arts'. Mission Gallery (2016). *About Raising the Bar*. Available from <www.missiongallery.co.uk/raising-the-bar/about-raising-the-bar/> [Accessed September 14, 2016].

CENTRAL SAINT MARTINS, UNIVERSITY OF THE ARTS LONDON

Soraya Rodriguez is Diploma Leader for the BA Fine Art Diploma in Professional Studies year (DPS) at Central Saint Martins (CSM), University of the Arts London. This interview took place via Skype.

Can you tell us a bit about your background and what led you into teaching at CSM?

I've been involved in the contemporary art world in London since 2000, really. I originally studied sculpture in Liverpool, and I then did my MA at the Royal College of Art. After that, I had a bit of a hiatus and then I worked at the Royal Academy for a while. I then started working for Max Wigram in his gallery, although it wasn't a gallery at the beginning. It was a sort of project space that became a gallery.

After three years there, I left and set up Zoo Art Fair, as well as an agency for unsigned artists called The Great Unsigned. Zoo Art Fair was a non-profit art fair for emerging commercial and non-commercial contemporary art organisations, initially in London but increasingly international. It went on for six events, and then, in part due to the recession, we closed.

After that, I went to work in Chisenhale Gallery for a while, as a gallery manager. And after Chisenhale I came to Central Saint Martins. So I've been more on the curatorial and arts management side, I suppose.

Can you tell us a bit about the DPS year?

Yes. The BA Fine Art Diploma in Professional Studies is an optional sandwich year that students, can take during their BA Fine Art (Hons) course, between years two and three. It runs over 15 months from June of the end of year two to October of the following year. During that time, they dedicate the year to researching and undertaking professional placements

that inform their personal, professional and artistic development. After that year they come back to complete their final year and graduate. As far as I know, it's the first and only course of its type in fine art. I've been doing this for coming up to five years now.

How many students get involved?

Generally speaking, the number of students has increased over time as they get more aware of what it is and what it involves. In the first year there were 16 students and we currently have 52 – that's about a fifth of the year group at the moment.

Which students tend to apply for the course?

So, the DPS course is very self-directed. I don't open up a black book of contacts, and say, 'Go and work over here.' It's very much not like that. The students have to submit an application stating the kinds of placement they're going to look for and why, and how that placement relates to their personal and professional development, and also importantly, their artistic practice. Once they have come up with what it is they want to pursue, I then help them achieve that.

Generally the students that I get tend to be pretty pro-active and ready, certainly in comparison to what I was like at their age. Some of them are just shocking. Like, one guy at the moment has just gone to Swansea and set up a functioning 300-seater cinema… really?! He's about to sell the business before he comes back to graduate.

It can be enormously varied what they get up to because it's drilled by artistic interest. All of the pathways can apply. For various reasons, it seems to predominantly appeal to 4D and XD[1] students. Maybe it's because it allows them to be project driven and engage with other people on projects. But that changes, it varies over the year.

You mention that placements are driven by practice. Can you give some examples of what this looks like and the types of things that they choose to do as part of their placements? And what do you hope people get out of that year?

OK, so you might have a student who, for example, is very concentrated on photography and they decide that they really want to get their photography skills absolutely pukka. One guy in particular went off and worked for a fashion photography studio, and photographed hundreds of objects in a studio setting. Basically, he acquired photographic skills to a really professional level. He eventually started to get paid, and he bought a high-end camera which he then would hire out as an income stream. So he came back to college with a new income stream as well as a whole skill-set. He was interested in art direction, so he then went on to work in advertising agencies, and also helping to make videos and actually directing some music videos.

The full length and breadth of student subject interests is very wide, as you can imagine. Some of them will go into theatre because they're interested in performance, or aspects of performance. One spent a whole year in a design agency specifically focused on animations so that she could learn the craft.

Within an individual's DPS year, they will also do a variety of things. I've had some that will start doing a very straight gallery assistant role, and then end up going to the Burning Man festival in Nevada, USA, and performing there.

I'm very open to what people want to do. I very much believe in the self-direction of the course, and on lots of levels it's about them learning to go out, identify what it is that they need to feed themselves, and then getting it.

What is your role? You mention the course is very self-directed but are their aspects of it that you teach?

The teaching is more of an advisory and supportive role. The only thing I teach is pedantic stuff, like how to do your CVs and how to keep contacting people. Don't just send them a blind email, keep calling them and turning up to events, that kind of thing. So I'll teach the mechanics of getting what you want, in a way. Beyond that, it really is driven by their interests. The best thing, I think, about the course is that because it is self-directed, they all increase in confidence enormously.

Can you give an example?

Yes. So I'll start with students at the beginning, like this one lovely girl who was really painfully shy. She sent out 20 emails, hadn't heard back, and had given up. She could barely talk to me, she was like, 'Oh, I'm really, really struggling.' Really soft-spoken. So we sat down and came up with a plan of action that involved chasing people up and identifying new placement potentials. By the end of the year, she was still very softly spoken, but she was so in charge. She'd done set design for a theatre, and built props and sets for a theatre production that was happening in a school. She was in charge of telling everyone what to do, and she realised that she really liked bossing people about. She was the same person, but a stronger, more confident version of herself. She was enjoying it so much that she actually thought about not returning to stage three. I said, 'No, go get your degree!'

I think one of the things that really frightens graduates is the abyss of leaving college and not knowing what's out there, especially if they're very young. This course, in a way, allows them to go out into the world and to see it as material. Not something that's going to eat them up, but something that they can utilise to inform what really drives them and what really interests them. So that they can be active agents in how they progress through and process the world. That's something I really like about it. It also means that they leave with a number of contacts, but most importantly with confidence in how to contact people and an awareness of their own capabilities.

Some of them become very ingenious at getting their foot in the door by the end of it. Also, because of the stuff that they've done, by the time that they graduate they have a much stronger, much better presented CV, which again helps them get ahead of the game, given that it is so highly competitive these days.

Are the placements paid?

Some of the placements are paid and some of them are unpaid. I teach them, generally, that what they have to look for is for the value exchange rather than whether it's just cash or no cash. For me, the value might be 'If you're giving your time for free, how much are you learning in return? What

access do you have to all aspects of the organisation? Who are you meeting – are they people of interest to you?' By and large, they will often start with unpaid volunteering roles, unpaid assistant roles, often assisting artists as well. By the end of the year, most of them have graduated to paid positions. So whilst I'd love them all to be paid, I'm also a bit of a realist on that front. I think the best time for them to engage in that kind of internship is while they're still a student. And as long as they identify what they are getting out of it, only once they have learnt everything they are going to learn from that internship do I suggest that they move on.

For example, I've had one student who was working, paid, at a gallery that was run by a coloured pencils brand. The gallery was essentially a marketing tool. The work that they showed was pretty craft driven, the artists that they were engaging with weren't really very professional and certainly not conceptual. So basically, this student was going in, learning the skills of running and assisting a gallery, but not really getting the context and the contacts, but it was paid.

At the same time, she was then offered a position in an artist-led organisation that was with people of her age, recent graduates, people who were really engaged in conceptual art that really interested her. But it was unpaid. We sat there and we weighed it up. We thought, 'Where is the value here? Is it better for you to learn the skills, but in a bad context, but be paid, or is it better for you to do this?' In the end, she went with the artist-led organisation, and because that allowed flexibility, she could then waitress to maintain that situation. She loved it.

I was going to ask you that, actually. How do students fund themselves throughout the year, especially if they are working in an unpaid position?
Often they start off in the summer, working to make money. I had one student who worked all the way up to December, and got a good chunk of cash, before then going to do an unpaid position at Flat Time House.[2] But it really spoke to her, because she wanted to work in a non-commercial gallery context. She was also really interested in radical pedagogy. Both of these things came up at Flat Time House. She learnt an enormous amount

there: how to do press releases, how to build databases. She basically inputted into the database all the directors of all the contemporary art galleries in the whole of the UK. Then she realised that all that information was in her head.

She was also assisting an artist with disabilities. She then paid to do a residency in Berlin. She was there for about two months and ended up making work and meeting people from lots of different backgrounds. She had two shows at the end of it and sold some work. After that, she went backpacking to ten Eastern European capital cities, researching contemporary public art galleries. When she returned, she started working for a friend's organisation that was an online music and art platform for emerging artists and using all of the PR skills that she'd gained at Flat Time House. She had a very varied full on year.

So some of them will make money at the start and then just do whatever they want for the rest of the year. Most of them maintain a paid job throughout, usually waitressing or bar work. Some of them even model!

So it teaches them how to budget, how to plan, and how to coordinate their time. There's a lot of self-direction that goes on, but there's also a huge learning curve in self-management.

When they come back to college as well, they suddenly realise like, 'Wow, we get space, criticality, we're able to talk to each other. All of this that we get in college is actually amazing.' Certainly, when they go back in stage three, the majority are really happy about college and what it provides. I often hear from the tutors that they're the ones that turn up to all the lectures and they're there on time. They realise, again, the value. They have a value lesson.

Do you think they approach their final year differently then to some of the other students who haven't had that experience?

Last year I remember bumping into a couple of DPS students about two months before graduation and they were saying that the students who didn't do DPS were really wishing they'd done it because they don't know what's going to happen after they graduate.

What are the costs of the year?

In terms of the finance, generally Home/EU students are now paying £9,000 a year, and the DPS year costs £1,800. For that, they get a tutorial every term. There's not too much that I make them do in terms of admin or assessment stuff because I want them to really concentrate on getting on with what they want to do. They do get a CV workshop and they also have to maintain a DPS diary throughout the year, which I feedback on. They also build and maintain a bibliography for their artistic concerns, so that during that year they are still engaged with practice. Usually, that dovetails into when they're returning at the end of the year about to get involved with dissertation. Then, at the end of the year, they have to deliver a DPS report which is 3,500 words.

Is it an assessed year, then?

Yes. Some of them realise that it's actually a good option, because you still get all of the benefits of being a student, but for £1,800, which in the bigger scheme of things at the moment makes sense, and you leave with a much stronger set of cards in your hand. It's not generally the finance that holds people back from doing it. It's often really that they want to graduate with their peers, or that four years feels too long. There are a variety of reasons why people choose not to do it.

Is there a reason that you choose to run the placement year in between the second and third year and not, say, after graduation?

If we did it after graduation, I would wonder how I could keep hold of them. Whereas in their mind, they're still 'in college'. They have to make a very academic approach to what they're doing. It's very much still an extension of the pedagogy. I think that makes a big difference in terms of what they're willing to look into, and also their mentality about it.

One of them was doing a presentation to all the incoming DPS students and she said, 'Everything that I did on DPS, I could have done by myself, off my own back, when I graduated but I wouldn't have, and that's the truth. Left to my own devices, I wouldn't necessarily have had the discipline then.

Having DPS meant that I had to commit, and I was pushed to do it and I had to push myself to do it, but I also felt that I had support to do it.' I think having it in year three makes a big difference that way. It also, then, hopefully informs what they do in their final year. Hopefully, it makes them appreciate the value of what's on offer at college and it makes them also enjoy making art again. They're there because they're not scared about the future and it's not so precious, maybe.

We have talked about adding on a mini DPS at the end of the year when they've graduated, but I just think that by then, it's almost too late. I think it works better to do it before they graduate, when they're still a student in their heads.

I'm interested in the variety of contexts that you said people end of up on placement. You have mentioned a theatre, a design agency, fashion photography.
Yes.

That's quite interesting, that they've gone into those sort of non-fine art areas to develop their skills…
Yes, yes, yes, yes.

It's different to what I'd expected before we spoke. I'd have expected more of the gallery…
Yes, and they often take up a gallery or artist assistant roles before doing something very liminal, something very 'other'. One of them this year is volunteering at various mental health institutions. That's because her work is around mental health issues and the perception of mental health. I think that's partly also why it's good to keep it between years three and four, as it is still about their practice.

I always tell them they've got three boxes, any one of which a placement can tick. One is their personal development, where they learn self-management and time management through working as part of a team or on self-directed projects. So that's developing their personality and personal potential. Then, there's professional development, which is more technical

skills, understanding of context, being able to identify the best organisation within a peer group, that kind of thing, so that you apply to the best first and then go down your list. Then there is also the artistic development. If a placement ticks any one of those three boxes, then it's worth it. Generally, it will end up ticking two or three because it seems these things go hand in hand.

You have mentioned artistic development quite a bit. Do students still make art during this year?

They're not asked to make art during the DPS year, because when they're learning new stuff in new environments, it's really head consuming. The studio mentality is very different. It requires another level of focus, a quiet focus and determination. So I don't ask them to make art, no. But if they do, that's fantastic if it works for them.

We do however request that they maintain artistic research throughout, so they are constantly watching lectures online, going to events, going to exhibitions, looking at artists, reading theory, all of these things that build up their criticality. Otherwise, it would be a bit boring if it wasn't about the art at some point.

Why do you think it's so important that their placements relate to their artistic practice?

It is about their artistic practice, but it's often more about the ideas and the concerns that underpin their artistic practice. It's the things that make them individuals, the areas and interests that fuel them, that get them excited, that get them annoyed, that get them wanting to change the world and make something as a consequence. It's those issues and concerns that I ask them to keep thinking about throughout their year, so that they don't ever disengage from their thinking or artistic personality, even though they're not making art.

So it's quite holistic in a way...?

Yes, very much so. Again I think it's because it's self-directed, they have to decide what's good for them.

How many placements do students do a year?

The average is seven to eight. One student only did one and then she did some of her own projects. A placement can be their own project, so they might decide to curate a show, or they might decide, like one student did, to form a band with her boyfriend and go to the Burning Man festival. She converted a great big truck into a living space internally, and into a stage by putting a flat roof on it. She then performed at the Burning Man.

A lot of students will end up doing their own projects at some point. Certainly, if students are having trouble finding a placement in an organisation, I always encourage them to take it into their own hands and develop their own. For example, one student, whose practice is very text driven, wanted to do a writing residency. He'd been researching some but hadn't really found one that worked. So, I just said, 'Why not develop your own?' A mate of his has a house in Cornwall, so I said, 'Go and spend a month there. Take a couple of mates who are also interested in writing, and think about spending four weeks just dedicated to writing, and maybe set up a series of workshops and lectures between you, where you share information or share your thoughts, set up a residency between you. Take charge of your own learning by setting up the conditions under which that happens.'

It is about that independence, and it is about not being passive. It's being an agent in your own destiny, which I like.

How many days are they on placements for?

They are required to complete 100 days throughout the year of placement activity. Generally, I think the average is about 157 days, but I always say to them that I am interested in the quality of placement days rather than the quantity of placement days. It's a bit like that girl at that marketing gallery. By the end of it, she was really not learning very much at all, and not really meeting very good people. Then she did two weeks in another place and got a huge amount from that, so actually that shorter placement was far more valuable to her. So the length of placements go from an average of 157, up to something like 365.

Do any of them decide that they don't want to make artwork any more and that they want to go off in another direction?

I've had people who've almost arrived at that, but generally they've come back and got stuck in again. Generally, it actually makes them want to make more. It also makes them appreciate what making work can be like, so that it stops being a demand and it starts being a joy again.

One student said, 'I realised during DPS that my art doesn't matter that much, because I can be all manner of things. I can work in a curatorial way; I can work in a writing way...' She realised that her identity as an artist wasn't confined to just making work. She could be an organiser or a promoter. She found that being part of art was a much bigger thing than just being an artist. I think most of them end up realising that. There are many nooks and crannies out there in the world to be involved in artistically without necessarily reducing it to being about the all-precious act of making art. Once they realise that, they get really excited.

Do you think art schools should have a role in preparing students for life after art school?

Yes, definitely, especially when students are paying £9,000 a year, you've got to think about the aftermath otherwise they're just having a nice hobbyist time in an institution. There is a responsibility. How you go about doing that, however, is up for grabs. I don't believe in teaching students that there is a tick box routine to being successful in art. I believe that teaching them how to contend with failure is far more important and far more relevant than teaching them the notion that there is some sort of galaxy guide to success in the universe, because that's bullshit. It doesn't work like that.

I think if art colleges are serious about art, and contemporary art, and culture in the world, they must equip their students with some level of confidence to believe that what they do can make a change. Students need to understand that the world isn't a given, that it's not just ready-made, that it hasn't just popped out of somewhere because somebody dropped a bag load of money and made it pop up like that. To understand that the world

is a fragile landscape, but that they are intrinsic to it and that they have agency within it, and that what they do does make a difference physically.

I think if colleges aren't doing that, then that's not right, given how difficult it is to maintain a creative career. Nobody has an easy time of it, even maybe the three artists right at the top that are selling millions of pounds worth of art, they're probably moaning about something or other, and finding things hard.

It is a very difficult practice to maintain and it's also a massive luxury. Often, some of these professional development things are just about ticking boxes and leading people through a passage of sameness. Whereas, actually, everything that happens in the art world is down to individuals generally wanting, belligerently, passionately, with difficulty, to make a change, wanting to take a stake. I think pulling that out of students is really important, and finding ways to do that is quite hard within an institution because an institution, by its very nature, is not given to risk taking. It's absolutely a place of safety and safety nets, so how do you teach risk-taking in a safety net? It's an interesting question but it is possible.

I do adamantly believe that DPS, through its self-direction, makes that possible because the students, to me, become a gift. It's amazing watching them. It's amazing what they can do for themselves, by themselves. That's quite rewarding. Yes, I do think it is imperative that they're prepared, and that their eyes are opened as much as possible to the challenges that are coming when they graduate. I do think that early engagement with the art world is a really important thing within that.

CSM also have an Associate Studio Programme, where they provide some graduates with a studio to make work, which is great. During the rest of the BA course students also get to work with a whole number of different external organisations like X Marks the Bökship[3] and The Wellcome Collection[4] as part of their units. I think being permeable to the exterior as an institution and really engaging with what's going on out there, and encouraging students to engage whilst they're in college, not just waiting till they're out in the big bad world is really important. Making it part of their practice to be interested in what's going on is really important. For

that, you have to have pedagogues that are themselves interested and also aware of what's going on.

Do you think that there is an advantage to being located in London? And do you need to be in a big metropolis in order to be successful in the arts?

It helps. I mean, obviously, the London art scene is something that's been built since the '60s, slowly but surely, by individuals. What we have now is not something that just appeared from a spaceship. It literally was bricks and mortar that people like Maureen Paley and Nicholas Logsdail built. That's not to say that other cities can't do the same. It's also not a given that it will remain in London, because at the moment, the one thing that made the city great was access to free and cheap space, hence the East End and recently, the south of London. All of that's going up the spout at the moment at quite a worrying pace.

The only thing that London retains, though, is these great universities, and therefore these students that are still here all the time. I do think London is an amazing resource for any artistic practitioner. Whether you're an artist, a writer, or a curator, there's an engagement, there's constantly stuff on. So on the one hand the connectivity in all of that is brilliant. But on the other hand, there are massive levels of competition, and there is the financial stress of living here.

I think the gallery network in London really helps artists, if you're lucky enough to get one. It's not like these galleries have an infinite number of spaces: they usually represent about 10 people, and then that's about it for the next 20 years. There's something like 3,000 students graduating every year, and there are probably about 5 spaces that come up in the commercial galleries overall in that year. One way or another, I think you have to be inordinately ingenious to keep your creative career afloat.

Do you think that's still one of the main goals for artists, to enter that commercial art market?

I think so. I've done talks in the past when I was running Zoo that were really soul destroying. We'd had a forum 'How To Be a Successful Artist'

where essentially all the speakers talked about being able to contend with failure, and that was the way in. I remember being in a panel with Nicholas Logsdail, who's an amazing gallerist. He was saying, 'Don't cold call gallerists because it's a very organic process, very personal process. Those gallerists are individuals with their own interests, so you can't just inflict them and ask that they solve your problems.' He gave a really beautifully worded paragraph that I'm not doing any justice to. Then when the talk finished, the first thing that happened was about eight students with psycho eyes rushed up, cornered me, and went, 'What's the best gallery to go to? Which one? What do we do?' I'm like, 'God, have you been listening? That's happened several times, and they just don't listen to the fact that it's going to be tough, and that there is no answer. You have to make it up as you go along all the time, but that's what makes it hard-won.

So yes, the galleries are a very good market resource. They also work with non-profit and public galleries in a very good, generally supportive, symbiotic role. There's a very good ecology in London, and a very good balance of non-profit and profit-making behaviour. I think that's healthy.

Generally, I think more important for graduates than finding a gallery early on is to certainly get with peers and make your own situation. Quite a few students that graduated from DPS are now running spaces or running initiatives from their flat, with peers. They create the conditions that they require in order to keep themselves going, and I think that is more important, more relevant, and more tangible than sitting in a café before your graduate, and running up a list of top gallerists to get in touch with, with White Cube at the top, which is just insane – but I've seen students do that.

Were you supported with professional development when you were at art school?
Back in the day, when I was at college, you got told precious little. Often students didn't really know what was going on. They certainly didn't know what was going on in the East End of London or up the road. You were just left to your own devices, really, and then you tumbled out in the world, and by hook or by crook, you had to make your way or not. I think it's different now. There's a lot more care and attention.

The difference between models of professional practice that excite me and those that I find really pedantic is the amount of self-direction that they allow the student. Anything that pacifies the student is non-productive. It conforms to this tick box mentality, rather than opening up questions, and encouraging energy and change, and for that person to take responsibility and do it their way.

It's interesting that there are now quite a few questions being asked about what the value of professional development is and what it should involve. Chisenhale Gallery with Rebecca Nesbitt did a really good paper on professional development about how art organisations are supporting the professional development of artists, so not just universities.[5] Some organisations realise that just showing artists isn't enough anymore. They have to support beyond this.

Yes, because it is hard, pursuing a life as an artist....?

If it was easy everybody would be doing it and art wouldn't be the luxury that it is in terms of the mind/self/space. It has to be hard, by its very nature. One of the things I really try to reinforce in the students is this idea that they are the principal active agency within their own life, and that they will hash out their destiny or die trying, and that the only option available to them is that self-determination. Otherwise, if you can't be self-determined, how the hell can you be an artist, or any kind of creative? You need to have the belief in change and transformation. For that, you need to be able to do it for yourself, by yourself, and about yourself, I think.

Is that what spurred you on when you were setting up Zoo, that way of thinking?

I think because I'd been an artist I had, in a way, the maker's toolkit of knowing how to put something in the world that hadn't yet been in the world. I'd sort of done that. By then I'd also curated shows and worked with artists. Predominantly, the thing that really pushed me forward to do that was just how excited I was about what was going on in the London scene. There were all these young organisations coming up that weren't going to be represented at Frieze,[6] which allowed this international platform. I just

wanted everybody in the world to know that London was bloody great again. Like, it had energy.

Would you have called yourself an entrepreneur?

I suppose so. If 'entrepreneur' is trying things out, taking risks, throwing the pasta at the wall, seeing if it sticks. Yes, I probably would. It's also 'entrepreneur', 'flâneur', it's just a funny word. More than being an entrepreneur, I think you have to be entrepreneurial. It's more of an adjective, rather than a character flaw. I think that certainly artists have to be intrinsically entrepreneurial and very adaptive, very quick to learn, to understand situations. Generally, artists are by nature very intelligent, because they have to have this ability to see multiple aspects. So yes, why not?

1. 4D is the Pathway focused on moving image and film; XD is the Pathway that looks at art beyond the gallery space in particular socially engaged practices.

2. Gallery in South East London

3. Project space in East London for independent publishers

4. Medical research charity

5. Nesbitt, R. (2015). *Mapping Artists' Professional Development Programmes in the UK: Knowledge and Skills*. Chisenhale Gallery, London.

6. Contemporary art fair

UNIVERSITY OF THE WEST OF ENGLAND

Sophia Hayes is Senior Lecturer, and module leader for Year 1 on the BA (Hons) Fine Arts Course at the University of the West of England (UWE). We spoke via Skype and email.

Can you tell us a bit about Bristol as a cultural place?
Bristol is a progressive port city, with a population of half a million. It has a culturally alive and thriving contemporary arts scene that includes many artists' studios, artist-run spaces and internationally established contemporary galleries, such as the Arnolfini and Spike Island.

What is the structure and ethos of the Fine Arts course?
Fine Arts is a multidisciplinary course where students can develop skills in one or a combination of media areas. After the first year, students can also choose from two pathways: BA (Hons) Fine Art or BA (Hons) Art & Visual Culture.

What's the difference between the two pathways?
Art and Visual Culture requires students to produce an individual studio practice together with written texts in their studio modules. Fine Art requires them to produce an individual studio practice. Both pathways involve the development of a self-directed practice and both require critical written reflection; they differ in the proportion between these two aspects.

Across both courses we run an extensive programme of studio critiques, seminars and lectures with high profile professionals. There is a programme of visiting artists, gallery directors, curators, critics, and industry professionals. The tutors and technical staff at Spike Island are active practitio-

ners with links to arts and media industries. At every level, for both courses, aspects of professional practice and longer-term opportunities are presented, experienced and evaluated.

Can you tell us a bit about Spike Island and also the studio set up?

The UWE Fine Arts studios and staff offices are based on the ground floor at Spike Island, which is an international centre for the development of art and design. It houses around 500 creative practitioners. It also has a café and a public gallery space providing exhibitions, talks, and other activities, all of which students are encouraged to engage with.

We have studio technicians at Spike who oversee the running of the studios and who provide some equipment (AV equipment, laptops, cameras, and tools). Spike studios also house a small fabrication area and a computer room with a range of relevant software. Any specialist technical work takes place at Bower Ashton, the main Art and Design campus. University buses go via our building to Bower and we also have a van that can be booked to transport artwork. For example, students can build something in the fabrication area at Bower, and book the van to transport it back to their studio. Students also use the Arnolfini, where the UWE Fine Art Lecture Series is run on a regular basis.

The advantage of being at Spike is that we are in a building where there are professional artists and art organisations, so that geographical distance between Bower Ashton and Spike doesn't really become problematic. Being at Spike is also a good selling point for recruiting students, because it has that direct connection with industry.

Does the course itself have many links with the city?

Yes. The course is interwoven into the Bristol art scene, and has links with galleries and organisations such as Spike Island, Bristol City Council and the Arnolfini, which are designed to directly benefit our students. Our students and alumni also contribute significantly to the city. They work into the local arts scene and they have many opportunities to exhibit their work, on campus and externally. We encourage residencies and

placements in the creative community and have strong links with the Arnolfini, Hauser & Wirth Somerset, Situations and other national and international organisations. Our students recently worked with Turner Prize winner Jeremy Deller, painting murals for his *English Magic* exhibition at Bristol Museum.

How do you prepare students for life after art school? Do you have a distinct professional practice module?

We provide 'Professional Practice & Work Experience' (PPWE) modules at every level, each worth 15 credits:

At level 1, students are introduced to the range of roles and opportunities within the field of Fine Arts through a series of case studies where early career artists and recent graduates discuss their career path. This year, for example, we had Steph Li, an Art and Visual Culture UWE graduate from 2014. She was involved in a Spike Island residency during 2015 and has exhibited across Bristol, London and Berlin. We had Kate Mackeson, a graduate of the Royal College of Art; Isaac Stacey and Jack Wilson, both recent UWE graduates and early career artists who have set up an ongoing publication, *lockjaws* and exhibiting organization, Champ; Rebecca Russell and John Steed, both UWE level 3 students, who have organized exhibitions and film screenings around Bristol; Elisa Kay who is Spike Associates programmer & freelance curator; and Juliet Lennox, Assistant Curator from Spike Island. The aim of inviting a range of speakers is so that students build up a picture of the many different ways that you can use a fine art degree.

The module includes on-site tours of artists' studios and related organisations located within Spike Island, as well as Spike Gallery tours where they can view installs in progress (most recently Michael Beutler's *Pump House*). Many students also work as invigilators in the gallery as part of a voluntary programme. I strive to make all these links visible and accessible to our new students.

Together with these case studies, students hold a group exhibition in the studios, which is regarded as their 'work experience' opportunity at

this level. They are required to form an exhibition committee and make decisions regarding organisation and publicity for this event. Assessment requires them to provide a CV and documentation of their current practice. This introduces students to developing their knowledge and awareness of the professional context of their subject. They are given clear guidelines about the relevancy of these assignments – for exhibitions, residencies, further study, and employment opportunities.

At level 2 students are required to find work placements. A lot of students find placements with organisations in the building. For example, some students have worked in Spike Gallery in connection with curating, marketing, technical installation; others have gained work experience at Situations, an organisation that commissions and produces public art projects. Others work in schools, as artist assistants, within community art projects, with graphic designers or within media industries such as Aardman and so on. For assessment, year two students are required to write an evaluation of their work experience as well as submit an updated CV, an artist statement and provide new documentation of their work.

At level 3, the professional practice module is designed to support students as they consolidate their knowledge and understanding of their area of practice, and develop strategies for graduation and progression to employment or further study. They are required to provide a relevant application for graduate study, or further employment, or a national exhibition competition including images and CV as appropriate. They also have to write an evaluation of their plans for the future as well as include discussion of what they have learnt during their final year. The aim is to provide students with both an insight into relevant professional opportunities as well as practical experience of submitting applications for these activities.

In addition to this module and spanning the three levels, the UWE Enterprise and Careers service provides students with ongoing opportunities such as small commissions, projects, and volunteering opportunities. There are also other professional practice activities embedded throughout the course such as student group exhibitions in all years, student participa-

tion in Spike Island Open Studios, Erasmus exchanges in year two, and opportunities for assisting artists exhibiting locally.

Why do you choose to run a modular approach to professional practice?

I think our approach is a reflection of current trends in undergraduate Fine Art courses. There is a focus in the university (and within university education nationally) on 'employability'. At UWE, professional practice within Fine Arts has been formalised through a modular system over the last 10 to 15 years. We provide students with a staged approach to understanding what professional practice is and how they might utilise it in relation to their own broad career paths. This begins with introductions to diverse case studies at level 1, through to work experience opportunities at level 2 and culminates in consolidation and practical application of their skills and attributes at level 3.

Who comes to the course and how are they selected?

One fifth of all applicants are accepted on to the course. The selection process occurs during the interview where we're looking at their portfolio and their passion for the subject, and also their ability to be critical, to engage in some kind of critical debate, and their knowledge of contemporary art practice.

Has the introduction of fees had an impact on who is coming on to the course and their expectations do you think?

I have worked at UWE since before the fees were introduced. I haven't seen a change in attitudes. I have noticed that at open days however, there are more questions about employment and opportunities after students graduate.

In terms of who comes, I did think when the fees were introduced that the cohort may alter, but we still get a diverse range of students. The biggest change I have noticed in the last few years is the increased rise of applicants from London: they want to move to a large art-active city, but don't want to stay in London.

What happens if people come to the course or decide during the course that they do not want to work as an artist when they graduate and want to do something else?

Well, first and foremost, this is a fine art course. If someone comes to the course with another aim in mind, they can tailor the Professional Practice and Work Experience modules to make it appropriate for them.

Do staff members also have a creative practice?

The tutors and technical staff at Spike Island are active creative practitioners (such as Kit Poulson, Monika Oechsler, Judith Dean, Wayne Lloyd, Markus Eisenmann, Jesse Darling) with links to arts and media industries. In any kind of teaching situation, sharing good practice and your own creative experience is highly relevant. That seems really important, and I think students value that. There are often direct opportunities as a result of our staff being practitioners including exhibition planning, curating, marketing and technical installation to name but a few. Simon Morrissey (Senior Lecturer in Fine Arts at UWE), for example, is a curator who has established a non-for-profit company Works/Projects and offers a number of placements for our students.

You mentioned placements with Arnolfini and links with other galleries. How do the students access those?

Some of them are provided through contacts with the fine arts staff team, others are in connection with our links within Spike Island, others are achieved through UWE career facilities.

Are those placements generally part of the curriculum or extracurricular?

A bit of both because they can formalise a placement by using it as work experience in their PPWE module, or they can do it independently. We have many students who, right from the start of their degree, are involved in extracurricular activity in addition to the formal requirements of the course.

What do graduates do after the course? Do they tend to stay in the city?

Our Alumni often stay in Bristol and the South West of England. Many them set up art organisations or join studio groups. One example is Bristol Diving School, established in 2012 by fine arts graduates and so called because it was housed in a former diving club. They initially held a running programme of exhibitions and events at this space and would directly involve the undergraduates in that process, building a direct connection between the pre and post degree students. More recently they realise their peripatetic projects remotely. Another current example is Champ, co-founded by Isaac Stacey (UWE graduate) and Jack Wilson. Some are also currently working at Situations, the Arnolfini, Spike Island, Plymouth Arts Centre or the The Architecture Centre, Bristol.

Our Alumni are also regularly selected for fellowships and national competitions, including the New Contemporaries (we have three graduates selected this year, 2016), the Wysing Scholarship and CASS Sculpture Foundation curatorial internship. Graduates move into careers as artists, designers, curators, arts administrators, and educators, or continue with graduate study progressing to excellent national and international institutions such as the Royal Academy of Arts, Royal College of Art, Goldsmiths, the Jan Van Eyck Akademie and Parsons, NY. In their final year students can also apply for the Spike Island Fellowship, which supports young artists in their first year out of university.

Is London significant do you think?

London is indeed significant, though Bristol, the rest of the UK, Europe and the World are significant for our students and contemporary art practice too. A number of fine arts staff commute from London. We arrange London exhibition trips on a regular basis with all our students and are regularly involved in exhibition exchange projects with Chelsea College of Arts. We also have a lot of students who go on to postgraduate study in London.

Is there any support for graduates?

In their final year students can apply for the Spike Island Graduate

Fellowship, which supports young artists in their first year out of University. Applicants are interviewed and two are selected. This fellowship provides free studio space for a year after graduation and an exhibition opportunity in Spike Island.

How do preparations for life after art school compare to your own experiences of art education?

I graduated from Fine Art at Nottingham Trent University in 1995. The assessment was based on the final year degree show. Though less structured, there were many artists' talks and continuous exhibiting opportunities. There was a marked difference in practical support of 'professional practice'. We were actively encouraged to consider our future and make applications for postgraduate study, exhibitions, and residencies but we independently formulated CVs and documentation and learnt through individual trial and error. Expectations of 'what's next' did not differ, but the amount of support and advice given now in comparison to my undergraduate study has changed dramatically.

Which approach is better do you think? Do you think courses should play a role in this?

Without a doubt, the approach at UWE now where professional practice and work experience are formalised into an accountable and assessed component part of their degree is better. Fine arts courses should, and do, play an active role in this preparation for life after art school.

GRAY'S SCHOOL OF ART, ROBERT GORDON UNIVERSITY

Dr Allan Watson is Head of Fine Art at Gray's School of Art, Robert Gordon University, Aberdeen. Michael Agnew is Course Leader for BA (Hons) Contemporary Art Practice; Keith Grant is Course Leader for BA (Hons) Painting; Craig Ellis is Senior Lecturer first year studies and Jim Hamlyn is Stage 2 Co-ordinator, both on BA (Hons) Contemporary Art Practice, also at Gray's. We interviewed Allan in a café in Stirling, whilst the others responded to our questions via email.

Can you tell us a bit about the art school and its location?
 Allan: Gray's School of Art was founded in Aberdeen in 1885. Whilst our intake historically was focused on Aberdeen, the North East, and the Highlands and Islands, this has now spread to include all of Scotland, the rest of the UK, Europe and International.
 The perception of Aberdeen as 'the oil capital of Europe' dominates the region's identity. However, the city and shire does have a rich 'cultural offer' via a range of arts venues, co-operatives, galleries, museums and artist studios. Whilst Aberdeen cannot compete with the critical mass of activity that is inherent within Edinburgh and Glasgow it can offer something different. Geographically Gray's is well situated for access to the Highlands, Orkney, Shetland, and Scandinavia. We encourage our students to look North as well as South.

Can you tell us of any formal provision that your courses have for preparing students for life after art school?

Michael: Increasingly student learning within the Contemporary Art Practice course requires attaining fine art demonstrable professional skills (for example, writing proposals and statements, documenting work, how to organise and deliver an event) and displaying abilities to engage with external academic institutions, arts organisations, galleries, and funding bodies. There is importance placed on professionally presenting oneself to the external world. We engage in conversation and evolving placement opportunities with respected cultural institutions in the city and hinterland, north, south and west. Our students participate in external projects, events, festivals, exhibitions, workshops, and also contribute to teaching in schools.

Keith: The BA Painting course has strong links with the local business community and arts organisations. As a result students have worked with a number of clients on live projects, competitions and commissions over recent years. Students learn how to compose a proposal and articulate their ideas to a client while also producing work to a deadline.

Allan: We run a professional skills' module at Stage 3 called 'Disseminating Practice'. This is a straightforward pass or fail module that places emphasis on the skills required for students to reach an audience. Students are required to work in groups and self-organise their own events. The module requires them to confront issues such as accessing and nego-tiating space, sponsorship, fundraising, health and safety, promotion and publicity, audience, and the curation of the show itself. They are mentored by staff throughout.

We have also developed a Stage 4 module called 'Professional Skills – Representing Practice'. It focuses on the articulation of practice – how one writes about, talks about and documents a practice. Web presence is a key aspect of the module as well as the ability to write short statements and funding proposals.

For many years we have also run a non-compulsory 'Life After Art School' (LAAS) programme for Year 3 and 4 undergraduate students

from across fine art departments to help prepare them for their future beyond Gray's. For this we bring in recent graduates, from Gray's and elsewhere, with a view to them sharing their personal experiences. Some may just be 12 months out, others two, three, four years. Some will have gone onto Postgraduate study, some will be involved with artist's collectives, some will have undertaken residencies or internships, some will have gone into teaching, and some will have changed career altogether. Whatever their personal situation we ask them to reflect on the skills they learnt as an undergraduate and how these skills helped them get to the situation they are now in. As well as recent graduates we also invite in a range of arts professionals. In the past we have had those from Creative Scotland, Wasps studio providers, Scottish Contemporary Arts Network, curators, project managers, artist collectives and gallery representatives both public and private.

As an example, speakers at last weeks LAAS talk covered these issues: why to consider postgraduate study and when to do it; tips for applying and choosing postgraduate courses; pitfalls of different types of study including funding issues; delivering your first conference paper; why third year is the difficult year; how to see your degree show and dissertation in the long term; setting up a limited business; getting charitable status; finding and setting up studio spaces (specifically in Aberdeen); gallery related work including set-up, curating and building; behind the scenes at major London galleries and collections; the commercial art world versus the publicly funded art world; why collectives are a good idea; how to approach your public persona; and making and keeping contacts.

We also work closely with our university careers service who deliver sessions to all years on CV, summer employment and recognising skills. In October 2015 we also ran our first Arts & Culture EXPO, which invited 25 arts organisations and providers into the university. This has enabled students to meet key individuals and discuss ways in which they could get involved with them in the future.

Finally, we also have a professional advisory group.

What's that?

Allan: The university requires all courses to have an industry group. We have invited a range of people including: representatives from the Scottish Sculpture Workshop, Creative Scotland, Aberdeen Art Gallery, Peacock Visual Arts as well as alumni including the deputy director of Fruitmarket Gallery. We also have a business representative, a non-art person who has sponsored art in the past. We have about ten people and, as getting them together is hard, we try to hold the meeting around the degree show. We can ask the group questions to help us develop the curriculum.

I recently had a session with them on careers and they said 'don't use that word, it turns people off'.

Why is that?

Allan: The consensus was that the word 'career' was a turn off. We also spoke about the term 'employability'. Employability is something that the university is promoting, which is a national trend. I'm not sure anyone teaching fine art is comfortable with the term. In subjects like nursing and engineering, employability is key. But for a fine art graduate you tend to see a career as a meandering path, with a sense of adaptability, responding to opportunities, and going off at tangents. I'd argue that our students and graduates are very employable but not in the straightforward sense.

How about the term 'entrepreneurship'?

Allan: It's taught in Aberdeen Business School (part of Robert Gordon University) and it features in our design courses but it's not an everyday term in our fine art courses. In its broadest sense it does actually describe what artists do: develop, organise and manage a business, and in that sense it may be a useful framework to help students understand the range of skills that an artist must call upon.

Another element connected to all this is work experience. The university may eventually make work experience a compulsory element of every course. I've asked the advisory group 'what is work experience for a fine art student?' One answer is working as an artist's assistant. I myself

worked with an artist after I graduated and it was incredibly valuable for my learning. But the reality of placing 80 students every year would prove impossible. Students can negotiate their own placements but as many arts organisations now offer paid internships for graduates, it can be harder for students to come and work for free as it interferes with the organisation's own graduate intern programme.

We don't want our students to just stay in the art school and be comfortable. We don't want passive practitioners. We want them to explore and be proactive in their city. So whether that's through work experience, or placement, or volunteering, it's crucial to build up their confidence and desire to get involved. Most people I know who work in the arts have done just that.

Can you give an example of some of the placements people have done?

Allan: We encourage and facilitate our students to become involved with 'local' arts organisations such as Aberdeen Art Gallery, Peacock Visual Arts, The Suttie Arts Space, SSW, Deveron Arts, Hospitalfield, and Woodend Barn etc. as well as more 'grass roots' organisations such as Wagon, Temporary Studio, SonADA, and The Anatomy Rooms.

We also facilitate a number of student commissions with local businesses. These are generally run in a way that mirrors the 'real world' commissioning process. We also develop projects around the delivery of art workshops. We recently enabled students to design and deliver a series of art classes for Alzheimer Scotland, for which they received training, and next week we have an exhibition opening that presents the work produced through a collaborative project between Gray's, a homelessness charity called Bethany Christian Trust and Peacock Visual Arts.

Are these assessed projects?

Allan: No they are extracurricular. The benefit is experience and something on your CV. We delivered an Artworks Scotland pilot project called *Participatory Arts Exchange*. The idea was to better prepare graduates for that sort of situation and give them the skills and confidence needed for teaching art and delivering workshops in the context of socially engaged practice.

We might look at delivering a module, not necessarily for those who want to become a teacher but rather, those graduates who may earn an income through workshop and community activity. I think there is huge demand for this sort of work.

For those that might want to enter the teaching profession, British Petroleum offers a tutoring scheme that enables students to work in schools half a day a week for several months.

What do people do when they leave your course? What does a 'successful' graduate of your course look like in your opinion?

Allan: Graduates pursue a variety of careers. Some are determined to pursue 'being an artist' and many in this category will go on to postgraduate study at some point in the future, either in art or related areas like curating or community arts etc. Many people come to art school with an ambition to be teachers and pursue that, or go into related professions such as art therapy. As someone who has to sometimes go into schools and talk to parents, I stress the 'long term' strategy of the fine art graduate – they are adaptable and responsive to opportunity. Whilst university processes for gathering information on graduate employment make use of data regarding what our graduates are doing 12 months after graduation, a more informative figure is five years. For many, it takes this amount of time to 'find their way'. As an example of what our graduates do, I often refer to four students who all studied printmaking: Graduate A – a successful artist living and working in Paris; Graduate B – working in television advertising; Graduate C – Deputy Director of a major arts organisation; Graduate D – working for a media company in charge of a major charity campaign. Only one of the four continues to make art as their main source of income. A 'successful' graduate is an individual who has the skills, confidence and creativity to purse the career of their choice.

Related to this, it's hard for graduates after 12 months to say they're fully employed in their profession. Most will still be making but won't be paid to do so and so this isn't recorded officially. Our head of school is adamant that if our graduates are making art part time, they should be recorded in

the DLHE (Destination of Leavers from Higher Education) as artists rather than as in a job that isn't linked to the profession.

Do graduates tend to stay in Aberdeen?
Allan: Graduate retention in the city and shire is an issue. Many of our fine art graduates leave Aberdeen immediately after their degree show is finished. I've just been doing a survey with our fine art fourth years about where they're going after they graduate. The majority are heading to Glasgow or Edinburgh as they perceive those cities to have more arts opportunities. Only two out of 30 students who are not originally from Aberdeen are staying in the city. An example from 2014: several painting graduates from Gray's moved to Glasgow and helped set up Visual Artist Unit; sadly they did not feel that doing this in Aberdeen was an option.

What factors do you think prevent people from staying?
Allan: Lack of studio space is an issue as the oil industry keeps commercial property prices high and landlords would rather keep property empty than lower their prices or let people use them temporarily. Also, people can't afford to stay because of the high accommodation costs, the rental market also being dominated by the oil industry.

Is it important for you that people do stay?
Allan: Yes, absolutely, because Aberdeen needs a critical mass of graduates to inject renewed energy and vitality every year. If there was a critical mass they would begin to make more demands of the city. Every year, at the degree show in June, Gray's delivers a fantastic group of graduates but a few weeks later they have mostly gone – the city's lost that creative energy.
Aberdeen City Council has recognised this as a problem, and in recent years has launched a series of initiatives to more fully understand what support and infrastructure is required to enable graduates to see Aberdeen as a viable base for their future careers. I have been meeting with a consultant from the council about this and I am passing him some of the information I got from my survey.

What are some of the initiatives you mention?

Allan: Creative Spaces was set up by Aberdeen City Council to support the development of affordable spaces for creative industries practitioners. In 2015 the focus was on independently run creative spaces in Aberdeen and the outcome of the first year of funding was the establishment of The Anatomy Rooms which now provides studios for around 30 artists. Even with the financial support available through this initiative, every application must of course demonstrate economic sustainability and I feel this stops new graduates from applying.

With this in mind and also with what you said about studio spaces, do you think it's easier for those students who are wealthier to succeed in the arts?

Allan: Only in purely practical terms. In any cohort there are graduates from a range of socio-economic backgrounds. Some will have the resources to continue their practice immediately after they graduate but for others this will not be possible. This is where having affordable studio space can make a difference as it's not just about space, but about peer support and community.

Do you think that art schools have a responsibility to prepare all students, and particularly those who are less wealthy, for life after art school?

Allan: Yes. I do. I think it's our duty to make sure graduates can operate in that world if they need to and make things happen.

How do expectations and preparation for life after art school compare to your own experiences?

Jim: Even if you begin art education with a very clear idea about where you want to be once you leave, there is always a good chance that the experience will significantly change your outlook. There is nothing wrong with forming plans of course, but sometimes it is more realistic to be responsive to opportunities as they arise. I had vague ideas about becoming an art teacher when I was a student, but even then it seemed unwise to limit my options. More important was to learn as much as possible about my chosen medium and to sharpen my practical and theoretical skills so that I would be prepared

for any opportunities as they arose. The situation is very similar when making artworks in fact. Invariably the best artworks are the ones that we discover along the way and that lead us into unexpected terrain. You have to have some expectations of course, and you have to apply yourself with all the resources you have at your disposal. But life would be very dull if everything had to be mapped out in advance.

Allan: I graduated in 1986 but I don't remember anything specific about careers advice. There were never any explicit skills taught about how you made the transition from student to artist. The focus was on your art practice as a self-contained entity. I do remember how inspirational it was hearing visiting artists talk about their studios, projects, exhibitions, residencies and commissions, and this made me aware of what was out there, what I might get involved with in the future.

A final few questions: firstly, what and who is a fine art education for today?

Jim: It is easy to overlook the fact that education in general is a transformative process. We don't strive to learn in order to remain the same. We want to grow, develop, and become more informed, skilful and knowledgeable people. Fine art education is for anyone who wants to use their skills as a maker of things in order to find out about the world and share their discoveries. I'm a great believer in the idea that education is a basic human right, because education is one of the principal ways that we develop our potential as beings.

Another thing that is easy to overlook about fine art education is that it sensitises people to experience – visual experience mostly – in ways that are very difficult to achieve by any other means. An education in the arts, at its best, seeks to sensitise students to the subtleties and nuances of processes and materials, to encourage and inspire a familiarity with the extraordinary potential of vision and sensory experience in more general terms. It can instil a sensitivity to the importance of inflection and an appreciation of the pleasures of lingering with, and savouring, the spectacle of the sensuous. Other practices can achieve these ends in various ways too of course, but an education in fine art is specifically devoted to our species' primary sensory

modality – vision – and the many discoveries that can be revealed through exploring its vast potential.

Perhaps more than anything else, fine art education encourages idiosyncrasy, difference and a tolerance of ambiguity. Innovation and creativity thrive in these circumstances, where speculative experimentation, testing and even play are seen as worthwhile pursuits rather than frivolous distractions. There are countless ways of exploiting the world. Fine art education seeks instead to celebrate the world and our place within it.

What do you think the role of an art school is in society?

Craig: An art school education gives the individual taking part in it a voice. Most importantly this is a critical and reflective voice, open to critique, negotiation, discussion and elaboration. This outlook is key to our graduates' usefulness in wider society. The values of this voice is most evident when graduates return and describe the lack of these attributes in other graduates they have engaged with in project situations. The role of the art school is therefore to supply society with the critical and responsive eye that it needs in order to fully function and fulfill its potential.

Thinking of the future, what and who do you think art school and a fine art education could be for?

Craig: As well as the fundamental need to increase the ability to generate cultural capital, there are other potential areas where the art school's influence could extend. Increasingly the skills associated with fine art graduates are those demanded by the work place. As the economy shifts from a knowledge-based one to a concept-based one, the ability to be innovative, free thinking and critical is fundamental at every level. The evolution of the art school's future relevance relies on our ability to engage in a dialogue that assures society and our own graduates that they are able to fulfill this need, and that they have the abilities to lead and manage situations within that landscape.

With the ever increasing level of 'big data' the role of the artist alongside the scientist and technologist, to observe, visualise and interpret patterns

of information should be crucial. The ability of art graduates to see past the known and to challenge dogma ideally places them within projects as interloper, agitator and instigator, but also as facilitator in the ultimate communication of complex concepts.

All students within all undergraduate courses now need a core module that deals with the skills of critical, conceptual and visual thinking in order to generate the mind-set to deal with the communication of complex information. The art school sector has a proven track record of doing this and it should become much more central in the understanding of what future HE provision should look like. The transfer of knowledge is now universally attainable and the future lies not in the dissemination of this but with the facilitating of the individual learner to conceptualise and transform information.

Within the Scottish secondary school system the Curriculum for Excellence has the potential to lay down the foundation for this landscape of creativity. However, unfortunately the constriction of choice within some local authorities and individual schools means the opposite is under way with numbers undertaking Advanced Higher Art & Design in decline in some areas. There are also issues over the nomenclature of courses and elements within the SQA (Scottish Qualifications Agency) paper work (the use of the course title 'Expressive' rather than 'Art' or 'Fine Art'[1]) that means the transition from school into HE is not always as fluid as it could be, adding unnecessary bumps to the overall educational landscape of creativity.

1. The study of Advanced Higher Art & Design under the Scottish Qualifications Agency is separated into two areas: Advanced Higher Art & Design (Expressive) and Advanced Higher Art & Design (Design). The use of Expressive as a title is used to represent Fine Art or Visual Art delivery.

UNIVERSITY OF BRIGHTON

Five members of the University of Brighton's BA (Hons) Fine Art Critical Practice course provided a written response to our questions. Matthew Cornford is Professor of Fine Art and Course Leader; Dr Naomi Salaman is Senior Lecturer; Dr Mary Anne Francis, Principal Lecturer, is Level 6 Leader; Susan Diab is Level 5 Year Tutor and Instigator, and Coordinator and Tutor of the Fine Art Placement Scheme; and Fay Nicolson is Level 4 Tutor.

Can you tell us a bit about the Fine Art Critical practice course?

Matthew: Fine Art Critical Practice is one of four discrete undergraduate courses in the Academic Programme of Fine Art at the University of Brighton – the others being Painting, Printmaking, and Sculpture.

The Fine Art Critical Practice course assumes the equal and interrelated importance of practice and theory in our students' activities. Whilst no one particular style, medium, process or site of production defines the course, it has never been a generic fine art course. The course provides students with digital resources: computers, cameras, video equipment; students also have access to school wide facilities. Importantly the course is light on material resources and free of the need for specialised workshops.

Opportunities to work beyond the studio are encouraged throughout all three years of study. Inspired by the Artist Placement Group (APG),[1] our second-year Fine Art Placement Scheme provides each student with the opportunity to work on his or her own artist placement within the

university. The course attracts a wide range of students from different backgrounds. We see this reflected in the varied career paths taken by our graduates – everything from Eva Wiseman, Observer columnist, to Keith Tyson, Turner Prize winner, to Ruth Noack, international curator, to Jack Layer, current Masterchef finalist.

Does art education, and your course in particular, aim to create artists? Or is it more about developing in people a certain set of attributes? How might these ideas have evolved over time or since you were at art school?

Naomi: Does our course aim to create artists? I would say that depends what you mean by the category 'artist', and what relation the art student has to that category. If an artist is someone who exhibits their work, has a gallery and lives by selling their art, then no, it would be completely unrealistic to have that as an aim. If, on the other hand, an artist is someone who is engaged in contemporary art and culture, contributing to an ongoing and now global conversation in art and culture through making things happen including exhibitions, art works, events, media and education, then I would say, yes, our students can learn about specific art contexts and art histories from us, from our perspectives and from our practice. In this sense the Fine Art Critical Practice course does indeed aim to address art students as young artists.

The experience of being an art student has changed beyond recognition from when I was a student – due to the fee regime, the cost of housing, the omnipresence of social media and consequent changes to students' time. What remains strikingly similar and has remained constant since the Coldstream reforms,[2] or despite those changes, is that learning about contemporary art by trying to contribute to contemporary art is more like an apprenticeship than studying an academic subject.

Do graduates of your course stay local or go elsewhere? How much of a centre is London still for the arts? Do students need to be in a big metropolis to be 'successful'? Can you give any examples of graduates who have stayed in the local area and/or initiated something?

Mary Anne: Here is a lexicon of place-related terms for the graduating Fine Art student:

— Gentrification: the 'regeneration' of (inner city) locations with attendant rise in property prices and the loss of in-between spaces that might have been used for young artists' exhibitions. Often facilitated by artists in the first place.

— Welfare cuts: no housing benefit for under 25s; income support for those aged 16–24: £57.90 a week.[3]

— Employment: no living wage until the age of 24, just the minimum wage.[4]

— Pre-post-graduation: doing things that used to be done after graduation while still a student for reasons of the new economic landscape. Enhanced on-course Professional Development.

Example: in 2014, Fine Art: Critical Practice third-year students staged *Art Fare*, a set of interventions on Brighton & Hove buses as part of the Brighton Fringe festival.[5] As the curator, student Megan Dawkins, wrote: 'Passengers on a variety of bus routes across the city encountered artworks including art installations and performances that interrupted the normal conventions of a bus journey and daily commute' (Dawkins, 2014).[6] This was then 'documented' for the degree show via *Art Fare: The Shop*, which was subsequently shortlisted for the Platform Award and two months later, shown at De La Warr Pavilion.[7]

— Example: can be tendentious.

Example: post-graduation, and with the best Professional Development education in the world, many students simply cannot afford to stay in the city of their place of study. Often, location for the graduated Fine Art student, first class included, is necessarily, 'back home'.

What role does the location of a university play in relation to art education?

Matthew: If you'd asked this question 50 years ago, there would have been very few universities offering art education. Most aspiring artists and designers would have begun their art education at what then was called an art school or art college. Surprising as it now sounds, most towns in England had an art school, a nineteenth century legacy of the need to train local artisans in the skills required for industry. The location and to an extent the curriculum of the first regional art schools was determined by the industries in these regions. Now the situation is very different; almost every former art school has been incorporated within a post-1992 university. As a result, many local art schools have been closed down and the idea of art school as an alternative to university has gone.

For instance, in Stoke-on-Trent the federation's six towns – Fenton, Hanley, Tunstall, Burslem, Longton and Stoke – all had their own art schools. The 1925 Report of Inspection of Stoke-on-Trent Schools of Art describes the relationship between the school and the local industry: 'The principal aim of the various Schools is to provide courses of instruction suited to the needs of those engaged in the pottery industry' (Burslem School of Art, 2011).[8]

Does location still play a role in art education? Yes, but no longer in relation to the needs of regional industries. The role of location is now crucial to student recruitment; university prospectuses often feature details on the local nightlife and shopping opportunities alongside details about courses. It's no coincidence that many of the most popular universities are located in cities students aspire to live and work in. I know from interviewing hundreds of prospective students that Brighton is one such location. As such, art education becomes increasingly commodified within the language of consumer choice and marketed as aspirational life style.

How do you prepare students for life after art school and what are you preparing them for?

Susan: When they graduate, art students have to fend for themselves so art education must equip them with intellectually emboldening, pragmatic

experiences that will best enable them to flourish. Accordingly, Level 5 Fine Art Critical Practice students undertake a 'fine art placement' in an area of their choice within the University of Brighton. They might elect to pursue their art practice within the Medicine or Earth Sciences departments, or to shadow a manager, or work with the university's surveillance systems.

The Fine Art Critical Practice placements arose out of my own and other colleagues' art practices, and an engagement in thinking about how artists earn a living. Resisting governmental employability targets and differing from industrial work placements, they are grounded instead in avant-garde traditions of contextual practices of the everyday, and are taught via a discursive and reflective approach. Students critically investigate 'post-studio' practices, including the Artists' Placement Group (APG) as one model of working in context. An important guiding principle is APG's foregrounding of 'that vital ingredient of not knowing' (Steveni, 1983)[9] to encourage the projects to be as open-ended as possible.

Our unique fine art placements inherently demand that students learn many aspects of 'professional practice' on-the-job by carrying out a project in a 'real', non-art setting. They have to negotiate others' expectations of them, make evident what they do as artists and establish a presence where no one has any need to be interested in them. They learn how to set up meetings, document processes and understand the theoretical and practical implications of their work, thus raising their ambitions and increasing their willingness to take risks.

From our own experience of art school (2007–2010), and from hearing numerous discussions unfold amongst students in Q-Art crits during and since that time, it seems that the aspiration to make money from selling artworks can be frowned upon. Is this an attitude that you recognise and if so, where does it come from? Is it essential to the discipline or is it a view shaped by context and over time? How might this idea sit alongside the introduction of fees and the need for students, particularly those from lower income backgrounds, to think about how they make a living after art school?

Fay: These are the kinds of issues we debate on the Fine Art Critical

Practice course to move beyond assumptions and consider how we are affected by particular issues in art, education and beyond. I feel I can only scratch the surface of these issues in this short response, and all opinions are personal reflections.

The questions touch upon a series of relationships: between art and the market; between educational and professional spheres; between student and tutor. Do you mean *artwork* as a verb (as working as an artist) or *artwork* as a noun (an art object)? All tutors hope for their students to develop successful careers that sustain them financially. Routes open for selling artwork early on in a career often do not offer opportunities for creative, intellectual or financial progression (such as e-bay or selling to a friend), as they are outside of the art world or market proper, which is a system of value operating within a wider historical framework and (late-capitalist) economy.

Education is both preparation for the professional world, and a respite from it. Art courses offer the opportunity to take risks, take time to learn (and un-learn), test ideas, develop and articulate a set of interests and positions. The pressure to finalise work into a commodifiable form can be at odds with a learning environment.

I recognise a dislike of 'selling work' but perhaps as a stereotype. As a student I have also experienced the encouragement of selling work in the form of collectors surveying final shows and dedicated sales teams within institutions (that take 30% of the profit). Nothing is 'essential' to the discipline of fine art. I think art is an organ that operates within a wider social body. Many artists teaching within art institutions also emerge from a critical or cultural history of leftist or historical materialist thought. And therefore will take a certain position in relation to work, value and the (art) market.

Art students becoming consumers of knowledge is a huge ideological shift that changes all educational possibilities. Unemployment and a lack of suitable jobs for an overeducated population is also an interdisciplinary and international issue that should be discussed as such. Perhaps the most important questions for students might be: Can I study on a course

that acknowledges and discusses these issues? How can I prepare myself for the reality of the professional world beyond education? How can I develop a support network that allows me to engage in practice? How can we develop new forms of living, working, thinking, making that allow us space away from market imperatives?

1. 'The Artist Placement Group emerged in London in the 1960s. The organisation actively sought to reposition the role of the artist within a wider social context, including government and commerce'. Tate. (2016). *Artist Placement Group*. Available from <www2.tate.org.uk/artistplacementgroup/> [Accessed 13 September, 2016].

2. William Coldstream (1908–87) was Chairman of the National Advisory Council on Art Education from 1958–71. During this time he was said to have reshaped British art education through what became known as the First and Second Coldstream Reports (1960 and 1970). Tate (2016). *Sir William Coldstream*. Available from <www.tate.org.uk/art/artists/sir-william-coldstream-927> [Accessed 14 September, 2016].

3. GOV.UK. (2016). *Income Support*. Available from <https://www.gov.uk/income-support/what-youll-get> [Accessed 13 September, 2016].

4. GOV.UK. (2016). *National Minimum Wage and National Living Wage rates*. Available from <www.gov.uk/national-minimum-wage-rates> [Accessed 13 September, 2016].

5. Brighton & Hove Buses. (2014). *Art Fare*. Available from <www.buses.co.uk/news/story.aspx?articleid=2785> [Accessed 13 September, 2016].

6. Megan Dawkins. (2014). *Art Fare – Interventions on Brighton's Buses*. Available from <www.megandawkins.co.uk/curatorial-essay> [Accessed 13 September, 2016].

7. De La Warr Pavilion. (2014). *Platform Graduate Award Show 2014*. Available from <www.dlwp.com/event/platform-graduate-award-show-2014> [Accessed 13 September, 2016].

8. Burslem School of Art. (2011). *Mapping the Practice and Profession of Sculpture in Britain and Ireland 1851–1951*, University of Glasgow History of Art and HATII, online database. Available from < www.sculpture.gla.ac.uk/view/organization.php?id=msib4_1221476770> [Accessed 13 September, 2016].

9. Steveni, B, 1983. *Artist Placement Group 1966–1983*. Aspects. 24, 5–7.

UNIVERSITY FOR THE CREATIVE ARTS

Paul Vivian is BA (Hons) Fine Art course leader at University for the Creative Arts Farnham. He has been working there since 2007. We met him at the Royal Festival Hall, London.

Could you tell me a bit about the area, and the history and ethos of the art school?
Farnham is in Surrey. It's a very rural town, it's very small and it's fairly affluent. It is surrounded by towns whose populations are probably more socially and economically diverse.

Guildford Art School moved to Farnham in the 1970s and became the West Surrey College of Art and Design, which then subsequently became Surrey Institute of Art and Design. The University in its current configuration was formed around 2009.

There has been an art school in Farnham for over a hundred years. In its earlier contexts it was very much focused upon the subject of Craft, though it did have a vibrant Fine Art department. Guildford Art School had a very distinctive firebrand identity and West Surrey College was an environment where sheep were kept behind the textiles studios, and students would literally work with the wool from these sheep. I think the Fine Art course, in a way, adapted to that ethos and became a course with a focus on developing material knowledge and technical skills. The lecturing staff had some incredible artists that went through there, but it was a very Atelier model, as with a lot of art schools at the time. When I took over the course eight years ago, students were streamed into Painting, Sculpture, Print, and the three areas wouldn't meet, they were very separate in ethos. I think the course had become, in my opinion, very inward-looking.

So can you describe your approach now?

The focus of the course is very much on professional practice and developing students who are adaptable and resilient within the world. We also encourage cross-disciplinary practice with a robust dialogue between ideas and making. Students can freely move across areas or focus upon a single discipline. Students externalise their practice early in the course and throughout whilst being encouraged to develop self-initiated opportunities, with staff guidance, that will enable them to develop networks and opportunities for themselves.

Where do you recruit students from – and has this changed over time?

Farnham's demographic is very broad. This is because of its reputation – it had a very clear identity. What Surrey marketed itself on, and I still remember seeing the prospectus in 1989, were images of students sitting on the grass with the sun shining. So you got this message that was essentially, 'We are less intense, it's more relaxed here, and there's more opportunity to develop' – and without saying it – 'we're not interested in the market'. It was the opposite message of the London based courses at the time. In contrast, Chelsea's 1989 prospectus was a long, rectangular pamphlet without images. It was just text and a focus on the artists you'd be working with. That was it. So there was a very austere 'we are serious' message against the mixed prospectus of Surrey, which talked about lifestyle.

Today the balance is right and the University's marketing projects a far more confident and diverse message. But the demographic has always been very broad and in fact we don't get that many Surrey based students, though we are always looking to encourage local progression through presentations in colleges and schools.

Why is that do you think?

In the majority, Surrey based students are more economically mobile. They are less likely to stay within the region to study at higher education level; they are more likely to stay locally at FE (Further Education) level.

How many students are on the course?

The numbers were affected quite dramatically by the introduction of fees. The year before the fees came in, we had about 80 students, but now each year we have 45 to 50 students. This means that we can provide them with individual studios and accommodate them in the workshops. Applications have risen again this year. Based on feedback, an aspect of our professional practice, which has had a positive impact this year, is the unit where our students go out in the third year and give talks to their former college or school.

Can you tell us more about professional practice and how you prepare students for life after art school?

Professional practice is embedded throughout all of the units. It is embedded within the ethos of the course and it starts from year one; you have to give students permission to seek opportunities from day one. In the first week we get students to go to London and do spontaneous live projects in non-gallery situations, for example in markets or other public spaces. The idea of this is to emphasise that art needs an audience.

Another important aspect of their first year with us is to curate an exhibition. The students source the venue, curate the space, and undertake all the publicity. We also have a project called *Black Box*, which students can elect to do from across all three years. *Black Box* is a nationally advertised space in the Quad at Farnham. Students invite artists to present work in there and this year they've secured Martin Creed, Gavin Turk and David Batchelor. It's got about £2000 of funding from a creative fund. The students are involved in all aspects of creative management; they're running the budget, contacting the artists and developing the publicity.

In the second year, we have a unit titled 'Contemporary Exhibition Practice' which has two live components. A project we've recently done for this unit is called *Kitchen Heterotopias*, based on Foucault's notion of heterotopia,[1] and again, they have to curate artists. They invite artists they have no connection with, from graduates to established figures.

We also have a blog that is very outward facing. It's a promotional tool but it also reflects back to the students that what they are doing is valued. Our blog is about emphasising the idea of a community, as is the entire course philosophy.

In the third year students study a unit titled 'Realising Professional Futures', in which they actively seek out opportunities. One of the unit learning outcomes asks students to demonstrate that they are submitting to curatorial projects and competitions etc. Students also do talks, as previously mentioned, in their former colleges or schools; they are also effectively building on networks established in year one and year two.

So professional practice is not something that happens just in year three. It's a spine, across the entire run of the course. Right from the start they are encouraged to be outward facing and making connections.

Why do you adopt this approach?

To begin to break down the fear factor and the elitism, and to ensure that they see art practice and developing a practice as something that's democratic. That it's also about being mobile, resilient and contingent. Students don't necessarily have to get a studio in London and have that myopic world. They don't necessarily have to have a studio at all. Some of the artists that we bring in actually don't have a studio themselves and work is conceived on a laptop, so there is a focus upon contingency. I think if you start saying there is a kind of ritual or tradition to art practice, you cut the permission to do it differently down immediately. That, to my mind, is a very unethical way of teaching art because the economic situation has changed. We want them to recognise that they can be flexible and open.

Are you training people to be artists?

Absolutely. But again, we see being an artist as something that's reflexive and it's got to be mobile. The days that artists could live in London and rent a studio are diminishing, so they have to be flexible in that. A lot of this ethos, in a way, comes out of my own experience as a

student at Chelsea College of Art and Design in the 1990s where we were taught that you couldn't really engage in professional practice until the very end of the course, that you worked within your network and that it had to be London based. Like a lot of my generation, when I was at college there was no real guidance in terms of how to manage yourself as an artist and as a creative practitioner.

So we are training students to be artists, but we're also training them to be curators and to work within the creative industries as well, and to be flexible in managing that. That means that when they go out there into the world they create their own opportunities. I think that's the key thing. Yes, we do create artists but we are also creating students and graduates who see things as possible. For those, perhaps, whose ambitions lie elsewhere, they've gone into teaching, or some of them have gone into writing. Others have gone into industries which, of course, aren't related to fine art whatsoever.

Something else we do is that we bring artists in. I always tell the artists that do talks for us to be honest about their experience, and so they paint a realistic picture of their trajectory. It has to be about demonstrating to students what working within these environments is like, to make this realistic. That's also why the work experience aspect of our course in year two is so important. I've had students now working with galleries as a result of a week's work experience that they did in the second year, because of course they've constructed a relationship. And if a student feels that they've claimed something for themselves, they're much more likely to be brave enough to take that on and to engage with it later. I think that's the key because if it stays theoretical, it becomes very elitist.

Do you talk about selling work?

We talk about the possibility of sales, but we keep that to a minimum because the reality is that that isn't often the case. As part of that 'Professional Futures' unit, students do an 18 month plan. They have to identify their financial situation, the reality of where they're going to live, and what they're going to need to do in order to sustain their

practice. One of the things that we talk about is the realism of the fact that they may have to work in jobs, professions to sustain their practice. So your practice is bolstered by a range of different things, and students don't necessarily enter the creative industries when they are looking for jobs to help them maintain that. We try to bring realism into this. Being an artist is about much more than the art market. An artist is someone who is engaging with ideas that are perhaps outside of our normal social experience. One should be fascinated and curious in developing that and retaining it in some way.

So is a fine art education equally about developing in people a certain approach to life or a certain way of thinking...?
Yes, it's holistic. I hear all sorts of stories about art schools where if a student doesn't get an offer from a gallery at their degree show, they quit. I think that's extremely depressing because art is much more than that, it is a state of mind. I think good teaching is about emphasising that. It's not about presenting it as a club, or as a space where to be included you need to know and engage with certain rituals. Of course there are rituals to it, and networking is one of them, and the need to build up some kind of audience, to get somebody excited about what you're doing is another. But we're realistic. We use tools like social media with them and we talk about online presentation.

I think the key thing is about building confidence, which is why after four months of the first year, the students are in Bethnal Green, for instance, curating their own show, promoting it online, distributing all this publicity, and feeling like, 'I'm engaging with this.' Then they start to believe in themselves.

Earlier you spoke about art being a state of mind. Could you expand on that a little and also to talk about what you see as the function of art?
Well I think artists think very differently. Making any kind of art, even work that doesn't particularly look radical on the surface, is about making some kind of agitation. It might be about making agitation within a space,

or it might be about saying something quite radical and challenging us with that. Any great art is like that, whether it's painting, sculpture, film, or music. It's about waking people up. I think that's an incredible enterprise to be involved in, it's very privileged, but unfortunately it doesn't necessarily come with the salary. We make the point within the institution that art students are different to illustration students, they're different to graphics students, they're different to photography students, or whatever it might be.

In what way? And how do you do that?

Well, we talk about the difference between art and design; design is utilitarian and art is kind of speculative. We make the point that they're not making objects for decoration, and that any time that they put their work into a public space, or any space, they're making an open statement. This is different to a product design student for example, who might show a model that could be manufactured, that's going to be put to use. It's about having discussions around capitalism and what our role is within this. Damien Hirst once said, 'Art is a game of money.' I think that's also the role of the artist – that you are embedded in this system, but you have an ethical and moral duty to question it. Our students, and artists, need to be politically and socially aware in order to be in some cases radical.

How do you teach this radicalism? Does critical theory have a role?

Critical theory is embedded within the course and throughout. We see the relationship of theory and practice as central to the teaching of art. Theory plays an important role in stimulating, defining and clarifying for students their material or non-material practice. Any radicalism is as a result of changing perspectives on the wider world, and raising important questions that begin in year one with a deep engagement with writing that has informed the history of art and culture.

So do students, through their practice, have much engagement with the residents of Farnham?

That's an interesting question. The thing is, the town probably has a

particular expectation. We've undertaken projects with the local library, with the local commercial gallery, and with local businesses, and we work with Frimley Park Hospital. But over the years, as the course has changed, that has begun to slip away. I think the students were looking for more in the way of a challenge and so began to seek out more urban spaces to explore this. Each student is, if you like, trying to find some sort of issue or statement that they can work with, and that isn't something that is easily palatable. The town is very small, and the visual arts community is very much based around craft.

I once described the art school as like a UFO landing. That's what it feels like sometimes. It feels very distinct. It's not like we've shut our doors to the town and it's not to be elitist, but a taxi driver once said to me, 'Where are you going, mate?' when I first started working here. When I said 'To the university.' He said, 'Oh, yes. The house of clowns.' That's an extreme example of the occasional local perception.

Are the staff practising artists?
Yes definitely.

Do they need to be?
I think it's important because you need to replicate the students' experience somewhat. They have problems to solve, and sometimes those problems will be solved in a way that's very simple, and other times difficult. I think that acknowledgement can only come from being a practitioner, where you do struggle and where sometimes you are extremely alone. Other times, you feel you have amazing success and then you can have nothing. We all come from very diverse backgrounds and we've all got very interesting personal narratives. I was in a painting department and it took me ten years after leaving to realise that actually I was something else, I was working in a very different way. So when you speak with a student who says, 'I feel lost. I love printmaking but I don't feel I can do it any more', one can empathise with that and relate to it from experience.

How do you find the time to carry on making work?

You have to adapt. You've got to be resilient. You have to be sustainable. It is no good for me painting 20 foot by 15 foot paintings in the studio when that isn't realistic. That's not necessarily a bad thing. In a way it's made me braver in terms of the choices that I've made within my work.

But I am caught between two: teaching and personal practice, and then there's life in the middle, like family and children.

What led you to teaching?

I was inspired by the tutors of my own education. My foundation tutor Paul Allcoat was a minimalist painter in the vein of British minimalism of the 1970s and 80s, and he was just the most amazing man. He inspired me to read, see films, and to examine painting and sculpture. He opened it up. What he taught me more than anything else, which is something that we've imparted to our students here, is to be a magpie, to see research as a wide enterprise, to look at all subjects.

When I was on my BA I was taught by Roger Ackling. Roger was an inspiration and taught me that your artistic life is an inner life. He came about it from a very spiritual way, and he made me understand that the practice that you have as an artist is almost quasi-religious. You're doing this thing when everybody is telling you there is no God, and you're saying, 'No, no. I believe. I believe!' I think Roger was probably the most important thing on my BA at Chelsea for the fact that he made art seem like a very important thing to do. When other tutors would talk about the market and where you're placed in the gallery system, I found that very intimidating. Roger would then come in and he'd say, 'Well, let's just sit quietly for a moment and think.'

When we start the year with these students, I always begin by saying, 'This is a life changing experience and you are coming in one way, and you're going to exit another.' That transformation is what happened to me with art. It saved me. The only thing that kept me going was that I kept making work, and I made work when nobody cared, when nobody was

seeing it. That resilience to just keep going actually came from my further education experience and Roger Ackling.

You mentioned that being an artist is about an 'inner life', is this something that you can teach?
Somebody who I find really inspiring is someone like Richard Wentworth. As an educator he is incredible. We brought him in and he had a bag on the desk. He said, 'Are there any questions?' and one of my students said, 'What's in the bag?' And he went, 'Ah, good question.' He started bringing out objects and every object had a narrative. So he said, 'As I was going down the Caledonian Road, I found this. I don't know where it's from but what I like about it is…'. It's that thing that being an artist is not a day job. You are doing it 24/7. And that actually, you also don't necessarily need a studio to do it. You can sit in the Royal Festival Hall with a laptop, and you can do something. That's democratising. I also think that as artists, with the Internet and with communications, we can all be international.

But going back to your question about whether you can teach this thing, it's a very romantic idea, I suppose, this idea of inner life. But it comes from the students opening up about their own narratives and developing that. This isn't the old school thing of splash your emotions all over a space, or an object, or a painting, but to begin to find a connection. A very good example of this is one of my students, a very quiet first year, who had done this not particularly fantastic piece of work which was a series of bottles covered in plaster, and it looked like a kind of knackered wedding cake. We got talking about it and I said, 'I'm not sure about the object, but I think this idea of concealing and covering is really interesting.' Then I said, 'but it's funny, isn't it? It looks like a cake and wouldn't that be interesting if the plaster was less art school materials and it was something which was much more out there in the world?' She said, 'Well, I'm a baker – in my other life, I bake.' She's only 19 or 20, but she's an expert baker who makes wedding cakes. She suddenly realised that this thing that she was probably making at a distance and thinking, 'Well, I'll

do this but I'm not sure what's really going on,' suddenly, she's made this incredible connection.

So I think it's about revealing something of yourself in the work, an aspect of yourself. That's a very practical example, but it might be something that you can't reconcile in the everyday. An obvious one is a particular desire about something or an obsession about something that could go into the work. So I think it's about teasing out that narrative. It isn't about art as therapy, which I have very strong opinions about. I don't believe it is or can be used like that.

Why not?

Because though I recognise it as an established subject that is extremely valuable, I'm not convinced that art resolves, it merely continues to open up questions – more so than answers. I respect Art Therapy as a psychological and healing practice, but I don't know if the subject that we deliver to students functions in this way, at least this is not my own experience.

Is there a tension around the idea of employability and the art school?

A lot of other art schools are intimidated by the shift in culture, of the student becoming a customer or client, so much so that they're reverting back to a modernist model of workshops and lots of technical tuition, including dividing the disciplines. This is seen as more attractive in terms of providing value for money. There is an increasing pressure within the sector to perceive the economics of studying as being closely aligned to tangible outcomes and anticipated success. This is in opposition to the notion of an education that creates speculation, self-knowledge and risk. I know at UCA there is a desire to develop students in a more holistic way, and this is certainly the approach of the Fine Art course at Farnham. To me, this practice of reintroducing disciplinary focused approaches to teaching is actually retrograde. Roger Ackling's view of the world, as with a number of his contemporaries, was that you just worked with the world around you. That's an incredibly powerful message, I think, encouraging students to be free, actually.

1. Heterotopia refers to a theory developed by French
 philosopher Michel Foucault concerning the concept
 of spaces that function in non-hegemonic conditions.
 He suggests that all spaces have layers of meaning or
 relationships to other places than one would expect on first
 entering, using or experiencing a space.

SCHOOL OF CREATIVE ARTS, WREXHAM GLYNDŴR UNIVERSITY

John McClenaghen is BA (Hons) Fine Art Programme Leader in the School of Creative Arts, Wrexham Glyndŵr University. John responded to our questions by email.

Can you tell us a bit about the art school and the area in which it is located?

The School of Creative Arts is housed in the North Wales School of Art and Design, a grade-two listed Victorian building in the centre of Wrexham, the largest town in North Wales. The school is a small but dynamic creative environment with a focus on live projects in the creative and cultural industries.

Wrexham grew up as a market town but also has a strong industrial heritage, notable through the long history of mining in the area. Miners originally contributed part of their wages to fund the creation of the institution that later became the university.

The art school and the university are at the centre of life in Wrexham. We have links to the community through facilities and partnerships with organisations in North Wales and the Northwest and we have our name on the Wrexham FC football strip. We work closely with our local contemporary exhibition space Oriel Wrecsam as well as Wrexham Borough Council and local arts organisations ThisProject and UnDegUn. These spaces often collaborate on exhibitions with our own gallery Oriel Sycharth.

In recent years, the town has seen many developments that have benefitted the visual arts. The People's Market in Wrexham town centre is about to be transformed into a new arts and cultural hub for Oriel Wrecsam gallery following major capital grants from Arts Council Wales, Wrexham Council and the Welsh government. Developments of this

kind, together with the emergence of a local studio culture, have helped encourage graduates to remain in Wrexham.

Can you tell us a bit about the philosophy of the BA Fine Art course?

Our programme is primarily driven by studio practice and aims to cover the extensive scope of fine art, guiding each individual in the exploration of a range of methodologies, strategies and tactics employed in professional art practice. We have a strong interdisciplinary philosophy where students enjoy good access to a broad range of materials and processes. We still have all the traditional kit as well as new high-tech facilities and the expertise needed to use them. The degree places strong emphasis on drawing, visual communication skills, critical thinking and the expression of personal ideas through the effective use of materials and processes.

We have small group sizes, currently around 25 per level, that allow for individual support. In year 1, students receive 16 hours of taught sessions a week. In year 2 they have 14 hours, and in year 3 they have 12 hours and they also meet with their personal tutor each week. This is in addition to input from technicians and demonstrators available within the school.

The BA (Hons) Fine Art course is a three-year full-time programme but we have also recently added two four year options where students can graduate with an Integrated Masters in Fine Art (MFA) or begin with a foundation year leading into the BA (Hons) Fine Art.

Who attends the course?

On average, around 30% of students are mature students. We normally have a high proportion of UK and EU applicants and a small number of international applicants. Most of our current students applied from Wales, the North West of England, Shropshire and the Midlands. Less applied from London, the Southern counties and Scotland. We have made a significant contribution to widening participation in higher education, and have been successful in helping students to achieve final awards well beyond what they may have believed possible based on their prior educational experience.

How do you prepare students for life after art school?

Students can gain a high level of realistic and practical work experience through our 'Creative Futures' modules which form part of each level of the course and encourage participation in live briefs that feature community engagement, collaborative practice and provide opportunity for students to establish their own projects. As part of this, students have worked in a gallery context, organised exhibitions in pop up spaces, found placements in theatrical contexts, and worked in educational contexts -sometimes leading to subsequent work after graduation in schools or FE colleges. One student recently worked alongside a major British artist and secured employment as their studio assistant upon completion of the course.

We also have a 'Creative Futures' student careers conference, organised by the School of Creative Arts and the university's careers centre. This takes place in the first week of March and is for all students. It gives them the chance to gain insight into a range of career opportunities within the creative industries and ask advice from over 50 creative industry practitioners and professionals.

The first step in students being able to achieve the future they aspire to is to know what it is. Every year students hear from a range of practicing fine artists as well as others working in the creative and cultural industries. These artists tell our students just how tough it can be maintaining their art practice, particularly in the first five years out of art school. They also provide practical examples of how it can be made to work and how it is possible to make a living through their creative practice.

As well as this we aim to be an outward looking art school and there are opportunities for our students to study abroad through the Erasmus Scheme.

What are you preparing your students to go on and do?

The fine art programme aims to provide students with a high level of technical and intellectual skill as well as confidence to make them competitive in later employment, either as self-employed practitioners or as they pursue other art related career directions.

Fine art education is no longer just for people who want to be artists. You can get a good education and prepare yourself for a range of activities by studying for a fine art degree. Some students enter the degree thinking only of being an artist and then discover that they want to work as an art therapist or a curator or as part of a team planning and creating events. Others begin with a goal that does not involve continuing their art practice and discover that they actually want to be artists. Throughout the programme students gain an awareness of their skills and aptitudes through practicing them in context and reflecting upon how these and their ambitions are changing.

Can you give any examples of what graduates of your course are doing now?
Our graduates, like the graduates of any fine art course, go on to do many things. Students are now more diverse in their aspirations and I think that the array of transferable skills and the ability to think on your feet that a fine art education provides, prepares graduates well for the contemporary job market. The idea that any of us do one thing for the rest of our lives once we have graduated is outdated and can be quite unhelpful in preparing students for life in an ever-changing professional environment.

An increasing number of students go into teaching and this is something we actively encourage for those who have a passion and an aptitude for it. We foster a network of graduate teachers working in schools and in further education, most of them within a 50-mile radius, and we seek to provide them with ongoing support as educators. As enthusiastic educators ourselves, we are keen to share the strategies we use in our own teaching with our students, explaining what is going on in a given learning situation. This undoubtedly encourages many students to see teaching as part of their future.

We also have strong links with the health sector driven by the School of Creative Arts Research Centre and this encourages many of students to pursue graduate opportunities in the area of arts in health. The School of Creative Arts works closely with The Betsi Cadwaladr University Health Board's Arts in Health and Wellbeing coordinator. Research projects grow out of this link and there is a continuing need for the work undertaken to

be linked to research, hence the growing number of PhD students in this field. Arts Council Wales recognise the good work being undertaken in North Wales in the field of arts in health and have funded projects with Betsi Cadwaladr. The School of Creative Arts Research Centre is part of the Wales Arts in Health stakeholder group that works with Arts Council Wales, Engage,[1] and helps shape policies for the Welsh Government.

Graduates have also set up a range of creative businesses, studio spaces and exhibition spaces locally and further afield.

Can you give examples of any graduates who have remained in the area?

A number of our graduates work in the university itself, supporting students in areas like disability support or careers guidance. Katie Brute, a recent graduate in Fine Art now supports students with a range of learning differences whilst also completing a part-time PGCE in the university. Bex Raven, one of our MA Art Practice graduates set up Funky Aardvark in nearby Chester, which combines studio space, exhibition space, and a contemporary craft store. Other fine art graduates have helped to establish the UnDegUn studios and exhibition space in Wrexham. A number of graduates have gone into teaching locally and in the Northwest. Graduates have also regularly found employment in the gallery sector including Oriel Mostyn Llandudno, Tate Liverpool, Whitworth Art Gallery, and the Liverpool Biennial.

What has been the impact of fees?

The introduction of fees undoubtedly altered the expectations of applicants and the way we respond to them. I think it is important to focus on why an individual decides to study fine art in the first place and consider this in relation to employability. Studying fine art is still a life choice. It is as much about aspiring to a sort of personal fulfilment as it is about earning power. Of course the two can sometimes go hand in hand but this can take time.

We are upfront with our students about how they will have to find a balance between the need to earn a living and the need to pursue their art

practice. We discuss what proportion of their time would be spent in the studio and what proportion of time they would be engaged in other activities, dependent on what they choose to do to support themselves as creative practitioners beyond art school. We also provide examples from our own experience, and that of previous graduates, and encourage them to be honest about what they want out of their lives beyond their degree.

How does preparation for life after art school compare to your own experiences of art education?

I did my fine art undergraduate course in the mid '80s and any discussion of what happens after was focused on being an artist, getting a studio and exhibiting. I think it was the same in all art schools at that time. Like most of my generation of artists, I received a student grant. I doubt, given my background, that I could have studied for a degree without one.

My first year at art school really did change my life, convincing me that art education can, and should, be a life changing experience.

How do you think the current challenges that art subjects face in regards to their position in the school curriculum will impact on the discipline at FE and HE level? What do you imagine art education might look like in the future?

It is easy to become pessimistic about the continual erosion of support for visual arts education in schools and colleges. It has felt like art and design foundation courses in particular have been under threat one way or another for most of my career. The time that foundation course teams have to prepare their students for application to undergraduate degree courses is constantly being reduced as there appears to be widespread institutional pressure to hit the January application deadline.[2] This is unhelpful for fine art education because it works against the rationale for having these pre-degree courses in the first place. Key differences in the art and design subject experience make it vital for pre-degree students to have time to explore subjects and processes that schools can no longer cover.

The target driven nature of the education sector as a whole, combined with increased student numbers, has the potential to erode the opportuni-

ties to nurture individual creative development and our ability to fully involve students in a community of learning. Unfortunately the process of studio-based enquiry is so easily replaced by an off-the-shelf mimetic approach, where outcomes are predetermined rather than arrived at through the acquisition of skills required to develop an art practice. Art schools are well able to adapt to change. We have been doing so for a very long time. I believe, however, the most innovative and creative solutions to this changing environment are likely to come about through the continuing evolution of the art school ethos.

I remain optimistic about the future, but for me the answer is to focus upon the teaching of art practice, its strategies and tactics. There is some fantastic work going on in UK art schools which is underpinned by a wealth of research exploring the nature of the subject. This puts us in a strong position to argue for a greater understanding of the uniqueness of our subject and an enhanced awareness of its wider benefits to society.

1. Advocacy and support agency for gallery education. See: www.engage.org (Accessed September 14, 2016)
2. The UCAS application deadline for most applicants to art and design undergraduate degree programmes in 2016 was 15 January at 18:00 (UK time). Source: UCAS (2016). *Key dates*. Available from <www.ucas.com/ucas/undergraduate/apply-and-track/key-dates> [Accessed September 13 2016].

THE UNIVERSITY OF WOLVERHAMPTON

Maggie Ayliffe and Laura Onions of the BA (Hons) Fine Art Course at The University of Wolverhampton provided a written response to our questions. Maggie is the BA Fine Art course leader, a position she has held since 2003. Laura graduated from the course in 2013 and is currently employed as a Graduate Teaching Assistant (GTA).

Can you tell us a bit about Wolverhampton as a place?
Laura: Wolverhampton is a city in the heart of the West Midlands, its Black Country heritage evident in the surrounding industrial landscape which is yet to be fully gentrified. Wolverhampton is culturally diverse and ever changing. There is a rise in investment, development and the formation of new arts orientated organisations. It has a large student population, and much of the university's premises sprawls across the city. With roots founded in production and making, there is an untouched potential here, which surfaces through emerging artistic production and activity today.

Can you tell us a bit about the art school and its history?
Laura: The Fine Art course sits on the top floor of The Wolverhampton School of Art, a strong building that dominates the skyline of Wolverhampton. It is a purpose-built art school spanning seven floors and it is surrounded by a concrete 'honeycomb' exoskeleton: a remnant of a Brutalist age. It was constructed in the late 1960s by an architect who had previously only ever built power stations.

Maggie: The first art school in Wolverhampton opened in 1851 and was built to serve the need for designers in the emerging industrial heartland

of the Black Country. The original art school building now houses the Wolverhampton Museum and Art Gallery. The new build provided space for bespoke studios, workshops and even included a greenhouse on the seventh floor. In the post-industrial city, art schools are still important: they serve the creative students who need to find conduits to art and design careers and freelance arts practice.

What's the art scene like in Wolverhampton?
Laura: A bit disjointed. There are organisations that are still in their early stages and organisations that have been established for a long time. Students and the art school are an inherent part of both of these worlds.

What relationship has the art school and the course had to the local community over time?
Laura: Our general intake has long been from the local radius, which has grown and grown since the emergence of polytechnics[1] in the 1970s. Polytechnics were tasked with becoming educational centres that provided access to a HE experience for a public within cities and communities who had previously not had the opportunity to engage with HE. Since becoming a university in 1992, the art school had greater access to funding, and was more equipped to widen participation and further develop its relationship with the existing local community.

Who attends your course now? Does it still aim to reach those who, as you explained, have 'previously had not had the opportunity to engage in HE'?
Maggie: The Fine Art course recruits students from a wide range of national, regional, ethnic and social backgrounds. Many regionally based students decide to study in Wolverhampton for a variety of social and economic reasons – for many going away to university just would not be possible. In this sense, even though we are working within a very different social, cultural and political arena to the polytechnic framework, our mission is still about opportunity and opening up the accessibility of higher education to new sectors of the community. It is important however, from an

educational perspective, to also reach out to people nationally and internationally in order to create a rich melting pot of students from a diverse range of backgrounds studying on the course.

How many people are on the course?

Laura: Fine Art has around 150 undergraduate and postgraduate students studying on the course. All applicants are invited to attend a portfolio interview and we select those with good portfolios, interesting ideas, clear engagement in the subject and on their overall ability to succeed on the course. The average intake at Wolverhampton includes school leavers, mature students, and full and part-time students from all walks of life.

Can you tell us a bit about the history and philosophy of the course and anything that influences its curriculum?

Maggie: The course title has changed over time from Fine Art to the discreet media subjects of Painting, Sculpture, Printmaking, Fine Art as Social Practice, and then back to Fine Art in 2003. The university has implemented a modular structure since the late '80s, early '90s. What is clear is that the curriculum, the profile of the course, and the work students make, is responsive to changes in the academic team, trends, and often reflects a resistance to prevailing economic and political imperatives.

Laura: I think Fine Art represents a freedom of choice and fluidity to prospective students. Before they start the course they tour the studios and are excited by the scope and diversity of what students are making and achieving. This ability to move between different media initially attracts students to the course but this can also be overwhelming.

What is the course designed to do? What are you preparing people to be?

Laura: My current position as a Graduate Teaching Assistant (GTA) is a role that requires a plurality of selves: a teacher, artist and a student of sorts, so I struggle with the idea that people should be a fully formed 'something' by the time they complete their studies. Fine Art is an open-ended course, with no pre-determined outcomes. There are key skills and

attributes that students develop, but in these turbulent times the best thing we can prepare our students for is uncertainty, and how to apply skills to a multitude of opportunities.

Maggie: A recent graduate said to me 'you teach us to teach ourselves', and providing students with the tools to learn independently and be self-motivated is a strong objective of the course. No two students study exactly the same forms of practice but there is a consensus in art schools about the kind of opportunities that should be made available to fine art students – so practical skills workshops, studio practice, professional experience and opportunities, practice based research, historical and contextual studies – it is how a student positions themselves in relation to these opportunities that eventually underpins 'a practice'.

Laura: Students are mediating many different voices during their time at art school. Enabling emerging artists to foster their own voices is vital to both their academic and vocational progression over time.

How do you prepare students for life after art school? Do you have distinct professional practice modules?

Maggie: There are distinct modules that connect students directly with the notion of 'becoming a professional'. For example, we run an 'Offsite Projects' module at Level 5 and an 'Employability and Creative Industries' module at Level 6. However, even though we have these distinct modules, the professional development of our students is core to all the studio practice modules. At each level and to different degrees students are tested on their ability to present and frame their ideas appropriately, and to sustain practice independently. Soft skills like learning to fail and re-work, critical and visual analysis, spontaneity and ideas-generation are fostered through practice as well as formally constructed professional experiences. The issue is that students often don't recognize or appreciate these activities as useful transferable skills until after graduation.

Laura: Professional practice should go beyond tarting up a CV – there is no point if there is no experience to go with it. On the Fine Art course at Wolverhampton, professional practice is embedded at multiple levels,

spiraling upwards through the three years, and increasing in complexity and responsibility as students progress through the course. At Level 4 students take part in a studio exhibition, begin to develop a range of writing skills and attend exhibitions and artist talks. This is extended at Level 5 through an offsite residency, the development of presentation skills, and research projects in which students start to place their work within an appropriate theoretical context. At Level 6 students are curating their own exhibitions, presenting their practice frequently and developing supporting documentation, including CVs, statements, and portfolios. This culminates in the degree show at the end of their university experience.

You mentioned the 'Offsite Projects' module and the 'Employability and Creative Industries' module. Can you tell us a bit about these?

Laura: The live 'Offsite Projects' module proposes the task of reacting to a local place or space – much like an artist in residence. The sites are part of the wider community (schools, rural sites, and urban buildings) in which students produce a practical response that is then inserted back into that site. Through this, links are made between the art school, the students, and the wider world, and collaborative projects, such as those between secondary school pupils and artists, evolve.

The 'Employability and Creative Industries' module in the final year of the course aims to pull together a range of issues relating to the pursuit of an active career in the arts. Students work through a series of tasks that encourage and diversify written, verbal and visual presentation techniques, applying this to live or ghost opportunities that are pertinent to the personal goals of the student. This module also considers ways in which artists work with and alongside organisations. A series of visiting speakers from the fields of education, artists and curators, and gallery management introduces students to the professional world and the pathways taken by others. These speakers clearly demonstrate that no career takes the same trajectory.

As well as this, students can take a professional placement module at levels 5 and 6, an option module available across the art school. Those that opt for this module are usually interested in gaining vocational work

experience in a school, gallery, art therapy unit etc. to support postgraduate applications.

Maggie: Knowing or learning how to be 'professional' is the key here – whether that takes the form of a written proposal/application, an artist's talk, presentation and display or simply turning up on time – a fine art course teaches students to deliver a project. Fundamentally, there is nowhere to hide from personal and collective responsibility in a degree show!

Laura: Students also actively share their work in different formats, building up varying types of vocabulary and modes of communication suited to their work and themselves as artists that could allow them flexibility in the professional world. Curating their own work in group shows within the school provides a safe space to test out ideas and mediate between different voices. It encourages students to think about their work from a professional standpoint.

The university also runs a business startup programme, which offers advice, support, physical space and opportunities for students and graduates looking to start up their own enterprises. A number of fine art students have successfully applied to this scheme.

What does a 'successful' graduate of your course look like, in your opinion?

Laura: Can there be a singular image of a 'successful graduate'? There are different perceptions of achievement, which are felt at individual levels.

Maggie: There is no preferred template for life after art school and although many students follow traditional routes onto MA and postgraduate teaching courses, this is not the only measure of success. A successful student at Wolverhampton might successfully achieve a third class honours against personal, social and economic odds or they might get selected for New Contemporaries or even become a GTA on the course!

Can you tell us a bit more about the GTA scheme?

Laura: In 2014 the GTA scheme was introduced with the aim to support and increase the engagement, progression and retention of level 4 students. It is a two-year contract in which recent graduates undertake a PGCE funded

by the university, whilst teaching in their subject field. In the pilot year (of which I was a part) 20 positions were created and subsequently there have been cohorts introduced in 2015 and 2016.

Maggie: The Fine Art course benefits from the input of its past students. Maintaining links with alumni is important as it can feed into and enrich the course. The GTA role is an excellent opportunity for one graduate to gain experience of teaching and supporting students on the programme but many students have benefited from Laura's ability to bridge the gap between the student experience and our academic expectations. She has also become a strong and vital role model for ambitious students who see the role as a pipeline to teaching careers in post 16 education.

How do expectations and ideas of 'what's next' compare to your own experiences of art education?

Laura: The question of 'what next?' hangs over students like an ominous cloud. It is thrown around at length towards graduation. It stirs up panic and the feeling of edging towards a precipice; this is the point where you have to bungee jump. I remember the anxiety myself but it comes to a point when this needs to be converted into a productive form of anxiety. Art education prepares for this on one level when it is taught in a manner that embraces the unknown and teaches how to navigate the difficulties of art practice – knowing how moments of creative emptiness can emerge into personal progression and inspiring turning points.

Maggie: 'What's next?' – the importance of this question in a discussion about fine art education is interesting. The question anticipates a level of critical reflection and purpose to progress an idea, activity or career, it also promotes the expectation of on-going practice rather than complacency and completion. The 'what's next?' question is fundamental to fine art education and methodology. A fine art graduate should always be asking 'what's next?' – that's what makes us resilient, reflective and independent thinkers and workers in whatever field we find ourselves.

Laura: Before graduating I was already seeking out a new artistic community to join. The fear was that by losing the bubble of the art school

I would fall out of that loop of peer support that is often taken for granted. Being an active member of a network of artists and creatives is imperative to 'what's next,' and now more than ever artists need each other in this fragile stage of their careers.

What and who is a fine art education for today?

Maggie: It used to be for people 'who could draw' – now it is for people who can 'draw upon' and 'draw up' a whole range of ideas and projects in response to the world they inhabit.

Laura: Art education has evolved dramatically, considering the influence of globalisation, competition and the marketization of higher education. The language surrounding it has also changed. Fine art education should take a critical position on the value of our society today; it is in the position to evoke a language of cooperation rather than difference.

What do you think of as the role of the art school in society?

Laura: The role of the art school in society can be traced back to the basic role of art in society, which is to attribute form and meaning to our understandings of everyday life, not through imitation, but lived experience. It has a tangibility that other subjects cannot achieve. In this sense the art school is a playground for the next generation of artists to explore, experiment and reinterpret human culture, so that we may share in it together or contemplate alone. It affects our self-consciousness and therefore our cultural-consciousness.

Maggie: In that sense, the art school is not a 'knowledge provider' in the traditional understanding of a school – our students mostly need support to work out the knowledge and skills they need and then how to find a means of acquiring this knowledge. This is often a problem for a society and governance that expects us to define a core curriculum and deliver it verbatim. Open ended and free-range learning is increasingly problematised in the current university structures and in quality assurance strategies that demand every student experience is the same and is measurable in hours and resources.

Imagining freely, what and whom do you think art school and a fine art education could be for?

Laura: Lose the model of growth defined by economy and neo-liberal thinking that suffocates art schools. Instead enable arts schools to maintain their own rhythm. One in which the percussion for creativity transpires in the communities they are grounded within.

A consideration for art education as not only the formation of fine art practices, but the formation of the artist as a whole – the wholeness of artist practice; reflexivity, deliberation and the creativity of action. Fine art education should be about artists shaping their own educational goals based upon passion and empowerment which extends to a lifelong love of learning. Art schools should become educational spaces that attempt to propose change but also change themselves, folding and unfolding from the outside in and the inside out, a movement that creases itself (see diagram).

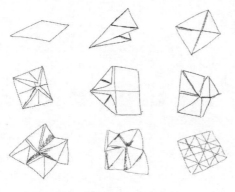

1. A higher education institution that offered courses at degree
 level or below, especially in vocational subjects. In 1992 all
 polytechnics became universities.

GOLDSMITHS COLLEGE, UNIVERSITY OF LONDON

Michael Archer is Professor of Art at Goldsmiths College, University of London. This interview took place in his office. This discussion refers to the BA (Hons) Fine Art Course.

Could you start by telling us a little about the structure and philosophy of the BA Fine Art course?
The programme is what we would call student centred or student led. From the time the students begin in the first year, they have a studio space and a tutor, and they're in a convenor group which includes students from all three years. They're also in a studio which contains students working from all three years in a range of styles, as the studios are not segregated according to the different kinds of practice. To begin with, then, they are in a very open space which has a lot of possibility. Because it is a student centred approach to teaching, we do not set any projects, and the first thing that the students will encounter in their first term is the need to understand for themselves what that really means.

How you prepare students for life beyond the course? Do you have specific professional practice sessions or anything similar?
With regards to the preparation of students for life beyond graduation there's a fundamental question right at the beginning: do you want the work you do in that area to be part of your curriculum or do you want it to be outside your curriculum? We (the staff) had that discussion some years ago – a discussion that has been regularly revisited since – and we are all of the very strong opinion that it should remain something that is outside the

curriculum. While it was important, we don't want it to become the reason that students are here.

We organise a series of sessions which are open to all of our undergraduates on both the single honours and the joint honours programmes. They are largely aimed at third year students, but if second year students want to come, then of course they're perfectly welcome to do that. It covers the obvious things: possibilities of postgraduate study, questions of how to present themselves, issues about the work that might be available. It covers questions about how they might continue an art practice: do they need to have a studio, for example, in order to think that what they're doing is art? If they do, then this is how they might go about it. If they don't, then there are other options which we talk about. It covers questions, importantly, about building a network and maintaining that once they leave because it's automatically given when you're here: students are in the studio with you, tutors are coming in and talking to you all the time, there are lectures and so on. How do you keep a conversation going once you have graduated and are working?

And, inevitably, there's a lot of fracturing that is bound to go on because there's no established path, there are no city internships for artists where you get inducted into a company and fed through – you have to make your own way. So there'll be a lot of part-time work, which means people doing different shifts, so it's not easy for them to meet up with each other.

When we run these sessions we also think it's very important that the range of people we get in to talk with the students are people that they can have some obvious connection with, which is to say they're not the people who are running large institutions who are already 30 years into a career. They're people who have, largely, only graduated themselves a few years before, and they are living precisely in the space that the students are about to enter, trying to work out how to develop a professional life.

Can you give some examples of the kind of people that come in to speak at these sessions?
They've tended to be ex-students either from the single or from the joint honours programmes here. There are some who will have carried on work-

ing as artists, some who have already been taken up by a gallery, some who are exhibiting, some who will have started to organise shows for not only themselves but also other people who are friends of theirs who they've met both in college and subsequently. Then there are people who've gone on to postgraduate study, people who have found residencies who can talk about that process, people who've moved into working in galleries or museums, and then people who are doing other things within what might more broadly be thought of as the creative industries: different aspects of film, theatre, design, media and so on.

So they're people who the students can recognise as being very much like them, having the same kinds of abilities and knowledges that they've gained while they're here, and then they can talk about how they've managed to find, or to use, the opportunities that have been searched out or have presented themselves to them.

So these sessions are not compulsory, and I'm assuming, not assessed either?

They're not compulsory, students absolutely don't have to go, and they're not assessed. Students do not have to present us with any work as a result of attending them. I have seen models where it has been a part of the curriculum for undergraduate students and I have not been remotely inspired by them, and the students I've spoken to who had to do that have not found it in any way helpful to them.

Are you training students to become professional artists?

I think we would not say that for two reasons. Firstly, central to the way the course is structured is that each student has a studio space of their own in which to make the work that they want to make. We will not tell them what to do, even at the beginning. Implicit in this is the recognition that the students are working as artists from day one, and everything that they present to us is understood as, and dealt with, and received as, art. The conversation is about that. If we were training people to be artists, if we said: 'We're giving you three years of training so that at the end you'll get a piece of paper certifying that you are now an artist,' by definition everything that

they presented while they were here would not be art. It would be something that was aspiring, or hoping or pretending to be art. The discussion could then not concentrate on the work and its qualities, but instead would become a judgement on how far the thing in the room with us fell short of some abstract ideal. So we are not training people to be artists, we're giving them the space and opportunity to gain practical skills and knowledge, to practice, to improve, to fail, to enquire, research, question, and to develop an understanding of what they do in relation to all the other things that are going on in the world. As a consequence they will of course be well able to work professionally as artists when they leave college.

Secondly, if we present the programme as such a training, then the expectation is that upon leaving you will suddenly appear as an artist, galleries will sign you, give you exhibitions and sell your work.

What's much more likely to happen is that out of your peer group, somebody might emerge who, actually, really likes organising exhibitions and who is the one who will set up the gallery and show the work of their peers. That network builds, and then someone else is the one who does the writing. So it's not some distant set of institutions out there who are just going to come and pick you up. What the students are gaining through doing the programme is the ability to do all of this for themselves.

So it's more about getting people to understand that they can make their own space?
Yes.

While they're here, students can become increasingly aware of how uncertain everything is, how unstructured the world is in all kinds of ways. And certainly, how the things that interest and motivate them may not be the kinds of things for which they will find an already established professional structure once they leave here. When they leave, rather than thinking, 'This is the question, I know the answer', they're able to think to themselves, 'What is the question? How can I answer this? Given what I now have, what am I able to bring to answering this problem?'

How aware of that, do you think, are people when they apply?

At open days we try to be clear with everyone about what they could expect from coming here. Very often you get a question from an anxious parent about what it is that we are providing to students who leave here, what is the guarantee? In response we would tend to say, 'If that is the most important question for you at this stage, which of course is entirely fine, then probably this is not the course for you'.

There is no doubt, as we've discussed, that if this is the area that you are actually interested in, it's not well structured in the professional sense as traditionally understood. There aren't jobs for artists in the way that there might be for solicitors, say. As a consequence, students well recognise the range of factors that are in play as they establish a way of living and working once they graduate.

When they leave here, they will be in a situation where they have to construct their own way of proceeding. Alongside the possibility of full or part-time work to support continued art making, there are numerous other avenues and we have many students who leave here to work in film and post-production, in set design, model-making, in fabrication, music, museums, galleries, and many other areas within the creative industries.

The fact that the programme is structured so that all three years are in conversation with one another, does mean that there is a continuum for all of our students beyond the end of their three years here which, for things like that, for making connections, is extremely important.

Would you say that it's an expectation that students maintain some sort of practice once they leave?

It can be although that's not a demand. And I think it's important that students all understand that. It might well mean that when you leave, in order to deal with the practicalities of continued existence, you don't spend money you don't have on a studio which you're never going to be able to get to anyway. The fact that you're not making ten paintings a month anymore doesn't mean that you've stopped, that you've lost everything that you've been doing for the last three years. You still have the abilities, you

still have the way you can look at things, and appraise things, and deal with them.

You shouldn't think, 'Oh my god, I've failed because I'm not still working in the same way as I was when I was a student'. Nobody can do that. The *Life After* stuff is, as much as anything, dealing with the inevitabilities of life and how you deal with those with equanimity. Other things happen – life events, family things – and those are the things that are unavoidable and that you have to deal with from day to day. The idea that the institution should add a further burden of expectation that you establish a career in a particular way once you graduate is just not right.

What do you think the role of a fine art education is in society?

I think that the ability to question, to ask oneself questions about anything is really valuable. What they have here is a space of possibility, and part of what they will, hopefully, come to understand and act upon during the time they're here, is what that means for them. Not that they should ask 'the possibility to do what?' That it is their question. It's not for me to answer, it's for them to answer, because as soon as they ask me, 'possibility to do what?' then we're back to the situation in which I'm telling them how to be an artist, which I'm not prepared to do. It's for them to do that.

PARTNER INTERVIEWS

KINGSTON
UNIVERSITY

Group discussion with the following staff from
Kingston University (KU): Mandy Ure Acting Head
of School of Fine Art and Head of Department
of Fine Art; Joanna Bailey, Faculty Learning and
Teaching Coordinator and Senior Lecturer in The
School of Architecture & Landscape; Alexis Teplin,
Senior Lecturer, BA (Hons) Fine Art and third year
coordinator; Adam Gillam, joint Course Director
BA (Hons) Fine Art; Jo Addison, joint Course
Director for BA (Hons) Fine Art; Mark Harris,
Associate Professor for BA (Hons) Fine Art looking
after second year Fine Art; and Dr Dean Kenning,
Research Fellow in Fine Art. This conversation
took place in an office at Knights Park Campus,
Kingston University.

Could you begin by giving us a description of the area in which the art school is located?
Adam: Kingston is a suburban art school on the fringes of London. My terrible phrase for open days is that we're kind of 'in it, but not in it.' There's a sense of a local campus community and the galleries and the art world in central London are easily accessible. I think the students that come here do so particularly because of this sense of community.
Jo: We think a particular organism of student and lecturer thrives here! [laughter]
Mark: I think the difference between us and other London universities is that most of the students live nearby.

There are two public institutions nearby, the Stanley Picker and the Rose Theatre. They have separate directors, curators and programmes but work very closely with the university to share many opportunities and events.

Jo: And Dorwich House now too, is a key partner of fine art here.

Mark: Yes. It's good to have all that as a small town.

Adam: The studios are open seven days a week. That also reinforces that sense of community, I think.

Jo: A lot of us have taught at regional colleges and central London institutions. So we feel it's got this quite strange and fairly unique combination of students living local to the university, but being part of a sort of very urban dialogue as well.

Adam: I don't know that many graduates stay on in the area after their course...?

Mark: No. Not in Kingston.

Adam: They can't afford it.

Dean: It's expensive. I mean it's quite an affluent area.

Adam: It's cheaper to live in Peckham, south east London. A lot of students who come back to give talks will talk about Peckham and also the very end of the Eastern District Line on the London underground...

Dean: Kingston has an enormous shopping centre. The major culture of Kingston, I would say, is retail. I suppose the college is also, in a way, on the outskirts of that.

Jo: But some of the dialogue between the university and the community in terms of culture happens via the Stanley Picker Gallery. There are people involved in the steering group of the gallery who are very embedded in the cultural activity of the community. So although I think there are probably lots of other links with the community, I feel that one is particularly strong.

Alexis: It also feels like a university town to me. There's lots of people of that age and demographic, which is very different compared to London.

What would you say are the demographics of the student body in fine art?

Alexis: It's very white.

Adam: Then it's about 80% female, 20% male. Our UCAS application is just over 80% under 21, 81% from England, 2.4% from Wales, under 1% from Northern Ireland and Scotland, and 15% non-UK. That's pretty much reflected, I would say, in our cohorts.

Joanna: In comparison to the rest of the university there are high numbers of those with dyslexia. The university also has a Key Performance Indicator (KPI) to increase the Black and Minority Ethnic (BME) attainment – so how white students are comparing to BME students in terms of their degree classification. This is an issue across the Higher Education sector and we're particularly trying to tackle it at KU because as a university, we have the most diverse student population in the UK. This diversity isn't, however, reflected in fine art. We are here at the Knights Park campus but the university has four campuses and other faculties too.

Dean: If you went to the campus ten minutes away from here it would be much more diverse.

Mark: It's markedly different.

Mandy: That's the Faculty of Arts and Social Sciences. I think the diversity issue on this course in terms of BME and also gender balance pretty much reflects fine art as a subject area. It's a problem for fine art, a very, very common one.

Why do you think that is?

Mandy: I think it's to do with the school people attended, expectations, misunderstandings...

Jo: Perceptions of employability.

Mandy: Yes, perceptions of employability. I think it's different if you're thinking about more media based courses, so things like filmmaking or areas that are seen to have higher levels of technical or employability skills. We need to get rid of that misnomer that one is more employable than another, because we do know that when they come out of fine art education students can go into design or film making areas, almost as successfully as students who come directly from courses in those specific areas.

Joanna: Teaching architecture, I sometimes see students who would have loved to have studied fine art but instead they had parental pressure that pushed them into architecture as a profession – and they're not happy. Sometimes they leave because of that.

Jo: We do have students transfer in, particularly from fashion and design courses. I think that's to do with the fact that after a year they feel able to stand up for their decision, or perhaps they get parental consent or something, because they can justify their choice with a bit more knowledge than they had when first applying.

Dean: I suppose the courses reflect a bigger question of cultural division anyway. I mean, the truth is that fine art is still a more middle class activity. The real worry now is what's happening in schools in terms of the English Baccalaureate (EBacc) and the loss of a lot of art courses or time given to art in schools. There is also the pressure of student debt and what that does to people psychologically in terms of them thinking about future employment.

Joanna: I think the EBacc thing is really significant. Students are choosing their GCSEs so they include sciences and humanities and a foreign language, and they might put something else into that mix which is quite often seen as a fun subject...

Adam: A hobby.

Joanna: ... something, which they can enjoy. And they can really only choose one of those. So they're choosing between art, music or drama, design and technology or whatever it may be, and it's really limiting them. And then when they're coming on to do their A-levels, art is not one of the facilitating subjects in terms of the Russell Group.[1] So even if they really loved it and want to go into that area, if they're only choosing three or four A-levels, are they going to choose a subject which is a non-facilitating subject?

Jo: Yes. I don't want to be too bleak, but I think it's the tip of iceberg. A lot of the work that we've done with TATE[2] exploring the early years curriculum reveals how art is no longer perceived as a subject in its own right but as a method by which other subjects can be communicated. My

five year old son's generation are learning about art as a facilitation tool, or as a way of approaching or accessing other subjects.

Mandy: Yes. 'Bring your creativity into science' ... or business.

Jo: Or into maths, which I do believe in, but not at the expense of art being a subject in its own right.

Dean: It feels like there was a period where art was opening up and becoming more inclusive. I think a lot of people currently teaching are from what would now be described as Widening Participation (WP) backgrounds, more so than the current student body. I think that's a worrying shift. It puts a lot of responsibility on anyone involved in art or art education to try to somehow negate that development, try to change the perception like you're saying.

Mark: I think from the parents to the schoolteachers, everyone thinks that the exit point is just to be a fine artist and that's it. Whereas actually, there's a much wider exit or career development.

Jo: We're asked that at every open day, and it's a really lovely moment when you can open up a new set of possibilities for them about what their son or daughter could be doing with a fine art degree.

Adam: They relax a bit don't they?

Jo: Yes. And sometimes they even endorse it, like that guy who attended the open day as a parent and said he had recently employed an accountant and two other people in his law firm who were fine art graduates.

Adam: He said they were 'Absolutely brilliant.'

Mandy: I'm not disputing any of this, but this idea of adaptability and transferable skills is recognised in the sector and is being trumpeted in university marketing and at open days, but it's not really going out or being heard in the wider community. We know it, the students know it once they've been here for a year or two and they've heard from other alumni, the sector knows it in things like the *Creative Graduates Creative Futures*[3] reports, but it still doesn't go beyond that. If you hear of people who are successful through the mainstream media, it tends to say they've studied art history when you know they've studied fine art. It academicises what they've done. So channels like that really don't help. If you're trying to get to

schoolchildren and to a WP audience, they're maybe not the people that are coming to open days. So how do you get to them before they get a misconception of what fine art education is about?

Jo: I don't think the sector is at all innocent. The media have done that, but within the sector I actually think we've collectively done a lot of narrowing of the description of a fine art practitioner and what's possible as a fine art practitioner.

We talk a lot here about being more pluralistic about what art practice might look like. Yesterday we invited nine alumni back to talk to our third years, as a pilot for an Alumni Mentoring Scheme. They gave presentations on what they'd been doing since graduating, then they had discussions and mentoring tutorials with current students.

We talked with them about the long shadow of the Young British Artists (YBAs)[4] and the broader perception of what fine art practice looks like, and the snobbery around that. I think we're working really hard to try to debunk that as a myth. All those things that are espoused as professional advice like 'go to openings and network' account for a really narrow perception.

Dean: What does success in art look like? I think the art system as it is, and the pathway that feeds into art education and so on, puts far too much emphasis on a certain type of visibility. I think most students are realistic. They know that there's thousands of fine art graduates every year and only a few are going to have any kind of success on those terms. And even quite 'successful' artists don't actually make enough money to live on just from their art.

Adam: It depends on your definition of success as well?

Dean: Well, that's what I'm saying.

Adam: You know, being able to carry on making work independently to some degree, however you do that, is a form of success.

Dean: That's right. I think so as well.

Adam: That long shadow of the YBAs has led to a sense that it's about making money and selling, and that success is about getting exposure and having status.

Jo: And representation and all of those things.

Dean: It's a certain glamorous notion of what it is to be an artist.

Adam: That can be very paralysing, I think, as a graduate, if you feel that's not happening to you. It can feel as though you're not successful. When we left college it was like you disappear and then 20 years later you have a show at the TATE.

Jo: It was the dark art really wasn't it? As a sector, with higher education as part of that, I don't think we've done a great deal to explore those alternatives, which is what we're trying to do.

Dean: There has to be some kind of avoidance of the notion that that's the only form of success, otherwise you're a failure, you know?

Can you give you an indication of what some of those alternatives are?

Jo: Well a couple of days ago at the Alumni Mentoring pilot, the thing we probably heard the most was the graduates accounting for the periods of time that they hadn't made anything or hadn't been able to be active. They talked about how difficult it had been to own or feel positive about that. But they had all come to a point where they were able to say, quite proudly, 'I haven't made work for ten months' or 'I make work in the moments that I can, and loads of people know about it through Instagram'. They didn't see themselves as unsuccessful because of those breaks or because of not being approached by a gallery.

Adam: I think, equally, a lot of that time was quite productive even though they weren't physically making.

Jo: Yes. And they all spoke about, in different ways, the relevance, or in some cases the usefulness of the temporary, mundane jobs they'd taken to get themselves up and running. So, one person got a job painting soldiers for tourists, and she admitted she found that an incredibly useful time. While she was earning money she found herself generating thoughts and ideas. Then she had a period without a job where she was really active with those ideas.

Adam: There was also a dismissal of working in the art world actually. Sometimes invigilation or gallery work might not offer the opportunities that graduates originally thought they would, and that can remind graduates

of what they would prefer to be working on. Employment that is less subject-related can sometimes be more useful.

Jo: Yes. Lots of them said that. They talked about being instrumentalised as well, the idea of something being presented as an opportunity when in fact it was a sacrifice of time and money for very little gain.

Alexis: I also think that that awareness comes out of the teaching here, that we've created that position that it's okay for them to work that way. I think that was the main reason we started having these curator and writer seminars, all day seminars with people from different parts of the art world coming in and talking about what they did, because most of those people came out of a fine art degree. So I do think as a team, we have been working very hard to start opening up possibilities and thinking about things like that. I've had graduates say that because of the way that the programme is structured and their ability to talk in seminars and things like that, they've found that they have been the best at jobs outside of the arts because they can think on their feet. So I do think all of this stuff actually comes out of their education.

Joanna: Yes, I think identifying those other jobs and how students can use skills in transferable ways is really important as well. It touches on the alumni mentoring project we are doing, which is really linked. As part of this there will be a whole series of case studies that will be created of alumni looking at where they studied, what they went on to do, and how they did that. These case studies will be available to undergraduate students as part of a larger alumni mentor project in Fine Art.

Dean: I think while not focusing on a certain notion of a successful art career, it's important to demystify the whole art world, you know, what galleries do, how to make funding applications. The fact that these things are available is really important. I did a workshop here a couple of years ago with first years asking them to do a map of the art world and to locate themselves on it – an 'X marks the spot' kind of thing. It was very interesting. They were certainly under no illusions. And that wasn't because they weren't ambitious, it was because they had a critical realistic sense of what was happening, which I think is probably a wider shift for this generation.

I mean it's not just art, all kinds of things are generally harder now for younger people, you know, like affording housing, living, existing.

Joanna: The idea of success, and what constitutes success is really interesting. In terms of architecture, I teach a professional module and at the beginning I ask students how many of them want to become an architect. Each year, every hand shoots up and I know that only 30% or 40% of them will actually become an architect. The course is preparing them for that, but it's also preparing them for other things, and their ambitions will change regarding what they want to do next as they move through the course. So I think it's important that they see other areas as being successful and valued as well, and similarly within fine art.

Jo: Quite a few of the alumni talked about this term 'success'. One said, in a really positive way, 'I'm not looking for success, I'm just doing what I'm doing.' She said she used to look far into the future at what she might do but now she's trying to just...

Adam: ... Do.

Jo: Do. Yes. And sometimes that involves making, sometimes it involves cleaning up images for websites for quite a while. It's a very changeable thing, and all of them had this sense that it's not just about their art practice, but also about their living circumstances, of being very peripatetic, very moveable, even to the point of how they live on boats and how they move their moorings to keep costs down. So they are physically, geographically moveable, and their work seems incredibly moveable too.

Mark: That is, interestingly, also the future of art practice isn't it? It's not going to be studio based...

Adam: No.

Mark: ...especially not in London, because the studios are all disappearing.

Adam: They're all being sold.

Mark: Studios don't exist for those graduates now. So it fits with what they're going to have to work with.

Adam: Just going back to this thing of location. I caught a programme on the radio last night about Glasgow. It was talking about how, because it's

cheaper and there is a smaller art world there, students are able to live in flats, convert them to galleries, and they're able to do things in a really low-fi way because they're not faced with the pressures that the students leaving here are.

Another one of the things that came out of the alumni meeting was their total use of social media in all its forms. I mean one guy had 13 shows from being on Instagram. So Jo and I were both like, 'Right, let's join Instagram!'

[laughter]

We asked them about how they filter the opportunities? And they were like, 'Just take everything. Do anything that comes your way.' One guy, he wasn't precious about any of it.

Dean: I think that's probably a good sign isn't it? One of our responsibilities teaching in art colleges is to think about the reproduction of art for the future. There is a certain view which is all about reduce the number of artists as much as possible so we have a few 'art stars' and everyone else will maybe be interning for free or trying to get in there. When people talk about the emerging artist, you've also got to think about the submerging artists, because you can't...

Adam: You could be emerging at 65.

Dean: Or re-emerging, and all kinds of...

Jo: Drowning.

[laughter]

Dean: And the other thing is sustainability. We want people to be able to contribute to the culture through this amazing art education, through sustaining something in whatever way is possible. I definitely wouldn't want to romanticise that nomadic lifestyle. There has to be some kind of stability and sustenance to maintain a practice. I think that idea of not following the 'correct' paths, not obsessing about the correct doorkeeper, not feeling that you might somehow lose esteem if you have an exhibition on the wrong platform or in the wrong gallery or something, I think that's probably quite healthy.

Jo: When we asked these graduates in to speak to our current students we thought it could also be interesting to bring in those who might be

interested in teaching, as these conversations could be useful to them as well as the students. After the event a student wrote an email saying 'Thank you for the other day', reflecting on how invested the graduates were in what happens to people who are younger than them. They were incredibly generous and community minded. They came with lists of things as well. So they didn't just give an account of their experience, they left lists of, 'You should try and go for these. Work for these people.' And they even mentioned things that they haven't got yet, so they effectively would be in competition, but they weren't precious about it. They were effectively saying 'You can do this as well. Go for this.'

Do you think that's a reflection of the ethos here somehow?
Alexis: Yes, I do. I think that that's something we really work hard to establish.

Could you say what the ethos of the fine art department is? If you can pin that down...
Mandy: I could and I've not been here that long. There is a real sense of everyone being proud of the course that they're on. The late and weekend access really does help with that. I might be leaving the building at five, six o'clock, but suddenly those studios come alive in a way that they haven't during the day. They work a lot together, and they have networks across London. They've been having shows in different spaces across Bethnal Green, Stepney, Peckham, wherever it is. They're able to integrate into a wider community and at the same time, there's a real support for each other. I've come from a very supportive place before this,[5] but it depended a lot on the local and a lot more on 'we're not London.' Whereas actually here, it's not about that and it's not even that they're in Kingston, it's just this course, I think. There is something quite unique about it and there is a sense of students supporting each other upwards as well. There's a sense of equality I think, and real discussions that happens.
Alexis: I don't think staff think of themselves as separate from the community either. I've just come back from doing this biennale. I sat down

on the couch with the students and showed them what I did, and we talked about that and how that worked. That's actually quite a normal conversation – that's not a rarity here. It has to do with where the office sits in relationship to the students' studios[6] and how we interact with each other.

Adam: There are also particular forums we have created in order to listen to the students. Every two weeks we have a studio meeting with the students, and we try to head off any issues that are festering. That also empowers students to suggest ways they might want the studio to be organised or what kind of events they want. It's trying to listen to their voice.

Jo: There is a sense of co-construction and while we haven't formally said that, we are definitely consulting with them very closely as we go forward. Student consultation and feedback is an absolutely genuine process on our course. It's really valued. I think the students and staff at those forums are taking those bits of feedback incredibly seriously. So there's a very healthy sense that we can be criticised as a staff team by our students and that runs through to critique of work. It's critique in the best sense, and it's offered very honestly and very generously.

Alexis: Also, if they come to us with something they're unhappy with or unsure of, we explain why it's like that. It's not like we go, 'Well, we'll do it your way.' It's more like, 'Well, this is why it's structured this way and this is why we think it works.' So it's also being open with the explanation of how we set things up.

Collaboration is a really big part of the curriculum. We start that up in first year with the students having to go and find a space and create an exhibition outside of the university somewhere.

Mark: I think to ask first years to go and set up exhibitions in the centre of London is incredibly challenging. I also think that because that bar is raised quite high right at the beginning of the course means that when they come and do the same thing in the second year, they're doing it in a very diverse way as well.

Adam: It terrifies them, but they love it.

Mark: When I first heard it, I questioned it, I thought 'that's way too...' But actually they do it. I think we're lucky because we generally get

students who are up for challenges and they throw themselves into these things, probably more so than an art student in the past would have. I think in the last five years or so they're much more ambitious, much more engaged, much more open to trying out things that may even be beyond, traditionally, what fine art is — because some of the events we are running are wider than that as well aren't they? They're not necessarily traditionally fine art opportunities.

Adam: They have to be quite resourceful in that first year, because so much of London is commodified and every little inch of space is costed. Sometimes they don't actually take a space but they might do something that's outside along the river Thames or…

Dean: In a park.

Adam: Increasingly, they find very peculiar, wonderful spaces under theatres or in disused swimming pools.

Joanna: And then they invite students and staff across the faculty to their show. I think that's interesting as well.

Mark: Yes.

Joanna: And it's important in terms of the understanding, I think, of our disciplines and where the edge of those disciplines are and how we can collaborate with others.

Is that something that happens here or is encouraged?

Joanna: There are shared spaces and workshops where students work within the faculty. So students are working on their own work, but also having discussions and seeing other students' work, both undergraduate and postgraduate.

Dean: It does have a strong feeling of an old fashioned art school here.

Adam: Yes.

Dean: It's quite rare now to have that sense of different arts disciplines happening within the same place. That's either because they've separated or because they've become part of bigger universities. So that is quite special.

What do you get from having those cross-departmental connections?

Joanna: I think some things are tangible and others aren't as tangible. Shared discussions, seeing each other's work. Thinking through making is important to all of us in different ways.

Jo: We were talking earlier about mythology. Through conversations with our students we can question or debunk or rethink theories about how making might happen for individuals. It's not new, but we spend a lot of time in the first year of the course legitimising thinking through making as an alternative to the other way round, which is how people have tended to be taught before they get here.

Dean: It comes back to this idea of confidence doesn't it, and building confidence? It's important to remember how special doing an art degree is compared to a lot of other degrees. I did a non-art, humanities MA and it felt so poor in comparison to what I'd had on my BA. It's that sense that you are actively producing stuff, but then thinking very deeply, critically, contextually, philosophically about this.

Jo: And what that means is that there has to be a period, possibly very prolonged and ongoing, of uncertainty.

Dean: Absolutely.

Jo: Uncertainty is very highly valued here.

Dean: That has to do with confidence as well doesn't it? You have to be confident to be able to take a chance with that fully, you know, to follow an intuition. That is one of the problems with secondary school art education because of the observation system – teacher assessment, classroom assessment, everything has to be evidenced in terms of what the students have learned. I know a few really good school art teachers, and I know one who got marked down at his observation because he was told that the students didn't know what they had learned in the class.

Mandy: They haven't got the confidence to say, 'I don't know what this is. I don't know what I've learned yet. I'm still thinking about it…'

Jo: If you're on a course that doesn't enable that, it's self-sabotage. Whereas I think on our course what we've done, and are doing, is trying to trust our students to have that uncertainty, and to trust ourselves to

be able to locate the learning and deal with 'evidence' a bit more creatively.

Dean: Well, evidence is the determining factor and it sometimes doesn't matter what is evidenced. I think a lot of the formal accounting systems that are imposed from above fail to capture what is valuable in teaching and learning. With art, the criteria for judging has to be very rigorous, but it's not something which is set. It's constantly evolving and that evolution has to happen through discussion, through uncertainty, through communication with each other. This is what happens in the crit. So it's not a kind of opinionated, 'This is what I believe', but at the same time it's not 'anything goes'. There has to be a rigour that happens through not immediately fully knowing, but instead feeling your way towards something.

Jo: I think that's about trust.

Dean: Definitely.

Jo: It's about trusting students, trusting one another, because we are in a very neurotic education system. I think we've reached a point here where we've all said, 'Okay. We get that. We understand where we need to structure things and the need to account for ourselves, but let's not let those things frame us'.

Mandy: In art and design education your work is on display all the time. Even if you're not using the studio you're presenting work in a crit, in a seminar. You've got to be quite brave because you're putting things out there before you've finished them, before you're sure what they are yourselves, and you have staff and peers, essentially, judging them at that point in time. So you have to trust that it's a safe space to do this. You don't get that if you're doing History or English. You can refuse to show someone your draft and often you're only showing that to your tutor. You're not sharing drafts out.

Jo: It's like always being in your underwear.

[laughter]

Mark: But it's things like that, which are the things we should promote fine art courses as being about, because that is such a useful skill for loads of different things in life. The difference with an art degree is that you learn practical skills, making skills, skills that you can take into loads of

different areas. But at exactly the same time, you're learning incredible analytical, critical skills. You're learning how to write and you're learning how to theorise as well. And the level of that is incredibly high now, I mean much higher than it was when I was in education. So you're almost getting two degrees. You're getting a vocational degree and a certain sort of academic level at the same time. Plus these key skills which are, I think, very relevant in today's job market, where you are standing up and having to explain what something is and to defend something. I mean that's probably why those employers put their hands up.

Dean: Well, exactly.

Mark: They have people who say, 'Okay. I've worked it out. I'll just get on and do it.' Not a lot of degrees do that.

Mandy: But also they're willing to backtrack, perhaps…

Mark: Yes.

Mandy: … because you're used to knocking those conversations around a lot more and saying, 'Actually, you know what? I was wrong about that.'

Jo: The ability to do that is incredibly hard earned.

Dean: This is why it's important not to get obsessed with graduate employment as such. There has to be advice on that, people have to understand the different directions and different professions that they can go into. However the justification for the rising fees is that it's an investment for higher future earnings, which doesn't really work for artists, as you know. Even if you manage to get a lecturing job, which is what a lot of artists really want, you'll very often want to do that at a 0.5 rate, which at the moment is not enough to…

Mandy: It's not enough to live on.

Dean: Well, it's not enough to have to start paying off your debt, which, interestingly enough, I think we should probably talk more about too.

[laughter]

Mandy: In this area they're having real trouble recruiting staff, because unless someone already lives locally or in London they can't recruit the staff to come and work here, because people can't afford to move from other areas of the country.

Jo: They can't relocate.

Mandy: And whether that's 0.5 or even senior staff I've been talking about, they can't find places. We haven't got graduate debts in that sense, but this just makes it triply important.

Adam: Yes.

Dean: Well, artists need time don't they? Time is something which is so precious and important, and I guess none of us have enough time.

Adam: It's a proverbial balance being an artist. I mean my decision to work full time was a result of the practicalities and cost of commuting out of London as a 0.5; I was unable to exist. In the financial sense it was either I give up my studio and make work in a different place or I have to think differently about how my practice can survive. I mean it is surviving but...

Jo: But what's really interesting, going back to the alumni thing, is that the balance is ongoing, in the sense that all of us around this table are still trying to balance those imperatives.

Mandy: But will they be able to do that? We probably had the option of a couple of cash-in-hand jobs...

Alexis: Oh crikey, I know.

Mandy: ... and signing on for six months was easier then. I do worry. When we're getting someone to do HPL (Hourly Paid Lecturing) for instance, they may not have had much experience, but you want them to build up their CVs so they've at least got the opportunity to be the next raft of lecturers. But you can't do that. They're all in their early 30's leaving London because they can't afford to stay now. So that worries me, we're all going to end up being exactly the same age and retiring at the same time and there has been no one who has been able to gather the same level of experience unless they have private incomes.

Alexis: I don't know. I have as much student debt as these students will have and I've managed to survive. So I think that...

Dean: From the United States?

Alexis: Yes. So I think we're underestimating that actually a little bit.

Dean: There could be unfortunate knock-on consequences, not for students individually, but just in terms of what happens to fine art courses,

particularly with the plans for the new Teaching Excellence Framework, which is actually judging courses on the basis of graduate employment and graduate income.

Adam: And then there's the NSS (National Student Survey) and retention.

Dean: Higher education gets reduced to the preferred government criteria, which is really to do with employment and economic growth.

Mark: Yes.

So is there a tension between the critical nature of an art school and the language of employability and enterprise?

Mandy: I don't think so, actually. I think you just reinterpret it. I think you can reinterpret the wider language into what it means for each subject area, and I think each subject area does that. It's just the word employability. We need another phrase for it. It's like professional practice. Well, all of it is professional practice. We need to just have a new language for what we mean by those terms. Because employability has almost become a byword for usefulness or something...

What's wrong with usefulness?

Dean: I think it's getting things around the wrong way. That's not what education or art education is about fundamentally, which is not to say that it's not important that students have possibilities to sustain themselves and their artworks afterwards. But I think what we've been saying is that that probably happens more through the confidence, through the skills, and through the kinds of knowledge that art graduates actually have. And to shift the focus onto specific forms of employability would really undermine that.

Mark: But also, it's not true for any degree as there's no job waiting for anyone. That disappeared in the last recession. So I think it's more about what opportunities it opens and what networks it creates for them as well. Just going back to that Kingston example, there is a network of either staff helping those alumni or other alumni helping each other and students. So when we talk to students about MAs we ask, 'That MA you're going to

invest in, does that help you invest in another network that will give you more opportunities?'

So there definitely isn't a job waiting in fine art in any defined way, because everyone's journey is very different. That can be seen as quite confusing and negative, but that can also be an incredibly exciting way to live your life because it's not planned out like 'you're going to work somewhere for 40 years and then get your pension'. It's more reflective.

Dean: The growth in employment in this country that they keep banging on about is really self-employment. There's a big shift towards that. I looked up some statistic which said that the medium income for a self-employed person is £9,000 a year, which happens to be exactly the same as the survey that was recently done for artists, not artists who are teaching necessarily, but artists. So I think that is part of the bigger shift towards more precarious employment for graduates. Higher income isn't guaranteed and the government probably won't get its money back from all the debt. But that was probably never the intention anyway. The intention was really to create a kind of intense, competitive market in education.

Would you recommend that someone from a low-income background embark on an art education, if that's what they are interested in?

Dean: Yes, absolutely, because it's such a brilliant education. Like I said, art education is something, which is much more active. You're a producer. It goes back to thinking through making. Because you're producing and because it's on display and you're showing, constantly talking, you're not just going to a lecture and going home. You're going to the studio. You're working. Also, from the other side as well, if we're not getting those low income students through then what's art going to look like in the next ten years? What's our visual culture going to look like in the future? It's going to be very much diminished. That, again, is a real worry and we have to try as far as possible to make sure that that doesn't happen.

Mark: It shouldn't be a riskier choice than any other degree. As I said before, I don't think any degree gives you any certainty at this moment anyway. I think that's something that's really quite important, because all

the perception and the media is going towards it being, 'why risk that?' Or 'Why risk going to do a history degree? What's the job at the end of it? A history teacher?'

Jo: I would recommend it but only if we are addressing this pluralism or the reality of what it looks like for anyone regardless of your background. And that won't be one answer. It will be hundreds of different answers. What I would want is that whoever comes in to study would have that awareness. And that's something that I think we're only just beginning to think through... because it's changing so rapidly and will probably continue to do so.

Mark: The irony is that most of the things that we celebrate in the UK come from our cultural history, come from the art colleges, but it's not seen as a positive thing to go and do.

Adam: Very rarely do you see them championed by politicians. You see politicians at business events; you don't see them visiting cultural events.

Jo: Unless you see David Cameron banging on about David Bowie and how much he loved him. David Bowie only had one O-level; one O-level and that was in Art.

Joanna: But the creative industries are so important, aren't they, to our economy?

Adam: Massively, yes.

Joanna: I think there is an acknowledgement of that at the highest level.

Dean: I think that's really true, but I also think we have to be careful of playing that game and justifying art in terms of economic gain, because it can backfire. The problem with the term 'cultural industries' is that it tends to aggregate all the things that are going on into one big, I don't know, Antony Gormley sculpture or something.

[laughter]

Mandy: Well, this is why I get annoyed at the term 'creative industries' and the employability word as well. This legitimisation of portfolio working is difficult, because although that's something that can be sustained by some people, some of the time, it's not something that you would actively encourage because if you're not careful you're legitimising unpaid internships and

very low wages. So it always has to be contextualised in the broader frame, going, 'It will prepare you for a fantastically self-sufficient career of portfolio working.' That may be true, but actually that may not be the best answer for everybody all of the time.

Jo: We also know that it's a political thing, because it keeps the unemployment figures down.

Adam: Yes.

Jo: As does your thing about self-employment.

Adam: Don't say you're unemployed say you're self-employed.

Mandy: Yes.

What do you mean?

Adam: The DHLE is a destinations and leavers survey. Graduates are interviewed six months after graduation about what they are up to. Often graduates from Fine Art might be in part time employment that isn't related to their study, but are involved in professional activity, such as portfolio preparation, or applying for residencies or MAs. The issue is that this might not get accounted for in the survey even though it would be counted as professional activity.

So we have to coach them a little bit to explain what they're doing with shows etc. as professional activity, and the other work as employment.

Dean: It becomes all about presentation, doesn't it?

Adam: And confidence as well, confidence to say that you are working in a professional capacity even though you're not being paid for it.

Joanna: I think the university should have a role there. It's the university that phones them up six months after they leave and asks them what they've been doing. There's lots of discussion within art and design institutions, certainly within this faculty, that we would like that to happen later. Six months after is too soon.

We talked about perception earlier on. It really does come back to that, and for students it's so important whether they perceive what they're doing as successful or valued in whatever terms, and if it's something they were expecting and hoping for.

Do you hope that students maintain a practice after art school?

Adam: If that's something that they want to do, yes. I think it has to come from the individual. It can't be that because you've done fine art, you have to only do that.

Jo: Some, before they leave, know that they don't want to have a practice.

Is that okay?

Jo: Yes, definitely. Some might have worked towards something else, but stayed on the degree.

Adam: You sometimes get first year students coming in and saying they want to be a teacher, and then through the process of their degree their aspirations and directions change. So it's very flexible.

Is that equally valued amongst students and staff?

Jo: It is on this course. I can say that very confidently. But I don't think it is always the case across the sector.

Dean: Yes. It's about the notion of success. I mean some jobs seem less glamorous in terms of the image of being a successful art graduate.

Adam: What sort of jobs do you mean?

Dean: I mean even quite well paid professional jobs. Certainly when I did a degree no one ever mentioned things like being an art teacher in school or going into gallery education, for example.

Adam: No.

Jo: No, it was a bit...

Dean: Or art therapy. There are all these kind of, what you would call 'proper jobs', with holiday pay and stuff.

[laughter]

Adam: Yes.

Dean: And that can be perceived as giving up of some kind of ambition, which is completely strange.

Adam: Yes.

Jo: Absolutely. But I really do think it's changing. It used to be the dirty secret that you were doing education work for instance.

Mark: I think it changed a long time ago. I think it changed when you couldn't survive on a 0.5. You couldn't survive on just that alone to pay for your flat, your studio, and your practice. It's changed since then where most people are having to do multiple things to be able to survive and to have that practice. That probably happened 10 or 15 years ago, it's not a recent thing.

Jo: I definitely only found my confidence to join all these parts of myself in the last few years.

You mentioned earlier that some of your alumni were initially a little sheepish about not having made artwork for a while but then they were OK with it.

Jo: They had struggled with it at first but then they had come to terms with it, and they all said, 'Don't worry.' I think that could be a really slow burning gift from the alumni to the current students. It was a really great thing that we didn't expect to hear.

Dean: Well, it's also like, if we do value our fine art education, why shouldn't that go into other areas of society?

Jo: Yes.

Dean: There is no necessary failure in not making art if you don't want to do that. I think a lot of people do continue to make art whilst doing other things. I hope it has changed, but I think there has been a real snobbery, a real elitism where people felt very reluctant to talk about certain jobs or would feel kind of ostracised if, within certain networks, they mentioned those things that maybe didn't seem so glamorous.

Why is that? That those things aren't seen as glamorous?

Jo: It's because of that singular model…

That you talked about at the start?

Jo: Yes. I really think it is.

Dean: The art world is a kind of feudal system isn't it? It's not even a fully capitalist system. It's about somehow associating yourself with someone who will open up a door for you. I remember a student at Central St Martins once telling me – and this was a surprise to me which shows how naïve I am

and how we learn from our students all the time – that she worked at the Frieze Art Fair and she said, 'You can't just go in there with £50,000 and buy an artwork. You know, they'll run a survey on you. They'll check you out. They'll see who else you're collecting.'

Adam: To make sure it's going to the right kind of person.

Dean: Yes, because if you sell it to the wrong person it…

Adam: It can break your career.

[laughter]

Mark: Well they'll make you pay for the lesser-known artist first. You've got to collect them before you can buy the better known artist…

Dean: Something like that, yes.

Mark: That's what Victoria Miro[7] does.

Dean: Yes.

Mark: To invest in the ones that are coming up. Well, that's how it should work, but…

Dean: So even as a buyer you have to somehow play this strange…

That's what came up when we did our gallery book.[8] They were saying, 'Oh, we won't just sell to anybody.'

Dean: But they wanted to remain anonymous?

Some did.

Adam: I want to go and try and buy some art now.

[laughter]

Jo: Some really expensive art.

Mark: I can sell you some Adam.

Adam: Yes, sell me some in the morning.

Dean: I don't have any money, but I'm very well connected.

[laughter]

That's the title of your next book!

Adam: It's a bit depressing actually, isn't it?

Mandy: You can't ruin your reputation by selling to the…

Dean: Yes. It's a reputation economy isn't it?

Mandy: You have to be building a collection to...

Adam: But that might take something away from the fact that you might just want to buy something because you really enjoy it. You can't just go and buy it.

Mandy: Get a print!

[laughter]

Adam: Well, yes...

Dean: Go to the Affordable Art Fair. You can buy there.

[laughter]

Mark: A couple of years ago the first cohort to pay fees did something for their second year show didn't they?

Dean: Yes and the invite was this big, stencilled number: £1.1m or something. It was a printed on a brown paper bag and you thought, 'What's that?' And then you worked out it was the amount of debt they were collectively in half way through the second year. But the thing I thought was very funny was that inside the bag were all these little business cards.

[laughter]

They were kind of hedging their bets, being quite critical on the one hand and... I liked that. I thought that said it all really.

1. The Russell Group represents 24 leading UK universities. Russell Group. (2016). *About.* Available from <www.russellgroup.ac.uk/about/> [Accessed September 8, 2016].

2. A family of four major art galleries in London, Liverpool and Cornwall. See: www.tate.org.uk [Accessed October 2, 2016].

3. Ball L, Pollard E, Stanley N. (2009). *Creative Graduates Creative Futures.* Report 471. Council for Higher Education in Art and Design; University of the Arts London.

4. 'A group of British artists who began to exhibit together in 1988 and became known for their openness to materials and processes, shock tactics and entrepreneurial attitude'. Tate (2016). *Young British Artists.* Available from <www.tate.org.uk/learn/online-resources/glossary/y/young-british-artists> [Accessed September 8, 2016].

5. Mandy formally worked at University of the West of England, Bristol

6. The office is just off the studio, so you have to walk through the studio and everyone working to get there

7. Contemporary Art Gallery in London

8. Rowles, S. (2008). *12 Gallerists: 20 Questions.* Q-Art. London.

Jo Addison and Adam Gillam are joint course directors for the BA (Hons) Fine Art course at Kingston University, Surrey. They have held this position for a year. We spoke with them in an office at the University's Knights Park Campus, where the course is based. This conversation followed and makes reference to the Kingston staff group discussion.

Can you begin by telling us about your own education and route into teaching?
Adam: I went to a terrible secondary school and I was terrible at secondary school. I had to retake some of my exams and I think that shook me up a bit; I needed to focus. After college, I studied sociology for a year at Sussex University before leaving to do a foundation course at Maidstone College of Art, which was a fantastic experience. I then studied painting at Liverpool John Moores University and then at the Royal Academy Schools, London.

Following postgraduate study, I won a printmaking fellowship at City and Guilds Art School, London. At this time I also had some teaching at West Dean College in Chichester and at Liverpool John Moores University. In 2001 I became 0.5 Senior Lecturer in Fine Art at De Montfort University, Leicester, where I worked until 2013. At this time, I also had regular teaching at Wimbledon College of Arts and visiting opportunities at other institutions before starting at Kingston in 2013.

How about you Jo?
Jo: I did a foundation course and then a degree and then I went to live in Glasgow for a couple of years. Then I came down to London to do an MA at the Slade. After that I did a lot of bobbing and weaving really, just trying lots of different things. Perhaps it was easier to do bobbing and weaving in those days.

Then I started doing gallery education work before working as a technician and doing some teaching. I thought I was sustaining three separate things: gallery education, higher education teaching, and an art practice. I was constantly hiding one of them because at that time gallery education was unfashionable or the three parts seemed incompatible. Then a few years ago, while working at Tate as a freelancer, and with quite a lot of support from their learning team, I started to see the potential in the space between these previously separate parts. It has been a really exciting time since then, thinking about the relationships between those things. And I'd say that's fairly typical for me, that things didn't even begin to make sense for me as an artist and teacher until very recently and I'm 46 now.

Adam: I still feel like that in this role. I said to Jo yesterday that I feel I have really learnt quite a lot since I have been here. I have had to. I never imagined I would be either full time or a course leader. I gave a talk last year to the students and I was really honest about how I have ended up here at Kingston.

You mentioned before the interview that you are joint course leaders. How did that come about?

Jo: Well, before we worked here Adam and I already knew each other. We used to be in the same studios and had done some shows together. When I came to work here in September 2014, Adam had been in the acting role for a year. During that year we shared a train journey and had lots of ideas about how the course could develop. When the course director role came up we decided to go for it together. We had no interest in doing it individually but were interested in the dialogue we could have by sharing it. We both work four days a week but the course director role is only a small part of that, so it can be quite intense.

Adam: So we are able to do more teaching than a singular course director might.

Since we began the role we have learnt a lot about how the BA Fine Art course has been operating, and through dialogue with the staff team

we have instigated a few changes which will filter through in the near future. For instance, we are making changes to the modules so that they become much more legible, much more logical, and much more obvious as to what the progression is from level to level.

Can you tell us a bit about this and as you do so, a bit about the structure and ethos of the course?

Jo: There are three modules at each level. Each year there is a Studio Practice module worth 60 credits. Next to that, running in parallel throughout the three years is our 30 credit Professional Skills module. These two modules aren't discrete or distinct from each other, but they are assessed separately. There is also a Critical Historical Studies module at each level, which runs alongside.

Can you tell us about what goes on during the professional skills module?

Jo: We invite a lot of people in. At the moment there is a curators', gallerists, and writers' day where two people who represent really different parts of those three domains come in and give a talk: so maybe an artist-run gallery, a collector, a private gallery, or a museum curator.

Adam: We also have professional workshops with Doug Fishbone and Matt Jenner who come in and talk about funding applications and about creating opportunities to third years.

There are other opportunities initiated by the university through KU Talent,[1] the university employability co-ordinators that invite local and national employers to talk to students. There is also the alumni mentoring project, a scheme to include recent alumni in working with level 5 and 6 students, that we have been successful in securing funding for. This will capture a lot of information and develop case studies that could become a virtual section of our student course handbook, and students could make reference to in those first six months following graduation.

There are also quite a few links with industry. There is an exhibition centre in the city called America Square where students can propose and mount exhibitions. It is quite interesting for the students because it is

not a white cube gallery space. It is an exhibition centre that big corporations pay money to go and hold events at. The walls that are available for students to use involve quite a bit of negotiation about what they can show, which I think is in itself a learning experience. We also have other one-off external projects such as the Carmen Birthing Centre in St George's Hospital where our students are currently making work for a very particular environment.

Jo: Students also work with the staff through their own practices. Another staff member invited a group of students to be involved in his own research, and I am doing something with a group of students on Saturday where they have been involved in interpreting a piece of my own research into film and it will be screened at Tate Modern.

I think most people who are on the team are quite invested in teaching as practice. When students are invited into conversations, they are live conversations. It's this thing we mentioned in the group discussion about co-construction. We are debating, we are trying to figure it out, and we always try and invite them into that, warts and all.

Is there a value in taking things offsite?

Jo: I suppose it's the whole hidden curriculum thing. Things slow down in big institutions. If they become part of the curriculum they need to be accounted for in different ways. I think other initiatives or projects can allow something that is perhaps more fleet of foot and a bit more responsive to how fast things change.

But also I don't think it is taking them out actually. It is not really about outside and inside. I don't think we would see what we do offsite as all that different to what we might be doing mucking about with bits of crap in the studio. It has got some of the same things at stake.

Adam: It is an opportunity for students to see what they do in a different context and a different environment, and to come up against some of the challenges you would be presented with as an artist if you are invited to take part in a particular event.

We spoke in the group discussion about the importance of perhaps showing students the various routes they can go into once they graduate. Do you actively support other routes?

Adam: We have curators and writers in the broadest sense, but we don't have gallery educators or people coming back to talk about things like teaching in all its forms. I think that is something we could look at more. Students would like a different range of paths represented. Generally, the people who come in to talk are primarily brought in because of their practice.

Jo: I suppose it is about balancing. We don't want to dilute their experience. We want them still to really engage with the principles of fine art practice in its broadest sense, education being a massive part of it. I think if they, for instance, wanted to go into teaching, we would say, 'Great, start looking at your work with that in mind. Let's start looking at the references and the frameworks that are in place for that.'

I think increasingly we are going to be presented with some real unknowns. There are going to be things that students are going to want to turn their attention towards that we don't know anything about, and we accept that. We would have to go and find people, bring them in and use other experiences and expertise to support that.

Do you have any opportunities for graduates from the BA Fine Art course?

Adam: There are a number of prizes and opportunities for students at graduation including the Da Vinci Painting prize, The Brian McCann Drawing Prize and the best dissertation prize. And as mentioned earlier, from next year there will also be opportunities for some alumni to come back and work with students at levels 5 and 6.

Jo: There are fellowships in each of the technical areas where someone, who has been really engaged in that area whilst they have been here, can apply to stay on for a year and get paid to work in that workshop area. We also have studio monitors, and currently two of them are ex-Kingston students. They get paid for a certain number of days a year to help manage the studios.

Do you think it is important to prepare students for life after their fine art course? Do you think the course has a moral obligation to do that?

Jo: I think it does.

Adam: I think it is important.

Jo: But I don't think that should be singular. It has to be a constantly live consideration of what that might be.

Adam: It is about being realistic. It is an incredibly different climate now.

Jo: There isn't a fixed philosophy, but there is something about authenticity that feels really important here at Kingston. If, as a staff team, we are able to be authentic in owning both conviction and uncertainty, then we are offering the opportunity for our students to be authentic too and that includes having unanswered questions.

As we said in the group discussion, the alumni mentoring event revealed that there really isn't any one way for graduates to survive. The main thing that all of those people were doing in all sorts of different domains, whether teaching, making or not making, was being true to themselves; they were being authentic, they didn't feel they were having to be something that they couldn't be. And they were really doing okay in all sorts of different ways.

When you were studying were you prepared for life after your BA course?

Adam: There was no preparation at all for leaving. It was this complete independence that I think was really formative actually. I learnt to be resourceful and independent and to sustain a practice.

Jo: Like Adam, there was absolutely no mention of life after graduation. I don't think I expected it either, but there was no real need because you could go and sign on and get some part-time work. Very different times...

In a way there is something to be said about that. It is such a balance. There are ways of supporting people that engender independence and there are ways that can be suffocating. I've got a five-year-old and I feel like as a mum I am always thinking, 'Do I, don't I?' It feels like that same thing of wanting to offer just enough exposure to something and enough of your experience to something, but not too much. It's a constant balancing

and whilst we don't always get that right, we keep trying to maintain that important equilibrium.

Do you have any thoughts about the future of art education?

Adam: There are so many papers and conferences about the future and the nature of art education now that everyone is in a state of curiosity or wonderment about what it is. I don't know that there are answers.

Jo: I think we are un-territorial in relation to other universities and we are quite excited about conversations with people in other courses. All art schools at the moment are in a massive climatic shift and I think there is more to be gained by sharing our thoughts and ideas. That is the same thing I think our students feel, that they are not overly territorial about their own creativity or their success.

1. KU Talent is part of Kingston University's careers service. See: www.kingston.ac.uk/careers/ (Accessed September 14, 2016).

Dr Dean Kenning is a Research Fellow in The School of Fine Art at Kingston University. He is also a writer and an artist, most recently writing about art education. We interviewed him at the Royal Festival Hall, London.

Can you tell us a bit about your role at Kingston, including what a Research Fellow is and what it involves?

My role was created originally to help develop a research culture in the recently formed Contemporary Art Research Centre. Alongside my own research I've organised public lecture programmes, symposia and published books through our imprint *The Centre for Useless Splendour.* I also work on our practice based PhD programme where I supervise several PhD students, take part in the regular PhD seminars, and organise seminars. I also have contact with BA students, doing occasional gallery visits, workshops and other activities. I had a first year BA tutor group for two years, so I'm familiar with what's going on at that level in the school.

Why did you start writing about art education?

I organised an exhibition and one of the artists was John Cussans. John wanted to do an independent art school type thing outside of Chelsea where he was teaching, so I asked him if he would do it as part of this exhibition I had organised. The exhibition was called *New Dark Age.* We started doing this thing called *Free School in a New Dark Age.* It is interesting what the term 'free school' and this notion of freedom has come to mean since then.

We would meet up on a Saturday and it was mostly based around texts, although we did produce a couple of publications. During the protests around the university fees increase, myself, John and other artists, lecturers, and art students became part of this thing called *Art Against*

Cuts. We organised teach-ins at Tate Modern, the National Gallery, and the British Museum.

It was very exciting because those teach-ins seemed to combine the critical thinking you get in art schools with something active and potentially transformative. For me, it was a question of these museum spaces being publicly owned by all of us, and the idea of education being a public provision available to anyone. There was a feeling of empowerment doing these teach-ins. It was a way of linking what was happening with education to things like the casualisation of labour occurring even in these museums, and the cutting of provision for public libraries and art centres which were the first casualties of massive local authority grant cuts. At the same time as all this protest and widening of political perspectives, there seemed to be a very competitive art culture. Things like the Turner Prize didn't seem adequate to address these issues, and in fact, they seemed to go along with a privatised notion of competition and privilege.

So it was in the atmosphere of those demonstrations that I first felt a need to write about art education, and in particular to address two things. One was to think about it in a wider context of what was happening across the board in education, particularly in schools. The other was to counter an argument that seemed to suggest that fees were an opportunity for art colleges to become like the old art schools again: to become independent, smaller, to disassociate themselves from the academicisation that had happened over these years. This was very problematic because it reinforced a recurrent elitism, particularly around the number of students enrolling on fine art courses. Certain independent art schools were also springing up which seemed to be more like residencies. They were based on an exclusive residency model because education had become something of a popular art world theme. There was something called the 'pedagogical turn', where all the biennales or big exhibitions would have some kind of schooling or curriculum activity going on.

So there was for me a strange conjunction between what the government wanted to happen through raising the fees, which was to allow non-conventional and private providers to come in to innovate, and a desire by some in the sector to return to an independent art school model. There was

a coalescence, which often felt very conservative to me, or at least, naïve. It needed to be thought through.

At the same time, I was asked by the *Schools and Teachers Programme* at Tate to be involved in a project they were doing around gallery education. I had previously helped to set up the Portman Gallery in a secondary school in Bethnal Green with a friend of mine, Andrew Cooper, who teaches in the art department there. I became interested in what seemed to be a very strict boundary between teaching art in higher education and teaching art in schools, and where A-level and FE fit into that.

That still seems to be where the debate and struggle is. At the end of the day it has to come down to the fact that you think art education is something worth saving. And when I say saving, I mean that it should be accessible to anyone.

Does it matter that art schools reflect the makeup of society?

Yes, I think it does matter. Art needs voices from different backgrounds.

There did seem to be a significant increase in levels of participation in higher education from the late '80s onwards. However because the funding didn't follow, staff-student ratios went through the roof.

Sometimes people criticise the incorporation of art into universities and even the beginnings of that formal 'academicisation' process in the '60s when a fine art qualification was made equivalent to a university degree. One problem with the incorporation into university systems might be that an overemphasis on exam grades could narrow the range of students who are able to coming through from schools.

Most of the students who were coming through Kingston, a few years ago anyway, were A-A-B[1] students, and it seemed, to me quite strange that that should be the case. I am not sure if that is a pattern that has followed in other courses but I would think it is. I failed all my A levels, including in art, and it never felt back then like a disadvantage in terms of what I wanted to go on and do.

It gets romanticised but I suppose you could bring it back to the way that pop music came out of a lot of art schools at a certain time. They

weren't going to dedicated music colleges. Those students were doing art as something which maybe you would do if you were interested in ideas and different ways of being, or maybe you had no idea what you wanted to do. A lot of that pop music was very angry and critical as well as experimental and hedonistic. I think it had a big political and social impact. Those things are so important if we want a living, breathing culture outside of the narrowly defined economic subject.

Young people need to be given the opportunity to find out what they want to do and have confidence to take what, from an economic perspective, may seem like a risk. If only posh people are making art then it's a massive problem and it's going to lead to a narrow range of art. The important idea that art is challenging and has a critical role within society is linked to that.

Are widening participation initiatives helping with this?

There has been a professionalisation within universities, with departments set aside to deal with questions of access, which are of course linked to funding incentives. John Beagles wrote a great piece about this,[2] and I would agree with what he says about the unfortunate separation of pedagogical and curriculum concerns from questions about student intake and the difference that makes to all aspects of the course. It is necessary to really go back to the idea of class. That seems somehow harder to talk about than 'under-represented groups' who are then identified under this broad category Widening Participation (WP).

The focus becomes about supposed bias at admission level rather than wider socio-economic structures. This is not to say that courses don't need to go out of their way to encourage a more inclusive intake. There is some excellent work done in WP – I'm more familiar with this at Central Saint Martins where I also teach. If you look through the statistics sometimes it is actually quite hard to figure out who is coming into fine art courses because of the way the figures are aggregated. This evidence about student backgrounds is usually quite anecdotal.

You just mentioned art's critical role within society. Is it important that art is critical?

I think art is often discussed in terms of individuality and personality, whereas actually what is really powerful about it is that, as an individual, you are able to lose yourself, give yourself over to something beyond the individual self. It is a commitment to something that is also about the formation of a subject, which is why I have thought art is always a collaborative or social act. It is about participating in a disciplinary community, which allows singularity to occur at the level of the production of art works and ideas.

That probably sounds a bit grand but that does seem important socially, even just from a human perspective in terms of a reality. We do create reality after all, we are not just there to adapt to the realities that exist, whether that is the job market or art market or whatever. There has to be some notion of invention, which is why I would still hang on to an idea of the avant-garde. That sense that there is a determined critical intervention in society and culture, or a kind of interruption or resistance in relation to certain things. To change the way it looks, to change the way humans can be.

You spoke about the need for a culture that stands outside of any narrowly defined economic subject. Why is that important? If I'm applying to university now, is it something I can afford to consider?

A lot of things in the world are organised through markets. You basically buy and sell stuff and people are able to make a profit through that process. In certain areas it fails, we have 'market failure'. You just need to look at what has happened to housing, especially in London and the South. Every day there is either a headline or an article about how there is a major problem with the current housing market and people can't afford to live here: the economy is going to collapse because workers are priced out, etc. But of course the next article will be a celebration of luxury housing, buy-to-let, etc.

And it's the same with art. If it was left to market values, then that is not going to produce very interesting art. What happens at that level is a circulation of luxury goods with certain names attached to them, or perhaps it's the

other way around – it's really the names that circulate. You see this if you go to the Frieze Art Fair. You won't see very interesting art in general if you go there, you will see the same artists represented again and again, because they are the ones who are going to make the money for the galleries who have to pay an enormous rent to be there.

If people want to make a lot of money that is up to them. I am not approaching this from a moral perspective on that individual level. I would say they probably shouldn't do fine art if that is the case. I mean, that is probably not a good bet if that is what they want to do.

The marketisation of education that has happened with the £9,000 a year fees is designed to accelerate that kind of thinking where, as a student, you are not only a customer buying a product in the market but you are also an investor in your own future returns. The logic of the fees system is that those future returns are generally measured economically, and I think that probably doesn't work for art education except to say that the logic of that is that there should be a massive reduction of fine art courses. That is the idea behind the Teaching Excellence Framework – to assess courses at least partly in terms of graduate income and the payback of student loans.

At the start of the interview you spoke about a mismatch between schools and HE. Do you think students and parents are always clear what an art education offers when they are applying?

Young people are being asked to make decisions based on the premise that they are rational economic actors who can shop around to decide what they are going to do for the next few years of their life. Then they're being told by the student loans company, 'Well if you don't like it, you can always transfer to a different course at another institution after the first year.' I mean, this is massively disruptive for the student, and on top of everything else, there is a massive pressure to change 'provider' if you feel you're not getting value for money. A degree is not a mobile phone contract.

Over the last 30 years there has been concerted effort to change the way people think about what is valuable and how they should behave and make decisions on that basis. There is that famous quote from Margaret Thatcher

'Economics is the method, the object is to change the soul.' The goal of that neoliberal project which she represented through the privatisation programmes, and which of course has continued ever since, was to change the soul, to change the subject. It was to bring into view another notion of subjectivity.

So, let's say there are different forms of value. I first went to Wolverhampton but I ended up doing a fine art degree at Goldsmiths. When it came to the graduation ceremony very few people on my course went to it. It tended to be more working or lower-middle class, or let's say people whose parents hadn't gone to university, who attended the graduation ceremony. I didn't want to do the graduation particularly; I thought it was nonsense because really the degree show was the thing. But I did it because my parents thought that it was important, and because they wanted a photo and stuff like that. So this is a value system based on the idea that higher education is some kind of good in itself, and graduating has a status which reflects that. The symbolic value of that moment that proves that you had a higher education was very important for my parents.

So the shift now seems to be towards thinking of education in purely economic terms. And this, I think, has permeated our culture. People can feel justified now about dismissing courses that don't bring in a lot of money. And that is realised through the fee system, which is the logic of making that money back and making a profit on that investment. And so, it is not a question of what an individual particularly wants, but it is a shift of cultural perception structured through institutions like the student loans company and investment discourses around future graduate earnings, etc. Maybe it is completely understandable, but now people are much more aware of needing to make money and needing to survive because things are harder.

So it is no wonder that potential students and their parents are thinking more in that mode. And I think it is true that it is a bit of an unknown to engage in a fine art degree. But I think that spirit of doing a course that didn't seem to offer a specific profession or job to go to, but seemed to offer a means to explore certain things or maybe just to make music or do something else, that was a very strong culture. It is an alternative value system.

Do you think that still exists?

I think it does exist. But I think the culture of entrepreneurship is very strong now. I think there has been a whole generation that has been educated in this mode of being, through things like *The Apprentice*.[3] Those shows are hilarious because they are living proof of the thin basis underlying the celebration of the 'entrepreneur'. The lesson is in ruthless competition between people, self-interested strategic teamwork, fawning respect for authority and the best ways to rip someone else off. Not only are these people usually egotistical idiots, no actual wealth gets produced. That always used to be the justification for a system based on self-interest – that society would benefit as a side effect of that through the production and exchange of useful things. With *The Apprentice* it is simply about buying something at a cheaper rate than you can sell it for.

The academisation programme in schools is part of that indoctrination. The ethos that comes from academy chains is very powerful. Many of these chains are run by former business people, former financiers. It might not seem linked to the curriculum but in fact the ethos can have very powerful effects. I've spoken to teachers: students are told to do 'Apprentice-like' fundraising activities in competing teams. It's the same thing as when Thatcher was talking about changing the soul. Things like turning a student into a customer and into an investor. These are powerful psychological forces: they do change the way you think.

Have these changes impacted on the way students approach their education?

You see changes in the staff-student relationship. There is this notion of, 'Well, I'm paying a certain amount of money. What am I getting for it?' Those things need to be challenged. It is very important to tell students they are not customers, they are students and they are not paying the university. The Government is paying the university, the government is then passing on that payment as a debt to the student, which they may or may not pay off.

It is the same with higher education institutions – their way of working changes, their ethos changes. As soon as they see themselves in economic competition with other universities, they start behaving like commercial

corporations that need to make money. They start seeing their spaces as potential money earners that they can rent out for private events, or they start looking at courses in terms of opportunity, you know, what could make more money and so on.

So I think these are very hard things to fight against because they are real. It is all very well saying to a student, 'You're not a customer' because they are the ones having to take on that debt burden. But at the same time it is really important that you do say that.

Students are in a bit of an impossible position aren't they?

Well I've had this come up. Some students feel like they are being made to feel a bit guilty about doing unpaid internships. Not only do they know that they are being exploited in some way, but they are made to feel guilty by tutors who have these relatively well paid positions saying artists should be paid, what about those who can't afford to do unpaid work, and so on. So it is a minefield. And I think that does go back to this point about creating a culture. The fine art course has been a way to figure out what this community might be and what these other forms of value might be.

Do you think it is a luxury to be an artist, i.e. to carve out a space to operate in these alternative value systems that you talk about?

Well it depends what you mean by luxury. I think it is about freedom and I think it is about time. Capitalism is all about time and how much time you have to yourself to do what you want to do. What might seem like old-fashioned Marxist ideas of non-alienated labour are really important.

Now, some people might want to define that as luxury but I think that is a very reactionary position. And that will become a self-fulfilling prophecy, as it will be only available to people with money, people with the ability to support themselves, and only private schools who feel that they are able to invest in an art department. We already see this quite a lot, especially in terms of actors or Olympic athletes that all seem to go to these posh schools. So this is real. The New Labour Government was all about meritocracy and social mobility. But obviously, that has not been happening.

We have to hold on to the idea that people, whoever they are, are able to spend time doing something that might not bring immediate economic returns either to them or for the economy in general. If we don't, it *will* become a luxury in the sense that only rich people are able to do that, and art simply feeds more and more into a luxury market where people put their money, take it out of society, and bank it in expensive artworks.

So it's how you get a balance isn't it, between carving out this time and operating in the mainstream system?
Yes.

Yet I get the sense from our own experience and in all the work we've done, that art students don't always feel comfortable raising questions or aspirations about setting up a business or making money from their work in an art school environment...
Many artists are self-employed and are basically running a business. They have to do tax returns. When we talk about freedom, it is very important not to fall back on those clichéd, romantic ideas as an image of total detachment, total individual autonomy, and total separation from social requirements. Because that is the aristocratic critique and we don't want an aristocratic critique. We want something more like a socialist critique. So those ideas of freedom, of gaining some ability to engage in activities that might not be immediately economically validated, absolutely necessitates some notion of economic support.

The problem isn't that an individual student might feel it necessary or has had this opportunity, let's say, to do an unpaid internship they feel will benefit them. The art courses themselves have a role to play here, and again it is a very difficult thing to weigh up precisely because of these ideas of professional development. I am worried that universities are in a quite powerful position to almost legitimise the unpaid work that is rife in the art world – because in a way it benefits them. Courses are in competition to a large extent now, their research is judged according to esteem indicators that are modelled on the art system, and in the future probably even more will be

measured according to how 'successful' their graduates are in terms of their position within the art world.

What are esteem indicators?

Research funding is provided on the basis of the quality of research. But how do you measure the quality of research? It is normally judged through things like peer review.

Now with visual art, I think those esteem indicators are very crude. They tend to be taken wholesale from the art market. That is a problem because it reproduces a certain system, which as far as I am concerned, doesn't offer a particularly rigorous idea of quality.

To give a really crude example, someone like Tracy Emin who is a professor at the Royal Academy, would be judged to be a really top international researcher because she has high esteem in terms of the prizes that she has won, the fact that she has done stuff at the Venice Biennale, and because her work is collected by the Tate. Of course, artistic quality is a very difficult thing to judge. But I think most people would agree that art world esteem in not a rigorous or sufficient notion of artistic quality. That becomes a problem.

I think the fact that fine art is a research discipline is potentially positive because it can make us think about the judgements that we are making in terms of quality. We have to have serious discussions and arguments about why something is valued and why it is more interesting, engaging or effective that someone has done something this way rather than in another way. So it is not about adapting these things to fit in with society. It's really thinking about what exactly are the methods that artists use, what processes, ways of working, aesthetic decisions, ways of thinking, and why are they valuable? Why do they seem so important? Why is so much energy given over amongst artists to thinking about these things? How can we talk about those things to a broader audience so that they can be recognised as valuable more widely?

That is potentially exciting. I supervise PhD students at Kingston. It is a very good programme. Kingston doesn't seem to be a place where artists

lose their direction in terms of experimenting and making work, and end up becoming rather dry self-reflective theoreticians of their own practice, or doing a PhD merely because it helps them to get a job. I would never criticise anyone for thinking in term of what helps them get a lecturing job of course, because that is part of, let's say, how the university system works currently in terms of the research agenda – they want applicants to have PhDs. The PhD becomes a form of recognition that allows you to progress in your career. But it also offers time, and sometimes it is funded time, to really concentrate and get back to that point where there is serious discussion and support amongst a group of peers.

So it seems to be that place for me, not where art gets watered down or diluted or turned into something else that we might call 'academic', but precisely the opposite: where we talk about content again, we talk about the art again, we talk about what is valuable. And we do it within a community of practitioners.

1. Refers to students who had achieved at least two A grades and one B grade at A-level.

2. Beagles, J. (2010). *In a Class if their Own: The incomprehensiveness of art education*. Variant magazine, Issue 39/40.

3. A popular reality TV series whereby 18 candidates compete over the course of 12 weeks to win £250,000 investment in their business and a chance to partner with businessman Alan Sugar.

ARTS UNIVERSITY BOURNEMOUTH

Richard Waring is Principal Lecturer on the BA (Hons) Fine Art Course at Arts University Bournemouth (AUB). Richard provided a written response to our questions.

Please can you give us a description of the area in which the art school is located?
Bournemouth is primarily a leisure town. Together with Poole and Christchurch, it has a population of around 400,000. It has no heavy industry, unlike my home city of Derby, and is situated on a stunning seven-mile stretch of golden sand, with Purbeck Island and the Jurassic coastline adjacent. There are no large contemporary art galleries or museums in Bournemouth and so the arts culture has long revolved around the Arts University, which has its own gallery and community of artists.

In recent years, as the numbers of students opting to study fine art here has increased, more graduates are opting to stay in the area. They have set up several artist run project spaces, new galleries, and other creative entrepreneurial businesses.

Who attends the course?
We recruit around 80 full-time students per year. Around five are international, five EU, ten are local, and the rest are from across the UK. About 70 students are aged between 18 to 20 and 73% of our students are female. Ethnicity is predominantly white British, with five to ten BME students each year. Each year we have around ten WP (Widening Participation) students.

Can you tell us a bit about the structure and philosophy of your course?

The course is multi-discipline. It is focused on making and thinking about materials and the concepts that arise from this. Asking 'why have I done that?', 'What language is it using and engaging with?', 'Is this the best way to communicate my concerns or is the making process and my intrigue with materials leading to new ways of thinking, and creating new and unexpected dialogues?'

All three years of our course are underpinned by extremely knowledgable technical demontrators who provide a broad range of practical instruction, from how to make a plaster cast to how to create interactive electronic sensory devices. Students can continue to test out many different practical processes or specialise almost immediately after the first few weeks of year 1.

In year 1 we run a broad range of compulsory skills and ideas workshops, alongside a series of contemporary art lectures and seminars. In year 2, we offer optional sign-up electives on various ways of making and thinking; this year we began with a two week making and thinking symposia called *Cultures of Nature*, that culminated in an exhibition in a Victorian bandstand in Bournemouth's town gardens. In year 3 students continue to have refresher workshops and a weekly opportunity to test out and exhibit work in one of our three bookable project spaces. Every Thursday at 4pm other students are invited along to this to give valuable feedback to the exhibiting students.

For all years there are six visiting artist talks per academic year and regular one to one tutorials. The course has very healthy contact time with both permanent staff and visiting tutors, most of who travel from London and are immersed in the contemporary art scene.

We pride ourselves on excellent teaching, learning and assessment, and so I welcome the impending Teaching Excellence Framework and hope this puts teaching practice on the same footing as research. I like the quote from Richard Sennet that says 'The good teacher imparts a satisfying explanation; the great teacher unsettles, bequeaths disquiet, invites argument' (Sennet 2008).

How does the course prepare students for life after art school?

We want students to be able to present themselves as professional artists, especially with the high expectations of the degree show and then our participation in Free Range.[1] In preparation for this we have a number of professional development opportunities spread throughout the course:

At the end of unit 2 in year 1 we divide students into groups of ten and ask them to curate and hang an exhibition of their finished or in process work.

In year 2 we offer work experience and off-campus activities that students can opt to sign up for. For example:

We run a paid internship for three students at the Charlie Smith Gallery, London.

We offer teaching experience in local schools and art therapy workshops in nursing homes as part of an optional independent study unit worth 20 credits. We have around ten students currently taking this option.

We have worked with the Structural Genomics Consortium, a group of scientists at Oxford University who investigate medicines for rare diseases. Around 20 of our students learnt about the science and then visualised this for a public exhibition in Oxford to help raise public awareness of the diseases.

We run a 'white cube' offsite gallery project, supported by and held in the Russell Coates Museum in Bournemouth.

We invite alumni to help teach an offsite site-specific project that's located in the lower gardens of Bournemouth's town centre. The project is endorsed by the council and presents contemporary art to locals and holidaymakers.

In year 3 we have a 'Developing Professional Voice' unit where students are asked to put together a portfolio of applications for residencies, MAs or employment. We also run mock interviews where students are invited to attend an interview at a fictional gallery, Bournemouth Contemporary. The students deliver a ten-minute presentation on their practice and are then asked a series of questions by a panel. This unit is expensive to run because of the extra staffing costs, so we canvassed student

opinion on this to see if it was worthwhile; it proved to be unanimously popular so we are continuing it.

This year all third-year students, in groups of 20 at a time, also undertook a three-week residency period at Artsway, a gallery space located in a sleepy village in the New Forest which AUB has rented. Each three-week residency period culminated in a public exhibition that often involved the villagers as active collaborative participants. For instance, one project devised by the students was to swap the traditional art work in the village pub and beer garden with their art and place the pub art in the contemporary art gallery, which villagers were then invited to go and see. Because the residency is more than half an hour away by train, AUB paid the students' train travel to ensure good attendance.

Why did you choose to work off campus?

We thought it would add another dimension to our course and allow students to work in more independent and responsive ways. On the back of this experience we have had an increase in participatory work in our degree exhibition.

In addition to what I've mentioned we have other things that run across all three years. It's important that students document their work professionally, so this is incorporated into unit outcomes and supported by technical demonstrator workshops throughout the course. Documentation of work must have professional captions and be accompanied by a critically reflective document. This level of professionalism is valuable for applications to competitions and opportunities.

We also run an optional yearly residential study visit to a European city and have several European course opportunities for students that run every year, for example: a video art competition run in conjunction with some Italian art schools in Bergamo, Turin and Milan; a two week long artist residency for two third year students in a gallery in Milan; and a week long artist residency for ten second year students in a gallery in Antwerp.

All of the activities are optional. We say they are all about professionalising practice and creating opportunities. They give students the chance to

have national and international shows on their CV and a chance to have trial runs at applications in preparation for what will be a very competitive residency and competition network in the real world.

Do you do anything to support graduates?

We have introduced a new role for the next academic year called Graduate in Residence. Through application, one BA graduate will attain full time employment for a year. This role has been designed specifically to help graduates progress their own practice and profile as an artist and to help develop specific course intiatives.

What is the course preparing students to go on and do?

We are preparing students to become flexible, professional artists who are equipped to deal with fast changing employment opportunities. I want students to leave with an enthusiasm and inquisitiveness for life in general. If they don't sell work immediately, they will have the motivation to make things happen, to set things and opportunities up themselves, and to think laterally about how to earn a living whilst continuing a practice. I think you can approach almost any job with a fine art attitude, an idiosyncratic and curious zeal for how to make things better or more interesting for people.

We don't encourage any specific model over another; each person finds their own way. Some people go on to be successful artists, others educators, someone recently trained to be a lawyer, another person an airline pilot. Perhaps Fine Art should be seen in the same way as English or Art History, i.e. as a great intelligence building experience for life but with the added benefit of having a practical making focus to work alongside the intellectual stimuli.

Students generally go on to have a portfolio career immediately after graduating, juggling several jobs and then practising, exhibiting, entering exhibition and residency opportunities, then gradually find their vocation. A successful graduate is someone who is happy and positive about life, whatever they do. Life to me is a journey of discovery, there is no 'destina-

tion'. I don't think anyone ever feels they have 'arrived', even if they are really searching for it.

How do expectations of and preparation for life after art school compare to your own experience?

There is definitely a lot more professional content within fine art courses now than when I graduated in 1995. I think the professionalisation of courses is a good thing as it helps people plan for various graduate careers or opportunities. It also asks tutors to reflect on what professional content should be, and to align some learning aims to this. We have found that asking students to make applications for opportunities and compiling a small folder of future opportunities helps them to focus and in turn plan more for the future.

There are however some negatives. I wonder if current practice is as experimental or inventive as it was in the late '90s. Even though we do stress that risk taking is rewarded in the grading criteria, most students will always have one eye on the 'real world', and understandably want to make commodities to sell or learn skills that they feel will help them get a job. There are many more commercial galleries than there were 20 years ago. This can be a good thing as we all have to make a living, but it can overwhelm the purpose of making work, and create certain market restrictions and expectations of the types of saleable and attainable work. My BA Fine Art course at Cardiff School of Art had no real professionalisation teaching sessions, it was focused entirely on practice, yet this gave me the enthusiasm to get out there and make things happen.

Everyone I speak to thinks that the introduction of higher tuition fees is very unfortunate. It is something we are now living with. Students are very aware of the personal financial cost of their education, and course expectations have to be carefully managed and made explicitly clear as students, and their parents rightly want to know more and more about the course detail at open days and interviews.

What do you think is the role of the art school in society?
The text below from *A Review of UK Research Councils* by Paul Nurse summarises my thoughts on this. When it talks about the role of research, this is applicable to the role of research as art practice:

'Research into the natural sciences, technologies, medicine, the social sciences, the arts and humanities produces knowledge that enhances our culture and civilization and contributes to the public good, for example through driving a sustainable economy, improving health and the quality of life, and protecting the environment.' (Nurse, 2016, 9)[2]

1. An exhibition in London's Truman Brewery for graduates of art and design courses from across the UK.

2. Nurse, P. (2016). *Ensuring a Successful UK Research Endeavour: A Review of UK Research Councils*. P. 9. Available from <www.gov.uk/government/collections/nurse-review-of-research-councils> [Accessed September 13, 2016].

CHELSEA COLLEGE OF ARTS, UNIVERSITY OF THE ARTS LONDON

Martin Newth and Dr Katrine Hjelde work at Chelsea College of Arts, University of the Arts London. Martin is the Fine Art Programme Director, overseeing the BA (Hons) Fine Art, the Graduate Diploma in Fine Art, the MA in Fine Art and the MA Curating and Collections. He is also the Course Leader for BA (Hons) Fine Art. He has worked at Chelsea since 2012. Katrine is a Senior Lecturer teaching theory on the BA (Hons) Fine Art course. She is also Course Leader for the new Graduate Diploma in Fine Art. She has worked at Chelsea since 2001. This interview took place in the Green Room at the college.

Can you give a brief description of the area in which Chelsea College of Arts is located?

Martin: Chelsea is located on Millbank in SW1 London, a site we moved to in 2005 from Manresa Road, which was in the Borough of Kensington and Chelsea. We are next to Tate Britain, adjacent to Vauxhall Bridge and opposite the river from the MI6 building, Britain's spy headquarters. The site on which the Tate and Chelsea now stands was the site of Millbank Penitentiary, an enormous prison built to the plan of Jeremy Bentham's Panopticon. The prison was used as a holding place for prisoners before they were shipped off to Australia. The Australian colloquialism for an English person, POM, is reputed to stand for Prisoner of Millbank.

The building the art school now occupies is a former military medical training barracks. So our location is characterised by a very strong sense of history. We are also just down the road from the Houses of Parliament so there is a feeling of being right in the middle of things. For example, the 2010 student protest marched past Chelsea's entrance. Being in central London means that very few of our staff and students live close to the college. Our students travel in from all around London and some from further afield.

Can you outline the structure and philosophy of the BA Fine Art course?
Martin: I describe our project on the course, which staff and students are engaged in together, as one that examines what contemporary art is and helps to form its future. Chelsea's is a broad based fine art course, which means that our students are not split into separate subject areas. We feel this better reflects contemporary art practice than the situation we had prior to 2005, which split students into subject areas that restricted dialogue between different approaches. The philosophy of our course is to try to give students as much agency as possible to define how and what they explore in their practice.

Ours is a course with enquiry through making at its core, and this is informed, underpinned and enriched by a theory programme which is embedded into the curriculum. So there is strong sense of the material and practical investigation going hand in hand with the exploration of ideas.

Our philosophy is to give students a sense of independence in what they do, so we do not set any themed project briefs. Instead the programme is characterised by building strong, critical communities around a vibrant studio culture, and providing regular opportunities to exhibit work both within the college and around London.

What is the intake of the course?
Martin: We have about 800 to 900 applicants a year from the UK and other EU countries for about 90 places. We then take about 30

international students each year. Our international students come from all around the world, with many from China and Korea.

Have the fees impacted on who is applying for the course?
Martin: Interestingly, since the fees were introduced, we have had an increase in students both from outside London and those who are first in their family to go to university. That is the absolute opposite to what I thought would have happened.

That is interesting. Why do you think that is?
Martin: From what we can gather from speaking to students on the course and at interview, it seems to be that this generation has a very different relationship to debt. There also seems to be a view that if you are going to take on debt, you might as well take it on at a place that you think gives you a bit more of a chance in terms of the opportunities available to you after you graduate. Relatively few applicants turn down the offer of places, but for those who decide not to come it's because of the high cost of living in London.

How do you prepare your BA students for life after art school?
Katrine: We have an embedded approach.

What does that mean?
Katrine: It means that through activities within the course, such as presenting, writing a dissertation and exhibiting, students develop a range of skills and critical attributes that are directly and indirectly transferable to different kinds of contexts. The challenge is how to make this embedded approach visible so that students are aware of how certain activities do prepare them for life after graduation.

How do you do that?
Katrine: Through discussion. It can be in a crit or other kinds of sessions where it is possible to have those conversations. It can also happen

quite overtly through encouraging visiting artists to talk a little bit about how they operate and the roads they took to get to where they are now, in terms of strategies for how to survive and things like that. There is also a strong emphasis on students recognising each other as important for their future. When they leave here one of the key things they take with them is the connections and friendships they have made. Beginning to understand how these can translate into professional opportunities after art school is key on so many levels.

This January we had an event called 'What is a Professional Artist?' It was not compulsory but all BA, MA and Graduate Diploma students were invited to take part. It aimed to dispel some of the myths and discuss the realities around what it means to have a practice and operate 'professionally', with big quotation marks, after graduation.

What did the day involve?

Martin: We did this thing where students could ask questions by texting them in anonymously during the session. They could ask any question about how to get on in the world once they leave. The questions ranged from, 'How do I sell my paintings?' to 'How do I juggle my time between earning money and making work?' The questions are extremely revealing in terms of showing how complex the whole discussion is. Some of the answers can be very simple and could lead to some very practical things we can offer, such as how to put together a CV or how to make an artist's website. But a question as basic as 'How do I sell my paintings?' can lead into a whole other discussion about who you want to sell your paintings to etc – and that might require a follow up session.

Katrine: Nick Kaplony from Artquest[1] was one of the invited speakers. After the event, Artquest gave us a whole set of links that responded to some of the questions – for instance a video called 'How do I get to meet curators?'

Martin: I think that event really highlights what our approach is. As a programme we try to set up a critical community and we extend that to everything we look at. So the event unpacked ideas surrounding professionalism and the sorts of skills, characteristics and attributes that you gain at art school.

Are there any other ways you help prepare students?

Katrine: University of the Arts London has a Careers and Employability department[2] who work across the six colleges of the University. They work quite closely with us on the course to provide sessions that we feel would be useful for our students. These could be talks, workshops or question and answer sessions here at Chelsea. These are often targeted to stage 2 and stage 3 Fine Art students but can be open to everyone on the BA Fine Art course. Sessions here have included workshops on CV writing for artists and writing proposals for residencies or funding. Our students can additionally attend other sessions they run across UAL. Careers and Employability are keen to work closely with courses wherever possible to ensure a useful connection between their provisions and course curriculum.

Martin: We have partnerships with companies like the Discovery Channel, Hitachi and Frontier who offer students the opportunity to make work to be in their office spaces for a year. It might only be a small number of students that get selected for those, but a lot of students go through the process of putting together a proposal and doing an interview. That is a really valuable process. At the moment these take place in the second year of the BA course, but they might soon become alumni opportunities instead of taking part during the course.

Why is that?

Martin: I am interested in us taking more responsibility for what happens to students after they have left. I think the partners get a better deal, and for the graduates it ends up being a very real addition to their CV because it is a proper commission post graduation.

It's interesting to hear about these partnerships because sometimes, in crits, if someone is making an artwork for someone else, there is almost an accusation of 'selling out'. Is this a conversation that you recognise at all?

Martin: We recognise that it can be a worry and we are definitely familiar with that conversation. Those sorts of partnerships are particularly commercial ones. We are giving students the opportunity to work in

a context like this because students will have to make a living after they graduate. This gives the chance for students to consider whether this might be an appropriate way for them to earn some money from their work. But by making this kind of opportunity part of the conversations we have on the course, we can discuss how an artist might work in an interesting and engaging way within a context like this. I talk to the companies who commission the projects about how their ideas or preconceptions about what they want will be shifted as well – because our students will approach it in an innovative way. So in this way we try to avoid any possibility that it might be seen as 'selling out', and instead try to ensure that the work is exciting and engaging.

I also think it is really important to say that those contexts are considered alongside other contexts that artists might work in. For instance, in the first and second year we also get students to self-organise exhibitions in London as part of the curriculum.

A really key part of the course takes place in the second year, where students are asked to really consider the context that they imagine their work could operate in and start to make work that is sensitive to that situation. That could equally be something commercially facing or something more socially engaged. We encourage students to consider all possible contexts for their practice.

The overarching philosophy of the programme is that it doesn't guide you to do anything that someone else thinks you should be doing. You are allowed the space, the time and the structure to be able to work out those things yourself, with your colleagues and with your peers on the course. That is what drives us.

Do you offer placements?

Martin: We don't do any placements as part of the curriculum. I know a lot of places do. We tend to do the kind of extracurricular opportunities that I've described. Also, we are fortunate that there are so many opportunities in London. Places where I have seen really fantastic work placement schemes tend to be where you have to work to find them and the institution can be a

big help with this. If our students decide they want to do that sort of thing, they can do them off their own backs. And lots of students do.

But in regard to professional development teaching on fine art courses, I am very nervous of what I think has happened in lots of art schools, which is to quickly get together a professional development package to deliver because it is felt that it is desperately needed.

In what way do you need it?

Martin: Because we are judged in the NSS (National Student Survey) against things like how well students feel the course has prepared them for life beyond the course. And so unless you want to do badly you have to do something, or perhaps more importantly, make students aware that they have done this stuff throughout the course. But putting together a very defined package is really not appropriate when we have a broad based fine art course where students have a lot of control over how they work and the pace they work at. So what we aim for, and what we need, is a critical discussion about the complexity of these ideas rather than to deliver a menu.

As an institution, we are also measured in things like the DLHE (Destination of Leavers from Higher Education) statistics against employability and what students go on to do.

So is there a conflict between the critical nature of an art education and terms like employability and enterprise?

Martin: I think there is a conflict between the kind of criticality we try to develop in art students and the governmental systems for thinking about what you should be doing with a degree, and how that should be measured. The government measures a graduate's contribution to society in a way that is about earning money instead of thinking more broadly about the kinds of skills, and potential for critical thinking, that artists can bring to society.

Katrine: Artists have a lot to offer society. It is not just about being successful artists in terms of selling work in a gallery. Artists have skills, sensibilities, and methods to offer that are very unique and could change the world potentially.

Martin: I have to supply data all the time on this. Actually our data in terms of employability is extraordinary. One of the real benefits of having a big course is there are always lots of examples of how people have got on really well. So I suppose we're quite lucky that we do also have the measureable stuff.

You mentioned this idea of selling work? Is it something you encourage students to do?

Martin: Well one of the realities about working at Chelsea, in comparison to some other places I've worked, is that individuals like Charles Saatchi actually still come and buy work at degree shows. Every year I get students asking me how much they should charge for their work. When they are the students I am also assessing that is a slightly tricky conversation, and so I try and point them in other directions to get that kind of advice. I don't say that selling work mustn't be an ambition. But I think we have a clear idea about what our values are on the course and they don't relate to how much money work is sold for.

Katrine: I don't think there is snobbery around it. If a student has sold something we would be pleased for them. There is nothing wrong with making money through your art if that is possible, but it is also not reducible to that. The monetary value on the product is not the only value. I guess we are interested in discussing all kinds of values that art may have in society.

An interesting thing came up at the 'What is a Professional Artist?' event, about how some people feel terrible because their work is critically acclaimed but doesn't sell at all so they are struggling financially. Other people's work sells very well, but there is no critical engagement and they feel completely ignored. Being successful commercially is one way to earn a living but it may not translate into full success – however you define that.

Thinking about this theme of how you might prepare people for life after art school, is there anything in particular you are trying to prepare people to be?

Martin: That is a really good question. You could be mistaken for thinking that Chelsea is somewhere that attempts to prepare people for

an art market. And this is what some people assume we are trying to do in asking students to exhibit their work a lot throughout the course. That absolutely isn't what our approach is at all. The reason why we ask students to exhibit so often isn't because we want them to be able to produce a really polished product. It is because we want to build our students' confidence in taking risks with their practice and the ways they exhibit their work – and that is much more exciting. Once you are confident about that, you can really question the whole structure and what kind of art world you want to be part of. Our students have all sorts of approaches to art and professional life.

Are you hoping they become artists?

Martin: That is another good, and tricky, question. But yes, absolutely. And our course is set up with that aspiration. That doesn't mean we are stupid enough to think everybody will become an artist. That doesn't devalue the idea of aiming for all the brilliant things that an education to become an artist offers.

Is an art education a kind of vocational course?

Martin: I have had arguments with colleagues about this. I have no problem with the term, I don't mind it being vocational. I think that is okay, but some colleagues disagree.

Why?

Katrine: I think vocational for me signals a real belief in the importance of what we do with the making, and the studio as a foundation for everything. That doesn't mean if you fail to enter that vocation something has gone wrong. It is important to think of it as a vocational course with a huge umbrella over it that encompasses all kinds of other things. One of the things that is great about art is the way it draws on, and feeds into, so many other areas. I think art is something that is very embedded and located, and yet has all of these connections as well. Perhaps you could describe it as being dynamically vocational or something.

Martin: That's right. I remember the argument now. It was actually with some designers. Colleagues who taught graphic design were adamant their courses weren't vocational because they were saying it narrows down the options. If your option is being an artist it couldn't be any broader, so you aren't narrowing anything down.

Katrine: Exactly. It is about being aware of that broadness if you like. We also encourage students to acknowledge that different kinds of practices may lead them to do different kinds of things in terms of their work for money later on. So if you have a socially engaged practice you will most likely do different kinds of jobs than somebody who has developed very good video editing skills for instance. There are ways of connecting into society through your practice so that there is some kind of critical overlap. Even if it is not necessarily seamless there may, at least, be some sense of it being a holistic practice.

When you talk about training people to be artists, is there a particular idea of what an artist is and also what they do? What their life looks like?

Katrine: For me there absolutely isn't this idea of what an artist is or looks like. When we had our discussion 'What is a Professional Artist?' we chose that title not to answer that question but rather to have a discussion about the multiplicity around that kind of question. It is much more exciting to think of being an artist as something that is constantly changing and being reinvented. In fact as a middle-aged person I don't know what the future holds in that way, and the students will go out and define that for themselves; that is much more exciting than having a fixed idea of what you must aim for.

Martin: That attitude runs right through everything we do. It runs through the course and it runs through the way we have rethought studio spaces in the college. For me there is a crisis in setting up a situation that is impossible to replicate once you leave art school. Having the individual studio space model in art school is setting people up for a life that is almost unattainable in London now because it is so expensive. So instead, we have a different model for setting up studios that is about students working in

groups to use space much more efficiently and much more effectively. And it is a situation that aims to create real dialogue rather than separate people. This approach is like a blueprint for how students might work once they leave. It can be a model where groups of students can get affordable studio space together after they graduate. So it's not accepting anything as being *the way* to do it, but allowing discussion, and an unpacking of what our main values are, to inform what our approach is going to be.

Katrine: In a way a studio can almost become this un-sited thing. It can become something that is about a group of people connecting together, keeping links, and working together in different ways. It is not necessarily about a room, it can be much broader than that.

I'm interested in how an art graduate can maintain a practice after they leave art school. Do you think this is harder for those from lower income families because of the high costs involved with things like materials and maintaining a studio?

Martin: It is a massive issue because everything is stacked against you. Luckily it is still possible to get reasonably well-paid jobs that don't take up all your time and lots of graduates do find work for half a day or something, and manage to keep some time for developing their practice. I think that is one of the benefits of being in London. Even though you have to pay ridiculous rent, having those sorts of jobs available offsets that slightly.

Katrine: Another thing to flag up of course is that in the cultural industries, and particularly in some museums and galleries, there is much exploitation of art graduates. I think a really big challenge for us is to make students very aware of how they may be exploited and how much they are willing to go down that road, and also what strategies there might be in order to try and change that system.

By exploitation, do you mean things like unpaid internships?

Katrine: Yes. It isn't sustainable and it is excluding because it means that some students can take unpaid internships for much longer because their parents will bankroll it, whilst others just can't. It creates inequalities that

don't serve any of us in the long term. I think we need to start having these kinds of conversations and make students aware of how these things operate. It is not just in fine art either; there are many other areas in arts and cultural production where it is the same. It is a big problem.

There is also this idea that flexibility and portfolio working is a great thing. In reality, for female graduates, it might just drive you right back to the kitchen in terms of where you are located. We need to have discussions about longer-term prospects, pensions and all of those things, which may be related to feminist issues. Although here on the BA it is about even, in art schools generally there tend to be more female students, and it is important to link some of these conversations to that as well. Also, when you look at the DHLE data on earnings there is a significant gap between graduates of different genders. You might expect that gap to be there after ten years or so, but it is there from day one. What is that about? Do we need to teach our female graduates better negotiating skills or to place more value on what they think they offer? Or do the male graduates lie? We don't really know, but there is a gap.

Do you currently do anything to support graduates?

Martin: Yes, we have a few things. We have quite a few partnerships with ACAVA[3] and ACME[4] that provide studio awards[5] – so free studio space for six months, mentoring and a cash bursary. There are a number of prizes and there is also a commission for a plinth in Chelsea's courtyard next to the Tate. There are various things that graduates can tap into but we want to provide more.

Katrine: Interestingly, a number of the prizes and commissions awarded to students on graduation, such as the ACME studio award, the Flat Time House award, the Chelsea Arts Club Trust Award and others, were initiated and set up by students, going all the way back to 2010 I think. There was a group of students at the time who wanted to take some leadership in terms of what goes on, and what potential there is, to develop practice and engage with other institutions beyond the course. A collaborative student group called the 'Claxton & Major Collective' began this process as part of their

own practice. These 'Chelsea prizes' have been largely student organised and led since then, which is really interesting and quite unusual I think.

Do you hope that your graduates stay in London?

Katrine: I think it is about encouraging them to really think through what is possible. The idea of being an artist can mean that you are not necessarily tied down to a place and so why not see if you can get a residency abroad and think about practice in a more global way? Having international students helps that conversation as well I think.

Martin: I know some of your questions are about our relationship to our location and one thing that Katrine is describing really well is that our location has an international dimension. We are really interested in the fact that we send our students out all around the world. For example, I have met alumni groups in Taiwan and China. There are extraordinarily strong communities of people who graduate from Chelsea.

A lot of my attention is currently on thinking about what it means to be located in central London. I think we have a responsibility to ensure that cultural production is still possible here. We are quite close to a situation where it is a bit like Paris, where the middle of the city is just for people to go to museums, restaurants, concerts and to shop. With the outside being where production happens and people live. That causes a very problematic dislocation between different parts of society. I think it is desperately important that we really engage with what it is to be an art school right in the middle of a big city.

Can the art school have any kind of influence on that?

Martin: I think so, for example through working with some of the studio partners as we are doing at the moment. Recently ACAVA, who are a large charity that provide studios for artists, have taken lease of a building that was previously a primary school under the Westway in North Kensington. Instead of organising the spaces into many separate individual studios, ACAVA have worked with a group of graduates to set up flexible working spaces in a way that mirrors our approach to the studio at Chelsea,

which I described earlier. Our graduates have decided not to use the whole building as studio space but have set up a gallery and they do some educational work. This can have a very direct and positive social impact for the community who live in the area. This is not an affluent part of West London, and this kind of initiative is certainly a very healthy alternative to buildings being purchased by property developers trying to turn a profit who then often leave premises like this empty.

And over the next couple of years we aim to set up an MA that has a focus on that kind of engagement with London. The proposal currently under discussion is to set up an MA where engaging with a context becomes an integral part of the course. What this will mean is that instead of the traditional approach where you work at the college until the final show, the degree show will not mark the end of the course. A period of the course following the degree show will challenge and support students to engage with the context in which they see themselves operating beyond. This could mean setting up a studio collective like the ACAVA project I've just talked about, or working in education, or exploring a theoretical context for your work through writing an extended dissertation if that is appropriate for you. Or potentially, it could mean setting up networks or collectives in your home country overseas. The aim is to bring the kind of mentoring that some recent graduates have benefitted from after they leave Chelsea, into the curriculum by making it part of the experience of the course.

Katrine: I think the art school has to be very reflexive in terms of its engagement with society so that this is not an ivory tower or an island. It has to be totally plugged in to what is around it physically, locally, but also globally. There are lots of things that maybe work against that but I think we have to keep trying.

Martin: That is a really good point. Some art schools will give you examples about how their students and staff go out into their local community and do stuff. But they are often quite bad at inviting people in and actually being part of the community. I think we could do a bit better by getting people to come and engage with what we do on a meaningful level in the art school.

Does Chelsea engage with its local community?

Katrine: The local community here is difficult to define I think. There is definitely more that can be done for sure. In the book *Art School* by Henry Madoff, Thierry de Duve talks about Chelsea as having this space, The Triangle Gallery, that is porous because you can just walk in there and there is something on.[6] There is sense that there is a part of Chelsea that is permanently public, perhaps even more so with the parade ground.

Martin: I have this idea that the parade ground should have a playground on it. The idea is that you would have a playground and then your library is at street level. And when you walk into the library the first thing you see are kids' books. This wouldn't of course mean that you wouldn't have all the other books and resources that the library already has, but I think we would be sending a powerful message of inviting people into our community from a very young age. Whilst this sounds to many like a bit of a crazy plan, it is actually something we could do. And at a time when art is being marginalised in schools with the threat that art might be removed from the National Curriculum, I think this sort of approach would make a welcome change. However, there are all sorts of people to convince about the quality of that idea before it actually happens!

What are your views on some of the challenges that the arts have been facing in schools, such as arts subjects not being included in the EBacc? Do art schools have a role to play here?

Katrine: The political situation is such that we have to really fight for the arts not just in the art school but more broadly. Otherwise how can children be in a position to think about art as a viable career or education when they have never done any art, seen any art, or had any engagement with it? The art school has an increasing role there I think.

Martin: In the near future that is a huge question for us. In many ways, it is a question that could end up defining us. Thinking about the way students get prepared before they begin a degree at Chelsea links right back to your early question about what kinds of students come here. We can't sit and wait to see who is going to apply to us. We have to be

much more proactive to make sure that everyone has equal opportunity to come. If we don't do anything, the only students that we will find applying will be those taught in schools where art can be afforded as an extracurricular luxury.

What do you think the future of fine art education might look like?

Martin: I think we have to rethink the start to our courses. I can't see foundation courses lasting long and there are lots of political reasons why that is. At the moment, the vast majority of our students come to us having completed a foundation course. But I think this will change. And whilst I think a foundation course is a wonderful thing, under current policy there is a serious problem in that it might be putting off students from less wealthy backgrounds. The reason for this is that you currently cannot get a grant to do a foundation course. So even though there are no fees for the course, many are unable to afford the cost of living and studying in London for a year. We have to ask ourselves whether we can cope with having that sort of barrier.

Currently, you can apply to Chelsea straight from school. But again, because we say you have to have an exceptional portfolio, those people who come straight from school tend to have been those that benefited from really good art departments, often found in private schools. So I think we have to think totally differently about how we encourage people to come and study art, how we interview them and how we prepare them for the course. I believe that we will need to build a foundational experience into the three year BA course. And this might mean that our art course in the future could look a little bit weird in that after the first term, there may need to be a little bit of a swap around with people moving from one course or subject area to another because they might feel they have not made the right decision. We will have to build in a mechanism to allow that to be possible. For other kinds of courses that might sound like an insignificant change. But for us it would be quite a fundamental shift. One reason for this is that the premise of the Fine Art course at Chelsea is independence, where we don't ever set a themed project. We expect students to be independent enough to make work that we

can respond to and talk about. But you just can't expect that kind of independence from people who haven't done something like a foundation course.

Katrine: Or maybe even A-level art potentially.

Martin: We have had conversations that maybe we should be endorsing certain A-levels qualifications. Different A-levels are run by different boards. Some are terrible but some are much closer to our philosophy. Maybe we should also be delivering some? Maybe we should be delivering extracurricular classes at schools to introduce people to the way we work and what we have to offer? Again, that is a big change from what we currently do.

Do you think that is something that is likely to happen?

Martin: Yes, I do. The other options seem a bit bleak to me.

Who do you think fine art education should be for?

Katrine: Everyone.

Martin: Yes, I wish the only admissions criteria was: 'Do you really want to come?' The thing I am most uncomfortable about in what we do here is the fact that we are very selective. We have to be selective and that means having to set up some sort of process. The only process which is efficient is unfortunately quite problematic. Like some other courses, we make students put together an online mini portfolio of ten images which we look at to filter out people we don't think are appropriate. The reason why I am uncomfortable with that is, it is asking applicants to do something that is really hard to do and something I still struggle with. So the first thing we ask students to do is something that is really difficult, which is to try to consolidate lots of work into ten images that crystallise their approach.

Katrine: Some potential students will have lots of help and support to do that kind of thing and others will have had zero, it is unfair from the start.

Martin: So we try to find ways of looking through that sort of coaching. But with the pressures of time this is very hard. But we strongly

welcome students who are the first in their families to apply to university precisely because they are proving how independent they are. With a course based on independence that is the best characteristic that they can show.

1. Artquest provides artists with information, advice, opportunities and services at any stage in their careers. Artquest is a programme of University of the Arts London and also an Arts Council England National Portfolio Organisation. See www.artquest.org.uk (Accessed September 14, 2016).

2. University of the Arts London has an extensive Jobs and Careers service. It's offer includes: funding & mentoring, jobs & internships, jobs advice, freelance & business advice, and advice on pricing and selling work. See: www.arts.ac.uk/ student-jobs-and-careers/ (Accessed September 14, 2016).

3. The Association for Cultural Advancement through Visual Art. See: www.acava.org (Accessed September 14, 2016).

4. Artist's studios provider in London. See: www.acme.org.uk (Accessed September 14, 2016).

5. See: www.acme.org.uk/chelseastudioaward.php (Accessed September 14, 2016).

6. 'This last example is an excellent indicator of current tendencies. Just like the Städelschule in Frankfurt, which is joined with the Portikus gallery, or the Chelsea College of Arts in London, which built a spacious gallery (the Triangle Space) a stone's throw from Tate Britain, Villa Arson brings together an art school and an exhibition center, as well as a program of artist residencies.' Duve, T. *An Ethics: Putting Aesthetic Transmission in Its Proper Place in the Art World.* In. Maddoff, H. (2009). *Art School Propositions for 21ᵗ Century.* P. 18.

SOUTHAMPTON SOLENT UNIVERSITY

Dr Atsuhide Ito is Course Leader and Nicola Chamberlain is Senior Lecturer in BA (Hons) Fine Art at Southampton Solent University. We spoke with them at the campus and also via email.

Can we start by asking you a bit about yourselves and how you ended up teaching art?

Atsuhide: I was born and brought up in Japan. I had some teenage years where I was confused and that led me into art. I studied social anthropology and fine art at BA level, did my MA in social anthropology, and after some years I travelled. I then did my PhD in fine art and that led me into a teaching career. I came to teaching very late though. Somebody told me that if I wanted to survive as a professional artist I could do some teaching as well, but at first I absolutely rejected the idea.

How about you Nicola?

Nicola: I was in my late 20s when I went to study. I did my BA at Goldsmiths and MA at the Slade. I was then part of that typical stable of artists represented by a gallery for a few years. All the way through, I really wanted to teach. I started off by teaching at what was then the Arts institute of Bournemouth[1] and then before coming here I had an artist in residency place at Gloucestershire University. I managed to get a lecturer's post here ten years ago, and very soon after that I became course leader, really because nobody else at the time would do it. I'm about to begin a PhD next year. For me, the dual passion of teaching and making art is really interesting; one has taken priority over the other at various times but both have been really important.

Can you tell us a bit about Southampton and the area in which the course is located?

Atsuhide: The course is a part of the School of Art, Design and Fashion at Southampton Solent University and is located in the heart of Southampton, a port city where many cruise ships have departed from – most famously the Titanic. The central part of the city was rebuilt after its bombardment in the Second World War and is now occupied by large shopping malls. The City Art Gallery and Solent Showcase Gallery, formerly the Millais Gallery, have played a key role in the development of the culture sector in Southampton, along with the John Hansard Gallery based in nearby Winchester. A new city development, the Cultural Quarter, opened this year and includes a branch of John Hansard Gallery. Southampton is proximal to Winchester, Portsmouth and Bournemouth, and is a commutable distance from London.

Southampton has a specific challenge as only a handful of major players in the industry act as employers or offer opportunities in the creative industry in comparison to London. However, there are numerous active artists' collectives and socially conscientious enterprises. Over the years, some of our graduates have become key players in the city's art scene and infrastructure.

Who attends the course?

We have about 30 students a year, all full-time. We have a sizable percentage of students from local areas – defined in terms of the South West region, and a large proportion of students from the UK including London, the North East, the Midlands, and Scotland. We have a small number of international students from countries such as Nepal, India and Taiwan, and we have had students from Poland, Latvia, France, Spain, Italy and Norway. They are small in numbers but consistently we have some from the EU and other Eastern European countries. We usually have up to four Erasmus students each period. Through Erasmus we have recently had students from Finland, Spain, and France. About 70% of students each year are female. We always have a small number of mature students, but

most are 18 to 20 years old when they start. We also always have a small number of students from mixed heritage and minority backgrounds.

Can you tell us a bit about the philosophy of your course?
Atsuhide: We see our course as a social and artistic experiment. The course team and the students work closely to transform the ways in which art is situated in wider society, as well as to reconstitute ourselves as political and ethical beings. The Socratic notion of 'epimeleia'[2] (care) is central to the organisation of the course as students are encouraged to lead their projects, and tutors are there to support their efforts instead of teaching in the traditional sense. Students are encouraged to explore personal, political or often socially challenging themes. They are encouraged to move across a variety of media to question the normative operations of the everyday, and to find inventive and imaginative approaches through art to relate to others.

Can you tell us a bit more about where these ideas come from?
Atsuhide: You need to have a structure that allows innovative thinking and also freedom. How you do that is always a big question – and there are different answers. We think that first of all you need to provide a caring environment in which students feel safe enough to explore ideas. That's where Foucault's adaptation of the word 'epimeleia' comes into it: so how do you take care not just of the product or outcomes, but also of the person? How do we look at the person and try to see where this person could potentially go in a few years' time?

In addition to this we are in discussion about Instituent practice, which Gerald Raunig talks about.[3] Here we ask: how do you keep openness without being institutionalised? When something works, then in a few years' time it becomes a dogma or dominant structure. Keeping this openness is a very difficult thing to do.

Another dimension is that we encourage students to come with genuine portfolios. We confront social, psychological, and all sorts of issues and problems, without hiding behind works that look like art. We're not interested in that.

Nicola: I think in part it's to do with wanting to teach to the individual. Part of doing that is caring for that individual in every aspect of who they are because, in a way, artists have a proclivity for vulnerability in the sense of doing something that is really exposing on a daily basis. You have to make sure that you create a safe, secure and nurturing environment for that to happen productively. The students need to feel safe enough to bring their own particular experience of the world to the centre of what they do, including their own personal experience of oppression and sometimes mental health issues, emotional health issues, physical health issues. And I call these 'issues' in inverted commas because in a way they are really just experiences.

So we just try to embrace all that they are. Everything about them is valid and relevant to them as makers and thinkers as far as we're concerned. So they bring whatever they bring, and some of them bring a very intellectualised approach, and some bring a more intuitive approach to their practice. They all bring something different, and we try to cater for that individual need. So that means paying a bit of attention, listening, and getting to know them.

We're not egocentric educators. I think in some art schools the persona of the artist can take centre stage. With us it's the student that takes centre stage, and then we do what we can to collapse any hierarchies and just support and facilitate their learning. At open days we talk about the students as a community of artists working alongside one another cooperatively. It's a small course, and the intimacy is a very relevant part. It is a family in many ways.

Do you recruit staff that share in your philosophy?
Nicola: I think, over the years, we've naturally invested in more generous educators. Obviously you're looking at someone's experience as an artist as well as an educator, but when we come to meet the individuals it is about what they bring, their humanity.

Is your approach a response to the students in your cohort, or a rejection of something you've experienced elsewhere?

Nicola: The student demographic that we have here dictates our approach to some degree. Over the last 10 years, every student I've met has had a huge impact on the way I view the world, society, education and art.

Atsuhide: I also think it's a response to some other places I've worked where there are many students and sometimes you don't remember names or faces, and you only see them at assessment. In a way, education has become a mixture of corporate strategies and is like a military training ground. We're against those aspects although at the same time, we do have to acknowledge that the course is within a university structure. Course leaders and others are under pressure to present their courses in a particular way in order to meet certain requirements from the university.

Nicola: But we're doing what the institution needs us to do in a way that supports the course rather than destroys it. A university has a mission statement that changes depending on the different pressures it's under, and those things are then passed down to course level. We have a duty to respond to those things, not just pay lip service, but to actually really think about what we're being asked to do and why. But then we also have a responsibility to the students and you learn to apply that in a way that is wholly supportive of the course and of the educational experience of the student. It requires real thoughtfulness, energy and enthusiasm.

Atsuhide: We are lucky because we do have strong support around us. Management do understand what we are trying to do, and they identify with our intentions.

Do you feel any pressure to prepare students for the world of work? And is there a tension between this idea and the more romantic idea of an art school that breads critique of a dominant system or agitation of some sort?

Nicola: If you bring it back to being student centred, to teaching the individual, then you have to accommodate a variety of different potential philosophies in terms of how you view art and what art can do and how it can be applied in our society. We do have some people who want to agitate,

who want to be social activists through the act of making, or who want to be represented by a gallery and show in the traditional white cube. We have other people who want to become teachers at every stage of a person's development from child to adult. We have people who want to be illustrators or photographers. We have people with an infinite number of different career aspirations.

So from my perspective, we are about finding ways to open up all those dialogues and practical strategies to support individual students to create portfolios that meet their individual career aspirations. We offer up a variety of different options to them by inviting artists in to talk to them, curators, critics, people who exist in that framework in numerous different ways and hold different philosophies themselves. What they're asked to do is sift through that information and make some decisions that are right for them.

I think optimism and the belief that anything is possible is key to education. So it's always about helping someone to believe that whatever they want to do is achievable.

Atsuhide: If you want to have an impact on the lives of other people, then you have to take care of yourself first. You have to emancipate yourself. That's our place in that task. That's again where this idea of 'epimeleia' comes in.

We have graduates who go on to do really exciting things, not just doing art, but really working with their conviction and conscience. It sounds really simplistic but I think that these graduates have been trying really hard to have an impact on their environments and social networks.

So they are also thinking about the wider world in which they operate?
Atsuhide: Yes. I do situate my position as someone who thinks about this perceived boundary between life and art. And then how do you challenge these boundaries when you want to do certain things for whatever reasons. You have to really think through what it means to break these boundaries and also what are the strategies to do so. Some of the strategies are very artistic and imaginative, and they really do bring up changes to a

person's life or to the people around them. I think the care, the 'epimeleia', is also relating to the effect on the wider society.

How do you prepare students for life after art school? Do you have distinct professional practice modules?

Atsuhide: The course offers a professional development unit in the second year in which the students work together to organise an exhibition of their work in a diverse range of platforms outside of the university environment, such as medieval vaults and shipping containers. The course also provides an opportunity for the students to have an artist residence experience at Lower Hewood Farm in Dorset, so that they can work in an environment that's different to the purpose-built studio spaces within the university.

Additionally, when professional artists and curators visit us to give talks we ask them to discuss not only their works but also their career trajectories, and to give practical advice to our students. These aim to demystify the art industry so that hopefully by the time students graduate they have developed a strategy to navigate it.

Nicola: As well as this distinct unit, professional practice is embedded in the course from the first moment they arrive to the last day that they're with us, in numerous, very subtle ways. The 20 credit unit is to show that the idea of professional development and employability has been dealt with on the course. Then for us the task is to make sure that we support and nurture those career aspirations throughout. Even more than that, we make sure that the unit really functions well so that it doesn't just become a way of making that visible to the institution, but it is actually an incredibly powerful and useful experience for the students. So it's trying to work on multiple layers.

So that distinct unit culminates in the exhibition at the end of the year?

Nicola: Yes, but of course that word exhibition can be interpreted in numerous ways. We're not closing down, we're not ultimately just saying you have to have an exhibition, you have to be an artist in this way, you

have to produce an art object and show it in a space. Actually that's open to interpretation, and so if they, for instance, had been involved with Showcase Gallery in terms of educational workshops, then they could potentially use that to form the exhibition, and give a presentation to the public about how they had interpreted or activated their art practice.

What do graduates of your course go on to do? What does a 'successful' graduate of your course look like in your opinion?

Atsuhide: A substantial number of graduates go on to MA programmes in London and the South West. Each year a small number of them start teacher training immediately after completing the course. Some others become involved in political, social and entrepreneurial activities. Successful graduates in my view are actively participating in the political and social spheres of their immediate environments and, through artistic means, emancipate not only themselves but others around them.

Do you hope that graduates stay local?

Nicola: Again, I think it comes down to where the student wants to go afterwards, what their aspiration is, and where the best place to achieve that would be. There are hotspots in various parts of the country but student retention has increased exponentially here over the last 10 to 15 years. Graduates have begun to remain in Southampton and make things happen, much more so than used to be the case. To give an example, Dan Crow is a graduate from the course and he is just opening a new arts centre in Southampton. He's not from Southampton but he studied and built his base here and has generated a lot of interest. He started by creating studio spaces, and from there has moved on to other projects to open up more diverse spaces for artists and creatives to work in.

Atsuhide: I think there is a serious level of engagement in Southampton at grassroots level and also at a bureaucratic level where the university wants to embed itself in the cultural aspects of the city.

Nicola: There's a hell of a lot of space still to be filled culturally. This is a place where you can come and make things happen. Whereas that was

much harder to do a decade or so ago, it's becoming easier because of these trailblazing things that have happened over the recent years.

How do expectations and preparations for life after art school compare to your own experiences?

Atsuhide: Life after art school is unknown and frightening. That was how it was for me and it appears the same for our students. However, as the university is increasingly focused on employability and encouraging industry informed teaching, there is a variety of programmes and workshops to inform the students prior to graduation. Despite substantial structural guidance for the students to find a sure footing in the industry, the perception that 'art does not pay' seems firmly internalised in the public opinion. It is therefore our duty to expand what may be possible in and through art, and to disqualify the notion of art as a narrow category and the notion of art as an institution exclusive to a particular class. I would also refute the notion of art as a solely humanist endeavour or the notion of creativity as an instrument for progress.

What do you think is the role of the art school in society?

Atsuhide: In my view some art schools have become a military academy to train students to fight cognitive wars through art in public and in private spaces of galleries and museums. They are trained to fight for others' interests, instead of their own. Against this backdrop art schools have a responsibility to acknowledge an individual student's potential for personal, social and political transformation. It is to question ideological entrenchments and to allow an exploration and opening of paths that are not yet open. Art schools also need to continuously re-examine how an institution, an organisation, or a team can be imagined and practiced in order to maintain a liberating and inventive platform for tutors and students.

1. Now Arts University Bournemouth

2. Michel Foucault re-introduces the Socratic notion of epimeleia in his late lectures between 1983 and 1984. In Foucault's writing, the care is a resistant strategy against authoritarian dogmatism as well as a self-initiated discipline for cultivating one's self. Foucault, following Socrates, sees the practice of epimelelia as producing generations of socially responsible and independent members of society.

3. For Raunig's discussion of instituent practices see: Raunig, G and Vilensky, D. (2008). *An Issue of Organisation: Chto Delat?* In. Afterall Journal. Winter 2008. Available from <www.afterall.org/journal/issue.19/issue.organisation.chto. delat > [Accessed September 13, 2016].

ISLE OF MAN COLLEGE

Helen Fox is the BA (Hons) Fine Art Course Leader at Isle of Man College, where she has worked since 2002. The Isle of Man is an island in the centre of the the Irish Sea, 33 miles long and 13 miles wide, with a population of 85,888. It is a British Crown Dependency, and the island's parliament is called Tynwald, which is the oldest continuously governing body in the world. There has been an art school on the island since 1884. Helen provided a written response to our questions.

What's the art scene like on the Isle of Man and what's it like to work here?
There are a lot of creatives living and working on the island, and a handful of exhibition spaces. There are five secondary schools, one private school and one college of further and higher education. Because of the small community and island context, it can be challenging for artists to sustain a living here. Norman Sayle, head of art at the college from 1954–1989 said 'Our basic philosophy at the art school is that we are dominated by nature whether we like it or not. If we were an art school in a big town, then our lives would be dominated by buildings and things like road signs, but here in this beautiful island it is different.' Partly driven by demand, it can be difficult for artists on the island to break away from this tradition of representing the landscape. As such, the production and consumption of realist work is prevalent.

What undergraduate art and design courses run at the College?
In September 2014 the college launched the first two of an intended four related undergraduate art and design degrees. Fine Art and Visual

Communication through Digital Media are running first, followed by Fashion Marketing and Communication, and Contemporary Crafts. The intention is to put equal emphasis on creativity, business, and technology to encourage the development of Fusion Skills,[1] which are what the creative industries increasingly report they need. This is exemplified by the demand for creative programmers, technical artists or specialists in one domain who can collaborate with those from other disciplines and speak a common language. All courses are taught in the same building in close proximity, and we have core modules which are delivered across degree titles.

Where are the studios based?

Our courses are based in new studios at The Market Hall, a large iconic red brick Victorian building that is also open to the public. There's a greasy spoon café, butchers, and public toilets. It's right in the city centre, on the quayside, surrounded by pubs and restaurants, and near the main bus station and ferry terminal. The venue has the potential to become a creative hub for the island where it can offer a multifunctional space all year round. The students have been accepted by the local community, providing them with lots of opportunities to network with businesses and engage with the public.

Can you tell us a bit about the BA Fine Art course? Does the location impact at all on the curriculum and how you prepare students for life after the course?

Being in the centre of town and in the heart of the community offers a new way of delivering an honours-level arts programme to students living in an island community. In recognition of our literal insularity, the programme insists from the outset that students establish connections with potential partners, employers, suppliers, and that they make themselves aware of business and creative openings on the island. We aim to enhance students' employability and focus their abilities to start their own creative enterprises.

Embedding employability into the structure of the curriculum is extremely important. We take a holistic approach to practice, and we have designed the course around a structure that focuses on entrepreneurship and professional practice, with modules such as 'Strategies for Creativity',

'Creative Identity', 'Getting Connected', and 'Collaborative Practice'. Through these, we have had students work in collaboration with the Arts Council on their loan collection, which culminated in an exhibition at the Manx Museum in collaboration with Manx National Heritage. Students are encouraged to take on external work for clients, and one of these has been to work with a local businessman to produce a graphic novel.

Other mechanisms for support include a business start-up scheme run by the government which students can access for support, and regular networking opportunities including our local network of open studios that we encourage them to take part in. Networking events help students to build external relationships from an early stage, help spread knowledge of opportunities and available resources, and help micro businesses in the sector to coordinate their activities.

The ability to be flexible, look for ways to apply the skills learned, and to make things happen for themselves are traits that the students must develop to be able to survive and continue to practice on the island.

What challenges and advantages does being on an island bring when designing your course?

There are approximately 20 students on the course, across all levels, who are all recruited from our own Foundation and Extended Diploma programme. The advantage with this is that we know these students and their levels of attainment, we prepare them well for study, we know how they work, we know their ambitions, and we are able to work directly with each student to develop their presence in the community as an artist.

In many ways, our students are faced with the same issues as UK students – such as securing a studio space and making economic success from their creativity once they leave – but we don't have the same opportunities. There are limited gallery spaces and only one small artist-led studio provision, which is quite isolated. We're working hard to make the creative industries more visible on the island. For example, this summer when the studios were not in use for 15 weeks, we ran something called MakeMarket in the studio spaces, where we hosted workshops, talks, and demonstrations

that covered as many of the sectors within creative industries as possible. This was open to everyone involved in the creative industries community and the wider public. We help our students to find their niche within the culture and context of the island.

Do you think you have a responsibility to help prepare students for when they leave after graduation?

With changes in higher education fees, more students want to study near home. To stay on the island is a big decision to make because it reduces opportunities for students to find new pathways and networks. In this respect, it is vital that we build modules into the course that encourage networking and that build external relationships from an early stage.

For years the Isle of Man has supplied the UK with students for degree level study, and the Further Education College has been the stepping-stone for many students. It is now not only a great opportunity but a huge responsibility to support our students into their careers. When we were designing our programmes, we were determined that our graduates would leave with a plan in place.

What do graduates of your course go on to do?

Our graduates have progressed onto a wide range of things, from teaching and MA programmes to running their own businesses. One student is studying Ceramics at the Royal College, and another student was a former English teacher who completed the degree to change her career and was promoted to head of art after graduation. It is very much horses for courses and what is right for one student is not suitable for another.

The Isle of Man has an excellent track record in supporting the entrepreneurial spirit, and we are committed to helping individuals and businesses become successful. Our sectors, which include financial services, manufacturing, shipping and aircraft management, e-gaming, film production, and precision engineering, are internationally recognised as some of the best in the world. At the heart of our proposition to those considering investing here is a promise that the Isle of Man is a land of possibility where people

and business will find the right environment to reach their full potential, whatever they feel that may be.

On the Isle Of Man we don't yet have a mechanism for measuring the GDP (Gross Domestic Product) of the creative industries. The recent Warwick Commission,[2] talks about a 'Cultural and Creative Industries Ecosystem,' a future of cultural value and about how the cultural and creative industries can work together to maximise value for the economy. Manx National Heritage, Arts Council, Isle of Man Heritage charity Culture Vannin, the Department of Economic Development and the Department of Education and Children, are the key stakeholders on the island and they have since come together to form a working group to look at and develop the creative industries.

1. Creative Skillset. (2016). *Defining Fusion*. Available from <www.creativeskillset.org/who_we_help/training_educators/ shaping_quality_provision/fusion_skills/defining_fusion> [Accessed September 15, 2016].

2. The University of Warwick. (2016). *Enriching Britain: Culture: Creativity, and Growth*. Available from <www.warwick.ac.uk/research/warwickcommission/ futureculture/finalreport/warwick_commission_ report_2015.pdf> [Accessed September 15, 2016].

EDINBURGH COLLEGE OF ART

Dean Hughes is Head of the School of Art at Edinburgh College of Art (ECA), University of Edinburgh. It is a position he has held for two years. Prior to that he has worked at ECA since April 2007 in a variety of different roles. From 2008–14 he was Programme Director for BA (Hons) Intermedia and in our conversation we refer specifically to this programme.

Can you tell us a little bit about Edinburgh College of Art and where it is located?

Edinburgh College of Art is located in the old town of Edinburgh, adjacent to the Grassmarket and within the central area of the University of Edinburgh. Edinburgh College of Art as it exists now is a unique environment for creative study. I cannot think of any other art college within the UK that is home to Art, Design, History of Art, Music, and Architecture and Landscape Architecture. The geographical closeness of these subjects along with their home within one institution provides distinctive collaborative opportunities for staff and students. ECA is located in the University of Edinburgh, which is the sixth oldest university in the English-speaking world. It's a rare environment I think for artists to study within.

Can you tell me about the bit about the Intermedia programme and its ethos?

Intermedia was validated in April 2008 and the first cohort of students graduated in June 2011. One of the central aspects to its thinking was to provide a conversation and ways of making artwork that is perhaps not captured within a medium specific art school such as Edinburgh. I was aware that historic modernism occludes certain artistic practices that have emerged

post 1945, and actually prior to this date. Intermedia was established not to contribute another medium but was rather presented as a strategy.

How do you prepare students for life after the programme? Is professional practice something that you teach?

We had a 20 credit professional practice course in the fourth year, but staff and students didn't identify with it as a discreet entity and saw professional practice as something that was embedded somehow within tutorial conversations. In a sense tutors might have spoken to students about how to prepare a very simple, what you might term professional, portfolio that you might give to a gallery or something. I personally am not sure at all about this approach. What one might do after college is potentially so varied and to prepare a portfolio for a gallery is just one route, and not a very good route – in my opinion it's out-dated. I worried about it… it made me anxious, to think what it might do, and what I might teach in relation to it. The other thing is of course that professionalism should invite subversion. Being an artist is not about what's in your pocket.

So one of the things I did for five or six years is I asked the students to come up with questions that they wanted the answers to – two questions each. I didn't really brief them about it or give them a context. There was no preamble as to the type of questions that had been asked or the kind of questions that they should ask. The only thing I gave them actually was a reference to leaving school, just to give them a sense of where this might go.

The first time I did this I would type up the questions and I would project them live, so by me typing them up we all had ownership over the questions – that is an important bit of it – and the questions would become the syllabus for the course. We then set out as a group to find out the answers. Often in the typing up of them, students would have difficulty in asking precisely what they wanted to know, in identifying the key words. Maybe what they were wanting to ask was always being displaced somehow? The act of typing them with everyone present became an important first step to finding answers.

Can you give an example of some of the questions?

Some of them were really simple and I could answer straight away, for example, 'Do I need a business card?' 'No you don't need a business card, of course you don't.' Some of them were quite pragmatic, such as 'How do I register to be self-employed?' Others were 'How do I approach a gallery?' – the usual suspects in some respects. Others were much more existential, like, 'How do I carry on working when I am in the void?' And then things like, 'Do I have to move on to a centre or a metropolis to have significance?' And 'How do I work when I am on my own?' So if someone asked about postgraduate courses that was quite easy to solve, but I suppose the ones that I was interested in as an artist were 'How do you maintain a faith in your work? In keeping, making artwork?'

So half of them were easy to deal with and the other half were more developed as questions. Each year we collated the questions and one of the classes, for example, was just to show the other questions. There is a usefulness for the students, I think, in them simply seeing what others had wanted to ask. We did also go out as a group and we asked other organisations the questions that we had collated. I interviewed people in front of the group and asked them the questions too.

You mentioned you ran the professional practice part of the programme for five or six years. Has this now stopped?

Yes, it finished last year in 2015. It felt like it had probably run its course. We made a decision at Edinburgh College of Art that a 20 credit professional practice course was perhaps a little outmoded and too much 'service' orientated.

I think one of the things about professionalism, and really it is a thorny and difficult issue, is perhaps that what one might teach would always be quite old fashioned. Students learn as much, if not more, from each other than they do from faculty, and what needs teaching really is the appetite and ability to destroy what has been taught, to replace the received knowledge with a new meaning. I think all teachers in art school know and understand this, even if they don't readily admit to it. So for example, one of the first

classes that I did was to try to discuss the folly in following what is set out as an example, to show that it is out-dated already. My problems are mine and are time sensitive.

When I left art school in 1996, I decided to keep everything that was given to me in relation to my own work – and this was a time before email. So every invitation I got, every letter, everything to do with my work, I kept this archive chronologically in a file. I mean everything. It starts with an exhibition that I did just before I graduated, then it moves forward. It's got stupid things that I didn't follow up. There was one letter where I was going to be offered a studio in Rome, which I just never replied to. So I got that. It goes all the way through. So it has got things like letters of acceptance for exhibitions, invitations to exhibitions, correspondence, everything. I pinned it up in the room as a timeline, starting from the point of graduation to five, maybe seven years on. I also described what jobs I was doing during this period and whether I was working at Dixons selling PlayStations or whatever.

The usefulness of the archive is that it is open to questioning because, although I have got sentimental value attached to it, it is actually really out of date. So the advice that I could give students from my own experience is really out of date now, and that is one of the big questions about education. When it comes to thinking about professional destinations, quite often we prepare students in our mould and it might not be a good fit at the time, and it is an even worse fit when they look at it 20 years later. One of the pertinent questions for education is how do we, as teachers, not place ourselves as unnecessary barriers to others' experiences?

So that class, for example, became an opportunity to talk about that.

In the last couple of years, we asked students to write case studies of other artists and then to contextualise how they saw themselves working in relation to them. They also had to do some kind of event, it didn't really matter what it was, they had to do something that wasn't geographically within the college, and that could be an exhibition or it could be a Zine. The idea was that their work had some kind of a public element to it.

So I suppose both of those things were about an idea of thinking about sustaining work and being quite open about what practice might be.

What do you hope that the Intermedia programme as a whole prepares students to go on and do?

Ultimately I am interested in students working as artists and making artwork. I understand that they need lots of different skills but also that this is what we are preparing students with. It seems to me that a good reason to go to art school is to be an artist. Now whether that is as an attractive a proposition now as it was to me in the early to mid '90s is a different question. And quite whether the mentality is the same of people graduating between then and now is another question which I think one should reflect on.

When I was at art school I wanted to be an artist. I moved back home after I had been at art school to carry on making artwork in my room at home. The parental home became the studio and I remember my mum saying, 'Can't you just do art as a hobby?' I was upset, and I think I felt like this because obviously art for me isn't a hobby, it is not something you do on the side, let's say. It is a job. But equally, the sort of climate we live in now is quite different and maybe we have a duty not to be so romantic as to say we just want students to be artists. I don't know how viable that is, which I guess is part of the quandry.

This was the background noise in my head when I was thinking about this idea of professionalism. I think whilst I do want people to be artists, I realise that a lot of them do lots of different things; so they will be setting up different sorts of initiatives on the side as well as many other things... but ultimately for me, I am a romantic and my interest really is on them being artists.

I've been thinking about a question that one of your students asked and I wanted to ask... do you do you think artists need to be in a metropolis to be successful? And related to that, what is the impact of being in Edinburgh?

I think if you had asked me that question a long time ago, it is probably one of the reasons why I went to art school in London. Now, I don't think this is as much the case today at all. I think one's reality of what it is to be an artist is to be made, just like one makes an artwork. I suppose when I went

to London to be a student I didn't consider this, but now I consider making the place, wherever that might be, central to the work of an artist.

Being in Edinburgh for students in that sense is quite particular. The art scene is small enough here to feel like you can participate fully and it's easy for people to integrate within it. The last thing I would want from Edinburgh would be that I became like a trampoline. You just go up and down on it, within it. It seems important for me that you need to go beyond it too.

One of the impacts of students studying at the art school in the University of Edinburgh is that there are more options for students to study beyond their disciplinary choice. Students in the School of Art will be given a choice to study a proportion of their credits outside their elected subject of art. 60 credits in first year will be a free choice for them. Of course, they can study art subjects if they choose, but also they will be able to study within the wider university.

One of the things that is certainly true about art-making is that you don't necessarily get better art from only looking at art. For me this initiative is part of this idea and is a motivation. This is one of the aspects of an art education we have been actively involved with. How is a mono-technic education altered within a university, and what are the different forms of artistic practice that can emerge?

Where are you from originally?

I'm from Manchester but I went to study at Chelsea College of Art and Design and that was an interesting time to be in London, you know, just at the tail-end of the YBAs and the big British Art Show in 1995, which was really the end of the YBAs wasn't it?

And then I moved back to Manchester. I have always found the centre not that interesting, whatever you want to call the 'centre'. It is not that interesting a place to be for an artist, personally. So a natural thing to say to students who ask that question is, of course it is possible to not move to a metropolis or a centre or whatever you want to call it.

Why?

Well on a personal note, I don't really find the company of artists that interesting in terms of thinking about other artwork. I really enjoyed being in college, and I enjoyed being with my friends and making artwork, and artists coming to speak to me about their work. When I left college, in my head I thought, 'I'll make a go of this.' So I got a studio. I think art is a stupid activity – at its best it should be serious, but the stupidity is really important. And I became really aware that over the other side of the wall was somebody else trying to do the same, stupid thing. And something about that was uncomfortable to me.

So as much as I like speaking to artists, I don't really like talking to them about my work. So one of the things we spoke about when we were thinking about if you need to move to the metropolis was about what you get for your work and what you can get from being alone… which I would argue is more vital, has more vitality to it, than what you get within company. So for me the high points of my artistic life have been on my own. For all of us, but thinking about artists in particular, loneliness is the lowest and highest point of our sentient life.

Equally there is something very attractive to not following another path but creating your own. I have always thought the kind of mad migration to the epicentre of the artistic world is odd because artists spend their life trying not to do this in terms of what they are trying to make. I suppose what we respond to in our work is different to the people producing a different way of thinking about something.

What is the art scene like in Edinburgh?

There is a history that predates my arrival here in Edinburgh in April 2007, but if you think about the Embassy Gallery which started 11 or 12 years ago, it is essentially a gallery started by students from the art school. I have seen a growth in this kind of activity. There has been more activity like that – Rhubaba would be a good example as it is an artist run gallery and also has studios, and it is much more of a commissioning agency. They are working very disparately in an interesting way, I would say, not purely

gallery-based work. And then even this year, third year undergraduate students organised an *Artist Moving Image Festival*, which took place at the Filmhouse cinema. So there seems to be a greater appetite of wanting to make something self-sustaining within the city. There is a movement towards a more cogent critical mass.

I think there has always been a migration towards other centres and that seems to be happening a little less now as people develop initiatives or camaraderie.

Do you encourage your graduates to stay in Edinburgh?

I don't know if I encourage them. I suppose it is about giving people options and there has been a focus over the last six or seven years on trying to explore options for them. I think it's been positive in that more people have stayed but that has not been my...

... agenda?

Not in a very particular way, no. Because it might be appropriate for them to go and live in a different city or go and live in a village, it is really up to them. And also I think the time is different. It would be wrong for me to present a model that is so one-directional. I think now there is a greater responsibility on students to really think for themselves of what is appropriate for them.

You said earlier that you want your students to go on to be artists.

Yes.

What is your definition of that?

I think one of the other things that appeals to artists about making artwork, is that there are so many different definitions. That is an important aspect, you know, contributing different definitions in a really fundamental way. Artists need to rethink what they are doing each day when they begin. If they are not bringing the periphery to the centre continually, I would start to worry.

Being an artist is about presenting a particular subject or example of subjectivity so that it can be discussed collectively, in the absence of the artist. That is the particular thing about it. But I also like thinking about what an artist is or what an artist could do and I think this originates in my interest in philosophy. So I am interested in questions, questioning things: that appeals to artists.

My original intention when I left post-compulsory education was to go to university and study philosophy. Something about the nature of philosophical questions interested me. I was interested in the type of question that was beyond the pragmatic, following the nonsense of questions. It was at this point that I encountered contemporary art and realised that philosophy, and its questions, could also be explored 'visibly' with encounters with artworks. I don't think this speculative spirit has left me, to be honest.

Yes, so for me an artist is someone who asks those sorts of questions, the questions that have a more philosophical bias. So as much as I know that it is good to be practical and how to build a wall and things like this, I was also interested in the, sort of, nonsensical aspects of that. I like very much the spirit of work in an artist like Andreas Slominski, where he builds a wall from the top down. I find the thought and experience of a work, how it can re-order us, invigorating. It refreshes me.

That is what artists do I suppose – they can offer a richer experience of what a life can be ultimately.

I was also thinking about what a fine art education is for...

Well again, it is part of the thing about professionalism – I think part of me withers away...

At the term?

At the term, because I can understand it, but equally... The American artist Richard Tuttle said a great thing, which is that he gets nourishment from his work, and that it's food for the soul. And I one hundred per cent know what he means by that. I have had real high points when I have been working on my own. But I think they are high points that extend into other

aspects of my life too. And the reason why I carry on making artwork is to keep looking for these high points… and part of my worry I suppose about professionalism, or the professional destination where people are going, is that it can mute some of these thought processes, I think.

I have taught for nearly 20 years this year and what I have seen, more so in the last ten years, is that students seem to be much more orientated to thinking about how you can make a living and how you can approach a gallery. They seem much more business orientated than they have been and I suppose much less focused on the more immaterial aspects of working as an artist.

Where do you think that comes from?

Well I imagine one of the things that it comes from is from people having to pay for education. I imagine also it comes from a more mercantile art world, you see that has happened, hasn't it? There has been a rise of that. I don't think I would be going to college if I was 18 now. I mean I don't think it would be open to me as a possibility.

Because of the finance you mean?

Yes, because of the finance. And I suppose that is always in the back of my mind. I do think that if you are paying for something and you are taking on debts, I guess it is reasonable to ask for some sort of remuneration for what you do.

The first exhibition I had, I never even thought about it… I mean, I thought galleries were interesting places where you could show what you had done. And it might sound really naïve and stupid but I never thought of making artwork as a process of making commodities for people to buy. I thought about it much more in the circumstance of experimentation, and… pursuing nonsense.

When I graduated you would go and sign on for two years, and that was people's postgraduate education. In your two years of getting not very much money, but enough money just to get by, that meant that you were free from thinking about what you might do in a commercial sense.

So I think potentially art changes. Art certainly changes because of the current climate but I think people's mind-set changes too.

It was free when you went to art school?

Yes, not only was it free but they gave me money. I had no fees and a maintenance grant. And lo and behold on the whole what I ended up making were not objects, they weren't object based. I was making very transient things. And I am not saying that doesn't happen now, of course it does, but maybe that is a riskier endeavour nowadays.

I think about the '80s for example, although I wasn't thinking about art back then, I was probably thinking about art school, but that was obviously a time with a deep conservatism in the art world, and maybe that is what we have experienced over the last ten years as well. And I suppose that is when education becomes interesting in that way because you don't really want the courses to be dovetailing into a commercial enterprise. Although I can understand that, I think art schools and universities have a greater responsibility than that.

What kind of responsibility?

I suppose to create a critical, wider, more open idea of what an artist could be. I like artists to be annoying and to be provocateurs, and that might be my romantic side again but I still think that is a good life for artists to live.

Do you get a lot of state school kids still coming in to art school?

Yes, we do. People still do go to art school from state schools, that is clear, that is really obvious. However, in the back of my head I worry about people like me. I would be classified as a widening participation student and I would imagine, instead of going to art school and higher education with very open eyes about what art could do for me as an intellectual pursuit, I think people go into it much more focused... which may be okay but I think it has changed people's mind-set.

It is funny, when I went to Chelsea in 1993 it was the first time I was a peer with students who had been privately educated, and I did recognise,

rightly or wrongly, that they had an advantage in how they had been taught. They were much better equipped for the more scholarly aspects of degree level education. At the same time Chelsea is such a salubrious location and there was something I enjoyed about that, about making art as a marginal activity in a place as commodified as Chelsea.

Who is an art education for?

Who is it for? I think my experience of being at art school, but also being a teacher – and I don't really like the phrase teacher, but being an artist who works in art schools – let's call it that, is that the people who have most benefitted have two sort of contrasting qualities. They are sort of punkish and revelling, and at the same time hardworking, and that doesn't exist in many people, I find. Art school is meant for them. It would be that weird contrast between wanting to smash things up and wanting to make things themselves, and to do that with diligence and hard work. That is a really rare quality, I think. But for me that is the best quality to be an artist.

Do you think there are people who might benefit from going into art school who don't because they don't know if it could suit them: because that whole thing about a lot of people still assuming that it is for people who can draw nicely?

Yes, I think quite a lot of times people do end up in the wrong place. For example, I was never interested in learning skills. I know a lot of people really want skills but I don't really know what skills people would want to know in terms of working as an artist. I could say reasonably categorically that any learnt skill is not going to help you advance artistically. I feel fairly secure in saying that, and that is quite often the most difficult thing for artists or students to understand. I think they come with a pre-sort of idea that they want to learn how to draw better and I wouldn't know what that was. I think I know what they mean by that but…

The other thing about art school, and I think this is really true, is what you can teach somebody in a transferable way is pretty inconsequential in the grand scheme of things. I suppose I am interested in art school being much more transformative than what education is currently seen as being.

Working as an artist is a long game, it is a life's work. And I think my experience of being at art school, it either changed me fundamentally or it made me realise better who I was. That kind of experience is transformative in a way that teaching someone a particular skill isn't. So I suppose I am saying that one seems a little bit more inconsequential in comparison to the other. I recognise from my education that it changed my life. That seems like a profound thing to say but its true and I would place more stock, if you like, with this kind of learning.

What do you think the role of the art school or a fine art education is in society?
The thing that I actually got from art school is still a thing I think we should aim for, whether anybody gets it or not, is the ability to dwell within and experience our conscious self. It is a point where I could work on my own, work on my own idiosyncrasies, and think about communicating through making artworks for other people. I think there is a healthy aspect to that too, in that it makes things better in a very broad sense. It is a healthy transaction. But the thing about is it good for society? Of course it is, but it has to come through the following of individuality and working on your own. Making art, however solitary, is ultimately an ameliorative act, and society underestimates how much it needs it.

That seems like a quite grand claim but I think it is a really important one, that aspect of being. I think art helps us to look more at ourselves and to dwell within, and to feel restored, and that is a really important function.

I think education has become technocratic. It has become quite functional, and art for me, as I have already alluded to, doesn't seem to have that. I am not saying it is the opposite, I am not saying it is dysfunctional, that is not what I am saying, but it has got a uselessness and somewhere it has got much more useful. Art schools seem particularly sensitive to the questions of how things can be taught, much more so in my opinion than in other subjects. Teaching art is part of the production of art and there seems to exist bigger scope to think about what teaching can be.

OPEN COLLEGE OF THE ARTS

Open College of the Arts (OCA) provides Higher Education online distance learning in art and design subjects. Its head offices are on the site of a former colliery in Barnsley, South Yorkshire and its tutors work from their homes or studios across the UK. In order to respond to our questions the following tutors spoke initially via Google Hangouts before using Google Docs: Jesse Alexander, Programme Leader for BA (Hons) Photography; Doug Burton, Programme Leader for BA (Hons) Creative Arts and BA (Hons) Drawing; Christian Lloyd, Programme Leader for BA (Hons) Visual Communication, Graphic Design and Illustration; Carla Rees, Programme Leader for BA (Hons) Music; and Caroline Wright, Programme Leader for BA (Hons) Painting, BA (Hons) Fine Art and MA Fine Art.

Can you tell us a bit about the history and philosophy of OCA?
Christian: OCA is an education charity that was established by Michael Young in 1987. His vision was to offer the general public the chance to take high quality arts courses via distance learning, without prior qualifications or restrictions. He saw the OCA as a means of transforming people's lives, giving them the opportunity and skills to express their creative talents under the guidance of professional artists. OCA maintains these values, and aims to widen access to creative arts education at undergraduate and

postgraduate levels through flexible supported open learning. Each year over 2000 students study with us part time. Courses have flexible start dates, a negotiated pace of study, and students only require an appropriate level of Standard English to enrol.

Who studies through OCA?

Christian: OCA students are largely based in the UK. 75% are aged 30 or above, half have an existing degree, 17% have disclosed a disability and many are self-funding. Courses can be studied from any location and do not require students to travel to attend classes – this is of particular relevance for those with mobility constraints, those who live in remote areas, those who need to work full time to support themselves, and those in custodial institutions.

In what way does the philosophy of OCA shape the curriculum of its courses?

Christian: All courses take into account students' access or lack of access to resources, the needs of students with disabilities, and different prior experiences of art and design. All students work from the same course material but the content, exercises and assignments are designed to introduce core ideas and competencies in ways that are supportive enough for those with little or no experience, and flexible enough to challenge others. The one-to-one relationship between students and tutors is critical in establishing the right level of study. If additional support is needed, it is available in the form of short videos and other resources, as well as course support advisors. Students also have access to their peers via forums.

Jesse: On the BA Photography course students are informed of the diversity of contemporary practice and the potential of photography to articulate a practitioner's 'personal voice'. Briefs encourage them to communicate their own critically informed point of view. Given the diversity of our students and the contrast to the demographics of a campus art college, it is fascinating to see our student responses that often draw on their immediate environment and situations. It is rewarding to witness the satisfaction that some students express when, often later in life, they

discover that they have an artistic voice that had been suppressed for many years for myriad reasons.

How do you deliver what are traditionally studio programmes online?

Christian: The idea of a local art school, where you met up with like-minded people was something I personally benefited from. This sense of the art school as creative hub has been well documented in terms of its relationship to the emergence of bands and other collaborations from the art school experience. On the surface, OCA looks like the antithesis of this set up. However, I feel there is something intrinsic in the motivation of OCA students that makes the experience close to the ideal art school experience. For the majority of OCA students I have worked with, there is a sense of self-generated enquiry, rooted in a desire to learn and to explore creativity in personally meaningful ways. These attitudes may be a reflection of the age of the students or a consequence of balancing part-time study with other commitments. The flexibility and timescale of OCA study, and the foregrounding of content and creative making over learning outcomes, may also have a part to play.

What particular challenges do distance learners face?

Christian: The challenge for students is to find ways to connect to one another. This has been partly facilitated by official student forums and the opportunity to meet up at regular one-off study visits, but has also been driven by students who have found their own ways to meet and swap notes.

Doug: The way students learn and connect with peers in order to create a sense of presence within an art school is a challenge, but it happens by using online resources such as blogs, forums and social networking. Tutors provide face-to-face online tutorials as well as written reports and so the relationship between tutor and student is very personalised even though the distances are vast. Students are encouraged to generate their lines of enquiry through accessing online materials as well as traditional resources, and also through their own geographical location.

Does the art school have any links with communities outside of its student population?

Jesse: The OCA has occasionally supported tutors' practice, through a Tutor Initiative Fund. This fund recently supported Andrew Conroy to lead a long term community project called *Street View*.[1] It allowed clients of the Cathedral Archer Project, a charity in Sheffield that supports those who are, or are at risk of being, homeless, to participate in a photography project and exhibition in the city. This project gave Cathedral Archer clients access to critical support, tuition, and an invaluable experience of creative collaboration. It provided a marginalised group of people with a creative outlet and an increased sense of their participation with, and value to, their community.

How do you prepare students for life after the course?

Caroline: At OCA, much of what might be called professional practice in a traditional face-to-face course, is in fact more about sustainability of practice, and what this means for an individual student. Many students are older and for them employability is something they no longer want or need. For others, perhaps living in an isolated location with a disability, continuing to make work is paramount. Through the course, a student is supported to find a path that is suitable, realistic and fulfils their own aims and objectives, be this working in the cultural industries, making critically rigorous work, showing work, or developing a socially engaged practice. The promotion of enquiry and curiosity, of debate and articulation of ideas, of awareness and understanding of context and development of innovative solutions to challenges, are all transferable and meaningful skills. These are equally as valuable in employment or on a personal level.

Jesse: The curriculum design of the BA Photography course has been responsive to developments within the medium of photography and the requirements of our students, rather than the shifting demands of the creative industries. That does not mean that transferable skills and employability are not embedded within the programme, but we are more preoccupied with facilitating students' development as practitioners, than preparing them for employment or freelance activity.

Christian: As a degree course at OCA takes on average six years to complete, many students establish their practices alongside their studies. This means the focus of any professional practice related content is about getting on and doing, rather than envisaging a future in which they become a practitioner. Our courses help prepare students to establish their own creative and professional networks wherever they are located, as well as offering a national and international network through their OCA peers and tutors. Many OCA students can be seen as sole practitioners, freelancers or portfolio workers in one way or another.

What do people do when they leave your course? What is a 'successful' graduate?

Jesse: I would say that many of the students who would possibly cite having a role as a professional, freelance photographer e.g. commercial/editorial practice as an objective for the completion of their degree, are in fact already working as a photographer when they enrol. They tend to use the degree to explore personal projects and expand their portfolio. Then through their studies, they often discover that there are far more interesting pathways to explore than being a 'jobbing' photographer alone.

Several of our photography graduates have gone on to postgraduate study, and others have chosen to exit the programme at earlier points to enrol on undergraduate study elsewhere. This might be after their first 40 credit module or, as per other HE institutions, exiting with a diploma or certificate in Higher Education with the requisite number of credits. While I think many institutions would regard their students exiting before the end of the entire degree programme as a negative, the OCA does not see it in this way. We welcome the fact that we are able to provide many students with a cost-effective and accessible experience of studying creative subjects at undergraduate level. OCA degree fees are roughly a third of those at mainstream Universities. Students can also study individual units without necessarily making the financial and personal commitment to a whole undergraduate programme.

As studying at a distance has certain challenges and can take a long time, we see the completion of each module as a success in its own right. In my

view, if a graduate is still making and continuing to progress his or her own photography and it is being shared with others, then that is a great success.

How do ideas of 'what's next' compare to your own experiences of art education?

Carla: The current funding climate for the arts means that salaried jobs are becoming more scarce, and those aiming to make a living through arts-based activities are more likely to engage in portfolio careers. These may encompass a broad range of activities including individual practice, teaching, or communicating about the arts in articles, blogs, and community based work. The rise in micro industry in recent years has also reflected this change of focus, and the flexibility of OCA study allows the student to develop their own individual practice with this in mind.

What do you think of as the role of the art school in society? What might its future look like?

Jesse: Although I am passionate about the traditional art school model, I am increasingly wondering whether alternative models should be explored. I would like to see more courses and opportunities for 'makers' to learn alongside those who don't necessarily make art but who are equally passionate about contextualising and communicating the arts, and having their contribution to the discourse recognised. Arts education should, genuinely, be for all and it has immeasurable benefits for society and the economy.

While I think that opportunities for intensive learning experiences and sharing one's practice with peers working in similar disciplines and media are invaluable, I also wonder whether such environments propagate a false sense of the arts operating in isolation from the rest of society and the economy. If creative subjects were taught alongside other disciplines, they might have a better chance of receiving the respect they justly deserve, for the challenges that they demand of their students and their value to society more broadly.

1. See: www.streetviewuk.me

LEWS CASTLE COLLEGE, UNIVERSITY OF THE HIGHLANDS AND ISLANDS

Dennis Magee is course leader and Michelle Letowska is a lecturer on the BA (Hons) Fine Art course at Lews Castle College's Taigh Chearsabhagh Campus, Lochmaddy. Lews Castle College is one of 13 colleges that make up the University of the Highlands and Islands (UHI). Years one and two of the four year BA (Hons) Fine Art course are taught at Lews Castle, after which point students have the option to leave with a Diploma of Higher Education or go on to complete the third and fourth year through Moray School of Art, Elgin. Students can do this either by moving to Elgin or via remote learning.

Can I ask how long you have been working here and what you did before?
Dennis: I have been teaching here since 2014. Before that I spent 29 years working in Australia with a long-term socially engaged art practice and teaching in both the university and vocational educational sector.

What took you to Australia?
Dennis: Well, it was the second term of Margaret Thatcher's Britain and I had to get out of the country!
[laughter]

And you Michelle?

Michelle: I started teaching here in 2012. Just before I took this job I was working freelance teaching art in schools and universities, and also doing socially engaged art projects. I went to Glasgow School of Art in my mid-20s, and before that I studied Politics and Philosophy at York University and worked in social policy research and arts development.

What led you into teaching?

Dennis: Through my practice I had been working on collaborative projects with landscape architects and urban designers and I was asked if I could come into the university and teach some art-based projects to the urban planning students. From there I started working in summer schools, and then Queensland College of Art.

Michelle: When I was at art school I did an elective course on art and education to give me a bit of experience in teaching in a supported context. The course helped us to design a project in a school and then mentored us through it.

How come you didn't study art first time around?

Michelle: I think, like a lot of people that I've met who come back to study art as mature students, including lots of our own, I felt it was the sort of thing that I could pursue in my own time. I felt like there were more important things that needed to be done before I did something that at the time I thought was so self-indulgent.

Do both of you still make your own work, and is that important to you if so?

Dennis: To me it is. I work part time three days a week and I wouldn't want to work any more than that. Because really, my art practice is of at least equal if not more importance in my life.

Michelle: I think for me it's proved really important. We teach practice-based process so unless you're doing that, it's really difficult to stay fresh with what that means, and to then have a dialogue with students about it.

Can you paint a picture of where the college is situated and what kind of building you are in?

Michelle: We are based in Lochmaddy, a port village on the island of North Uist, in the Outer Hebrides of Scotland. It's a remote, rural context with a population of about 300. The campus itself is part of an arts centre, which also functions as a post office, a museum, a café, and is a sort of social hub for the community.

Dennis: The campus is right on the water's edge. The main studio window faces north with views as far as the hills of Harris. Occasionally you'll find otters splashing outside the windows. It's really quite a beautiful location.

Who attends the course?

Dennis: In the past it's very much been people from the local area. But this year there seems to be a bit of a mix. We have a student from Denmark and a couple of English students. Most of the students who are local attend part time.

Michelle: The course really grew out of local demand. People in the community set up the Arts Centre and once that was set up, there was an art context and art happening and local people who wanted to be part of that. So they started delivering short courses and the BA evolved out of people who lived locally and couldn't travel but wanted to do a degree. The partnership with UHI and Lews Castle College was established and every year that the cohort of students got through one part of the course, they established it as a qualification so that they could effectively graduate. After about ten years the degree got validated.

Dennis: When they added on the two-year external third and fourth year option with Moray College, that enabled them then to develop the course up to an honours degree level.

How do those students who are not local find out about the course?

Michelle: It's quite hard to know! I think it's predominantly word of mouth, because our institution has really limited resources. Our formal marketing is pretty limited and low key.

Dennis: Quite often people will just come across us almost by accident. They will be visiting the Island as tourists and will come at a time where we're having an open day or an exhibition.

Are you really keen to get people from other places to come?
Dennis: Yes. Well, as much as we can.

How many people attend the course?
Michelle: Less than ten in each year. Actually our local participation is on the decline because most of the people on the island that want to do the course, have already done so! Young people on the island who come out of school, will maybe come and do a National Certificate (NC)[1] or foundation year but then they want to get off the island and go to another city. So even if there are students that want to do art, they generally tend to leave us by the time they're 17.

Dennis: Or they might want to do other creative industry courses rather than fine art. I get the feeling that it's quite often driven by the desire for some sort of employment.

So are there more mature students on the course?
Dennis: The age range is from 18 to 66 at the moment. About half are school-leavers and then there are retirees and those who have always wanted to dabble in art in some way. And because the NC has no minimum entry requirement, quite often people come and do this as a kind of taste test, then make a decision to continue on and participate in the honours degree course. We often get quite highly qualified people on the course, who have had fairly successful careers, from wing commanders, to bank managers, to architects – all sorts of people. That feeds the course in an interesting way but it also sets its own challenges. It's interesting to see how the school leavers react to working with more mature students. I guess some of the older students give support to the younger ones who are maybe struggling a bit. It makes for a very interesting kind of peer structure.

Michelle: The community and the remoteness create a really specific social context that the art school and the student body can't not be part of. All the students are really pushed together. It's not like in a big institution in a big city where they can just drop in and out, come in for lessons and then go out and have their own social life. Because of the geographical and social remoteness, and the fact that there's only a few hundred people, all those relationships between the students, and between the students and the community, become super important. They need to make their own community and make a real effort to be part of it, otherwise it can be quite an isolating experience, especially in the winter and with the extreme weather because there will be times where you are quite literally stuck out here. It becomes about survival!

[laughter]

Wow.

Michelle: So it's a really unique environment. I think there are lots of students whom it wouldn't suit, and we do have students who come and try it out and it's not for them. But then it does attract these really interesting, quite strong people who like the fact that the community is such an integral part of everyday life, and like the fact that everybody knows who they are, and looks out for them, and is interested in them. And I guess it was the same for us. We came out here for our jobs and you become part of something that you wouldn't have the opportunity to be part of in a bigger context.

Dennis: Another thing worth mentioning is that we have a lot more females. This year there are no males on the course. I think last year there was one. I don't know if that's part of a national trend. I know in Australia there's certainly a majority of students that are female.

Michelle: So students really make the course what it is. We have this studio pedagogy and whoever turns up in each year group really defines the experience for all the other students. That probably happens in a lot of other institutions too, but I think it's magnified within our context. If you have a bunch of students who are really enthusiastic and have formed

good social bonds with each other, that will impact on the way the course runs and what they get out of it. The scale also means that we can be quite flexible in the way that we teach. I often consult the students about what we do, and whether and where we work on location.

So are you thinking about the type of student who'd fit this unique environment when you're interviewing students? Do you interview students when they apply?
Michelle: We do, but we're definitely not a selective institution.
Dennis: We're a recruiting institution!
[laughter]
Michelle: I think that's a really important social function. We're able to take on students who might not be taken on by other institutions for whatever reasons. That creates its own problems, and I guess it's a bit utopian, but it feels like quite a good service that we're providing: to be able to allow students who maybe haven't had the time to develop the skills or the sophisticated ways of thinking that other art schools would require at entry level. And there's a lot of support for students who would very easily get lost in a big institution, students who've got maybe emotional needs or psychological needs or educational needs. The nature of the campus community means that students and staff share more time together.

Can you outline the structure and philosophy of the BA course?
Dennis: Well it's a modular course and in terms of the philosophy I guess we're talking about a studio based pedagogy. The philosophy is influenced by things like the student numbers and the fact that we have a strong working group and cohort. The critical, contextual and theory side of the programme is shared through video conferencing across campuses.
Michelle: It's hard in a way to have a unified course philosophy because it's taught across more than one institution. But we are very responsive to working with what the environment can offer. It's quite a unique ecology, archaeology and history, and I think to some extent we do push that in the day-to-day teaching. I mean, it's part of the reason why

we choose to live there. And I think the joy or the excitement we get from living in a place like that does extend to the students.

Most art schools have metropolitan contexts and we do something quite different. Because of our remote location and the fact that art resources are so limited, we can't just send students out to the national galleries, and so we emphasise that the environment is the context for the course. Everything is built around that.

So what is your relationship to the wider art world? Are you in dialogue with that?

Michelle: Yeah, definitely. We're based in an arts centre that's got an arts curator, and that brings art to us. That's a fundamental part of how we can operate without being seen as parochial or reactionary. We are able to keep in touch with the contemporary art world through that.

Dennis: There are a lot of visiting artists, mainly Scottish artists but we also have international artists. There is a very active exhibition and artist's residency program in the arts centre where we are based and most of the visiting artists are happy to talk to and interact with the students.

Michelle: We also encourage students as part of a requirement of the course to visit different galleries and to draw on that experience as much as possible. But I think we've got a nice critical distance from the art world and students don't feel like they have to be part of it, it's not overwhelming. There are artists working in the local context who have a real diversity of practices that the students can meet, talk to, find out about, that represent not just what's going on in contemporary art or the art market but other sorts of practices which maybe aren't quite as fashionable. And they can also play with how art fits with crafts because that's a strong local theme – textiles, ceramics and so on. So those hierarchies can be challenged in this context.

So do you offer anything in terms of professional practice, if you even use that term? How do you prepare students for life after the course?

Dennis: Professional practice is part of the course structure during years two and three and is a 20 credit module. Then there is also the

potential for them to engage with projects that are running through the Arts Centre as well. During Fresher's week students are also encouraged to join the Uist Artist's Association, which is a fairly active artist group. That gives them an opportunity to exhibit and to sell work, and to think about how to curate an exhibition.

So what is involved in the professional practice modules?
Michelle: I run it in year two as a weekly session. It's very much about encouraging students to engage their critical skills, so reflecting on their own and other artists' practices, presenting skills, thinking about how they could present their own work, other people's work. At the end of the course they are expected to pilot a small project, and they can direct that however they want. For example, it could be a small show, it could be a public art project, it could be some sort of community art project, or working in a school, and we, the staff, support them with that. So it's mentored a little bit like the art education project I did when I was a student but with a wider scope and more autonomy.

The content of any professional practice modules are shaped by the individual staff member who is teaching the course at that time. I think colleagues of ours at Moray currently teach it in a way that's much more about the business and marketing of the individual student as artists. We do also get a lot of mature students who are really savvy and don't expect to make a living, and they're not interested in promoting their individual artistic identity. They're interested in doing something different. So it might be more useful for them to reflect on artist run spaces or guerrilla projects or whatever it might be.

Dennis: But I think because they are with us for two years and then they go off to Moray, we're not really thinking so much about what would happen when they graduate.

Michelle: I think they get quite a different experience when they go to Moray where they would be working towards their degree show and maybe thinking beyond that. I could be wrong, but I get the sense that there's an emphasis there on continuing to work as an artist beyond degree show, but I

think that's quite an idealistic aim. I think we're in quite a fortunate position here because we don't have to think about that so much, but we also get a lot of students who aren't expecting to go and do that either. They seem to understand that it's not very realistic to expect to be picked up by a gallery and to become a global artist when you finish your course. They're here for other reasons. And I think they, and we, probably understand what it means to be an artist in a different sort of way.

Dennis: There are strong musical and poetic traditions on the Island and I think people see an intrinsic value in someone who isn't working or doesn't have a traditional job. The poets, the bards, the writers, the people who write the songs and make the music, it's seen as a very important part of that culture. And there's a sort of broadness to that. I do think that permeates our thinking there. What do you think about that?

Michelle: I don't know. I think it's complicated because I guess on North Uist there's quite a Calvinist work ethic and I think there's probably quite a lot of people who see it as an even more decadent thing.

Dennis: Do they? [laughs] I obviously haven't tuned into that!

Michelle: I've definitely had that with a few students who are local who have got kids, businesses, all the rest of it, and they feel like there's external pressure to not be doing the course because it's just something silly and where's it going to get you? It's also manifested in the pressure some of the students feel in terms of the sort of work they produce for public exhibitions; they're thinking about what their community is going to like. I've often heard mature students saying 'Oh, my husband would hate this'.

So do you think the community engages with the kind of art that people make on the course?

Michelle: There is a local art audience, but I think that even if in the wider community people don't understand or aren't interested in what is being made or done in the College, there is an appreciation of the fact that it is a bit of a lifeline for the local area. Without the College, without the building, without the students, then the community would be a different place. It brings a lot in terms of people, resources and money.

Do you think a BA in Fine Art is a vocational or academic course? Can it be both?

Dennis: In Australia it's a very clear division between the vocational sector and the academic sector. The vocational sector is very practical, very much about preparing people with a set of skills for work in the creative industries, whereas the degree courses tend to be more academically focused.

Michelle: I suppose both of those concepts depend on the context: what is the vocational context? What would the work be for an artist? I think to describe it as a vocational course in relation to a specific trade or job wouldn't be realistic. For me it's not about teaching somebody to be an artist, like a course might teach someone to be a plumber or joiner, but it's a desire to develop skills that they can take into other contexts. So basic, fundamental, practical making skills, like drawing, making, painting, sculpture, fabrication, video editing, and darkroom photography – and then more ephemeral skills like project development, process thinking, collaboration, reflection, self-motivated studio practice, and working within a community of practitioners.

Dennis: It isn't like a hard-core vocational programme where they end up with a specific job role. There's a broad set of skills that would take them through, potentially, into some future role. I guess there has to be an academic component to the course, such as the dissertation, for those people who want to pursue further academic study or go into teaching, for example. It's important that it does have that academic role.

Michelle: So it's not about preparing people for a trade or a profession. I feel like it's really about an ethical consideration, just being better people through doing it and feeling more like themselves. It's like a process of human development.

Dennis: I think that's really important, that it's a growth experience, that they actually gain something as individuals no matter whether they're a retiree or an 18 year old. It might be building up a greater sense of confidence in what they can do as a young person and reflecting upon it, more than a job outcome. It's about letting them see what the possibilities are.

Michelle: I think that if we can do anything, it should be to open their eyes up to the reality, if they don't already realise, that being an artist, being recognised as an artist by the market, doesn't really have anything to do with their own individual creativity or potential as creative people. It's much more to do with wider socioeconomic considerations, and they can still enjoy being an artist in lots of different contexts.

Do most of the graduates of the course stay local or do they go elsewhere?

Dennis: I think really it's a very individual thing. I've got two first years, one from England and one from Denmark, who are already asking me where they can stay for the next four years on the Island. They are interested in what the place offers on a long term basis.

You described earlier some of the skills you hope people gain. Do you think students are aware of these before, during and after arts school?

Michelle: Your question makes me think about how hard it is to explain to a student what they're going to learn, because in my experience of having been a student and my experience of having worked with students at different stages, I don't think you really know what you learn at art school straight away – if at all, if ever. Sometimes it can take a really long time to really understand what you've learnt.

I was talking about how I think we emphasise skills and material making in a way that a lot of other courses maybe don't. However I've noticed that there is a balance required at this level of study between teaching making skills and encouraging students to understand that any skill requires practice and an active engagement in making, not a passive banking model whereby students think they'll learn through demonstrations and workshops alone. I think there's a need for students to understand what the skills are and how they'll learn them, to acknowledge that a lot of what they'll learn won't be through those sessions that you're teaching, it'll be through conversations that they have with their peers and the work that they'll do independently.

When I first started teaching, I thought I could give students all the things that I wanted out of art school and never got. I then realised that

you can't teach students in a few months the things that took you ten years to learn! They are their own people and what I needed may not be what they need. I think when I was at art school, I felt like there were these mysteries that nobody ever explained to me. It wasn't until five years out of art school that I really understood what was actually going on: this subtext of taste, personal relationships or personality that was affecting how work was received or who was successful or who was popular, or what we were supposed to be making and thinking. There were all these mysteries, and I think I tried to compensate for that in my early teaching by getting all these issues out on the table from the start. In actuality that was too much to deal with for a lot of the students.

Dennis: The other thing that is always a difficulty, is the fact that we have these modules that have stated outcomes on which we assess students. Because of this, students think of learning as a very linear process, 'You'll start here and then you'll end up here' and about being able to meet a particular criteria or outcome. I mean, just by being in that context, work- ing in that environment with those group of people that you'd probably never have otherwise met or worked with – that is as much a part of the learning experience. Whatever programme happens to be on at the arts centre, all those kinds of things impact upon it too. It's not just about what we can teach and it's very hard to say, 'This is what you will learn'. They're all different people with different experiences.

Michelle: I think on the one hand it's really easy to explain what the criteria are, but then on the other hand…

Dennis: It's relating those criteria to their learning. In a way I find that's always been difficult. I think for them it can be confusing.

Michelle: We all get really caught up in evidence and what things look like because that's how we assess. That's in complete tension with what we're trying to teach, which is much more about internal develop- ment. There is then the whole range of issues to do with taste and personal position, and politics, and all these things that come into assessment and into work. I think we're probably quite good at opening up conversa- tions with students about those things, but we still have to go into the

assessment room and assess on criteria that can't ever be clear enough to assess artwork.

Who writes the criteria?

Dennis: The Curriculum Development Group at the Institution.

Michelle: It uses really difficult to define, subjective terms like 'excellence'.

Dennis: I think there are six levels of excellence or something.

Michelle: We do talk to students about the issues around that, but when we go to the exam board and we talk about these things with the external examiners, it just highlights how subjective and opaque the whole thing is.

Do you know what people from your course are going on to do? Are there particular jobs they go on and do, or are they practicing as artists full time?

Dennis: It's a mix. I think what's interesting is there's quite a broad range of environmental and archaeological activities that are happening on the Island, and people are seeing opportunities to explore that in relation to some sort of creative industry outcome. I was looking at research groups in places like, I think it was Aberdeen or Dundee, where one of the main research topics is art on the farm. There's a change in culture within the potential of how artists can engage, and I think there is a lot of potential for development for people from creative backgrounds. One of the things I'd like to see happen in the future is for some of the local industries to adopt artist in residence programmes so we can work with them in some way in a bigger context.

What do you think about the term 'creative industries'? It's a term that has been used quite a lot by art schools when recruiting graduates, particularly those from lower income backgrounds.

Dennis: I don't like it. We are a member of the Creative Industries group.

In Australia I had real difficulties when it came to the term creative industries because to me it seemed like they were lumping a really disparate

group of industries together. In a way it justified creativity as being something that you could relate to economically rational outcomes. In Australia it included things like the publishing and film industry. With publishing, it ended up including all magazines, and newspapers, and the Murdoch empire, and things like this. I haven't quite worked out how it's defined here, but within the University it includes design, music, fine art and film, and TV is about to develop.

Michelle: It's a New Labour term, isn't it? I've always been really cynical about the way that it's tried to quantify creativity and justify funding for creative pursuits. But then in a purely pragmatic way, if we understand ourselves within that wider, political, economic context, then it's a bit of a lifeline for us within the UHI.

How so?

Michelle: The Creative Industries group within the UHI is trying to bring together all these creative disciplines and get them some recognition, because so far, the UHI has been very science based in terms of the Research Excellence Framework and funding – focusing on things like wind energy and archaeology. These are the big subjects and disciplines within the UHI that get recognition and funding, and I think that the Creative Industries network is a way of trying to acknowledge what we do, and maybe develop what we do with careers and postgraduate trajectories. In a way we're able to live in this utopian Highland bubble, allowing the students to roam around making lovely work about the islands and this rural idyll, without having to take responsibility for how they got there, how they're paying for it, who they are in terms of their social class, and where they're going to go when they're finished.

We all live within a particular socioeconomic and historical context, and wider issues affect everything we do. It's quite easy to fall into being cynical about that term, but it might help us do better for the people who come to us as students.

Dennis: I do think it will benefit students to be part of a greater network and maybe give them more postgraduate opportunities, but I don't promote

the idea that people will come and do creative industries training and get a job, or be working towards getting employment in the creative industries. I don't really subscribe to that concept.

Michelle: But they will have to get a job at the end of it.

Dennis: It's how the creative industries people can move and work with other industries as well and the kind of lobby that they might have. It probably gives us a stronger lobby than just working as fine artists.

What and who do you think a fine art education is for, and what do you see as its role in society?

Michelle: I think art education, like all education to a certain extent, is about human development in some way. I have seen lots of different people flourish in lots of interesting ways through the space that art making and education provide.

Dennis: I think it's very important in any society to have groups that are continually challenging society, continually challenging politics, continually reflecting upon what's accepted and what should be accepted. I think art schools have always played a really important role.

Michelle: I think maybe in theory, but I think in terms of what they produce, it's often pretty reactionary.

Dennis: Well to some extent now, but if you go back to perhaps the traditional role...

Michelle: Back in your day?

Dennis: Back in my day.

[laughter]

Dennis: I was a little bit past that time. One of the great justifications I heard for art schools was that without art schools you wouldn't have *The Who*, you wouldn't have the *Rolling Stones*, you wouldn't have *The Kinks*, because all these people came out of art school.

Michelle: They are millionaires.

Dennis: They are now... although Keith Richard refused his knighthood. You're right though, I mean it is interesting how these people do become part of the establishment.

Michelle: It's a bit of a game, isn't it really? It's a public school – historically, I guess when you were at art school there were grants.

Dennis: It was different, yes.

Michelle: I'm not sure, but I am guessing that that would have affected the demographic slightly, but it still would have always been, and even more so now, a pretty privileged situation to find yourself in, even entertaining the idea of going to art school.

Dennis: It was wonderfully privileged. When I went to art school in the '70s up till the early '80s, you did get grants, you did get funding, you did get all your materials provided for, and there was a very broad range of people. It wasn't a middle class demographic. It may have changed since then, but in Scotland it's somewhat different and remains a broad range, don't you think?

Michelle: I think it depends on the institution doesn't it? I think some of them are probably just as elitist as Oxbridge in terms of who attends. You were talking about society needing groups of individuals who can be critical of it, and I think, if you're talking about what the art school could do or could be, I would be more interested in models that try to… It depends how you understand creativity. If you understand creativity as a fundamental human need, and something that everybody needs and has the potential to be, then you've got the opportunity to have an art school that doesn't really look how an art school does now.

I suppose there are those two sides to it. On the one hand, I do really feel like the skills, the material making, craft making, is a really important part of what it is to be human. I think that's a tool through which you can gain that understanding of what is going on in the world, a criticality. But there are lots of people who aren't interested in those aspects. If you could re-envisage an art school it could effectively work for all sorts of different echelons of society, to give all sorts of different people the opportunity to engage in not just making, but critical thinking, conversation, dialogue, collaboration, participation in things…

Dennis: I would agree with that. I was talking about it in terms of what fine art is, being something quite different in terms of that economic model

of creative industries. I think there's a really important role that maybe it isn't in the current structure of institutions. It would be a good opportunity to be a little bit freer in what we could offer nowadays.

Michelle: Definitely. I feel like we're really lucky where we are, in a way because we operate on the periphery, not just geographically, but in terms of the art world and in terms of the University. I feel like what we're able to offer is participation to people who wouldn't necessarily be part of the centre, people who wouldn't necessarily be able to or want to participate in a more mainstream context in art, and there is the time, the space, the support and the ethic of care to allow them to flourish.

I'm not trying to be too utopian about the socioeconomic groups we attract and we still predominantly attract students for whom the possibility of going to university or the idea of going to art school isn't a million miles away; that's why they're there. Does our institution do much in terms of widening participation and access? Not to my knowledge.

Dennis: I can't see that it really does. I mean it's one of the things it stated in the mission statement. It may well in other programmes.

How does teaching in an art school sit within your personal ethics if it's not more open as you describe?

Dennis: The great fear I have for art schools is that they could become like finishing schools. With the fees it could fall into a situation where people who are from more working class backgrounds might choose courses that have employment outcomes, whereas people who have more disposable income may have an option of a choice. As a reaction to this though, a new type of art institution might emerge, something like working persons' colleges or colleges for life-long learning.

Michelle: How does anyone change anything? Our roles might not be particularly radical, but I know that studying art was a life changing experience for me and I remember the teachers I encountered along the way. I hope I can contribute something to enable others to have the same opportunity.

It feels like a real privilege to be able to have this sort of meaningful work. I feel a responsibility – whether I enact it is another thing – to bring

an ethic of care into all the relationships within the institution, but also to act beyond it as well. You can't expect to change society just within the confines of the art school; I think we have to acknowledge ourselves as operators in lots of different sorts of contexts, politically and socially. The longer I'm in this job, the more I realise I have particular political views about things. What I think that we should be doing as an institution and what I think the students should be doing as individuals, as a collective, as a group of people, it's often radically different to what they think. I suppose what they think they're here to do may well change over the time that they're here. I'm sure it did for me. I mean, I left working in social research because I was completely frustrated, and burnt out, and disappointed, at how little I could achieve, and I decided that I just needed to look after myself a bit and do something good for me. I then realised that actually everywhere that you go you operate politically.

Dennis: I think to me though, just thinking about when I was teaching in the western suburbs of Brisbane, it had the highest number of detention centres and there was something like 30 different cultural groups in that area. Even just having someone being willing to shift from holding a really racist view of an aboriginal culture to broaden their outlook, in some way felt like an achievement. It's actually just letting people see that there is a different way of looking at things – that can be a great achievement. It's not necessarily about having a revolution and changing things quickly. But moving from putting endless racist comments on a Facebook page to actually being excited about an indigenous artist's work is quite an achievement.

Michelle: Despite the many challenges, it feels rewarding to work in a context where you can try to do some of the things that you think art school is there to do, whatever scale it is on. It's life changing. I mean it was life changing for me and I think it's life changing for a lot of students that we work with. It's really empowering in lots of ways.

1. A National Certificate in Art and Design is a qualification that sits at level 5 in the Scottish Qualifications Framework and is a group award offered across numerous sites at FE level in Scotland. At the Taigh Chearsabhagh Campus of Lews Castle College it is taught over two semesters in studios adjacent to where the BA students work. Many students who graduate from the programme use it as a way to build their portfolio for entry into HE course at UHI and other colleges.

UNIVERSITY OF SALFORD

Brendan Fletcher is programme leader for BA (Hons) Visual Arts at the University of Salford. Brendan provided a written response to our questions.

Please can you give us a description of the area in which the Visual Arts Programme is located?

We are sited on the main University of Salford campus on Salford Crescent, the city's main artery and home to its Cathedral, Salford Museum & Art Gallery, the Working Class Movement Library and The Crescent public house, reputedly the watering hole for Marx and Engels.

Salford sits side-by-side with its 'noisy neighbour' Manchester. It's a post-industrial city that is reinventing itself. Salford Quays is home to the largest hub of digital and creative industry professionals outside London; it is home to the BBC, ITV, the University of Salford, the Lowry Theatre and Gallery, and countless media start-ups. Around Salford Crescent another cultural space is emerging that's home to Islington Mill, Hot Bed Press, Suite Studios, Artwork Atelier, and The International 3.

It struck me after reading John Beck and Matthew Cornford's splendid polemic, *The Art School and the Culture Shed*[1] that despite their contiguity, Salford and Manchester have different approaches to culture. Salford is rebuilding. It is earning a reputation as a city in which artists can live and work. It is home to studios and 'makers'. Manchester retained its historic art school and, perhaps because of this, the civic focus has shifted onto the 'culture shed'[2] and the exhibition and reception of art. Between the two cities there is a vibrancy that brings dividends to both.

Visual Arts is about to move into a new £55-million-pound home, The New Adelphi Building, as part of a major investment in a new campus. This will be another space for making. It's an exciting time.

What relationship, if any, has the art school and the Visual Arts programme had to the local community over time?

The School of Arts and Media, in which the Visual Arts programme is embedded, evolved from the Royal Technical College, Salford, at the end of the 19ᵗʰ century. Following various incarnations, including the Salford College of Technology, it became a part of the University of Salford. It fed the community with vital technical education and industrial training that underpinned Salford's economy. The programme has inherited that bond with the community and with it the commitment to contribute to its cultural economy. The University of Salford is currently setting up Industry Collaboration Zones (ICZ's) and working with industry partners to develop closer and mutually beneficial relationships with the university.[3]

The Visual Arts programme has close contacts with local schools and colleges in Salford and Greater Manchester. A number of staff and students have over the years worked with community groups and housing associations. It's an ongoing and evolving relationship. We draw a large number of students from the city and the region so it's just part of what we do. We have also developed a close working relationship with the Haworth Charitable Trust, which supports artists, musicians and organisations. The trust currently funds a life drawing class, an exhibition, and a travel bursary for the School of Arts and Media, which is led and hosted by the Visual Arts programme.

How many students are on the programme, and what's the demographic?

We have 105 students, roughly 35 per level. As programme leader I know the name of every student. I know their needs and ambitions. It's a size that helps create a 'community of learning'. The University of Salford is a recruiting university. We draw a large proportion from the Greater Manchester region and the North West. We also recruit EU students and international students. We currently have students from across the world including: Afghanistan, Cambodia, China, Nigeria, New Zealand, Poland, Portugal, Romania, Russia, Spain, Norway and the United States as well as from all the nations of the British Isles.

We are a Widening Participation (WP) institution and the demographic of the programme reflects our commitment to WP. The students' ages range from 18–65. The gender make up is around 70% female, 28% male, and 2% identify as agender.

Can you tell us a bit about the history and philosophy of the programme and anything that shapes its curriculum?

It's almost 25 years since the BA (Hons) Visual Arts Fine Art programme opened its doors. The first cohort graduated in 1995. It's a young programme unburdened by history or tradition. It was originally called Visual Arts and Culture and was set up and led by Tim Dunbar. The programme embraced an inter-disciplinary approach to practice from the outset, integrated theory and practice holistically (all taught by the one team) and sought to inculcate an internationalism that looked to and beyond Europe.

The old subject-specific hierarchies were rejected – painting's place as the de facto 'aristocratic' practice is no more – and students can explore painting, sculpture, print, film/video, installation, fibre/textile, sound art, book works, art as social practice/community engagement and more. The programme has always been keen to stress that art is an activity that takes place in a social and cultural context. We're also keen to offer students the opportunity to engage and benefit from 'real-world' experience. This 'real-world' experience can take many forms from exhibitions and art fairs to community events.

What are you preparing people to go on and do?

The course prepares students to become artists. However, we would be failing in our duty if we ran a programme that expected each and every student to become an artist. Many of our students graduate and become professional artists, and many others build careers as lecturers, curators, arts administrators, arts consultants, teachers, art therapists, and self-employed creative practitioners. I believe strongly that a fine art education is a portal through which students gain access to a world beyond – it opens

up students' intellectual curiosity. Following graduation, they don't seek a career 'off the peg'; they forge a career of their own.

How do you prepare students for life after art school? Do you teach 'professional practice' specifically?

We think it is important that the students are not sealed in an academic bubble and insulated from the real world. We're keen for students to gain experience of professional practice from the moment they arrive but I think we need to take care with our definition of 'professional practice'. Painting in the studio can constitute training in professional practice. There are however modules that tackle professional development.

There are two modules in level 5, Professional Context 1 & 2, that concern models of practice which explore the myriad of ways in which artists establish a career. The student can elect to choose the model of practice that best suits their career aspirations. The modules prepare students to take part in a 'live brief' module that offers opportunities to work on a project, exhibition or placement with a partner. So this might involve organising and curating an exhibition, a formal school or college placement, a site-specific project, or a curatorial opportunity in a gallery. In recent years we have worked closely with the Castlefield Art Gallery, Manchester (New Art Space at Federation House); Artwork Atelier, Salford; John Rylands Library, Manchester; The Class of '92, Manchester; Littoral Arts Trust, Cumbria; Flat Time House, London; Arts Council England, Manchester; Hot Bed Press, Salford; Object A Gallery, Manchester; The Double Negative, Liverpool; as well as numerous schools and colleges in Greater Manchester to offer teaching opportunities. And we continue to build relationships with other agencies.

There is also a level 6 module that prepares students for life after art school – the preparation of a professional portfolio, digital identity, personal development planning, CVs and interview training – with support from the Arts Council England amongst other partners. All this professional development produces assessable outcomes.

We encourage students to take up a wide range of extra-curricular projects and they have worked on projects that support professional

practice and development. Students have worked with the Class of '92 on a commercial project for Hotel Football and more experimental projects such as working with Walk the Plank theatre group on live events, to name check just a few.

What do people do when they leave your course? What is a 'successful' graduate in your opinion?

Graduates go on to work in a myriad of careers. We have produced some first rate artists who have built careers on the national and international stage, represented by galleries and dealers. Many students go on to further study on postgraduate programmes. Visual arts has provided many of the art lecturers and art teachers in universities and schools across the region. Our graduates occupy senior positions in galleries and arts institutions including Arts Council England. We don't prioritise any route. We support students to achieve their ambitions and we do, of course, do our utmost to raise them.

I think a successful graduate is any graduate who understands the value of the transferrable skills they have developed over the years, and how they can continue to enrich their lives.

How do expectations and ideas of 'what's next' compare to your own experiences of art education?

I entered art education over 30 years ago. I had little awareness of the structure of the taught programme, little awareness of intended learning outcomes, and little awareness of the assessment criteria by which my work was assessed. Much of the teaching appeared to depend upon a 'mentoring' approach. But it worked.

I don't remember any preparation for life after art school. I spent three years concentrating my time and energy on the activity of painting. I was supported by some fantastic tutors who had the time to teach and to pursue their own practice. It was a terrific time – I had a ball. I'm not sure I was prepared for what came next. I had to learn how to adapt when I graduated.

However, there has been an ideological shift in recent years. We wanted to learn for its own sake. Today there is a much greater emphasis on careers and employability and it has to be negotiated. We must prepare our students for 'what's next'.

What and who is a fine art education for today?

I remember when I was a foundation student in the mid-1980s, I came across an article in the Observer Sunday supplement. It was titled *Educating Arty*. Like all good art students, I cut and pasted it in a sketchbook and I have it still. In the supplement, your question was posed to a number of artists and interested parties. Patrick Caulfield answered, 'Art schools used to provide an alternative education for people like me who didn't know what they could do. Now they are trying to make them respectable. That's not what it's about. They are an extraordinary luxury, but they must be protected.' I can't think of a better answer. So little really changes.

The artist, musician and raconteur George Melly claimed, 'Arts schools used to be lovely, subversive, frivolous and serious places. Now they are for training the makers of plastic telephones'. In a pre-digital age, little did he know that Jonathan Ive et al would go on to inherit the earth.[4] So much changes.

What do you think of as the role of the art school in society?

I'll draw more inspiration from the same article. The artist Richard Hamilton offered, 'Art schools should be seen as places where civilised behaviour can be taught better than anywhere else'.

1. Beck, J; Cornford, M. (2014). *The Art School and The Culture Shed*. The Centre for Useless Splendour, Kingston University. London.

2. Beck & Cornford use the term 'culture shed' to highlight the emergence of a new kind of 'destination' art gallery in Tony Blair's '90s Britain that served a purpose of urban regeneration in designated 'cultural quarters'.

3. The ICZ strategy aims to create cultural, physical and virtual environments within which staff, students and industry partners can collaborate, innovate and learn from one another.

4. Jonathan Ive is the Chief Design Officer for Apple Inc. He is responsible for the design of the iPhone.

PARTNER INTERVIEWS

THE GLASGOW
SCHOOL OF ART

Dr Alistair Payne is Head of the School of Fine Art at The Glasgow School of Art, a role he has held since September 2012. We spoke in his office in the Tontine Building.

What courses exist in the fine art programme at undergraduate level?

There is one undergraduate BA (Hons) Fine Art programme with three Departments in the School of Fine Art, the Departments are: Painting and Printmaking, Sculpture & Environmental Art and Fine Art Photography. We have about 500 students in total studying across the four years of this programme.

Where do you recruit students from?

Just over half of our overall intake is Scots/EU, about a third are from the rest of the UK (RUK), and the remainder are international students. It's a very interesting question actually because there has been a reduction in funded places across Scotland. The Scottish Government used to fund all Home/EU places including those from England, however the Government has now reduced funded places with the introduction of fees in England and those students became what is now termed RUK.

There's a cross party discussion on culture next week that's starting to look at the problems of art education across Scotland, what it means for Scottish students trying to study in Scottish institutions, and how that moves forward.

Can you say a bit about where fine art at GSA is located?

The Garnethill Campus, the Mackintosh Building, housed the School of Fine Art up until the fire on the 24th of May 2014. It's arguably the most renowned building in Glasgow, and was very much renowned for holding the School of Fine Art. After the fire we had to look for a new

building. We moved the whole of Painting and Printmaking, the Master of Research in Creative Practices, the Master of Letters in Curatorial Practice (Contemporary Art), and some of the Master of Letters in Fine Art Practice, to the Tontine Building in Glasgow Cross which is on the corner of Trongate and the High Street. When we moved we had to construct a building within a building; we had to construct studios, offices, a lecture theatre, and crit rooms for 300 students and 30 staff.

I think by moving into the Trongate area,[1] we have raised the number of artists working within a four block radius to over 800, with other institutions like Wasps Studios and the Briggait.[2] There is also the Modern Institute Gallery over the road, Transmission Gallery, Mary Mary Gallery, and a number of other contemporary galleries in the local area. It's interesting to note that the High Street is also where the original art school was. It was attached to the University of Glasgow. It dates back as far as 1740, and the success of the High Street was interlinked with the time of the Tobacco Lords, in fact the Tontine Building was where the Glasgow Chamber of Commerce began. Back then this was a very wealthy part of the city. It's now not so wealthy and it's on the gateway to the Barras and the East End.

We will hopefully be moving back to the Garnethill Campus in 2018.

Glasgow has become a centre for artists. How do you think this has this happened and how long has it been the case?

The Glasgow Miracle, or what became known as The Glasgow Miracle, reflects some of the graduates leaving the art school between the mid '90s to the early 2000s, of which you can include Ross Sinclair, Douglas Gordon, Martin Boyce, Claire Barclay, Christine Borland, Nathan Coley, Jim Lambie, Roddy Buchanan, Peter McCaughey and many more. Of those graduates a number are Turner Prize winners, Beck's Futures winners, and internationally renowned artists. They've maintained a link to Glasgow. For instance, Douglas Gordon owns the Common Guild, one of the most well-known contemporary art galleries in Glasgow, and Jim Lambie's studio is literally over the road from where we are sitting at the moment. All of these

people have in the past come in to talk to students either as visiting lecturers or on fixed-term contracts, and they've really supported the growth of the creative community within Glasgow.

You can track the link back even further to the '80s with the Glasgow Boys, which would include, off the top of my head, Ken Currie, Steven Campbell, Peter Howson and Adrian Wisniewski. They also lived in Glasgow and offered their support to Glasgow School of Art. Alongside the Glasgow Boys we also had the Glasgow Girls, who were also extremely famous at around the same time, including Alison Watt and Helen Flockhart. So the trajectory is not just a recent one. It dates back to the '80s and well before. The constructs within the school haven't changed massively either.

What do you mean by that?

Well. Painting has been taught here for the last 145–150 years, and it has been taught more recently as a sort of non-modularised subject-specific area. So the department itself has an enormous history. The MFA is 27 years old and also has its own history. Environmental Art was constructed by David Harding and Sam Ainsley, and some of the graduates who emerged from these areas were ground breaking.

The economic, social and political history of Glasgow has had a really important impact on the art scene in Glasgow. Students' acknowledgement of their place and space in the city, and the historical context it has provided for them, is vital. That historical context goes back to the economic and political history surrounding Britain in the '70s and earlier, with the cultural shifts, economic downturn, and the disappearance of the shipping industry. The school, as part of the city, reacted to that, and a lot of the work generated then was related to that history. So it constructed a very specific type of engagement with practice. That's something that the students working now cannot forget, because what has been constructed in all of that time has developed through the school's relationship to the city, and the social, cultural, economic and political changes that have happened over that time.

Can you tell me about the current links between the art school and the city?

I think that the School of Fine Art has always felt that it needs to be integrated within the city. There is a very strong link to Glasgow City Council. We work very closely with them, in terms of festivals, events, and ensuring that, if things are happening then we can collaborate with them and provide some interesting public-facing events. For instance, the School of Fine Art supports and helps to run the Glasgow Havana film festival on an annual basis, Havana being one of the cities that Glasgow is twinned with. We're currently also working on a High Street Festival where we're asking the council for permission to take on 28 vacant high street shop premises as part of a festival that will look at literature, history, art and music, within the city of Glasgow.

We also have relationships with all of the gallery owners, with the studio providers, with the different institutions within Glasgow, whether that's the NHS, Housing Associations, Prison Services, museums, the University of Glasgow, the Royal Conservatoire... all of these links allow us to develop opportunities for students, and it also engages the public in the creative activities of the school. Our Friday Event series as well, which is an open public lecture, is provided by the School of Fine Art.

With this as a backdrop, can I ask you to give an overview of how the various undergraduate departments at GSA prepare students for life after art school?

I suppose there are a number of different ways of thinking through how students might move beyond the art school. My perception is that the school should not be this, sort of, white walled fortress. Students need to be able to have a relationship with the external world whilst they're studying and that engagement feeds an understanding of what might happen upon graduating. One department that does that extremely well is Sculpture & Environmental Art. They're currently doing a prison project which they run with their second and third year students. Last year they had 26 students out working in prisons across Scotland.

So fine art students should constantly be thinking about questions like, how do they relate to an external society, outside of the art school? How do

they relate to the art school itself? How do they contextualise themselves within an ever-changing world, in terms of things like migration, and the opening of borders, things that are happening, as we speak? The digital world has also given students a global awareness. Whereas before it would have been book-based, now a student knows what the latest news is in South Korea, Japan or Mexico, the moment it happens. That openness of knowledge can flood straight back into a student's understanding of how to consider and construct the making of their own artistic practice.

Would you say that students are aware of this idea that their whole course is preparing them for life after art school?

We undertook a project called the Anatomy of Employability[3] a while ago. It looked at where employability was structured within the curriculum, and the language of employability from a fine art perspective. As part of this we did a survey where we asked staff and students where they perceived employability and professional practice was taught. I wanted to see if it matched but of course it didn't! There was a difference in perception of what professional practice might be. So a student might see a show as being about professional practice, whereas the staff member might be thinking that's part of being an artist, as in, yes, professional practice, but you have to do that anyway. I was also really interested in the question of whether there is a particular language of employability that is bespoke for a fine art graduate. I believe there is, and some of the outcomes we got from that project definitely show it. Employability may be the wrong word. You could interlink employability with graduate attributes and with the students finding a space in the world.

There seems to be some tension around this term employability? As well as words like enterprise and professional practice...

Yes, they are awkward words. They are awkward words in terms of fine art. I think they'd work for other disciplines, a more vocational subject maybe that would have direct employability, because it's interrelated with your future, and directly related into the teaching, the pedagogic structures.

It's imperative that we consider employability and professional practice. But it's how, when, where, and what all of that is. I can see why people dislike the word employability and I can see why people don't like professional practice. I also understand, from Glasgow School of Art's perspective and its histories, and the non-modularised aspects of it, why people are reticent to see professional practice as this bubble that is suddenly treated as something different to everything else you do, because actually, it's not. It's part and parcel of the curriculum that we have constructed. So, if you put a label on a specific aspect of the course, it means that everything else you're doing doesn't include that specific aspect, which wouldn't actually be the case. Do you see what I'm trying to say?

Yes, I see what you mean.

That's one of the major risks, in terms of modularised structures, where you might add 15 or 30 credits in year 3 for professional practice.

Now, a student will see that as a block of time where they learn everything they need to know about employability, professional practice, or whatever you want to call it. So whether that's CV writing or bid writing, whatever that block of time is perceived to offer, it will be seen as separate from everything else that's going on unless it's done cleverly. You could then look at modularity, and say that if you block learn, then people will only perceive learning in blocks, and they don't necessarily interconnect the blocks. Done cleverly it can, but there is a danger that a student will see it as, 'I need to get an "A" there, that's great, tick box, done.'

I'd like to make sure that we're doing everything we possibly can and that we're not missing a trick anywhere, but I don't think it needs to be separated out. What we're trying to do is embed it.

I was talking to another staff member recently, and half his time at the moment is spent writing bids to get funding to make the work. And a lot of what we do in the world is looking for funding in order to establish different things. Now students might go on to do residencies, they might apply for projects, competitions, lots of different things in the world. Not that they all necessarily pay huge amounts of money, but they need to

understand the complexities of bid writing, construction of a CV, how they explain themselves, and how they support themselves in moving forwards.

We do have some professional practice lectures, and we are doing a whole set of these right now. They're about an understanding of professional practice as an artist, so legalities in terms of selling work, self-employment, contracts and insurance. It's about setting up the student's understanding of how they might move into a professional world, when they leave the art school.

Is that the goal then, that everyone or as many people as possible, become artists?

I think there are different goals. I think one goal is to provide an education that would allow the possibility for students to go on and become artists, curators, researchers, or other categories of creative practice beyond the art school. You are teaching conceptual, practical, and theoretical skills that will allow students to work in different areas, primarily coming from that background of artistic practice, but they don't preclude the opportunities of using that practice in different ways. So, I think that the transferability of the skills that we offer is fantastic, because students can move beyond the idea of being an artist, and transfer the knowledge learned into multiple arenas. I think this is a really important thing to try and achieve.

Also, yes, you want to be able to produce world-renowned, internationally famous artists, absolutely. I think that's an aspiration of all fine art programmes throughout the UK and I would suggest that if people weren't trying to do that, then I'm not sure what they are trying to do. But mapped in alongside it, you also want to ensure that the student has the opportunity to undertake an understanding of being in the world, to find a position and a space within which they are happy and can inhabit and be successful within. Which is why I go back to this idea of the art school being open enough to allow the world in. So an understanding of the transferability of their skills, and how they are usable in the world is key. That also becomes another structure of learning.

Can you give some examples of those skills that people gain within the core programme?

OK, let's take a look at the structure of the crit. You have to be able to speak, explain ideas, and negotiate with other people over the possibility of those ideas. That is a taught transferable skill. Then putting on a show externally, curating with other artists, understanding the quite complex concepts and structures of putting a show together, that is also a transferable skill. You could pick lots of them. They are embedded within the structure of the curriculum. If you then want to pull out graduate attributes, you could identify any of those. That's where the language of that transferability needs to be thought through and articulated better, I think.

So do those skills make our graduates instantly employable? I would suggest it makes them interestingly employable, because they have a set of skills that would benefit companies, industries, and employers in different fields around the world.

You mentioned earlier that there is some support for students who might want to sell work. From my own art education and some of the conversations we have experienced since in our crits, it seems like there is another sort of tension around the idea that a student might aim to make money from their practice. People talk about not wanting to be 'too commercial', that this is somehow 'selling out'. Do you recognise that as an attitude that exists? And if so, where does it come from do you think?

If I were reflecting on my time as an undergraduate student, I would say the idea of being commercially successful was frowned upon, you are absolutely right. But it's difficult, isn't it? If you want to become a successful artist, and work in the field, and have people working for you making your work, and selling your work, then you have to sell your work!? And there's a very clear history of that.

I don't think it is frowned on in such a way here. You could chart back to Jenny Saville, for instance, completely selling her degree show. Look at her now. Douglas Gordon is also obviously selling work as are the artists I mentioned earlier. The students in the art school see these people

because many of them are still in Glasgow and have a connection to the art school and so they know, to become a successful artist, then they will have to understand the commercial aspects of being an artist. I think there's a very clear understanding that selling is important.

Some of the professional practice lectures that I mentioned give students a knowledge and understanding of how to sell their work. Who do they sell to? What are the percentages that galleries take if you're selling through commercial galleries? How do you work with a dealer? How do you work with a gallery owner? How do you work with curators? So there is an acknowledgement that there is the distinct possibility that you may sell work.

So the Glasgow School of Art has a history of selling work at the degree shows, but that doesn't mean that the students are making work with selling in mind. Rather they understand that to become successful, they must be aware of the complexities of the commercial world, and who to deal with, how to deal with them, price structures, and all of these different things. If a student didn't understand what the probability of price and the sale would be, you would be letting them down if it came to the degree show and a dealer or collector walked up to them – and this happens every year – and asked to buy the work. They would need to know how to negotiate that sale. So we work with them to support that.

If you looked at the artist list at the Modern Institute, most of those have graduated from Glasgow School of Art, and most of them would have worked out that to become a successful artist, they have to understand the commercial aspects of working with dealers, collectors, and how to engage with that.

Is it important to you that graduates stay in Glasgow? Is it something that you encourage?

As you are probably aware, many of the students who graduate from the School of Fine Art don't leave Glasgow. Or, they may leave Glasgow, but they don't traditionally head south which is what happens in many other places. They may go abroad. They may follow some of the exchange

routes that they've held on their course. They, maybe, want to think about moving internationally.

I don't think the staff and the programme encourages students to stay afterwards. I think the reason so many stay is because the arts infrastructure of the city works so well. In Glasgow, you have activities happening continuously. Almost any night of the week during term time you could probably find a student show, or a graduate show, or something going on in the city. That's not just in the commercial spaces. Rents are quite cheap in Glasgow relative to London prices, and there's a possibility to actually live, and live relatively well, off a low income. Studio rents are also not as expensive as the south of England, so the cost of living is generally lower than many other parts of the UK, which is beneficial to artists.

Considering we don't have lots of commercial galleries in Glasgow, it's incredible to think of how productive the studio set up and the links in Glasgow are. Those links are predominantly international, and many of our graduates will go on and probably not show directly in London, but will maybe show abroad in Germany, or across Europe, or America. I think that's happening, even though they don't leave Glasgow.

Another thing is that at many private views I've been to recently, I've met more people who graduated from London, including CSM, Camberwell, Chelsea, Goldsmiths, who have moved to Glasgow because they cannot afford to live and be an artist in London. It's completely impossible to have a flat, to have a studio, to maintain a job and work as an artist. I think graduates are then looking at the 'second city', and I'm not suggesting they only move to Glasgow, there's also Birmingham, Newcastle, Manchester... but I think people see the strength of the infrastructure that is embedded within Glasgow, and so more and more people are coming here. That is good for our postgraduate programmes too as many of them will want to have some kind of relationship with the Glasgow School of Art.

Does fine art at GSA currently provide any support for graduates?
A recent project in terms of transitioning out was the Phoenix Bursary Project. The Phoenix Bursary supported students who lost their work

in the fire, to make a new body of work.[4] After the fire we received an amazing response from institutions worldwide, who then went on to take some of our students during the bursaries. We had students as far afield as Argentina, Mexico, Canada, USA, Mongolia, China, Japan and across Europe. From my perspective, the reason for dreaming that whole idea up with the Heads of Department was to look at the idea that, whilst a degree certificate is important for a fine art student, it's not the be-all and end-all, because actually, the body of practice constructed is equally significant. So to leave with a grade and a piece of paper but no body of practice, and no supporting evidence of the work with a portfolio and projects, is terrible. You couldn't allow it to happen.

In terms of the next phase, we have been thinking about how we could use some of the things we learned as a premise for thinking through how we could support graduates for a transitional phase beyond the art school. For instance, if there were a possibility that we could retain the Tontine Building which we're in now, and provide a space for graduates before they move on and leave the art school proper... It could be a space where visiting staff could come in, do projects, the odd crit, and there could be studios and a base to work within.

As you know, I recently worked as a research assistant at GSA where I interviewed many of the Phoenix Bursary recipients about their experiences. During that research it became very clear how hard it is, without some sort of support, to maintain a studio and a practice after art school...[5]

Yes, absolutely. I mean, when I left the only way I could sustain a practice was to go on Jobseeker's Allowance, and pray to God that they wouldn't offer me a job because that was my only income! And then, when that wasn't working, it was trying to get the minimum amount of work with the maximum pay, which is never easy. When students leave, there's not a huge amount of support out there. I've got to be honest, that was where the Phoenix Bursary Project was interesting, just to give them that possibility. And it's never happened, ever, and probably never will happen again.

Do you think art education is a tougher choice for those from lower income backgrounds? And has this been made worse by the introduction and rising of tuition fees?

To take the second question first, I think the fee system privileges those who are willing to take on debt and those who do not have to move into debt.

With the first question I think if you're coming from a low-income background, where outside of the loan you have very little or no further support from your parents etc. you put everything into your study. Then in fine art there is a cost involved in making and that can't be taken away. You could be next to somebody whose parents have paid all their fees, bought a flat in the West End of Glasgow for them to live in while they're here, who then can actually make money off the back of it because they can put some of their fellow students in the same flat. They're driving round in a car and they've got the latest laptop. It's a completely incomparable experience. I don't know how that disparity gets resolved, but we are working extremely hard to find possible solutions to this issue.

It becomes complex when you might want to put on a study trip and some students can't afford the flights so they can't go. Where's the equitability in that? We don't have the money to just say, 'Right, you can go and we'll pay for you.' You can see the impact of that, I think, and you can feel it at times from the student body.

1.	The Trongate is one of the oldest streets in Glasgow's Merchant City area.

2.	The Briggait is a Grade A listed building in Glasgow's Merchant City that has been turned into a home for visual art and cultural organisations, including Wasps studios.

3.	The Anatomy of Employability project was a collaborative project between GSA and Bucks New University funded by the Higher Education Academy. It mapped and analysed all employability related activity in the curriculum (embedded or otherwise) across all departments within The Glasgow School of Art (Fine Art, Design, and Architecture). The outcome was a series of collaborative events and a website. See: www.artanddesignemployability.org (Accessed September 14, 2016).

4.	The Phoenix Bursary scheme was set up to support 100 BA Fine Art graduating students who were affected by the Mackintosh Building fire of May 23rd 2014. The fire took place just as final year fine art students were preparing for their degree show assessment and as a result a significant number of students had their degree show and supporting work destroyed or damaged. There was overwhelming support received after the fire from the local community, alumni, the Scottish Government and from art institutions around the world. Some of this was harnessed into creating the Phoenix Bursary – a scheme designed to give these graduates the opportunity to build a new body of work and exhibit it one year later. The bursary was set up with £750k financial support from the Scottish Government as well as in kind support from institutions around the world that offered access to studios and technical support facilities free of charge. The European League of Institutes of the Arts (ELIA) was key to supporting this. The Phoenix Bursary offered: a 15-week opportunity to make new work, a weekly stipend of £315 per week (£4725 total), a materials budget of £1000, studio space, and some tuition. Each of the 100 students could state where they would like to spend the bursary period. Of the students that applied for the bursary, 47 requested to stay in Glasgow and to accommodate this Glasgow School of Art (GSA) rented a space within the 4th floor of The Whisky Bond. Studios were built within the space and a team of tutors was allocated to provide support throughout the period, including one dedicated tutor. 37 students were placed within partner institutions across the world. A further 14 graduates took part in self-organised residencies or internships. After the bursary an exhibition of new work took place in the Reid Building at Glasgow School of Art from 24th July–2nd August 2015.

5.	Gunn, V.; Rowles, S. (2016). *Phoenix Bursary Summary Report*. The Glasgow School of Art.

Dr Marianne Greated is Year Tutor on the BA
Fine Art Painting and Printmaking course and
International Academic Lead at The Glasgow School
of Art (GSA). We interviewed her in her office at
the art school.

*Can we start by talking about Glasgow as a place? There is a lot happening here
and it has become quite a centre for artists.*

Glasgow is an amazing place to be as an artist or a creative individual.
There is a large thriving creative community within Glasgow which is
accessible to make contacts or links within because of the size of the city and
the open nature of the scene. It is a supportive and vibrant place to be and a
range of factors have enabled that.

Glasgow has a history of DIY culture that has been nurtured through
a few different support mechanisms, one being the art school itself. The art
school has been very connected with the city and with artists in the city; the
tutors are also all active practitioners.

Historically, the city council has been supportive of the arts. Glasgow's
industrial background meant that it has had lots of empty disused spaces
in the city centre and the council has allowed these to be used by artists,
studios and galleries. Creative Scotland (formerly Scottish Arts Council) has
also been key to developing artist run spaces, funding various key galleries
at pivotal points. For example, they supported the Modern Institute gallery
to attend international art fairs at an early stage in its development and they
still fund the Transmission Gallery. In addition, there has been ongoing
support within the Scottish funding scheme for individual practitioners and
curators. There is also a strong connection between the art and the music
scenes in Glasgow and many arts spaces have had connections with both of
those communities.

Did you study at GSA?

Yes, I studied here and graduated in '98. I then set up and ran an artist run space called Switchspace, with my friend Sorcha Dallas who graduated in the same year as me. We ran that for six years.

Can you tell me a bit about that?

In our final year of art school the artist Cathy Wilkes gave a talk to students and she mentioned that she had held an exhibition in her flat. The summer before we graduated, I had also helped an artist Julie Brook put up some work in her flat, so we knew that organising your own exhibitions outside of the gallery system was possible to do. At that time Transmission Gallery was already reasonably established, therefore as recent graduates we felt it was out of our reach. We wanted to do something ourselves, to have opportunities to show work, to support the scene, to be active and extend our creative outlet.

Switchspace had over 50 exhibitions in flats, shop units and warehouses all around the city. We were lucky because we received incredible support from the community. We used Sorcha's flat initially and then set up an agreement with a property developer who let us use their flats while they were sitting empty. When we started there were only two exhibitions planned, but it quickly grew into quite a major project. Artists included Karla Black, Beagles and Ramsay, Craig Mulholland, Sue Tompkins, Alex Frost, Cathy Wilkes. Some of the shows were of recent graduates from the MFA or other emerging artists. We also put on the opening event in The Chateau with bands Franz Ferdinand and Uncle John & Whitelock on one floor and Switchspace set up and curated the other floor. People were open and responsive and our shows were very well attended and received. We also held fundraisers where we asked people to donate work and we would sell them all at a standard price. The first one was £5, the second was £10, the third one was £15. Each time we received over 100 pieces by different artists who donated work who wanted to support the gallery, including some very established artists.

In Glasgow the community supports events that are going on, and people are interested and willing to take a risk in something that is

developing and emerging. That follows through to all aspects of the city including the art school, and students feel empowered and able to put on their own events and take charge of their direction. Lots of students have set up their own shows, events or performance nights in flats, disused spaces or galleries, either whilst they are students or after they have graduated. It is a very active environment where people take the initiative and do it themselves. They don't have to rely on external people to come in to support their work or allow them to do something.

Where do you think that comes from? Is it because you recruit a certain type of student to come here? Or is it because they see examples of it happening – like you did when Cathy came in?

I think it is because they see examples of it happening. Also they are given the permission by the environment they are in. When you see things like that happening you realise that you can do that yourself.

We are also lucky, as an art school and course, to have very strong applicants. We are able to select ambitious risk-taking students, which makes for an energetic and exciting student cohort.

Can you tell me a bit about the course, and how you prepare students for life after art school?

Painting and Printmaking is a studio-based course. It introduces these mediums but is also flexible enough to allow students to try out different materials, methods and ways of working. The first year of the course is quite structured, the second year is slightly less, and so on, encouraging the student to become an autonomous learner, maker and thinker by the end of the course.

Students develop their own practice within a studio environment where they are supported by their peers and staff through a variety of teaching methods. We have workshop sessions where we introduce techniques, materials and methods to students; we have lectures and research seminars; we have crits and one-to-one and group tutorials where we discuss and think through work, alongside ongoing practical and theoreti-

cal research and support to develop contextual understanding. Students also present their own work regularly and engage with the wider context and community. We encourage students not to see these elements as entirely separate but as aspects that feed into each other, helping to develop the work and themselves as developing artists.

Throughout the course we also give the students contact with artists, creative practitioners and the art world beyond their own studio. We have a number of visiting artists, gallery visits, events and external projects such as an impressive third year group exhibition in the Glue Factory last week where they took over the entire building.

As part of the course?

On the course we do many things to encourage that like having shows in project spaces or in the studio. Even in the first couple of weeks of first year there is a small show where they share work with other students. I know it sounds minor, but it sets a precedent where quite easily they can transform an environment or their work, view it and have feedback. It also encourages professionalism and develops a wide range of skills at an early developmental stage. In second year there is a slightly more professional exhibition held annually within one of the galleries in the art school. Then in third year they have a more ambitious exhibition which prepares them for their fourth year experience where the degree show is public facing and presents the outcomes of their final year. We are gradually building and progressing the types of opportunities that students have to develop and show their work, and also that exposure to external audiences or professionals. It then doesn't become a massive leap for students to show a piece of work in a gallery or create their own opportunities.

What are the benefits of exhibiting offsite?

I feel it's important for students to see their work outside of the context of their own studio. In terms of the work itself it is helpful to get distance or clarity. You can get a different type of feedback or reflection on work when you see the work in a new setting.

When students put on an offsite exhibition, they experience what that entails whilst still being supported by the course. There is fundraising, finding the space, all the red tape you have to go through to put on a public event in an external space, all the planning that it takes before the exhibition itself. Then there is the actual installation, the curation, documenting it, talking to visitors about it when they come round. There are so many layers of professional practice that happen within an experience like that and it is healthy for students to understand what is involved.

As a student group it can be helpful too as it provides opportunities for collaboration and group work in addition to the peer learning they obtain from exhibiting together and discussing work. It also exposes them to different spaces in the city and lets them see those spaces from the point of view of a participant rather than a viewer; it has many benefits.

Does the course also have any distinct professional practice components or would you say this is more embedded in the course through things like the exhibitions that you have just mentioned?

There are events and talks that happen during the course specifically focussed on developing professional practice, for instance early on in the course we have sessions about networking with Lesley Black, GSA's Careers Advisor. We have a great careers service which students can contact directly and also a website. We also have an Employability and Enterprise Manager, Libby Anson, who works with students throughout the school to embed and develop employability and professional practice through a range of projects and initiatives. In final year there are sessions on funding and other specific guidance run by Fine Art. There are also some excellent public sources of information like Artquest[1] or a-n[2] that we can point students to for up-to-date detailed information.

So yes, there is specific input that relates to careers or professional practice, but much is embedded within the course.

Why do you choose that approach?

I suppose I don't see professional practice as a completely separate

thing within education. Professional practice is a way of identifying and having skills that will enable you to progress in your life and be a successful individual.

Even though many core activities are not identified as professional practice, GSA prepares students extremely well for life after art school and life in general. That's because of its emphasis on independent learning, self-management and in students creating their own path within their work and their learning. There are numerous transferrable skills that are developed within the course such as communication skills, presentation skills, self-management, working autonomously, time management, organisational skills and creative thinking. The students are taught to be reflective of their learning, which helps build a sense of self-confidence, self-efficacy, and an understanding of their own abilities that they can then take forward in any direction.

1. Artquest provides artists with information, advice,
 opportunities and services at any stage in their careers.
 See: www.artquest.org.uk
2. a-n The Artists Information Company. See: www.a-n.co.uk

Lesley Punton is Acting Head of BA (Hons) Fine Art Photography at The Glasgow School of Art (GSA). She has held that position for three years, and she has worked as a lecturer at GSA for the past 16 years.

Could you tell me a bit about the philosophy and ethos of your course?

There are many photography courses in existence across the UK as you might imagine and most of them deal with things like editorial photography, feature photography, design, fashion, and advertising. We don't do any of that. We are a one hundred percent fine art based course. Our students are seen in the context of the School of Fine Art. They're artists that happen to use cameras. Our students are also free to expand their practices into different media as and when appropriate.

Does that happen much?

It's a mix. Creative artistic practices evolve in an organic way that you can't necessarily predict. A student who enters the course thinking that all they want to make is photography may continue that way through the four years, but equally they might get to their fourth year and not have a single photograph in their degree show. I think in terms of an ethos, we guide students along a journey of developing and articulating their ideas as individual artists; as staff, we're a conversational and critical voice that accompanies them on that journey.

Can you give me an idea of who comes to the course?

Well as you'd expect, we get a good few Scottish applicants but, proportionately, we probably have more candidates from the rest of Europe. We have a lot of Danish students in particular and also Swedish. We have built up networks and relationships with people and places in Denmark.

In what way?

We have alumni that go back to Denmark and tell people there about the course. These alumni also, perhaps, get teaching jobs there. Over the 30 years that the course has been running, that connection has been solid. We also have a lot of students from Hungary, Slovakia, Lithuania and Eastern Europe and a fair number of RUK (Rest of UK) students, so students from England, Wales and Northern Ireland.

The way that the funding has changed in the UK has impacted quite significantly on the numbers of students that we are required to take into the various categories. There was a point where we would have 30 spaces to fill and we filled them with whoever we wanted. Now that's actually broken down into quite discrete groupings and so there are certain target numbers from each group. In amongst the Home/EU students, we take widening participation students as well, which is probably around five students out of a cohort of around 30.

What is your balance like between entry-level and more mature students?

We tend to get higher numbers of slightly mature students actually. Those applying straight from school usually don't have the skills compared to the ones that have maybe been out of education for a wee while. We get over 300 applications so we can afford to be quite picky.

What is it that you are preparing students to go on and do?

The main thing that we are preparing people to be is artists. However we know that in terms of employment, that isn't going to mean that people are all going to be working professionally as artists.

I think that because art education allows people to be critical and lateral thinkers, they can gain employment in all sorts of areas. We get people going on to teaching, we get people doing arts administration and we get people becoming commercial photographers as well, even though we don't formally teach those skills. If you've got the technical skills you can quite easily transfer that into the commercial sector. We do have people that have graduated now working like that, but critically it's a little bit at odds with the

ethos of the department so we don't really see them necessarily doing that whilst they're studying here.

You do also get people doing really quite unexpected things.

Like what?

Well, after 30 years of the course we did a survey of what graduates ended up doing and there were a surprising number of psychiatric nurses.

Really? That's fascinating.

It was a bizarre one. We've also had quite a few film-makers and writers. Many others are not necessarily artists but a lot of them do still work in creative professions. As much as we might talk about the artist being the thing that we're most easily looking towards, we do recognise that they won't all be doing that, although quite a lot of them still do. Whereas previously you'd lose track of what people were doing, it's more noticeable these days through things like Facebook, as you get things bouncing into your news feed for exhibitions that graduates are involved in.

Do graduates of your course tend to stay in Glasgow or go elsewhere?

It's a mixture and it depends where they originate from. Some will go back home. If they're from Glasgow or Scotland, they'd be likely to stay in the city, although we've had quite a few going over to Denmark. We've got a wee Glaswegian contingency of Scots in Copenhagen at the moment. There's a gallery called Green Is Gold, which is run by a couple of our ex-graduates, and they create that Glasgow vibe there. A lot of the DIY culture of Glasgow's art scene has in some ways been translated over there. I suppose Copenhagen had that anyway a little bit, but there's a similarity. Both cities are of a similar size.

Some people also go off to do a Masters. I've noticed in the last few years that more are staying, in particular those from countries in the EU, more so than those from other parts of the UK, which is great. There's a wee handful that previously I always expected to go back, but it's not such a given now.

Is it important to you that people do stay? Is that what helps develop Glasgow's art scene?

It's nice when they stay. I mean, it's great when they go away and then they create a bigger network whilst they're still in contact with us. That's why I mentioned the Green Is Gold gallery because suddenly there's an internationalisation of the opportunities that our students are met with. I have to say, if they all went I think that would be really problematic. Max Slaven and Ralph McKenzie, founded the David Dale Gallery in Glasgow and it's really nice to see that they're contributing something to the infrastructure of the Glasgow art scene. Kendal Koppe is another ex-graduate who has an eponymous gallery space in the city centre. Street Level was also founded by photography graduates. Those spaces are important. Sometimes there's a perception that all the people that do well in Glasgow come out of the sculpture and environmental art department at GSA. It's not actually true. More and more these days people in the photography department are doing really active things in the Glasgow art scene.

Can you tell me a bit about how, throughout the course, you prepare students for life after art school?

We do hopefully try to prepare people for life after art school but it's a contentious issue. The idea that preparation for your life after your degree should be the focus and the imperative of an arts education is, I think, something that should be scrutinised. The value of an arts education is actually something that's much more profound. It's much more deeply about education rather than about vocational skills or job opportunities.

Having said that, we live in a real world and we do recognise that students want to have those transferable skills. We certainly wouldn't say they were irrelevant; of course they're important and we do a professional practice conference each year. At first it was with third and fourth year students but now it's for the entire department. We invite various practitioners in who give talks on their experiences during their first few years out of art school, looking at the challenges, how they found opportunities, curators talking about things from their perspective, and arts

professionals talking about applying for funding and opportunities, and more.

We also embedded exhibition practice into the curriculum. In second and third year there are exhibitions that are formalised parts of the course. In fourth year the degree show is a central part of their exhibition practice in terms of putting together a body of work, where they are learning the professional skills of presentation and so on. We also find that more and more of our students are taking it upon themselves to organise these exhibitions off their own back. For instance the first year students last year used studio SWG 3 and made an astounding show.

We also have exhibition spaces at GSA available for students. In this building we've got a wee space called The Cell, which we encourage students to use for installing work. The student union also have spaces and our students use places outside of GSA too. We try to get them to do as much of that as possible throughout the year: it's hands on stuff.

I think sometimes they don't realise they're 'doing' professional practice because we don't go into a classroom and say, 'Today you're doing professional practice.' It's very much embedded through everything they do. If they're giving a presentation on their work, that's an aspect of professional practice. Students are regularly required to do that whether it's through a critique or a more formalised presentation of their research work.

Is your course modular?

No. No courses in GSA are modular. We have a project structure in first and second year, and projects in the first year may be four to six weeks long. It's not like the American system where you've got a project or an assignment and a week to complete it. Students are given a brief but those briefs are open ended so they don't determine what the work is going to be. They might deal with a philosophical aspect of photography, but the work that the student makes is still going to come out of their own personal interests. That encourages a sense of continuity from one project to another. Of course a student may decide to radically alter what they were making from a previous project and experiment in a different

area of interest – but they can quite easily link one project to the next, so it's about deep learning.

Is that the aim…?
Yes. So by their first term in third year, it's entirely self-directed. The students are writing their own programme of study, which is basically a statement of intent or a plan of the term ahead, so that they're not completely free range. They also get quite a lot of support through individual tutorials, group tutorials, critiques, and lectures. By fourth year the students are very much focused on writing their dissertations and thinking towards their final degree show.

Why do you choose an embedded approach to professional practice?
I think it's more holistic. I think if it's embedded within the curriculum, it's a natural process and not something that's tacked on. So it's more genuine and about the authenticity of that learning. We do add a few other sessions that would be readily understood as professional practice activities of course.

The problem with it being mainly embedded though is that sometimes there is a lack of awareness on the part of the students of what skills have been acquired or what knowledge has been accrued.

What are the other sessions that you mention?
Well in fourth year there are some professional practice seminars on pricing your work for the degree show and also on copyright. And for this we hire someone external to come in. The reason why we don't explicitly teach copyright ourselves is that it's such a minefield and you almost need a copyright lawyer to really discuss it. It's not that we're teaching students the ins and outs of copyright, but we give them a basic awareness of it.

Is that a compulsory session?
No, it's voluntary.

You mentioned the seminar on pricing of work for degree show. Do you encourage students to sell work? I know sometimes people get a bit frosty if an artist confesses to setting that as their primary aim. Is that something you recognise?

I recognise that pretty clearly. I have known students that have been fixated on money and grades. It's the acquisition of some sort of external form of worth rather than an intrinsic motivation for what they themselves do. We don't really come across very many though to be honest.

I studied painting and I do remember that approaching degree show times, there would be students that would be making things because they knew they could sell them. They weren't expecting a particularly high grade and they didn't really expect to be making much beyond art school – or maybe they just wanted to be somebody that would do their wee paintings and sell them in wee shops, which is fine if that's what you want to do. That's a bit disparaging I suppose! But they didn't really have much interest in the critical content of their work. It seemed that that was a little bit at odds with the context of their studies on the course.

There's a much greater complexity now. We're not talking about tea rooms in the Highlands selling landscape paintings or something like that anymore, but the UK dealership system has become more visible in Glasgow. There was a long time when that wouldn't even have entered anybody's mind because there were no dealers, but now we have the Modern Institute, Mary Mary, and Common Guild. The art fair circuit has also extended to Glasgow based galleries in a way that it never used to.

I don't think students put up a degree show thinking, 'Right, how do I get represented?' And anybody that is represented realises very quickly that it doesn't actually mean that you get a pay cheque at the end of the month or that you don't have to push the work. You still have to do an awful lot and what you get out of a gallery will depend on the profile of your work at a very early stage, and the practices and profile of the gallery that represents you. You've got to actually reach a fair degree of success before that happens. That's not the kind of thing that's appropriate to talk to students about because it takes away from the endeavour of making the work, and can create unrealistic expectations. But what do I think about students that are

aiming for money? If it's realistic, we're not going to prevent somebody from making money out of their work and we would like our students to sell stuff at degree show. But we think that the work itself is the most important thing. If you make good work it's more likely to sell whereas if you aim to the lowest common denominator, you're probably going to make rubbish. It's a bit chicken before the egg.

Except you could actually talk about the high-end commercial contemporary art world being where a lot of the most cutting edge artists actually come out of. Places like the Common Guild and Modern Institute are actually showing a lot of the most challenging work. I think maybe 20 years ago the balance was different in that it was big institutions that would be giving those opportunities, but now I think it's more integrated with the market.

Do you think in order to be a successful artist, however you want to define that, you need to engage with the commercial art world?

I think a lot of artists do, but I don't think it's absolutely necessary. I'm trying to think of some examples of people who are successful that haven't done that. I can't off the top of my head but I do know that they exist. It's maybe more to do with the form that the work might take so something that's maybe more – I hate the term – relational, that kind of work. It doesn't necessarily have an output but it can still be very, very successful, yes. And 'successful' is a pretty subjective term. People can be successful without being known and hugely visible.

What do you think about the language of employability?

I have a massive problem with it.

Can you explain why?

Because it's the language of the corporate world just tacked on to the art world. I also have a problem with the term 'creative industries' because it's a way of justifying being an artist in economic terms. It's absolutely rubbish. For me, employability and entrepreneurship or whatever the word is, it's all catering to a justification of what we do on economic terms. Actually, artists

should be challenging those neoliberal systems and positions. The idea that we would just sit back and fit neatly into that context fills me with horror.

A student here recently came up with an alternative phrase – which was something like, 'getting things done'.[1] It's like, use real language rather than talking with words that you hear used on official documents! It's not the way people speak. It's almost like it's infiltrating and actually shaping the direction of public policy. I think, as I said right at the beginning, the educational aims are much deeper. They're about enriching people's lives for the rest of their life and not just about getting a job, because you can get a job in all sorts of things that aren't going to enrich your life.

If you're engaged in culture and literature, that can have a much more profound effect on who you are as a person and how society is shaped. It's an ethical position that we might have in the world, rather than focusing solely on employability and making money.

I totally get the position. But how do you reconcile that position with the rise of tuition fees and people coming in to study at art school who might be from lower income backgrounds? Is there a tension?

There is. For the first time last week I was in a meeting where I was told that when we have applicants, they have the right to appeal decisions even on getting in, because they're now classified as customers. So no, that language doesn't sit with me very well at all.

Thankfully in Scotland our Scottish students still don't pay very much money. It's a completely different situation to those students that are coming from over the border. If you're from Newcastle, you're going to be paying £9,000 to study here whereas if you're from Scotland or the rest of the EU you're going to be paying in the region of £1,500 plus living expenses. I suppose philosophically it still feels like we're in Scotland and Scotland doesn't charge, so there's some semblance of that democratic position of education. Those kids from poorer backgrounds in Scotland, particularly those that might be in the widening participation category, hopefully won't leave with massive debts, whereas obviously it does affect the students that are coming from England, Wales and Northern Ireland.

I have a real issue with that. I think there shouldn't be tuition fees. It's difficult. It's a real problem.

So there is a tension, and I suppose parents are paying for their children's education and they want to see some sort of safety net and return. Some parents might accept that the return might be a philosophical enriching of someone's life, but others are going to want something a bit more concrete. I can understand that. As a parent myself I suspect that when my son is a bit older I will want him to get a decent job – although I actually just want him to be happy.

Would you say that the course is more about aiming to push the boundaries of the discipline, or is it more about developing the individual and the kind of sensibilities in a person that you have described?

It's probably both of those things. It's certainly the position of developing the individual. I think when people come on a degree course at GSA they probably leave as different people. Not fundamentally different, their values may still be the same, but they've hopefully been challenged in numerous ways and they've considered a lot of things that maybe they wouldn't have considered if they hadn't gone through an arts education. That individual position is really important.

Of course we're also interested in the discipline of fine art photography and where that sits. And students are regularly the ones that push those boundaries, because they are dealing with new technologies and new ways in which photography might be encountered, for instance in web based or interactive work. Coding has become something that we're seeing right across the school of fine art as being an area of growing interest. Actually, it is in the school of design too for that matter.

I heard recently that coding is being taught in primary schools, so of course we're interested in those developments. We want our students to leave with current, up-to-date knowledge. We want them to know about current technologies, and although we still teach things like alternative processes, black and white, and analogue, we wouldn't ever just do that. We'd absolutely expect them to be 'competitive' – to use a financial business-y term – as an artist.

We do expect them to go out and get jobs, and they usually do. It's not that you do an arts degree and you become unemployable, far from it. It's just there's not an easy answer to what happens. It's not like medicine where they become doctors: it's actually really intricate.

If someone said to you, 'I don't think I'm going to come to art school because I don't know what use it is and I don't know if I can get a job afterwards,' what would you say to them?

Well I wouldn't automatically say that it will be fine because if they're really focused on that, then it might not be the right thing for them – it *is* uncertain. But we're living in an age of uncertainty. I would encourage them to look a wee bit more laterally at those skills and at that versatility that arts graduates have. They can find creative ways of contributing to endless numbers of scenarios and contexts. I think it's sometimes persuading the mums and dads. If they really want to do it though, it's maybe not such a massive concern because they'll be driven to create, and that will be almost more important than a hypothetical pay cheque.

What does the life of an artist look like?

Most artists are going to have some other employment alongside their practice. They find some sort of job that allows them the time to make that work. Teaching is one job that, if you're REF-able,[2] provides you with some time to do that, but not always enough. I look at recent graduates and I've known people that maybe work three mornings a week with old folks and then the rest of the time they're in the studio. Hopefully they have a studio. There are people that work in libraries, bars, in arts organisations, all kinds of things. Sometimes it's good if the work is completely unrelated. At those early stages it's almost about finding some kind of supplementary income because you can't really sign on in the way that you could 20 or 30 years ago. When I graduated I was able to sign on for a while and there was no big stigma in that. You didn't feel that you were going to get your benefits cut or sanctioned every week. That is a massive shift in public policy. The demonisation of the poor by the Tories makes it impossible for artists to

work within that benefit system anymore. Some folk will think that's quite right but I'm not at all comfortable with it.

So, outside of their paid job, some of their time will also be spent writing applications, trying to find ways and opportunities to get work disseminated, organising shows with other peers. I think that their peer network is really important because the people that students graduate with will also be the gallery managers, curators and arts professionals in 10–15 years' time. Sometimes they forget that. They look up at these people that seem to have made it, and forget that they actually were in that same position not that long before. I think unfortunately the daily life of an artist sometimes doesn't include enough time to make the work. I know myself that the pressures of full time work in an institution and family life mean that you've got a very small window. You may have that research time but as soon as you open your email on a research day, at the back of your mind you're still in work.

Personally, I find it difficult, but I do still make artwork. It also depends on the type of work that you make. I know some people that go into the studio every day and they maybe spend a few hours of that time making work. I know some very successful people, who maybe actually only do a couple of afternoons of actual physical production a week but are at the top of their game. It's really variable.

That's interesting.

Also, we mentioned the REF just now. The REF has had a massive impact in the way higher education in the arts views itself. With public cuts, research has become something that institutions need to generate income. We've become reliant upon it. Artists aren't seen as people who 'make artwork' – they 'do research'. Why is this? What is this shift in what we do? It feels as though art practices have been quantified and measured against a system it doesn't really fit comfortably into. Art practitioners actually don't naturally generate obvious income in the way that those in the sciences do, or their contribution is less valued by the policy makers as it isn't so easily measured. The humanities are at a real disadvantage there. I think it's at the

country's peril that they start being so reductive that everything is down to income generation because if you do that, then you're going to lose a whole raft of culture within quite a short space of time potentially. But the excessive quantifying of art making, it's also changing the way we sometimes view our practices in the studio, when you're trying to make new work, test ideas out, and have space for the necessary failures a creative life requires. We need the space for speculative research as that's essentially how most of us create, and that seems worryingly under threat.

1. A student came up with this phrase during a Learning and Teaching day at the art school in April 2015, during which all students and staff were invited to discuss the topic of employability.

2. To be REF-able mans that staff are doing research/ practice that can be included in the Research Excellence Framework (See glossary)

Lesley Black is Careers Advisor at The Glasgow School of Art (GSA), a post she has held for thirteen years. Libby Anson is Student Employability and Enterprise Manager, also at GSA, and she has been working there for three years. We interviewed them in their office.

Can you each tell me a bit about your backgrounds and what you did before working at GSA?

Libby: I did a fine art degree in painting and printmaking at Newcastle University, and a postgraduate in art gallery and museum studies at Manchester. I then worked in public and private galleries before becoming a freelance art critic; I started teaching and coaching in creative and professional practice at the same time. Directly before working here I was Enterprise Support Manager at Ravensbourne.[1]

Lesley: My undergraduate degree was in fine art printmaking here at GSA. At the end of my degree programme I undertook a year of self-employment and was then employed as the intaglio technician at GSA. After about four years in that post, I decided to retrain as a careers advisor and undertook the Postgraduate Dip QCG[2] at University of West of Scotland. Before I took up my careers adviser's post at GSA, I was a careers advisor with Dumbarton and Lomond Career Service, and Careers Scotland, which later became Skills Development Scotland.

Can you each give me an outline of what your role involves?

Lesley: Well, when I started as a careers advisor I was working part-time hours, and the service was very much driven by one-to-one career guidance appointments. The GSA career service now offers approximately 400 one-to-one guidance appointments a year, and around 60 events that

are a combination of careers service seminars run by the GSA Career service and invited guests, such as employers and professional organisations. The service also shares a variety of career related opportunities and points of guidance through the GSA Career service social media platforms, and there is a weekly email that highlights upcoming events, graduate opportunities, paid placements and job vacancies, and related creative sector news.

I also run bespoke career workshops for different departments within GSA supporting work delivered within the curriculum.

Libby: My role began by looking at the big picture of what GSA should be doing in terms of enterprise and employability, but it's since segued into concentrating more on enterprise. I tend to focus on the 'transitions out' side of what graduates do, specifically with a view to business development and entrepreneurship and I deliver an elective for postgraduate students across the school in 'Business Skills and Creative Entrepreneurship'. I'm also looking at how the school can add value to what is happening city-wide in terms of support for graduates, to help them either run their freelance careers or develop a business through incubation, acceleration, or summer school programmes – that kind of transitional support.

Is there anything specifically that the careers service provides for fine art students?

Lesley: Yes, we do specific sessions such as developing artist CVs and statements, career related professional practice seminars, and I will often work with external partners, such as Glasgow Life,[3] and help them recruit students for opportunities, or explore the possibility of live project work or residencies. For example, recently Glasgow Life recruited GSA students to participate with *The Turner Prize* exhibition. The GSA Career service worked with Glasgow Life to create roles that gave students a comprehensive experience of working within a high profile exhibition.

There are also career guidance sessions that run throughout the year that are targeted towards fine art students, but I tend to get more engagement from fine art students through the one-to-ones. I haven't actually

analysed the data on this, but it feels like I get more fine art students using the service as graduates, during that first year out.

So they can use the service once they leave?

Lesley: Yes. Often fine art graduates will call the careers service and go, 'Oh, I don't know what I'm doing. Can I come and see you?' It's generally that transition issue: their undergraduate degree has been about practice and that practice has been about making and so it's that transition as to, 'How do I develop a practice which allows me to continue to make, earns me a living, and helps me find opportunities, and networks?' I find that quite a lot of fine art graduates consider their practice as physically making work, and because of this the transition into professionalising practice can be challenging. So generally we have a discussion about, 'What is your practice? Where are you moving to with it? How are you developing your pathway to a sustainable practice?'

There are lots of demands on emergent artists especially with the tensions around working to pay the bills, building a visual arts practice, and engaging in all the activities that an emerging artist will do to support it. It can be a steep learning curve and can feel very overwhelming.

How long are graduates able to come back and see you for?

Lesley: I don't have a limit – the door is always open. In any given year I will probably have a few people who are maybe two or three years out of art school. But the majority of graduates who come back to use the service are generally early stage graduates.

A question to both of you: do you think that art schools should have a role in preparing students for when they leave?

Lesley: Yes. Bottom line, yes.

Libby: I get caught in that debate... I think it's tricky because there are still people here, and in most art schools, that will say students are here to learn their subject[4] rather than to prepare to respond to the demands of the market.

Lesley: Yes, but I think the subject is also about how to *be* as well as how to *do*. I think there is the practical aspect such as developing conceptual approaches and a skill base, which is around making. But how to actually *be* a visual practitioner is an important part of that conversation too and you do need to have it.

Libby: Yes, and I'm playing devil's advocate a little when I say that. I would be interested to know what the academics say about the question. I think that now it has to be both and it depends what students think they want to use their education for, because as you've discovered,[5] they don't all want to be in a studio.

Lesley: Absolutely, but I think part of that is your career planning and your career management skills. It's not just preparing an artist for an arts career. It's preparing an individual to understand their skillset and learning, and how to utilise and apply that skillset and learning in a variety of different ways and contexts. And it's about confidence-building as well.

There is a real challenge in art schools about making the implicit explicit within the curriculum. I think if you're a confident student you manage your learning in that way and can reflect more widely on the experiences and development that you are gaining, but if you're a student who is less confident, then that becomes quite a difficult thing to think about.

Libby: Yes, it's all stuff that isn't uncovered, it is implicit rather than explicit, which is why I'm also trying to change the way employability skills and enterprise skills are assessed and how and what feedback is presented to students. We can tell students what we're teaching them, but actually I don't think we've discovered what they're learning, what they take away with them, and what they can actually identify and rearticulate about their learning. Often they don't know what skills they have until you sit down with them and tease them all out.

I think that kind of teaching has to begin at school, because if it's not taught at school, students don't expect it as part of their on-going education here, so inevitably it then gets left until the last minute.

What you mean by this?

What I mean is that schools could introduce the early stages of preparing for working life – and all the forms this takes. I believe that if from Year 6 (age 10 to 11) onwards you were introduced to the idea of life after education, that would mean that students would expect that their professional development learning continues into tertiary education. And if they choose to leave school at 16 or 18, they would have some preparation for work. Educating children in self-awareness and emotional intelligence can support them to think about who they are, and what skills and qualities they bring to their world.

Many undergraduates and even postgraduates have not done a S.W.O.T (Strengths, Weaknesses, Opportunities and Threats) analysis, or some other self-audit. They haven't necessarily considered their values or their goals and they lack confidence and self-efficacy. They do not see themselves as rounded individuals; they are what their grades tell them they are. Bringing such topics into schools, and allowing the freedom to debate them in the classroom, keeps this way of thinking alive and ready for further and deeper development during higher education.

As soon as they walk through the doors of GSA, they should think of themselves as potential professionals, and part of their education is to learn how to be and how to develop this.

Lesley: I think some courses do exceptionally well in preparing students for when they leave, especially the courses that are engaged in a lot of public art and those that bring professional practitioners in to work alongside students on live projects. The nature of the live project work facilitates professional practice learning, for example through delivering the project and the types of discussions, via crits and mentoring, that the student has directly with the professional. This type of live project learning opportunity goes beyond professional practitioners delivering presentations that focus solely on making visual art, and brings a range of professional practice thinking into a students learning experience in a more natural way.

Do you do anything to get students to recognise the skills that they're gaining?

Libby: We try, but because Lesley and I are not part of the curriculum...

Lesley: Yes, through one-to-one guidance sessions and seminars, but it's that whole thing about who is going to self-select and engage in a career service seminar or employer event that's sitting alongside the curriculum.

Libby: Yes, and students get so focused on the next assessment that they sometimes dismiss anything that gets in the way of that, even if it might be useful like how to prepare a portfolio for example. If it's outside of their curriculum and there are no credits attached to the learning, they are naturally going to choose working towards what is assessed instead.

Lesley: That's if it's not relevant to their thinking at the time, then students often won't engage with it. For example, we ran an a-n[6] session on paying artists which is a really critical topic, so 'How are you pricing your work? How are you identifying your hourly rate?', yet hardly any students turned up.

Why do you think that was? Was it because of the timing?

Lesley: Perhaps. And because it's thinking about that element of your practice that is the business side. A lot of students maybe haven't considered that as an important part of their practice yet, even though the likelihood is that if they continue with their visual arts career they will be self-employed. I don't think we have that conversation much with students. We talk about practice as a separate thing and not, actually, 'We're self-employed as practitioners.' We often miss that message, so it comes as quite a surprise post-graduation. I think quite a lot of students think, 'Well, I will just apply for a fund, and that will support me to continue to make', without making the leap to self-employment within that. It's also because of the tensions that sit within visual art practice and business.

Could you say a bit more about this tension between visual art practice and business, and where you think that comes from?

Lesley: About six or seven years ago GSA Career Service undertook a longitudinal graduate destination survey. One of the questions in that

survey asked graduates what kind of value set they hold around their career ambitions. The results from that question clearly indicated that the majority of GSA graduates who are working in creative industries are not career driven in the way that, say, a non-arts graduate might be. They're not necessarily interested in having a formalised career structure, or earning a graduate-level salary, and they're not necessarily driven by making massive profits either. What they're interested in is giving back to society and being effective within the community. They want to use their creative practice in that context. So if you take that into consideration, and then reflect on messages that sit around business within HEI's (Higher Education Institutions), you notice a different tone. For example, business competitions such as Converge Challenge, is a competition focused on product development, innovation and ideas generation. This type of business approach is fantastic for creative students from other disciplines but it is often incongruent with how a visual artist will see themselves or their practice.

I think as an art school we need to think about how we develop our tone for business. I'm not a fan of changing the language around business, but I'm a fan of thinking about the context. I'm thinking, well, why aren't we talking more about business as social enterprises within art schools? Why aren't we talking about business in terms of more supportive business models for visual practice, ones that would sit much more comfortably and relate more to fine art contexts such as an enterprise residency?

Before the interview you mentioned that you were phoning up graduates for the DLHE. Do you have an indication of what people go on to do once they graduate from their fine art courses here? Do people continue to work as practitioners? Is that the goal?

Lesley: Yes, they do, and within our destinations results you will find a cohort of fine art graduates who follow a fairly tradition route of testing the creative sector with regards to their own visual art practice, and earn a living at the same time by working part-time. The majority of those graduates are aiming to build up exhibitions, and make connections and

network with the creative sector. Bearing in mind it's barely six months after graduation, so they're still in that trying-out and establishing period of their career.

Do you think people can feel a bit guilty if they don't want to be an artist anymore?

Lesley: Yes, because it's that thing about, 'What is success?' And, 'what is success from a visual arts degree?' I think the sector can be a bit guilty of promoting visual artists as successful and quietly ignoring the rest. We know that we have a percentage of leavers who graduate from arts programmes who will go on to maintain an arts practice long term but many of our graduates won't. What happens to the rest of us? I'm an arts graduate. Libby, you're an arts graduate.

[Lesley points to Sarah]

Are you an arts graduate?

Yes.

Lesley: And now, we are out doing other things, and contributing to other sectors and the wider society in really interesting ways. I graduated with 15 people who I'm still in contact with. I'm talking 20 years ago. Within my cohort there are further education lecturers, IT professionals, HR managers, as well as those still working in the creative industries. These fine art graduates are contributing to society in other positive ways, and bringing their creative skills and applying them within those sectors. I think that we're missing an opportunity if we're not talking about that, and we're not sharing that success. We're almost colluding in that myth of the graduate from an art school who is either the superstar artist Damien Hirst type, or they're doing that minimum wage job. I actually think there's a gap in how we talk about the success of visual art graduates.

Libby: Students have said they want more examples of the whole range of careers opportunities and professional options that are open to them with the degree towards which they are studying. They want to know what futures may be possible for them.

Lesley: I think it's really important, because I think there's an educational element for other stakeholders within that message. I've been working with organisations like ScotGrad,[7] and Adopt an Intern.[8] I've also worked with the Saltire Foundation which offers paid placements to Scottish students to expand their knowledge of our student and graduate attributes beyond obvious creative practice skills.

GSA's first Saltire scholar[9] was a fine artist who undertook a placement within a petrochemical company. The petrochemical company took a risk and it worked out beautifully. It built confidence within the company to see that fine art students have comparable skillsets to other students and graduates in the market, and can contribute to their business in a really positive way by expanding their awareness of the breadth of practice on offer at GSA and creative practice skills.

So of course it's about sharing the message of success as a visual artist, but it's also about managing information for graduates who are aiming to change direction or pursue different career paths in different sectors. It's about sharing their success too and conveying that employability message to other partners such as employers.

You mentioned before the interview about digital skills...?

Lesley: Yes. Well, what I was thinking is that arts organisations are increasingly utilising social media and digital management tools as part of their processes. Students digitally make, which I think they do really well, but perhaps there is also room to have a conversation about platforms and programmes that support practice such as social media administration and management tools. I suppose it goes back to the business models, because small businesses especially are being challenged to remain competitive by digital means.[10]

I know a lot of graduating fine artists put an incredible amount of effort into establishing their own website. That's great, but you need to activate that website and really understand the purpose of it within your practice. You need to be thinking about how are you engaging an audience through it. If you're not putting out any social media, or maintaining that website, or

thinking about how it acts as a promotional tool for you, and it's just sitting there not having an impact on your practice in any tangible way, then it could be a fairly pointless activity.

There's also a practical discussion to be had around protecting the copyright of visual images, using found images online, and the professional practice that's required to manage that within ever changing technology.

Libby: I think that often it's a case of students not knowing what they don't know. So there has to be a mechanism within their education to show them that, 'You don't know this yet and you will need to, so you had better find out!' Students will also learn things when they think they need to know them, which is often not until they have graduated. This is not too late, but it's then going to take them a lot longer to be in a position to make the most of opportunities, and they really need to hit the ground running when their higher education finishes and working reality begins in earnest. The very least I can do for students is to support them to save them time during this process!

Would you recommend that those from lower income backgrounds go and study a fine art course, and is it tougher for them, in your view?

Lesley: I never recommend. I always advise and guide!

[laughter]

I would advise a student about entering into an arts degree, and I think I would be very clear about the benefits – and there are many benefits to an arts degree. I would discuss the types of career options that the course could lead to, and encourage them to research further.

I would advise pre-entrants to really focus on the learning opportunities within their course. I would talk about their academic self-efficacy. I would be saying to them, 'You're in charge of your learning and you need to be thinking about what the exit points are as a graduate.' I would be guiding them to identify the types of experience and networks that will support them in the future. I would be encouraging them to really build structures within their learning to allow them to fill experience and knowledge gaps, so that when they graduate they have a good idea about what's happening

in the sector and are prepared for entering it. Building their commercial awareness so that they're informed, and they're making realistic choices at the end of that degree.

Is there anything we've not discussed that either of you would like to add?

Lesley: There's one thing. I think we could celebrate our student's achievements more. Art schools have a fantastic cohort of students who are already going out and developing pop-up exhibitions, and doing a whole range of performances and things in the city that are really exciting. These take place outside of the programme, so how do we capture, celebrate and share this more?

One last thing Libby, can I ask you to say a bit more about the incubation idea you mentioned that GSA is working on? Is there an aim there to keep graduates in the city? And do you think that's important?

Libby: The intention is that however GSA manages this idea, it is not something that is already being done in the city and it needs to contribute to the growth of the creative economy in Glasgow. Currently we train our artists and designers here, and then off they go to London when they graduate because there isn't such an exciting job market in Glasgow for them.

I was under the impression that quite a few artists stayed?

Libby: Well, according to a recent scoping report produced by Sam De Santis for the art school, there are a pretty equal number of designers and artists in studios in the city of Glasgow. However, in terms of working for companies, many of the designers and architects disappear down to London because that's where most of the job market is for them. It appears to me that fine art students may stay local but they are not necessarily contributing to the economy of Glasgow as artists. To sustain their practice, they may be working in low value jobs unrelated to the creative sector. As a fine artist working in this way, it is cheaper to survive in Glasgow than in London, so there's no real incentive to move away.

Sam also found that although there exists lots of studio spaces for artists and designers in Glasgow, these spaces are full and there are long waiting lists for them. There are more spaces being created, but there isn't a structured, supportive programme of business development or guidance to support graduates to use that space effectively, or to work towards getting out of that space and progressing to the next stage of their professional life.

If we can give graduates the right support to start developing businesses and innovative collaborations, whether that's as a freelancer or running their own business, hopefully that will then start to invigorate the local creative economy so that more graduates are tempted to stay here and contribute to building the economy and the creative community.

1. University Sector College

2. Qualification in Career Guidance

3. A charity that delivers cultural, sporting and learning activities on behalf of Glasgow City Council.

4. Refers to: Rowles, S. (2013). *The lay of the land: current approaches to professional practice in visual and applied arts BA Courses*. Commissioned and published by a-n.

5. Gunn, V; Rowles, S. (2016). *Phoenix Bursary Summary Report*. The Glasgow School of Art.

6. a-n The Artists Information Company. See: www.a-n.co.uk (Accessed September 14, 2016)

7. An organization that offers graduate and summer placements across Scotland. See: www.scotgrad.co.uk (Accessed September 14, 2016)

8. Not for profit organization that offers paid internships in a range of companies throughout the UK. See: www.adoptanintern.co.uk (Accessed September 14, 2016)

9. Match funding scholarships between the Scottish Government and Scottish Higher Education Institutions that contribute towards tuition fees of Undergraduate, Masters or PhD courses at any of Scotland's Higher Education Institutions.

Lewis Prosser is Student President and Kirsty Hendry is Student Engagement Coordinator at The Glasgow School of Art's (GSA) Students' Association. The Students' Association is a charity that runs The Art School, a cultural venue in its own right. The profits raised through The Art School support the activities of the charity including supporting student led projects and initiatives. This interview took place at The Art School.

Can you each tell me a bit about your background and what led to you working at the Students' Association?

Kirsty: I studied my undergraduate in Fine Art Printmaking at Gray's School of Art in Aberdeen, then straight after graduating, I went on to do a two-year master's programme, again in Printmaking at the Royal College of Art, London. After graduating, I returned to Scotland to work at Edinburgh College of Art (ECA) on a temporary contract in a role that involved working between the printmaking workshop and the painting department. Whilst in Edinburgh I was also one of the co-directors of Embassy Gallery, which is an artist-led space based in the city. The gallery coordinated a professional practice module for students at Edinburgh College of Art, where we worked with both the undergraduate Fine Art students and the master's cohort. This programme comprised of a series of talks and exhibitions in the gallery alongside workshops and various different activities around professional practice, with an emphasis on what we could offer to recent graduates. I started working here at GSA a couple of years ago. My experience at Embassy Gallery has really shaped how I've thought about this role in terms of what the Students' Association offers as resources to its students.

Lewis: I graduated from Painting and Printmaking at GSA last year. I ran for the position of Student President in my final year. In terms of my practice, I spent a lot of time trying to understand what I was doing as an artist. I found that the school wasn't very good at articulating my kind of practice, and it's something I still struggle with now. I would say it's more of an organisational, or events based practice. You could say it's curatorial. I think the fact that I came to work in the Students' Association reflects a lot about my interests both politically and as an artist.

What is the relationship between the Students' Association, The Art School and the Glasgow School of Art?

Lewis: The Art School is a subsidiary company limited by guarantee and is the commercial operation for the Glasgow School of Art Students' Association (GSASA), which is a registered charity. The GSASA is a completely separate entity to the Glasgow School of Art and so works with the school by a memorandum of agreement. The GSA pays sabbatical wages and gives some money for sport and societies but all of the project funding and student lead activities are financed by our own commercial activity.

Kirsty: Our value is in our scale, in that we can do something quite specific for our students in terms of understanding and addressing their needs.

Lewis: The larger you are, the more generic you have to be. Other students' associations, because there are so many disciplines, have to focus on things that run through all areas of study. Because everyone who's here has a creative practice, we can cater to that.

Can you tell me a bit about the aims and activities of the Students' Association?

Kirsty: The Students' Association at GSA is unique because whilst we do the typical things that Student Associations do in terms of representation and so on, we are also a venue. We programme a range of events, gigs, and club nights that are aimed not just at students but also the wider public. We provide the time, space, and resources specifically for our students to put on events and explore ideas and areas of practice that can be hard to accommodate within their individual studios. We see ourselves as a cultural

organisation as much as anything else, and we have real links with the community that some of our graduates will be entering into. In that sense I think we provide a kind of meeting point between the institution and the outside world.

Lewis: I agree, we are quite different in that respect. I'd say we align ourselves more with cultural organisations in the city, such as Tramway, Transmission and the CCA.

Can you tell me more about this?

Kirsty: So we have three project spaces that we make available twice a term via an open call for applications.

Lewis: We also make £1500 of project funding available each term for student projects that fall outside the curriculum. More often than not those tend to be students that work collaboratively so it helps to facilitate ways of working that are not so readily facilitated in the school. I think that having the caveat that all projects 'must be extracurricular' is beneficial for the kind of proposals we receive. The projects are amazing and they are all stuff that you could not do within the institution.

What kinds of practice do you mean?

Kirsty: So it's maybe sympathetic towards more performative or events-based practice. Plus, there are also exhibition opportunities for students that maybe aren't from a discipline that works within that convention. This is a space for people who are interested in the relationship between art, music and performance, and how these three things might intersect. It's a space for trying stuff out as well. It's not about it being a really slick thing.

Lewis: The irony is that students are freed up by the fact that they get access to space. So they test stuff out and it then becomes part of their practice. It also becomes something that they might want to take back into the institution to be critiqued by their tutors and peers.

Kirsty: It's also a way of testing things out that is public, but also supported. There's not the same kind of pressure attached to it as there might be in curricular opportunities to present work.

Lewis: It's like a soft version of a 'real world' scenario because you're exhibiting amongst other students. The audience consists of people who are sympathetic to your position. You're playing to people who might also be performing or who will never have done this before, so it acts as a really encouraging tool to try stuff out.

Kirsty: And it's not just one particular group of students that apply for the project funding either. It ranges from first year to PhD students from across all departments.

Can you give some examples?

Kirsty: We part funded Kirsteen Macdonald's *Curatorial Studio* project, which is tied to her PhD research but is also about creating a supportive peer network for discussion around curatorial practice across Scotland.

Lewis: We also had a student from Communication Design – Illustration who we funded to do performances in the Assembly Hall[1] that were pseudo-theatrical. He built a set that used the full space.

Kirsty: Students have also developed outreach projects with community groups and shelters to run art projects and workshops with the refugee community.

Lewis: And they all stem from 'here's funding, apply'. If you give people a platform they will do something amazing with it. It's interesting seeing how different students around the school use the spaces and funding.

Kirsty: There is a professional practice dimension to the things we make available. To use the project spaces students have to submit a proposal. To apply for the project funding they have to fill out an application form and they have to present their project. I also run a drop-in session to support students in structuring their application, as often this can be their first encounter with presenting a project in this way.

Lewis: We get first year students who apply who have never encountered something like that and don't know how much to ask for.

You said there was £1500 available. Is this per person?

Kirsty: No, that amount is for everything. We get about 30 applications and we're usually able to support about 20 of them. It's always oversubscribed. Last term the amount that people were applying for totalled £30k!

Lewis: Yes, so we might get a first year student applying for £4k but then they understand a more reasonable sum to ask for might be £100 to produce a publication. So people begin to learn through the process. By that understanding we do end up funding a lot of projects that are achievable. Often students can make £100 go a million miles.

Kirsty: We usually end up making a contribution towards the costs of something and then a contribution in kind as well, so if they need printing or a venue we try and give what we can in kind alongside what we can give financially.

Lewis: Applications are also a way of us finding out about what students are interested in and what they're doing. From there, if we can't help we can put them in touch with other people that might be able to, or let them know if it syncs up with something else happening in the institution.

Kirsty: And a lot goes towards helping students participate in things like New Designers[2] or London showcase projects. These opportunities can be a bit of a grey area as it's not strictly part of the curriculum, but as these projects have set a precedence participation is often expected. So we've also developed a student fundraising pot which is helping students to put on fundraising events in the Students' Association to help support the costs of attending these expensive opportunities.

Lewis: Again the professional practice element is invaluable. If they do an event they have to think about the marketing, ticketing, planning… even down to things like AV and how to rig a projector. We might also be asking questions like 'maybe a double floor club night isn't the best thing for your group of five people?' So we get them thinking about the different ways they can use space to their advantage.

Kirsty: All the fundraisers that have been run by students this year have been really successful and have all made a profit. The funds they raise

all go straight back into supporting their projects, whether that's taking their show to London, producing a degree show publication, and so on.

So those particular fundraisers are made possible by that initial injection of cash...
Lewis: Yes, and the fact that we subsidise a lot of stuff and make in-kind contributions. So with the events, we come to a deal with the student groups. Maybe we will pay 50% of the costs associated with putting the event on, or help out with promotion or whatever way we can. We're not going to make students pay to hire their own venue.

You mentioned earlier that use of the project spaces gives students an opportunity for their work to 'meet the outside world'. Can you say a bit more about the advantage of this?
Kirsty: It depends a bit on the discipline. We always speak from a fine art perspective as that's our background so I know I'm making generalisations, but working in the studio is very distinct and it can be quite insular. I think what's important about the project spaces is that they encourage students not to be insular. It's about making things visible and exploring what it means to put on work in a public context.
Lewis: As a student I put work on here and I can confirm that the experience is about testing boundaries. It's about learning what you can and can't do within the studio. You can't do everything in a studio and you cannot get an audience in it.
Kirsty: And it makes you think about stuff like promotion and all those little things we're inclined to think about at the last minute. It's getting students to consider these as being part of the process rather than an add on.

How do you decide who gets the funding?
Lewis: The Student Rep Council (SRC)[3] forms the panel.
Kirsty: Following the deadline for the open call, students submit their application forms and are then invited to informally present their project to the SRC. We think it's important to do this because some people are better

at presenting things in person than in written form, so it's to give all applicants the opportunity to represent their project to the best of their ability. We then convene the SRC and we ask the students which applications they thought were strong, which were not so strong, what they feel is valuable about the projects they'd like to support. We discuss each one in terms of how we can support them and what form this support might take. I collate all the feedback from the SRC along with our own reflections and give this feedback to all applicants, whether successful or not.

Kirsty, you mentioned earlier that when you were at Embassy Gallery you coordinated a professional practice module for ECA. Can you tell me a bit more about that?

Kirsty: The professional practice programme took a different form each year because Embassy has a rolling committee and things would also be changing within the landscape of ECA in terms of staff leading particular modules. The programme needed to be responsive to these changes, so there was always a lot of discussion about where it was best placed in terms of the curriculum.

The first year I was on the committee, we ran the programme as part of the visual culture curriculum and we held presentations and seminars over one intensive day. The next year, we took a different approach and curated an exhibition as part of our regular gallery programme, which formed the core of the programme. For this exhibition, which was entitled *Vitae,* we commissioned four artists that were dealing with this idea of 'professional practice' in different ways, and we used the work of those artists to instigate discussions and to develop different sessions for the students. Some of the artists also did workshops with students. These workshops got students to think about notions of 'value', how they conceptualised this within their practice, and what they thought it meant to them. The sessions also encouraged students to reflect on how they related to the language of 'professional practice' as well.

Part of the process of developing those different activities was based on student feedback gathered through an open call to students asking, 'Well,

what do you want to know? What do you think you don't know?' There were loads of really diverse questions from students, so we tried to group them thematically, and then address some of them quite explicitly, and then others more laterally. That programme was the end of my involvement, which crossed over with me working here.

Do you think you were prepared for life after art school as part of the curriculum?

Lewis: It's difficult to say because to some extent, I'm still here!

Kirsty: Are you 'emerging'?

[laughter]

Lewis: Yes, I'm an emerging practitioner.

[laughter]

Kirsty: It's interesting that you say you weren't taught how to do that but it's also this thing about, how explicit should it be? If you're given structures to learn for yourself, that's very different than not being taught, do you know what I mean?

Lewis: Yes.

Kirsty: I went to two totally different institutions in terms of their pedagogical approach. Although I studied printmaking at both institutions, Aberdeen and London have very different cultural contexts. When I did my BA the thing that I would consider, looking back, as being 'explicit professional practice' was a 'Life After Art School' lecture we were given during the week of our degree show.

Lewis: Here, at GSA, we had a lecture telling us how to price our work. It's not as open as those discussions that Embassy did around, 'What is value in relation to art?' Instead, it was more 'It's that size, it costs that much. That's how much you're going to get at a degree show. You're not going to get any money if you do performance,' that kind of stuff. Then there are aspects of professional practice that are encouraged but not led by the school, such as fundraising for publications or means of disseminating their contact details during degree show week.

Kirsty: I guess it was quite a small artistic community, but my experience at Gray's School of Art was that there probably were professional

practice opportunities, but it was very much about being a specific type of artist. There wasn't much diversity in terms of different approaches to what it might mean to be an artist. It wasn't really built into the curriculum in the same way that it is here, for example, that there would be regular opportunities to show work publicly. We did try and find those opportunities but because the cultural context in Aberdeen was so different, there wasn't the same numbers of artist-led spaces, DIY activities or any of the infrastructure that there is in Glasgow.

Then the Royal College of Art in London was just a totally different platform in terms of visibility. There was a lot of built-in opportunities to 'show' work. Personally, that was quite an intense transition from Gray's where you just have your one show in the fourth year.

Lewis: It's a lot similar here. You have your shows, but they're always at the end of the year and it isn't until the degree show that you're given the opportunity to really curate that yourself.

Kirsty: That's why I think spaces like this are so important because if you want to try something out, you could make an application and do it.

Do you think students should be spending more time when they're at art school just developing their 'craft' so to speak, or is it important to be getting out there, doing stuff and showing your work?

Kirsty: I think it's really important to get out there and show work in a public context because part of the 'craft' is it being out in the world. It's a holistic thing.

Lewis: Yes, you can be the best painter in the world, but if you don't know how to show people that, then...

Kirsty: I think not having regular supported opportunities to show work can make it a really difficult experience when you do eventually have to publicly present work. It can create a huge amount of anxiety if it's not something you're used to doing. I was speaking to a student from the Fashion and Textiles department in the run up to their big fashion show in third year. She was trying to get shots of people's work to put on social media and create a bit of hype around the event, and people were saying,

'Don't put that online.' People were really anxious about how their work was going to be perceived. I'm speaking from one student's perspective of course, but I guess if there's not a lot of opportunity built into courses to publicly present work, when it does happen, it's really intense...

Lewis: Yes, it's funny, because in terms of GSA, that kind of engagement seems non-essential. For me, I think that's really interesting – like social media, having a website and stuff like that. As soon as you graduate, you really realise that there's no way that anyone could see me unless I build these connections.

If a painter paints in a studio and no-one is allowed to see it, is that painter painting at all?

[laughter]

That's the New Age Philosophy course!

[laughter]

Kirsty: Yes. I think there's something about it being holistic. It's not an add-on.

Again, when I was an undergraduate, my conception of making work was me in my studio or in the workshop. It was tied to a very specific mode of production, and the aspect of actually showing the work, presenting it or thinking about how the context of it changes when it is publicly presented, was just not a facet that was really introduced until the point where you were having to do it.

Lewis: Yes, because I definitely stumbled upon it. There was nothing there to direct you towards understanding the difference between having work in one place and having it in another, or having an audience as opposed to a peer group, which is completely different. It's just all those millions of different ways that can subtly change something without actually changing the physical object. That needs to be more accessible within the curriculum I think, because it's the context. It's entirely the context of making.

Kirsty: When do you learn to appreciate that that's important? I guess that's why I feel quite strongly about what we provide as an organisation for the students.

I had such a limited way of thinking about what I was doing that I didn't even realise with some of these opportunities that weren't strictly part of my curriculum, how valuable they would have been to my development. It's a feeling of loss that I wasn't able to recognise that. So how are you supported to recognise that? That's maybe more of a challenge. You can put it in the curriculum, but whether people...

Lewis: Yes, but it's never going to be the same as actually doing it.

Kirsty: Yes, and having that feeling of learning for yourself that actually, this *is* important.

Lewis: Yes. It has to be 'trial and error', really, doesn't it?

Kirsty: Yes.

We have used the term professional practice quite a bit in this interview. Is professional practice something that the Students' Association is directly trying to support students with?

Lewis: I think the term 'professional practice' gets a bad rap.

Kirsty: Yes, definitely.

Lewis: It gets viewed alongside 'employability' and all these sorts of things that are being done through the institution but that are add-ons to what you practice. What the Students' Association wants to do more is to get students to think about their practice in relation to the public that also inhabits this space.

Kirsty: It's also on the student's own terms as well. There are loose structures in terms of a funding application or a project space proposal, but it is really the students that shape what those opportunities are. We're not necessarily dictating how the spaces should be used. Students are able to mould those opportunities to what's useful in the context of their own practice. That feels like more of an important distinction. If you imagine this opportunity being in the curriculum and it being more standardised, it would have to be applicable to more students. I don't know, maybe that's a generalisation.

You picked up on the terms, 'employability' and 'enterprise'. What do you think of those terms?

Lewis: I think they're too much associated with TV shows like *The Apprentice*[4] – that's what people think about when they hear those terms. The way I understand entrepreneurship, employability and all that kind of stuff is 'opportunism'. It's the ability to make the most out of an opportunity or to see an opportunity, which I think we're very good at.

Kirsty: I guess it's challenging within the context of the art school. I think people associate those terms with a very distinct political ideology. From a personal perspective, it's attached to a very specific form of rhetoric that I don't think applies to how I would conceive of my practice.

It's challenging because a lot of what art schools talk about is this idea of creating a community, or there being a creative community. What terms like 'employability' or 'enterprise' suggest is something that is competitive. What does that mean when you're trying to nurture a community but then there's also this layer of competition that's inflecting it and impacting on it? It feels a bit incongruous.

At the Glasgow School of Art, there is an emphasis on, 'the people you're studying with, your peers and your community, that is the most valuable resource you have as an artist.' It's really important to find ways of maintaining that opportunity for discourse, post-graduation, but then the 'competition' aspect disrupts that or creates new tensions, and people feel disenfranchised.

Lewis: It goes back to the idea of the school promoting a certain type of artist, and this idea of competition only fits a certain type of artist. Employability, in terms of art practice, only fits into certain aspects of creative work. If you walk around the degree show, you see these massive plaques where people have won prizes and stuff like that. How can you not recognise the competitive aspect of that?

It's a value system. It's a grading system, in terms of, 'This is good. This is bad,' but no one is actually talking about what it means to grade work.

Kirsty: I think it also suggests its own definition of 'success' as well.

Lewis: Yes, it's financial success.

Kirsty: Yes. I know lots of people who are incredibly successful and show very regularly, but that's not their source of income: that's not how they support themselves financially. So then, what is the measure of success in terms of that relationship to employability? These are difficult relationships between things that are really complex, and I guess it's the feeling that the language doesn't capture that complexity and that it in fact flattens these discussions.

Lewis: At the end of the day, 'employability' is about promoting financial success, I think.

Kirsty: It's not to then say it's wrong to want to be financially stable.

Lewis: No, I think it's a good thing in a sector which is so financially unfair for the people within it, but it's then hypocritical of a sector where they'll build this 'employability' agenda but then, they're also encouraging you to get unpaid or precarious work.

Kirsty: Well, it's mainly because of who that precludes from those opportunities. I am a practising artist, but I'm also maintaining full-time job.

Lewis: Well, the same here, yes. I cannot maintain my practice as much as I would like because I have a full-time job. I am employed, but what does that mean?

Kirsty: This whole entrepreneurial thing is also tied to your ability to extract value from yourself and present that in a specific way. I find that quite challenging as well.

Lewis: Definitely. There was an article recently that said the most successful people in the arts world are the people who talk about themselves, which is very true. I remember a friend saying that her New Year's resolution was to be more arrogant, because it works.

Kirsty: It's a horrible perception that you need to be a certain kind of person to 'make it'.

For those coming to art school from a low-income background, earning a living after art school is a pretty big priority. Is there any tension between this and the tension in art schools around the language of employability and enterprise?

Kirsty: Yes, I think there definitely is a tension. From a personal perspective, I come from a working class background. I'm the first person

in my family to go to university. I worked all the way through my under-graduate and my master's. It's really difficult. Although I was fortunate in being able to get bursaries and financial support from different organisa-tions, there were points where I was still working 30 hours a week on top of doing a full-time master's course in order to earn enough. There was a load of extracurricular stuff I could have done at RCA, but because of the financial pressure of needing to pay rent, pay fees, and have money for materials, I wasn't always able to participate in those things – that tension was always present.

Whilst I do really enjoy the job that I'm doing, it's essentially a way of supporting my practice. I think the thing that's difficult about the 'employ-ability and enterprise' agenda is the fact that it's taught as if it's independent from the job market. It deflects the responsibility of being employable onto the individual student. It doesn't really take into account the fact that there aren't jobs, and if there are, they're part-time and/or temporary contracts.

Lewis: I remember in the fourth year, as a student, we took a tour around the Modern Institute gallery. If you want to sniff out the money, you go down to the Modern Institute. It was Victoria Morton's show and Victoria Morten was doing a Q&A session. I remember as a class, that we were in the fourth year and we were all thinking, 'Logistically, how do you make money from your practice? Is that even attainable?' Who do we ask? Victoria Morton. She is someone who is doing that. Then, as soon as you ask the question, 'How are you funding yourself from this? How does it work?' As soon as you ask that question, it's deflected. It's like an embarrassing thing for a group of students to ask an artist.

For us to ask her that was embarrassing for her, and I don't think that should be the case. She was almost like, 'Oh, God, I know that so many people are not doing what I'm doing.' She was more talking about the people who weren't able to do it than those who were. I don't know. That stuck with me, that point – that the people who are able to fund themselves from their art are almost embarrassed to do so. I don't know why, but a very touchy issue for a lot of artists is money, and how money works in relation to their practice.

Is it selling out then, to sell art?

Lewis: I think that was what she was alluding to. 'I haven't sold out. I've just sold my paintings.' She was talking all about what themes went into the work and stuff, but for us students listening it was like, 'We're past that now. I don't care anymore. I just want to know how to...'

Kirsty: ... How you make it work?

Lewis: Yes. 'How do I make it work?' I can do all that 'statement' stuff. I can do all that talk, but in terms of actually doing it... she was just saying it was 'luck'.

I found it really awkward because I was quite like, 'I'm not going to attend some of these professional practice classes because one, they're not aimed at me because I don't make work like that and two, I don't believe they're going to be propelling an idea of actually how to sustain the work. They're just going to big up this idea of "feast and famine" – that's how an art school is, always has been and always will be.' We never even get taught how commercial gallery systems work. You have to figure that out by getting burnt.

There is no talk of paying artist campaigns and stuff like that. There's no talk of any of this. I don't know. I found it really bad, the way the money was talked about in terms of art. For me, it was like, 'Right, I've got to continue paying my rent. That is my main, prime objective.' They don't focus on the idea that anyone won't have a job outside of their career in the sector. They're like, 'Oh, if you've gone to the Art School, you will always be an artist, a graphic designer or an architect.' It was like, 'That's not how the real world works.'

Kirsty: Well, you can still be those things, but more often than not, you also have to be something else alongside that.

Lewis: That's what I mean.

Kirsty: Again, it's how these things become bound together in terms of employment and financial reimbursement. Everyone, I guess, has different strategies.

Lewis: Yes, and about the value of yourself as well as the work.

Would you recommend art school for people who are not from a particularly wealthy background, particularly if they're having to pay fees?

Kirsty: I'm obviously fortunate that I'm Scottish and was able to study at a Scottish institution, but going to the RCA, if I was having to pay what the fees are now... I could barely pay what in retrospect was a very small amount of money. It's not even just about paying the fees. It's supporting yourself. It's the material costs. It's the cost of producing stuff, buying books, and all of that.

Lewis: Yes, it's hard to say to someone, genuinely, 'You should do this because it's a really open education and you'll learn new things.' It's hard to say to someone to do that when there's no guarantee of security. Then, that's the same across everything. It's not just about going to art school. It's about going into higher education in general.

Kirsty: You could do something that is more traditionally vocational and still not be guaranteed a job.

Lewis: Yes, it's really odd, isn't it? They're trying to promote everyone going into higher education, and then there's this massive inflation in terms of places and students in higher education. I came during the last year of the subsidised fees for UK students. That was the cheapest option for RUK, I would not have come to the Glasgow School of Art if I was born a year later.

What would you have done?

Lewis: I think I would have probably focused on doing something in the Humanities department. I would have still gone to university because that felt like the done thing. When you're at sixth form it's assumed you are going to university, but there's no understanding of the HE sector when you're in sixth form. My school didn't even know that you had to do a foundation course if you were planning on studying Fine Art. That's why I got in here, pretty much, because they did an optional first year. I got rejected from everywhere apart from Glasgow School of Art, because Glasgow School of Art included a foundation.

Kirsty: My school had a very broad demographic, so it wasn't necessarily assumed that everyone would go to university. I always knew that I wanted

to study art, and I remember even my guidance teacher saying, 'Oh well, Kirsty, that's very competitive. Maybe you should look into doing some other subjects as well, just as a back-up.' This was before she'd even spoken to my art teacher. Then she came back to me and said, 'Well actually, your art teacher says that you're very good.' When none of your family or parents have gone to university, you don't know what it's going to be like. You have no clue.

Lewis: Yes, it's really funny, because I'm also one of the first of my family to go university. My dad started a course at the Open University but never completed it. I got home and my mum said, 'Oh, are you sure you want to do that? Not much money in it.' I was telling her that I was not going to remain as the student president for another year and she was like, 'Oh, security is the most important aspect of anything.' I think that's a really alien way to think about things.

1. The Assembly Hall is the 500 person event venue at The Art School. Alongside hosting gigs and clubnights from the commercial programme, the Assembly Hall is also regularly used for workshops, performances, and student projects.

2. An exhibition of the work of design graduates from across the UK – held in London.

3. The Student Representative Council (SRC) are the group of elected student representatives that oversee the running and development of the Students' Association. The SRC is formed of students from across all disciplines, programmes, and levels of study at Glasgow School of Art, from first year through to PhD study.

4. A popular reality TV series whereby 18 candidates compete over the course of 12 weeks to win £250,000 investment in their business and a chance to partner with businessman Alan Sugar.

THE FALMOUTH SCHOOL OF ART, FALMOUTH UNIVERSITY

Dr Neil McLeod is BA (Hons) Fine Art Course Coordinator at The Falmouth School of Art, Falmouth University. Neil provided a written response to our questions.

Can you give a description of the area in which your course and the art school is located?

Cornwall, the county in which Falmouth is located, is picture postcard stuff – beautiful landscapes with Famous Five beaches,[1] brooding Poldark[2] moors, sou'westered fishermen and aproned fisherwomen with their mackerel catch. It's heady stuff, captured in time by the romantic daub of oil paint or the poet's scribble. But there's also the scarred post-industrial landscape, unemployment, the second holiday homes of 'outsiders', the emptying seas. In and among these conflicting currents are the artists and writers who across the decades have made Cornwall their own – some working towards the idyll, others responding to political and cultural pressures at local and international level. It all amounts to a diverse but thriving arts community, or rather communities, supported by critically engaged public and private galleries and, of course, The Falmouth School of Art – where visual arts have been practiced for over a century.[3]

The fine art studios themselves are located within a subtropical garden environment in close proximity to the beach. This is a draw to many aspiring students.

Can you tell us a bit about the BA Fine Art course and how it is structured?

Students are encouraged to develop their own practice which may be process specific or interdisciplinary. Early on in the course students

take part in introductory studio-based exercises and workshops in a wide range of media including drawing, painting, print-making, performance, writing, installation, 3D, video, digital, and lens-based. As they move through the course they begin to define their own specific interests and develop skills in their selected process or processes. Increasingly students work collaboratively, and we aim to support whatever they pursue. Critical studies and reflective practice modules provide opportunities for written assignments and help students to contextualise and analyse contemporary arts practice. Teaching consists of individual tutorials, group discussions, critiques, technical workshops and student-led initiatives in exhibitions and presentations of work.

Who attends the course?

There are between 80 and 100 students per year group; they are selected at interview. Applicants to the course are mainly white British, with more female than male, and tend to be between 18 and 22 years of age. There are a small number of mature students, a few EU students, and between six and eight international students per year. We are looking at ways in which to encourage a greater diversity in our student profile.

Outreach has always been an important part of the art school. Going back decades before the term 'widening participation' was coined, fine art lecturers could be found running workshops and projects with local schools.

How do you prepare students for life after art school?

I think that professional practice is something that happens every day in the studio, when researching or when writing. I say this because I think the really important professional practice often happens through 'soft' learning. We do provide a range of supporting seminars such as creative writing and research workshops, but one of the most important professional practice skills a student needs is how to deal with that blank canvas in that blank studio space on a Monday morning.

Having said all that, we have created some aspects of the course specifically to cater for this area:

- We have strong links with local industry partners such as Tate St Ives and Newlyn Art Gallery & The Exchange with whom we run work experience programmes throughout the three years of study.
- We run professional practice seminars throughout second and third year that cover practical subjects like how to make funding applications, health and safety and presentation skills. And we have seminars by established and recently graduated artists and curators. These seminars cover a broad range of topics that are determined by the speakers, discussing topics such as exhibiting, residencies, the gallery process or internship opportunities.
- We have a Transition Project for final year students. As part of this:
- We run a top-up series of seminars by established and emerging artists and curators in the weeks leading up to the degree show.
- Students can also apply for two residencies, each a month long, at Porthmeor Studios in St Ives and the Back Lane West Studio in Redruth. They both take place after graduation.
- We have a three-month graduate residency at Spike Island in Bristol.
- We offer one or two deserving students post-study scholarships for professional practice, for example we have one that supports a student for a year after study to set-up as an artist. They are selected through an application process which is open to all final year students.
- At the end of their degree show around 30 students are invited to participate in a London showcase event. The work is selected by curator and writer Sacha Craddock and the show is curated by Jesse Leroy Smith. We see this London link as very important because it takes some of our degree show out of Cornwall to a wider audience. It also allows students to collaborate with each other and industry professionals following the time they've spent in intensive focus on their own work for final assessments.

Most of this is extracurricular but can form part of a student's portfolio of supporting work.

What do people do when they leave your course? What is a 'successful' graduate?
The whole point of the course is to help students identify their real areas of interest and discover what they want to do with their lives. To this end, the possibilities for the students and their futures is almost limitless. We do not favour any particular routes but rather, through a close working relationship with the student, we aim to equip them with the necessary skills and experience to pursue their ambitions. As well as developing technical knowhow, the more intangible skills can include problem solving, multitasking, working with limited resources, dealing with uncertainty, and developing a different way of looking at the world.

Many students seek a future in the arts, either directly as an artist or indirectly through an arts related career such as curating or teaching. Some students decide upon a completely different career route or indeed, no career route at all. Even in these cases I hope our graduates find their lives enriched by the experience of studying fine art. Various surveys have shown that an arts education often leads to a high level of life satisfaction. This is perhaps as good a definition of 'success' as the more tangible signs of career achievement.

What and who is a fine art education for today?
A fine art education is for anyone with an inquisitive mind who has a desire to channel this questioning disposition into and through the arts. The reality is that a fine art education remains largely a middle-class enterprise, and arguably this is becoming ever more so since the introduction of student fees in England and the removal of bursaries for those from low income households.

What do you think is the role of the art school in society?
If the question is specifically in terms of fine art, then the role is the same as ever – to encourage and equip people who, through the arts, will

demand that political and social givens are always questioned. That there is affirmation (of life, personal goals, the ability to express oneself etc), and that culture is enriched by these contributions. It has long been acknowledged that a fine art education adds value to other professions and forms of employment.

1. As portrayed by English children's book author Enid Blyton in her *Famous Five* book series.
2. British drama television series filmed in Cornwall.
3. The Falmouth School of Art, now part of Falmouth University, takes its name from the original art school at Falmouth, which was founded in 1902.

MANCHESTER SCHOOL OF ART, MANCHESTER METROPOLITAN UNIVERSITY

Brigitte Jurack is Head of Sculpture and Time Based Arts on the BA (Hons) Fine Art course and a Research Leader in Art at Manchester School of Art, Manchester Metropolitan University. Brigitte provided a written response to our questions.

Can you describe the area in which your course and the art school is located?
Manchester School of Art is located on the Oxford Road Corridor in Manchester. The Fine Art course has its studios in the purpose built 19th century art school, which also houses the Holden Gallery. Manchester has become a modern post-industrial city, with two mayor universities contributing significantly to the city's national and global significance.

The art school is in the centre of town, where surrounding Victorian warehouses have been transformed into inner city apartments. Greater Manchester still has a lot of 'sleeping giants' (empty mills and warehouses) and remains industrially very active. Even within the vicinity of the art school, students have found vacant buildings and railway arches in which to stage exhibitions and events. Manchester and Greater Manchester have a thriving art scene, and students access this through word of mouth, social media, the Skinny[1] and Manchester School of Art's long standing co-operations with the key providers in the city.

Beyond the densely populated area of the conurbation lies some of the wildest and bleakest countryside: Saddleworth Moore, the Transpennines, and the Peak district.

Do you know of any links the art school has or has had with the local area?

Manchester School of Art is the second oldest art school in the country. It opened in 1838, the same year as the Royal College of Art, and was initially founded to provide the growing industry of Manchester with the creative, avant-garde and skilled workforce that enabled the city to be at the forefront of innovation in manufacturing, craft and industry. At that time, the art school provided the education and training of sign writers, mural artists, stained glass artists, painters, sculptors, textile artists, potters, industrial photographers, actors, architects and engineers. The link to the city and the local community has continued. Whilst methods and materials of making, teaching methods, and curricular have changed, Manchester School of Art, its staff and its students still work across the Greater Manchester conurbation. We contribute to the city through placements; research; public commissions, programmes and lectures; outreach activities with schools, and participation in city-wide art festivals.

Can you tell us a bit about the structure and philosophy of the BA Fine Art course?

Fine Art is a studio-based course – in full acknowledgement that the street, the edit suite or the library can also be considered the studio. At the heart of what we teach lies the development of ideas and work in a critical feedback environment. Inductions into analogue and digital making technologies take place alongside studio work, as do field trips and gallery visits, and taught classes on the history of art. Following an indicative period of four weeks at the start of the programme, students work either in Painting and Print Media studios or in Sculpture and Time Based Arts studios. At level 5 students enrol in courses such as *Architecture and Sustainable Futures, Art and Society* or *Art and Film*. At level 6 students write an extended essay or devise an extended project. Throughout the course, students spend 75% of their time in the studio and 25% in lectures and seminars. As well as tutorials and group teaching, we also have studio based masterclasses and thematic workshops that provide cross-year and cross-area teaching and learning.

We believe that teaching should be research led and as such all staff are either artists understanding their particular practice as research or they are art and visual culture historians and curators, who research existing practices. The methodologies and methods employed, and the knowledge gained, are taught at all levels of the course. Students participate in research-led conferences, for instance, a recent *Teaching Painting* conference organized by the fine art painting staff.

Who attends the course?

We have about 90 students in each year group. About 35% come from Greater Manchester and the North West, about 3% come from Northern Ireland, 3% from North Wales, 7% from the North East, 24% from London, 20% from the Midlands and the West Country, 2 % international, and 6% from Europe. About 8% are classed as mature students (over 25) and about 60% are female. Diversity has increased (BME 14%) but does not yet reflect the diversity of Greater Manchester.

How do you prepare students for life after art school? Do you have any distinct professional practice units?

First of all, let's consider what we mean by professional practice. If we consider Donald Schön, John Dewey and James Elkins, it is evident that we mean a combination of tacit knowledge accumulated through practice, theoretical knowledge and practical skills.

I like to look at a GP (medical General Practitioner) for comparison, whose professional practice is the ability to make a diagnosis based on gained theoretical and practical knowledge, expertise *and* through verbal and sensual dialogue with the patient. Professional practice for an artist thus would mean that I, the maker of, let's say, a sculpture, performance or painting, the designer of a building, the planner of a town, would be able to make a diagnosis in regards to the progress and completion of the artwork (drawing, plan, performance or sculpture) based on gained theoretical and practical knowledge, expertise, through verbal and sensual dialogue with the artwork/design, and if applicable the collaborators and commissioners.

Thus professional practice is first and foremost the practical and theoretical knowledge of medicine (for the GP) or art (for the artist). It's the professional practice of painting, writing, drawing, filming, sculpting, designing, singing etc.

Just like medical schools are beginning to train students in skills which are often described as 'soft skills' but which should be re-named communication and business skills, we, at the art school have embraced communication and business skills training into the curriculum.

The Fine Art course is a modular course and students have to study 120 credits worth of modules each year, which are called units. Throughout the three years, the studio-based units are developmental and interlinked, and so are the theory-based units. Whilst the course is modularised, we understand studying and learning as progressive and developmental, thus the units are large and inclusive of professional practice rather than perhaps a more American system that offers lots of smaller distinct units – for example, a friend in the USA told me they have 10 credit modules in sound art, installation, community engagement, education, drawing, proposal writing etc. This inclusive approach sees professional practice as the application of oneself to the demand of the work in a professional manner – the demand of writing an essay as much as the demand of painting a painting or filming a documentary or conducting primary research.

However, each academic year, all students do study either *Unit X* or *Art and Audience*. These units focus more extensively on the professional context of practice, and include the teaching and assessment of skills pertinent to various professional contexts. By this I mean that the project negotiations, that is, the actual application of the professional practice of organising an exhibition, insurance, publicity, curation, documentation, communication, team work, collaboration, problem solving, proposal writing etc., are assessed as much as the artwork/intervention itself.

Can you tell us a bit more about these units?
Within our Fine Art curriculum, planning and managing exhibitions, communicating to galleries, curators, commissioning agencies, community

groups and businesses has become part of the training throughout the three years of the course:

Unit X at level 4 provides students with an opportunity to collaborate and respond to situations and buildings in Manchester, for example: Northern Quarter, Hulme Hippodrome, and the Museum of Science and Industry (MOSI), culminating in a public off campus exhibition and event.

Unit X at level 5 provides students with opportunities to engage in learning that takes them off campus into schools, National Trusts, MOSI, Manchester City Art Gallery, architecture and design companies in Manchester, Manchester rooftops and Community Groups.

Unit Art and Audience for level 5 and level 6 students focuses on the theories and practices that underpin working and exhibiting in the public domain.

The option of choosing between *Unit X* and *Art* and *Audience* continues in the third year, and whilst it is distinct from level 5 it is underpinned by the same philosophy: to create a study and learning environment that can be shaped by the professional aspiration of the student on the course.

We also stage an annual conference for level 6 students, *Future Now*, that brings recent graduates and professionals, working both as artists and/ or in education, health, finance and the cultural sector, together in a day of talks, breakout sessions and workshops. Speakers might include those from galleries, Art for Health, or Commissioning Agencies. Our staff have facilitated breakout sessions on topics such as 'first steps to self-employment', creative CV's, portfolio presentations, gallery education and funding. Through the range of people we invite, we aim to cover a broad range of approaches in employing one's creativity in the world. A 25-page booklet produced alongside the conference provides a mixture of first-hand accounts of recent ex-students, useful websites, bios, and advice by guest speakers and regular staff.

Regular *Visiting Artist's Talks* and a programme of *Conversations in Curation* for level 5 and level 6 also exist to make processes such as applica-tions, selections, exhibiting, curating, residencies and the development of work outside of an institutional framework tangible and transparent.

Is there anywhere else that students get professional practice opportunities?

Throughout the three years of undergraduate study, students can respond to internal open calls, for which we help students develop their proposal writing skills, interview techniques and costing projects. Examples have included: working as research assistants alongside an artist; developing a public art proposal in collaboration with architecture students; working as part of a team of volunteers in the Holden Gallery; helping to facilitate workshops for schoolchildren and community engagement workshops with researchers; proposing work for public facing Manchester School of Art events and exhibitions, including an exhibition at Parque Lage, Rio as part of the 2016 Olympic Games. These open calls are 'extra curricular', however any work created as part of these can, of course, be submitted for assessment.

As part of the *Unit X* and *Art and Audience* units we also encourage students to apply for such opportunities. Completed application packs can be submitted as an assessable component of the unit, since we have formulated learning outcomes in those units that focus on professional application and aspiration. This really motivates students to actively look for opportunities and to apply themselves to the process of 'pitching an idea'. It also motivates students to understand their art practice in the studio as a professional practice and not just a dry run.

Going back to the medical degrees analogy, the internally advertised opportunities range from those where the student tries out their practice on a test bed (or medical dummy), as close as possible to what it would be like in real, but with the added benefit of immediate feedback and support throughout, to the 'real living and breathing patient' in this case again, with plenty of support, guidance and feedback, but for real.

What do people do when they leave your course? What is a 'successful' graduate?

Over the three years, students develop a much clearer understanding about themselves, their professional expectations and dreams, and what they hope to achieve in the medium to long term. The course is structured in such a way that a range of career paths can be explored by the students whilst they are studying. I think that this is important. Whatever one

eventually decides to do and whoever one eventually decides to become is an emancipatory process that continues beyond the programme.

I studied at the Kunstakademie in Düsseldorf for four years, and I recently met some of my contemporaries from the late '80s, who were signed up by commercial galleries straight after leaving. Some of these contemporaries are now professors, others are struggling in freezing cold studios and others are still working part-time in an office to subsidise their work in the studio. I think all these and many more ways of working are possible.

One graduate from Manchester School of Art has re-made a crumbling building in Almeira, Spain, into an off-the-grid artist residency place, creating an influential programme of artist-led projects and music events that focus on sustainability and repopulation of rural areas. We also have great musicians on the course who sway between signing with a record label and working in the studio.

Not every good bricklayer runs his own business, not every excellent doctor sets up her own clinic, why should we expect this from every good artist, writer or performer? An art student or art graduate, as the question poses, is successful when they are ready to leave, when they have outgrown the art school studios, when they can see and understand why something works and in which context, and when they realise it is their vision and their work and ideas that drive them forward in order to change and challenge the status quo.

Art education is no different from music, medicine and any other subject that is chosen out of passion and dedication. What's different is perhaps the vastness of fine art history, the difficulty of finding and developing one's own practice, the need to spend long hours alone with one's work and the need to get it seen, heard and shared.

What do you think of as the role of the art school in society?
Education is really only education when it is life-changing and as such fine art education is life changing too. Fine art, music, drama, architecture, design, medicine, philosophy, theology, physics, literature are all subjects with similar importance and cultural significance, articulating, and thus

affirming, our humanity and enriching our spiritual wealth. A human society needs the Humanities, which includes art schools. Art does not kill, does not wage wars and does not destroy. Art affirms, celebrates and laments life. Without art we wander in darkness, speechless and imageless. A world without art, poetry or music would also be without humanity. Thus art schools and art education are as essential as air, water and fire.

1. Online and print independent cultural journalism

PARTNER INTERVIEW

a-n

We spoke with Gillian Nicol, Deputy Director of a-n The Artists Information Company, about the organisation's history, aims, activity and what resources it has to support students, staff and graduates of higher education.

Can you tell us briefly about the history of a-n and its aims?

a-n aims to support artists in two ways: in direct practical ways and in ways which make a difference overall to working conditions within the sector. We've been around since 1980 and whilst the means of delivery has changed somewhat over that time – from black and white newsletter to digitally-interactive membership organisation – the core purpose of support-ing artists through connection and advocacy, which we set out in the very first newsletter, hasn't.

We have over 20,000 members – mostly artists but also curators, producers and those that work with artists – making a-n the UK's largest visual artists membership body and a powerful collective voice for artists. It's a not-for-profit company, meaning any money made is channelled back into our membership. Many of the people working for a-n are themselves artists who are based around the UK, ensuring that we reflect practice happening in all different places and are well connected with artist-led activity.

Can you give us an overview of a-n's activities and resources? In particular, how do staff and students in higher education use a-n? Do you have anything to sup-port recent graduates?

a-n has a broad range of activities both online and in the real world. On our website we produce daily visual arts news and host community tools for members to connect and share their work. We run professional development events around the country and a bursary scheme for members. So far this year we've supported 83 artist members with £70k of bursaries, supported

members to develop coaching skills, and supported the first dedicated Visual Artist Fellowship on the Clore Leadership Programme.[1]

Community resources include tools to post blogs, reviews and events, which are all available for student members[2] to use. We help promote this content to the wider world via social media to well over 100,000 people on a daily basis, so it's a great way to make activity visible and to share with peers.

Our resource section covers the logistics of practice including things relevant to new artists like legal and financial information – how to calculate your day rate, setting up as self-employed, using contracts – as well as materials around studios, residencies, self-organising, art markets etc. There are extensive profiles of artists showing the vast variety of career paths and types of practice. We also have Signpost[3] – a 58-page PDF guide aimed at new graduates negotiating the first few years out of higher education and rich with artist-led voices and experiences.

Our resources can of course be used in teaching. There's a wealth of stuff for tutors to back up or inform professional development modules, and we're working on new learning resources specifically for HE now. Some courses encourage their students to make specific use of our blogs and reviews, to learn how to promote and discuss practice, and how to get experience publishing in a professional arena.

We produce a guide to around 70 different degree shows across the UK each year. This promotes students' final shows far and wide, and often highlights the work of students who've been blogging for a-n throughout the year.

Can you tell us about a-n's research and advocacy – including your current work on artists' pay?

The huge critical mass of our membership and the input from our artist advisory council gives us an amazing ability to seek out the views of artists in order to be a strong collective voice on their behalf. It also means we get strong evidence back about what artists want and need.

A core part of our work is to advocate for better working conditions on behalf of our artist members. Research in 2013, for example, identified that

71% of artists were not receiving payment for exhibiting in publicly funded galleries. This led to us forming the Paying Artists campaign[4] in 2014, and after extensive consultation and testing with artists and artist-led galleries and funders we're publishing a definitive Exhibition Payment guidance in October 2016.

Our well-known public liability insurance came about after our research identified the huge need for affordable and relevant insurance over ten years ago. We've worked really closely with our brokers to make sure the cover includes all the kinds of things artists often do, and then some. They're unlikely to be shocked by anything they're asked to insure now!

Most recently we surveyed our artists around the impact of the UK's vote to leave the EU, and we're just completing the biggest research project into artists' livelihoods to have been tackled for over ten years for Arts Council England. The findings from that will help us advocate even more strongly for our members.

Do you have any resources to support those who might choose not to be artists but to go into other related careers after their fine art education?

For those that go on to work with artists in curatorial roles, many of our resources will be relevant. Our Artists' Fees Toolkit, which helps calculate a daily rate, is of equal use to other types of freelancers. We have a specific membership for arts organisers which includes access to Creative Freelance Insurance, a unique insurance that recognises the varied and portfolio nature of freelance working in the visual arts.

1. A training leadership development programme for selected individuals in the creative sector. See: www.cloreleadership.org/ (Accessed September 15, 2016).

2. For HEIs with a JISC licence, students can access a-n member resources for free and sign up for a free individual student membership (usually £15). This membership allows them to fully use the site's community aspects and access job listings. Find out more at www.a-n.co.uk/join

3. See: www.a-n.co.uk/signpost (Accessed September 25, 2016)

4. See: www.payingartists.org.uk (Accessed September 25, 2016)

GLOSSARY

The following terms are referred to a number of times in the interviews:

A-levels: The A-level (advanced level) is a secondary school or sixth form leaving qualification offered in England, Wales and Northern Ireland, typically taken at ages 16–18.

Advanced Highers: The Advanced Higher is an optional qualification which forms part of the Scottish secondary education system. It is normally taken by students aged around 16–18 after they have completed Highers, which are the main university entrance qualification.

Crit: A crit is a model of learning whereby artists present their work to a group in order to gain feedback on how that work is being 'read' and ways that they might develop it further. Crits are part of almost every art course at further and higher level education in the UK. For more on crits see: Rowles, S. (2013). *Art Crits: 20 Questions.* Q-Art. London.

The Curriculum for Excellence: 'The Curriculum for Excellence is designed to achieve a transformation in education in Scotland by providing a coherent, more flexible, and enriched curriculum from ages 3 to 18. The curriculum includes the totality of experiences which are planned for children and young people through their education, wherever they are being educated. Its purpose is to enable each child or young person to be a successful learner, a confident individual, a responsible citizen and an effective contributor'.[1]

Destination of Leavers from Higher Education (DHLE): The Destination of Leavers from Higher Education Survey collects information on

what all leavers from higher education programmes are doing six months after qualifying from their course. The data from the survey is published as part of institutional performance indicators, and like the National Student Survey (see below) it is used to provide information for prospective undergraduate students through the Unistats website (www.unistats.direct.gov. uk) as part of the Key Information Set (the information which students are reported to say they find most useful when deciding which course to study). In England the DLHE survey is a condition of HEFCE grant funding.[2]

The English Baccalaureate (EBacc): The English Baccalaureate is a school performance measure that was introduced in 2010. It allows people to see how many pupils get a grade C or above in the core academic subjects at key stage 4 in any government-funded school. In the EBacc, core academic subjects are defined as: English, mathematics, history or geography, the sciences, a language.[3] The exclusion of arts subjects from the EBacc has led to widespread concern, campaign and petitioning against the government from the arts sector and beyond.

Erasmus: Erasmus is an EU exchange programme, providing foreign exchange options for students studying within the European Union. It is currently uncertain what impact the UK's vote to leave the European Union will have on the programme.[4]

Further Education (FE): Further education includes any study after secondary education that is not part of higher education.[5] The Diploma in Foundation Studies in Art & Design and the Diploma in Foundation Studies in Art, Design & Media are a further education qualification designed to help students make informed decisions and facilitate their progression into higher education in the subject.

Higher Education (HE): Higher Education courses are for those over 18 years of age and are taught in universities, colleges, and specialist institutions like art schools or agricultural colleges. Higher education qualifica-

tions include: diplomas, bachelor degrees, foundation degrees, and post-graduate degrees.[6]

All BA (Hons) fine art degrees, as referred to in this book, are higher education qualifications. In England and Wales these tend to be three-year courses, and often HE institutions will request that applicants have undertaken an Art & Design Foundation course (see above). In Scotland fine art degrees are four years long. There are no Foundation Art & Design courses in Scotland and so students will typically enter directly from school into year one of the course or directly into second year if they have a Foundation qualification from England or Wales. In the interviews, the staff at institutions in England and Wales refer interchangeably to the years of the degree as follows: Level 4 = Year 1, Level 5 = Year 2, and Level 6 = Year 3.

Higher Education Funding Council for England (HEFCE): Promotes and funds teaching and research in Higher Education Institutions in England.

National Student Survey (NSS): The NSS is a national survey of nearly half a million final year undergraduate students across the UK, which has been conducted annually since 2005. It asks students for feedback on what it was like to study on their course. The results are published annually on the Unistats website,[7] which is designed to allow prospective students to compare information across higher education courses.[8]

Open Day: A day when prospective students can visit an institution that they are considering studying at.

Research Excellence Framework (REF): The Research Excellence Framework (REF) is a system for assessing the quality of research in UK higher education institutions.[9]

Teaching Excellence Framework (TEF): The government is due to introduce a Teaching Excellence Framework to monitor and assess the quality of teaching in universities.[10]

Widening Participation (WP): Widening Participation is a government-driven initiative to increase the number of students from underrepresented groups participating in higher education.[11]

1. Source: Education Scotland. (2016). *The Curriculum in Scotland.* Available from <www.educationscotland.gov.uk/learningandteaching/thecurriculum/whatiscurriculumforexcellence> [Accessed September 19, 2016].

2. Source: HEFCE (2016). *Destination of Leavers from Higher Education Survey.* Available from <www.hefce.ac.uk /lt/dlhe/> [Accessed Sept 8 2016].

3. Source: GOV.UK. (2016). *English Baccalaureate.* Available from <www.gov.uk/government/publications/english-baccalaureate-ebacc/english-baccalaureate-ebacc> [Accessed Sept 8th 2016].

4. Source: *Erasmus Programme.* (2016). *Home.* Available from <www.erasmusprogramme.com > [Accessed 13th September 2016].

5. Source: GOV.UK (2016). *Further Education Courses and Funding.* Available from <www.gov.uk/further -education-courses/overview> [Accessed 13 September 2016].

6. Source: GOV.UK (2016). *Higher Education Courses.* Available from <www.gov.uk/higher- education-courses-find-and-apply> [Accessed 13 September 2016].

7. See: www.unistats.direct.gov.uk [Accessed October 2, 2016].

8. Source: The Student Survey. (2016). *About the NSS.* Available from <www.thestudentsurvey.com/about.php> [Accessed 8th September 2016].

9. Source: REF. (2016). *Research Excellence Framework.* Available from <www.ref.ac.uk> [Accessed September 13 2016].

10. Source: Times Higher Education. (2016). *Teaching Excellence Framework: Everything you need to know.* Available from <www.timeshighereducation. com/news/teaching-excellence-framework-tef-everything-you-need-to-know > [Accessed Sept 8th 2016].

11. Source: Brunel University London. (2016). *Widening Participation.* Available from <www.brunel.ac.uk/about/ administration/widening-participation> [Accessed 13 September 2016].

FORTHCOMING PROJECT

What follows is an extract from the first in a series of interviews
with recent fine art graduates in towns and cities across the UK who are
actively contributing to the development of their local art scene. The project
aims to provide inspiration to current and prospective art students.

Q-Art is working on this project with Marie Taylor and Amelia Webster,
both third year undergraduate Painting, Drawing & Printmaking students
at Plymouth College of Art.

Marie Taylor & Amelia Webster are third year undergraduate Painting, Drawing & Printmaking students at Plymouth College of Art. In April 2016 they visited Transmission Gallery in Glasgow, an artist-run organisation that was set up in 1983 by graduates of The Glasgow School of Art. They interviewed its current committee members: Joe Sloan, Sophie Pitt, Adam Lewis-Jacob, Andrew Black and Winnie Herbstein.

How does the committee structure work?

Sophie: There's a rolling committee. There are six people in the committee at one time and they each stay for two years. Those in the committee are completely in charge of what goes on. As such the aims of Transmission are constantly in flux.

Are you able to articulate the current aims?

Joe: Well, it's an artist-run gallery. The programme doesn't have one particular aim or thing that it always wants to represent, but the space is supposed to function to support other artists in Glasgow to make their work and provide a platform for them. Maybe that is part of our ethos – supporting others in the city.

Winnie: We have equipment and editing facilities, televisions, cameras, plinths, woodwork items, and stuff like that that are used a lot by our members. I think that once you are out of an art institution, it becomes far more difficult to access that sort of thing. For me, one of the most important things that Transmission does is to provide equipment like that. You can become a member by either doing a day in kind helping out in the gallery, or it's £10 a day if you're not earning a wage, and £20 a day if you are.

How is the space funded?

Sophie: About 80% of the funding comes from Creative Scotland and 20% comes from Glasgow City Council.

Are you paid as committee members?

Winnie: I think one of the things that has stayed important here is that everyone apart from the committee gets paid and there is a monetary exchange for people in the space, for example if they are doing a talk or show we try to pay them as promptly as possible.

Andrew: We are volunteers.

So how do you find a balance between being on the committee, maintaining a practice – if you do – and trying to earn a living?

Adam: It's different for everyone. I don't have a studio and so I use this space sometimes. I'm also working freelance and temporary as well as signing on, which allows me some free time in a way I wouldn't necessarily have if I was working 9am to 5pm Monday to Friday.

I don't think it's a perfect situation though. As well as spending a lot of time here I also work in a kitchen, which is very demanding and so I don't have much energy at the moment. I certainly don't have any time to practice – but I hopefully will do soon. It's about finding the right balance. It's not always perfect having to be here for a minimum of two days a week, unpaid. But, it's part of the constitution and the constitution is what makes Transmission's structure what it is.

Joe: The reason that Transmission started this way was because there was a thing in the '80s to fund young art graduates to have a practice. So as well as getting the equivalent to Job-Seeker's Allowance, they also got a studio space paid for and money towards being an artist. It's that entrepreneurial thing of getting you to see your art as business. That's what Transmission was enabled by, as there was money there. Whereas now…

Do you think you were well prepared by your course for life after arts school?

Winnie: It probably differed a lot between different departments.

KEEP UP TO DATE

The remainder of this interview will be published at a later date. To keep up to date with news of this and other Q-Art projects sign up to our newsletter at www.q-art.org.uk, or follow us on Twitter and Facebook